SPLENDORS OF THE SEAS

THE PHOTOGRAPHS OF NORBERT WU

SPLENDORS OF THE SEAS

THE PHOTOGRAPHS OF NORBERT WU

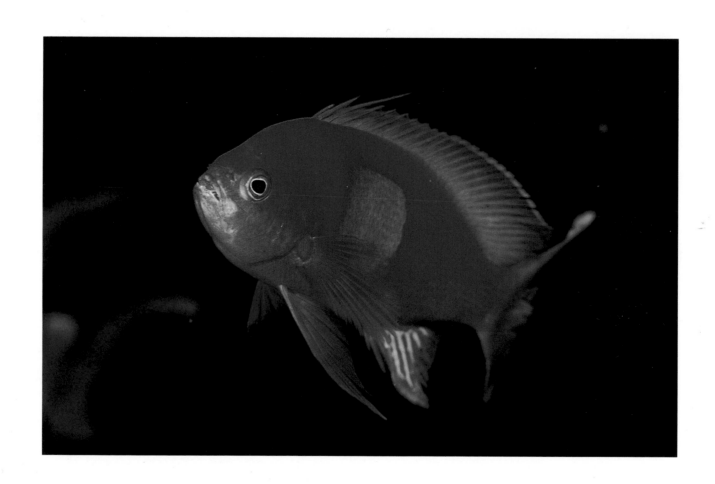

HUGH LAUTER LEVIN ASSOCIATES, INC.

To all the people who have

shared their love and knowledge

of the sea with me.

Design by Lee Riddell
Illustrations by Priscilla Marden
Printed in Hong Kong

ISBN 0-88363-594-1

Jacket front: A coral grouper sleeps among yellow clump corals. Sipadan Island, Borneo.

Jacket back: Schooling hammerhead sharks. Cocos Island, Costa Rica.

A diver swims through an immense coral canyon. In rare places, a split in a coral reef may leave huge fissures. Roatan, Honduras. / 2

A male square-spot Anthias patrols its territory off a coral dropoff. Males are females that have changed sex. Sipadan Island, Borneo. / 3

ACKNOWLEDGMENTS

It would be impossible to thank everyone who has contributed to the making of this book. For those of you who have so graciously lent your time, energy, and facilities to the making of the photographs and experiences in this book, thanks from the bottom of my heart.

In particular, I would like to thank my diving buddies and friends, whose time together I will always treasure: Howard and Michele Hall, Peter Brueggeman, Brandon Cole, Mark Conlin, Ken Corben, Bob and Cathy Cranston, Andy Day, Dr. Leon Hallacher, Lori Jackintell, Burt Jones and Maurine Shimlock, Henry Kaiser, Charles Lindsay, Matt Murphy, Sam Shabb, Marty Snyderman, Dan Walsh, and Spencer Yeh. I would also like to recognize Dan Auber, Marjorie Bank, Hal and Shirley Brown, Tom Campbell, Steve Drogin, the Day and Ellis families, Nancy Jacobs, Randall Kosaki, Emory Kristof, Mike and Sherry McGettigan, Mark Olson, Rogelio Pedraza, Doug Perrine, Joseph Stancampiano, Bret Walker, and James Watt, who have all helped me with my photography or with my travels through the world. Thanks to my family — my parents, Bing Mah, Alberta and Lance Choy, and Deanna Mah — for their love and support through this strange career of mine.

It is a rare pleasure to encounter institutions that embrace outsiders. The wonderful people at the Steinhart Aquarium and California Academy of Sciences in San Francisco, particularly Dr. John McCosker and Ed Miller, have always made me feel welcome. Dr. Jack Engle and the Tatman Foundation deserve a standing ovation for their dedication to research and education. At Scripps Institution of Oceanography, Dr. Richard Rosenblatt, Dr. Ken Smith, and H. J. Walker allowed me to become involved with their projects, as did Dr. Richard Harbison, now of the Woods Hole Oceanographic Institution. Thomas Linley, park manager at the Homosassa Springs Wildlife Park, allowed me to photograph their manatees. Special thanks to Glen McGowan and Pt. Lobos State Park, who facilitated my work in their underwater preserve and rescued me and my boat one memorable day. The folks at Rolex Corporation and Our World-Underwater in Chicago helped me jump-start my career, and Ernest Brooks allowed me to study at his Brooks Institute of Photography.

I have always been heartened by the energy, commitment, and generosity of the crew of diving operations. In Borneo, one of my favorite wild places, I give special thanks to Ron Holland, Jon Rees, Samson Shak, Peter and Paul Sugiono, Graham and Donna Taylor, and the staff of Borneo Divers. I've had wonderful times and diving courtesy of the following operations: Heron Island Resort in Australia; the *Dream Too* and Dive Dive Dive in the Bahamas; Captain Morgan's Retreat in Belize;

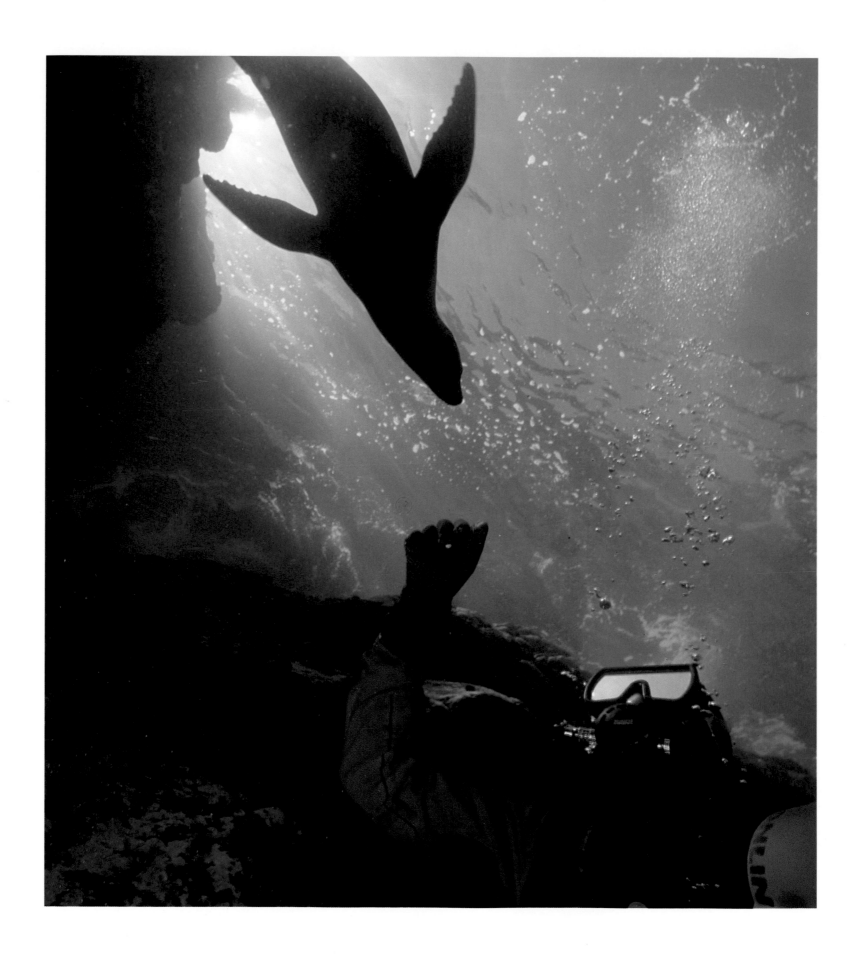

the *Temptress* and *Okeanos Aggressor* in Costa Rica; Dive Taveuni, Ocean Pacific Club, and Sea Fiji in Fiji; the *Galapagos Aggressor* and *M/Y Eric* in the Galapagos; the *Clavella* in the Queen Charlotte Islands; the *Ghazala II* and the *Perla* in the Red Sea; the *Isla Mia*, Anthony's Key Resort, and the Institute for Marine Sciences in Roatan, Honduras; the *Caribbean Explorer* in Saba and St. Maarten; the *Ambar III* in the Sea of Cortez; Seychelles Underwater Center in the Seychelles Islands; and the *Fantasea* and *Crescent* in Thailand.

The following airlines and tourist boards assisted or sponsored my travel to some of the finest diving destinations in the world: the Queensland Tourism and Travel Corporation and Qantas Airlines to Australia; American Airlines, the Belize Tourist Board, and Jeremy Pask Associates to Belize; Malaysian Airlines to Borneo; Aggressor Fleet, LACSA Airlines, and Temptress Cruises to Costa Rica; Sahsa Airlines to Honduras and Panama; Aggressor Fleet, Temptress Cruises, Galamazonas, Galapagos Network, Ocean Voyages, and SAETA Airlines to the Galapagos; Air Seychelles and the Seychelles Ministry of Tourism to the Seychelles Islands; and Fantasea Divers, South East Asia Divers, and Thai Airways in Thailand. Many thanks go to the individuals at these organizations who placed their faith in my work and gave valuable time to arrange my trips: Maarten Brusselers, Ric and Do Cammick, Curly Carswell, Monica Chetty, Mary Crowley, Harlan Feder, Herbert Frie, Julio Gallendo, Arnold Griessle, Jill Haines, Robert Kane, Marc Marengo, Jeremy Pask, Tomas Pozuelo, David and Glynnis Rowat, Megan Socha, Jonathon Tromm, Beth Venza, and Larry Waterman. Ken Knezick of Island Dreams Travel, Kathleen MacLennon of Journeys Etc., and Bob Goddess of Tropical Adventures Travel helped me get to the most remote corners of the world.

The editors at *Nature Photographer* and *Scuba Times* magazines thought enough of my work to make me an associate and contributing editor. Thanks to Helen Longest-Slaughter, Fred Garth, and Gwen Roland for the recognition. Great thanks go to the editors of the publications that have used my work frequently, and in so doing have enabled me to continue my work, particularly Bob Dunne, Helen Gilks, David Alan Jay, Debbie Kjærsgaard, Elvira Mendoza, John Nuhn, Cindy Sagen, and Robin Wilner.

Stanley Hopmeyer of Aqua Vision, Geoff Semorile of Camera Tech, Gale Livers of Ikelite, Bob Hollis of Oceanic, Don Frueh of ScubaPro, Glen Williams of Stromm, and the folks at Dacor Corporation have helped me through the years with my diving and photographic equipment. Bud Dippo and Roland Peterson of the Orinda Camera Shop, Greg Faulkner of Faulkner Labs in San Francisco, and Curt Grosjean and Bilou de Neckere of The Darkroom in Northridge, California, ushered my precious film with care.

Thanks also to the people who gave time and effort to this project, including the many colleagues who proofread my work and identified photographs. Any remaining errors are my own. Lee Riddell, the designer of this book, did a magnificent job putting the pieces together with great care and understanding. Jack Bishop helped with the manuscript, and Jeanne-Marie Perry coordinated the thousands of details involved with the production. Hugh Levin placed his confidence in my work, and his support made this book possible.

Female sea lions are often curious and friendly. This particular female in the Pacific Ocean off Baja Mexico, was particularly gentle and playful. Coronados Islands, Mexico.

The food producing blades of the kelp plant need to be kept at the surface to gather the energy of the sun. They are kept afloat by gas-filled bulbs. Santa Catalina Island, California. / 8

CONTENTS

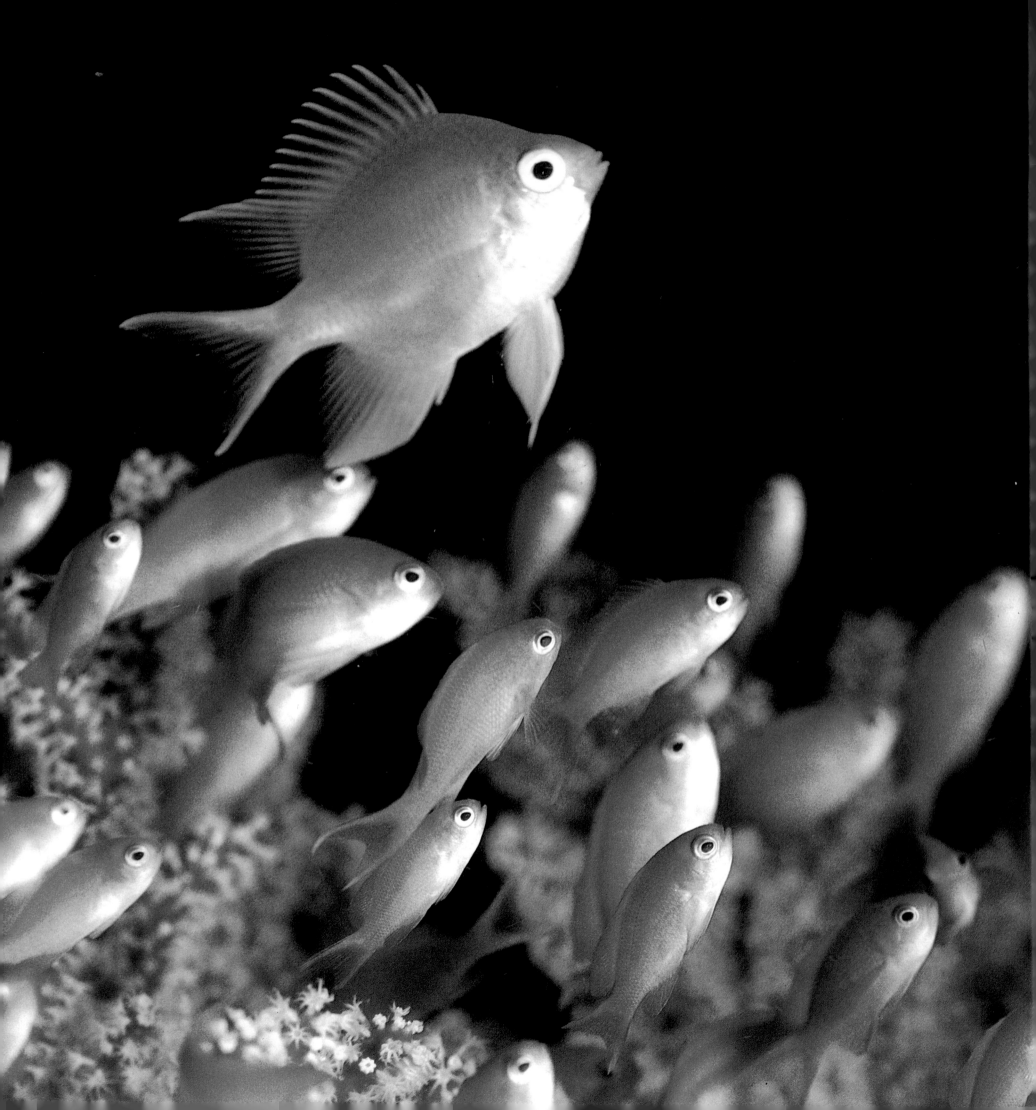

INTRODUCTION

Most people are a bit disappointed when they first meet me. Instead of an athletic, macho, rum-soaked descendant of Blackbeard, they find instead a short, rotund, Asian man, hardly the sort of person most people envision doing battle with sharks and whales. However, other divers afflicted with the disease of dunking expensive cameras into salt water love talking to me. They figure that if a puny guy like me can make a living as an underwater photographer, anyone can do it. And they are absolutely right. I use the same equipment and film as most serious amateurs, and my relatives do not include anyone with the surname of Cousteau or Trump. I have an extreme aversion to hard work and exercise, as well as an addiction to junk food. I hate boats. Once, for five weeks on a heaving, rolling, great steel hulk of a boat in stormy weather in the Northern Pacific, I stared at Samuel Johnson's

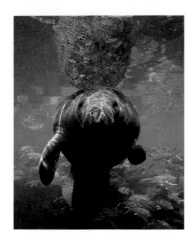

adage taped above my bunk and saw the wisdom in his words: "A ship is like a prison with the possibility of being drowned." I do, however, have a great love of my subject matter and an intense desire to be underwater. I've been lucky enough to make a living doing the sort of things I dreamed about as a youngster. And yet, in a great dose of poetic justice, I get seasick.

Being underwater is the reward for the seasickness, the work, the long waits, the steaming in wetsuits in full tropical sun, the flooded cameras. Diving is like being in a big air-conditioned jungle. It's cool, comfortable, filled with life, and there are no mosquitoes. Diving is neither inherently dangerous nor extremely physical. Diving safely depends as much on mental preparation as on physical conditions.

But most people don't believe that. They view diving as it is often portrayed in Hollywood — fighting off sharks, enemies, and sea monsters. The gear is heavy and bulky on land, but in the water you glide with weightless ease. Moving in any direction can be accomplished with easy, languid strokes of your fins, and often you are assisted by currents. It's the closest thing to flying. Being able to swim freely underwater gives a wonderful sense of freedom, a sense of peace. There is nothing more fulfilling than swimming effortlessly through a colorful coral reef and languidly hovering in crystal-clear waters.

SCUBA DIVING

I first learned to dive at the age of fifteen, after many years of snorkeling through the reefs of Florida and catching glimpses of marine creatures at aquariums. Scuba diving is easy to learn, and people from the ages of eight to eighty have trained at various schools. The equipment is relatively simple. A steel or aluminum cylinder (the tank) contains a supply of air compressed to as much as 3,000 pounds per square inch. Depending on how deep you go and how hard you work, a tank can last anywhere from thirty minutes to an hour and a half. A regulator takes the pressurized air from the tank and delivers it to your mouth at a low, easy-breathing pressure. A pressure gauge tells you how much air remains in the tank, a depth gauge tells you how deep you are, and a

A golden damselfish and school of Anthias keep close to the shelter of a sea fan as they feed on plankton passing in the current. Batangas, Philippines. / 10

compass helps you find your way underwater. A buoyancy compensator keeps you neutrally buoyant in the water, so that you neither sink nor float to the surface. A thin neoprene rubber wetsuit may be used for both protection from stinging animals as well as for warmth. The wetsuit keeps a layer of water, warmed from body contact, close to the body. In cold waters, a thicker wetsuit may be used, or a drysuit, which has seals at the neck and wrists to keep water out. I wear thermal underwear under the suit for warmth, as the drysuit itself provides little insulation from the cold waters. Because the drysuit is sealed from the water, special valves in the suit allow air to flow out as you ascend. Without these valves, air in the suit would expand as you rise, leading to an out-of-control situation in which you would rocket up to the surface like an expanding balloon.

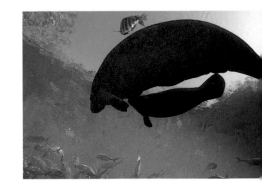

During scuba training, you learn to put your gear on underwater, clear a mask that has been flooded, and breathe from your tank with a regulator. More importantly, you learn to dive safely. The most dangerous aspect of diving results from breathing compressed air at depth. If you ascend too quickly, compressed air could expand in your lungs or blood vessels. The "bends" occurs when you exceed allowable time at depth, and upon surfacing, bubbles of nitrogen come out of your blood, much like gas fizzling out of a soda bottle. If these bubbles form in the elbows and knees, excruciating pain results. An embolism occurs if you ascend while holding your breath. In this case, the air in your lungs expands, and bubbles can block the blood vessels from the lungs. If bubbles block the bloodstream to the brain or the spine, you can die or become paralyzed. Both of these problems are easily avoided. You must simply breathe normally as you surface, and ascend slowly rather than shooting to the surface.

Diving in different locations and conditions may entail different procedures. In currents or the open ocean, knowing how to navigate underwater using a compass and underwater landmarks is essential, as is an understanding of how easily a person can be lost in the open ocean. The best divers anticipate possible outcomes to different scenarios and proceed with an eye to possible emergency situations. Contrary to popular belief, nearly all

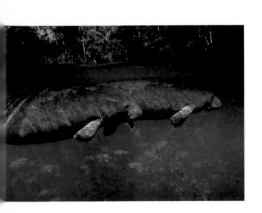

Manatees (above, right, and left), also known as sea cows, make their way to warmer waters —usually warm, spring-fed rivers—when winter turns surrounding seas below 72 degrees F. Manatees are placid herbivores that are vulnerable to accidents with boats as they hover at or near the surface. Homosassa Springs, Florida.

dangers arise from a diver's inexperience or misjudgment of ocean conditions, rather than from animals like sharks.

THE MECHANICS OF UNDERWATER PHOTOGRAPHY

Underwater photography is a narrow specialty with an incredibly diverse range of subjects. In fact, the photographer of marine life has the opportunity to draw upon the largest living space on earth, a living space that is one thousand times larger than all terrestrial living spaces combined.

Three things happen when light goes underwater — light rays are bent or refracted, colors are absorbed, and light is scattered by particles in the water. This leads to the cardinal rule of underwater photography — get close, and then get even closer. This rule makes the choice of equipment relatively simple. Nearly all photographs are taken with wide-angle lenses or close-up macro lenses, and nearly all subjects are lit with underwater flash as fill or as key light. Water absorbs warm colors very quickly, so flash photographs of colorful subjects are rarely taken more than six feet away from the subject. Since an image is significantly degraded by scatter, wide-angle lenses are used to get close to the subject, and flash is used to bring out the colors.

The choice of cameras and film formats is also simple. The 35mm format is used by the vast majority of professional underwater photographers, and the Nikonos amphibious camera or an SLR land camera in a plastic or aluminum housing are the only practical choices. The Nikonos is a complete underwater 35mm system with lenses that are specially designed for underwater use.

I choose a specific camera depending on what subject I plan to encounter during my dive. For fish portraits and close-up work, I use a housed Nikon system with 60mm and 100mm macro lenses. The Nikonos camera with a wide-angle underwater lens is perfect for large animals, underwater panoramas, and fast action involving larger subjects such as sharks, divers, and marine mammals. For underwater scenics that require careful composition, I use the housing with wide-angle lenses ranging from 16mm fisheye to 24mm. The automatic through-the-lens (TTL) flash control in underwater systems

Pink jewel anemones cover a rock wall. Coming in almost all colors of the rainbow, these corallimorphs, commonly called anemones, are probably all clones from one common ancestor. Poor Knights Islands, New Zealand.

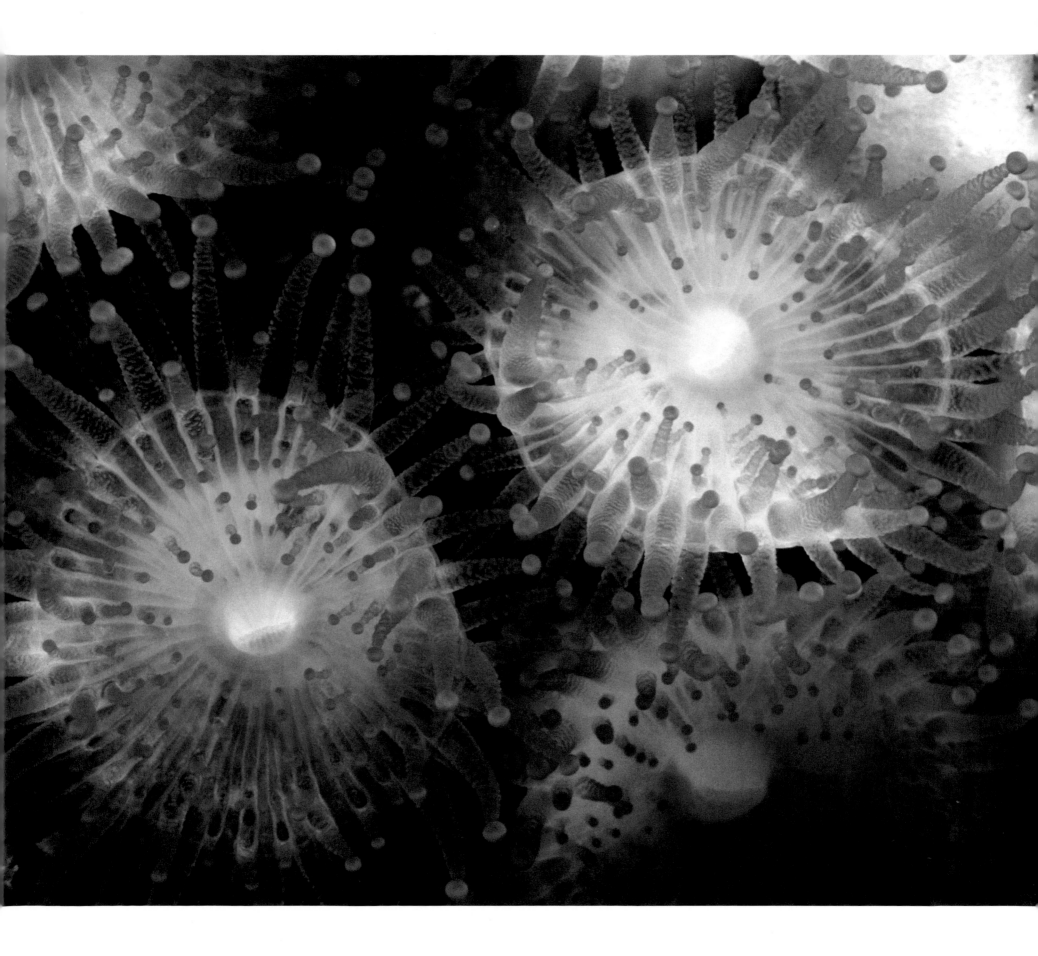

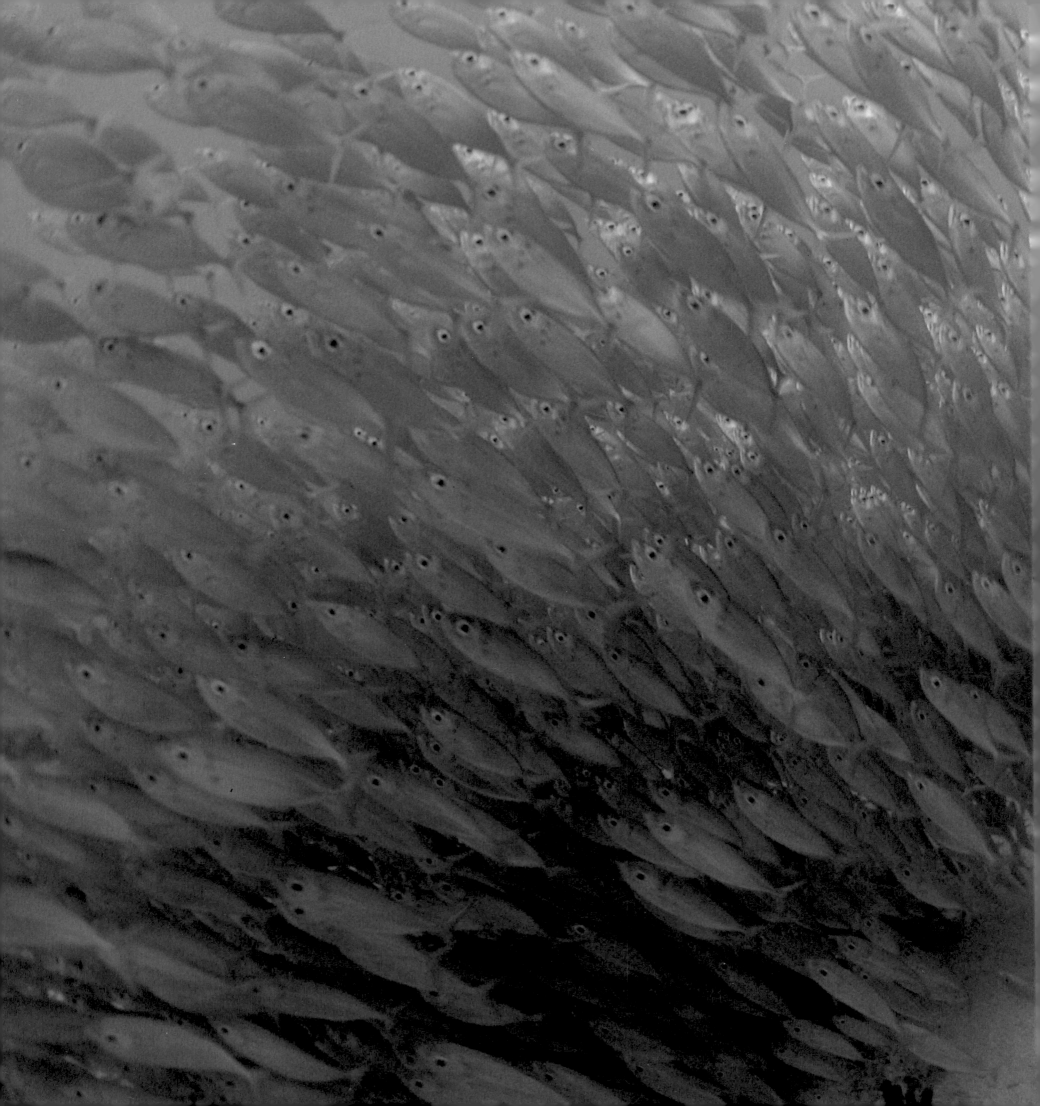

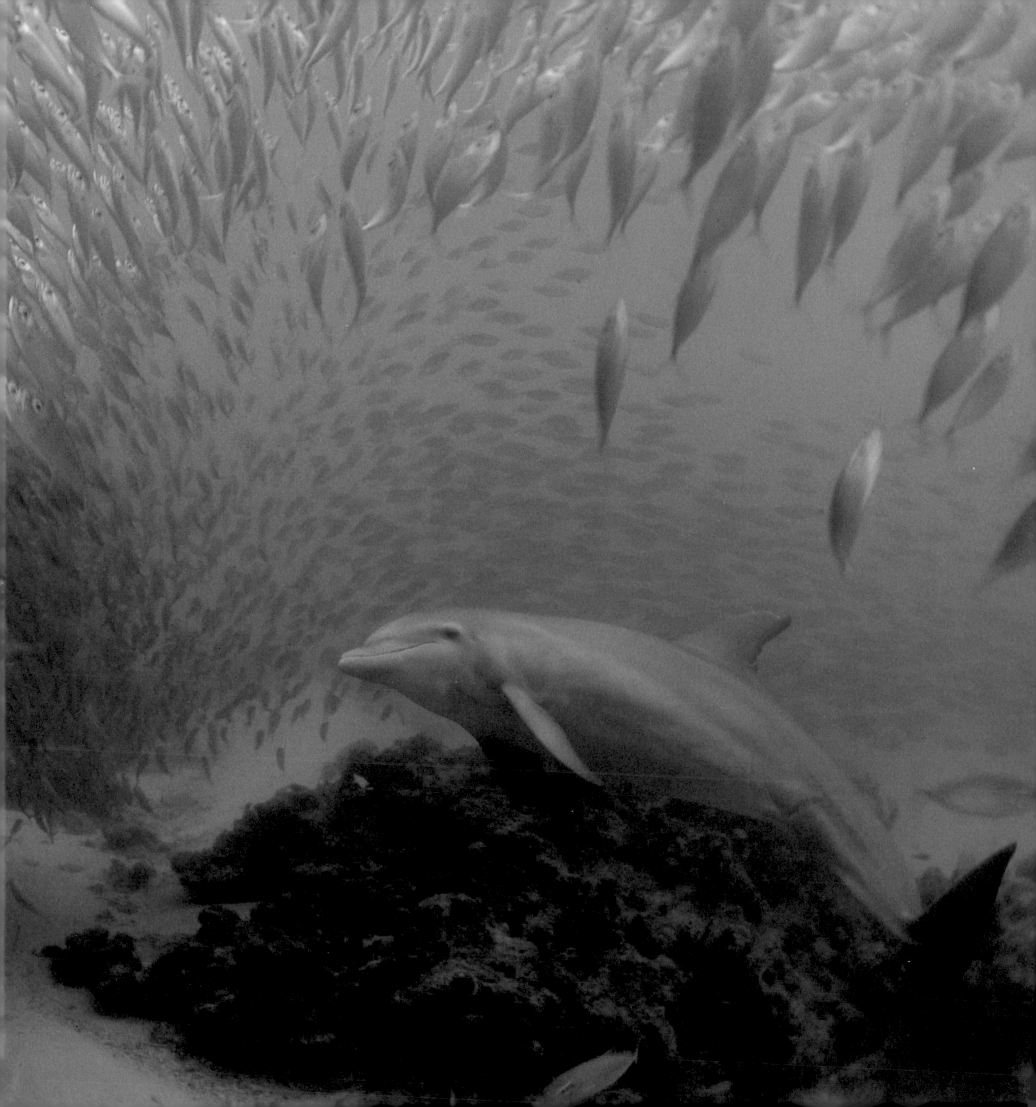

works well, especially with close-ups. Autofocus cameras work as well (or as poorly, depending on how you look at it) underwater as they do on land.

Before going underwater, the cameras, lenses, and film must be set up and sealed. I sometimes carry a Nikonos with wide-angle lens as well as a housed camera with macro lens together on one dive. I'm limited to one roll of film for each camera, and if a subject doesn't fit within the capabilities of one of those systems, then I am out of luck. If I am diving in a strong current, I will be limited to carrying only one camera.

Since light underwater is so diffuse and blue in color, the sharpness, contrast, and color bias of Kodachrome transparency film works well, and I use it almost exclusively for underwater work. Since I almost always use an underwater flash, I am limited to the flash synch speed of my cameras. The majority of my photographs are taken using a flash synch speed of 1/60th or 1/90th of a second. This relatively slow shutter speed is sufficient in most situations, since animals don't move as fast underwater and low light levels need slow shutter speeds in order to register an image on film. In darker waters found off the California coast, I will often use Fujichrome 100 film, which responds better to low light levels and makes the muddier, greener waters look more pleasingly blue. Night photography is similar to diving in the daytime, the only difference being that I take a strong underwater flashlight down to see what I am focusing on, and I take care to stay close to my boat.

Though I have taken my camera as deep as 240 feet, I get much more time underwater if I stay in shallower waters, sixty feet deep or less. At sixty feet I can generally stay in the water for an hour or so at a time. As an underwater photographer, I must pay particular attention to currents, bottom time, and remaining air supply. My dive computer, which calculates these guidelines, is essential for allowing me to concentrate on photography. A quick glance at the computer gives me my time remaining and keeps me from getting into trouble with decompression or air supply. I may dive alone in the course of my work, but I only do so in conditions where diving solo does not present unreasonable risks.

A bottlenose dolphin swims through a school of baitfish. Dolphins can work together to round up schools of fish, then take turns feeding on the school. Roatan, Honduras. / 16-17

The sunflower star is among the largest and most active sea stars in the world. It moves rapidly and can use over 15,000 sucker feet. Monterey, California.

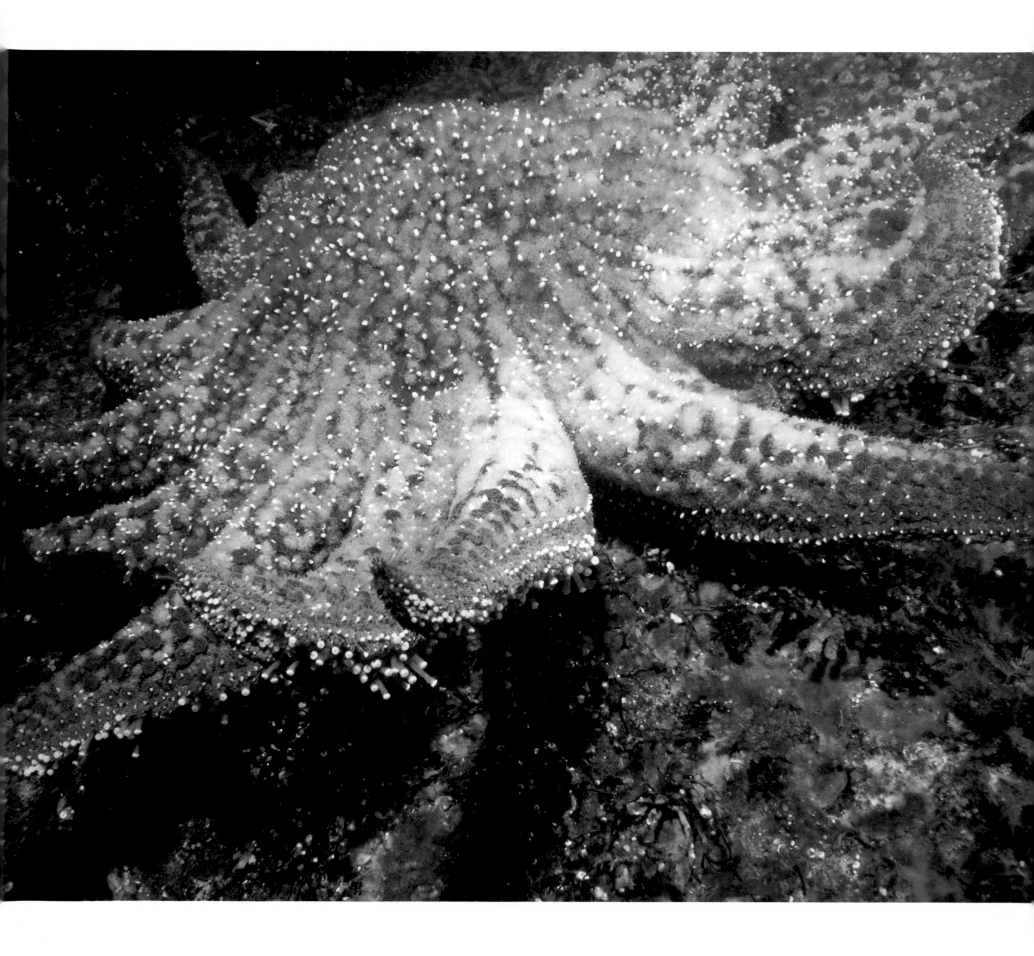

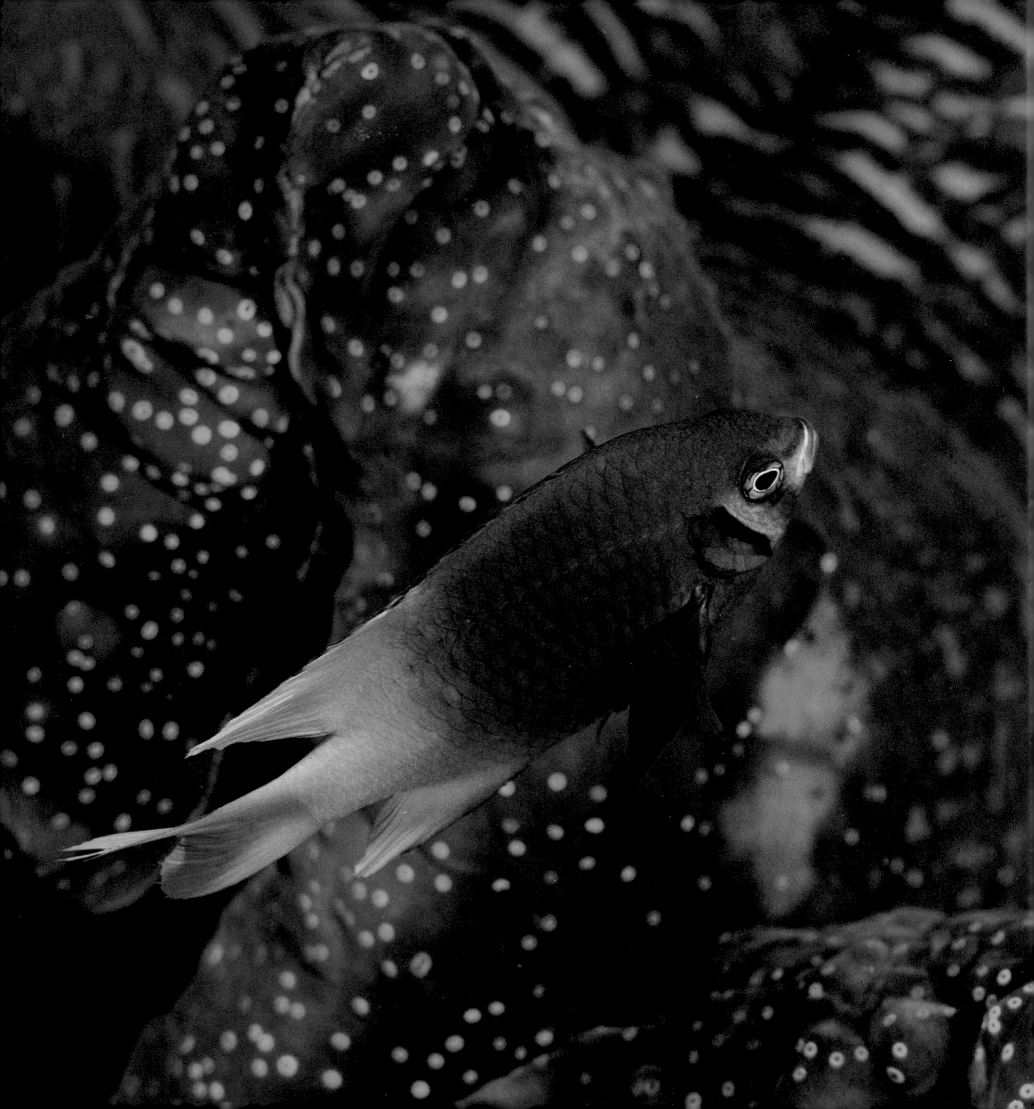

WHY I BECAME A NATURALIST

At the age of six I wanted to become a marine biologist. As a teenager growing up in Atlanta, I spent summers snorkeling in Florida waters and became fascinated with wildlife. When the time came to choose a college, I went to California. Like all naive teenagers in Georgia, I thought that California meant beaches, sun, and *warm water*. I was in for quite a shock during my first encounter with the bone-chilling waters of Monterey Bay.

Once in college, deluged with the advice of dorm mates, professors, and parents, I decided on a degree in electrical engineering rather than a major in my lifelong interest of marine biology. I kept up my diving, however, and explored the waters of Monterey Bay after investing in a wetsuit and basic diving gear. The electrical engineering degree was a pragmatic choice; the job situation seemed much better, and I always figured I could go back into marine biology. The situation seemed the same after four years, and so I obtained a master's degree in engineering and got my first steady job as a computer engineer in Silicon Valley. The job paid well, my boss was easygoing, and the work was routine and unstressful. Of course, I was bored. My thoughts kept wandering to tropical breezes and coral reefs. After nine months as a corporate player, I took an extremely low-paying job as a research diver with the Smithsonian Tropical Research Institute on one of the San Blas Islands of Panama.

This time I had been much more careful in my choice of dive sites. The island is about 100 square feet of sand, and the researchers lived in bamboo and plywood huts right above the water. Most importantly, the water is warm there, and I had all the time in the world to dive. Prior to this trip, I never had the slightest interest in photography. But before heading south, I bought as many books as I could find on the subject, as well as an underwater flash and Nikonos camera system with extension tubes and close-up attachments.

For the four months that I was out in the San Blas, I only shot about ten rolls of film. However, the photographs from those rolls have been published over and over again. Because I was diving the reefs every day, I knew their inhabitants intimately. I was able to return to photograph an octopus, a

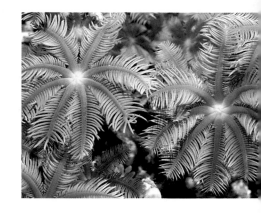

Polyps of an organ pipe coral trap plankton with feathery tentacles which can be withdrawn into protective tubes if disturbed. Solomon Islands.

A yellowfin damselfish swims above the mantle of a giant clam. Usually solitary, it is found in shallow reefs and lagoons. Solomon Islands.

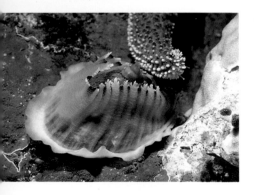

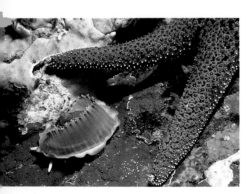

flamingo tongue (a snail with a spectacular shell), and a spotjaw blenny again and again over the course of my four-month stay. This in-depth look at marine life's habits and behaviors has become my specialty. Being able to spend weeks working on a project rather than a few hurried weekends has made a big difference in the quality and content of my photographs.

Underwater photography is different from photographing on land. Because of the limited visibility underwater, I am usually very close to my subjects, often no more than three feet away and sometimes even closer. As a diver, it is impossible to truly blend into the surroundings. The loud noise of your bubbles will always alert sea creatures to your presence. An underwater photographer must move slowly and in a non-threatening manner to get as close as possible to the subject without frightening it off. An understanding of a subject's behaviors and its reactions to your presence is essential.

After my San Blas experience, I took courses in marine biology and eventually spent two years as a doctoral student at Scripps Institution of Oceanography. Photography took up more and more of my time. I convinced my friend Spencer Yeh to spend two months with me, diving every day in the cold but astoundingly rich waters of Monterey Bay. I took my first course in ichthyology and was fortunate enough to be exposed to the encyclopedic knowledge of Dr. Richard Rosenblatt, the curator of the Marine Vertebrate Collection at Scripps. His course was filled with the details and observations of natural history that I had been looking for my whole life.

The field of marine biology is a tough one. It's not as much fun as it used to be, and there is little money available. One fellow student at Scripps finally received his doctorate after eight years of hard work. His job prospects are dim; every job he has applied for has had a minimum of 70 applicants and as many as 200.

Nowadays, many marine biologists seem less concerned with natural history than their predecessors were. Scientists in the old days had many mysteries to solve. Where did eels go to spawn? Where did sea turtles spend the first two years of their life? What exactly were these strange life forms trawled up from the deep? Good science is no longer so simple. Most marine labs have turned to biochemistry and other laboratory-oriented research —

SEQUENCE: Sea stars feed upon almost anything that can't escape their grasping tube feet. One limpet (a type of snail), however, extends a slippery white mantle when grasped by the sticky tube feet of the sea star. The sea star can't hold on to this slippery mantle, and the limpet then speeds away to safety. This sequence of photographs shows a giant-spined sea star approaching and initially grasping the shell of a limpet. The limpet then exudes its protective mantle and moves away to safety, its two antennae protruding. Monterey, California.

research areas that can yield quick results and are good candidates for research funding. Field biologists are few and far between, and their financial situations are often dire.

In some ways, natural history photographers have taken over the role filled by old-time naturalists/scientists looking to represent and explain the big picture. While a modern research scientist may be forced to spend months and years studying a very small issue, I have the luxury of presenting my work without the burden of proof he or she must bear. The fact that I catch something on film makes it valid, and sometimes valuable. The proof is in the picture. Whether it always occurs in the same place at the same time in the same manner is not really an issue.

Photography has become a way of life for me, a good excuse for seeing the world. At my best, I am both scientist and artist. The photographic possibilities underwater are truly endless, and discovering new life forms and learning about the interconnections between various species make my work a fascinating blend of science and art. A wonderful thing has come out of this blend of disciplines — this book. I hope my words and pictures will serve as a guide to this wild and remote place. Many of these creatures will be new and unfamiliar. The animals and their habits are fascinating, and the colors and patterns of life continue to enthrall me, even after seventeen years of diving and ten years of underwater photography.

As your guide, I hope to bring the sea alive for you through my photographs, and show you what I have learned and discovered, so unscientifically, about marine life. Let me introduce you to this very special place, our last true wilderness.

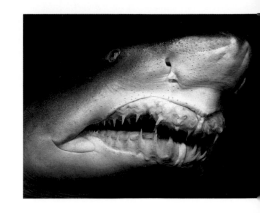

The ferocious-looking sand tiger shark is actually considered harmless to humans; its wicked-looking teeth are used only for capturing fish. It is a fairly common shark. Steinhart Aquarium, San Francisco, California.

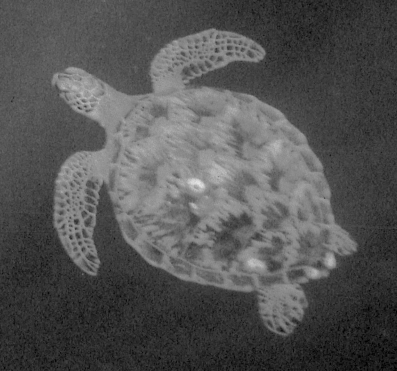

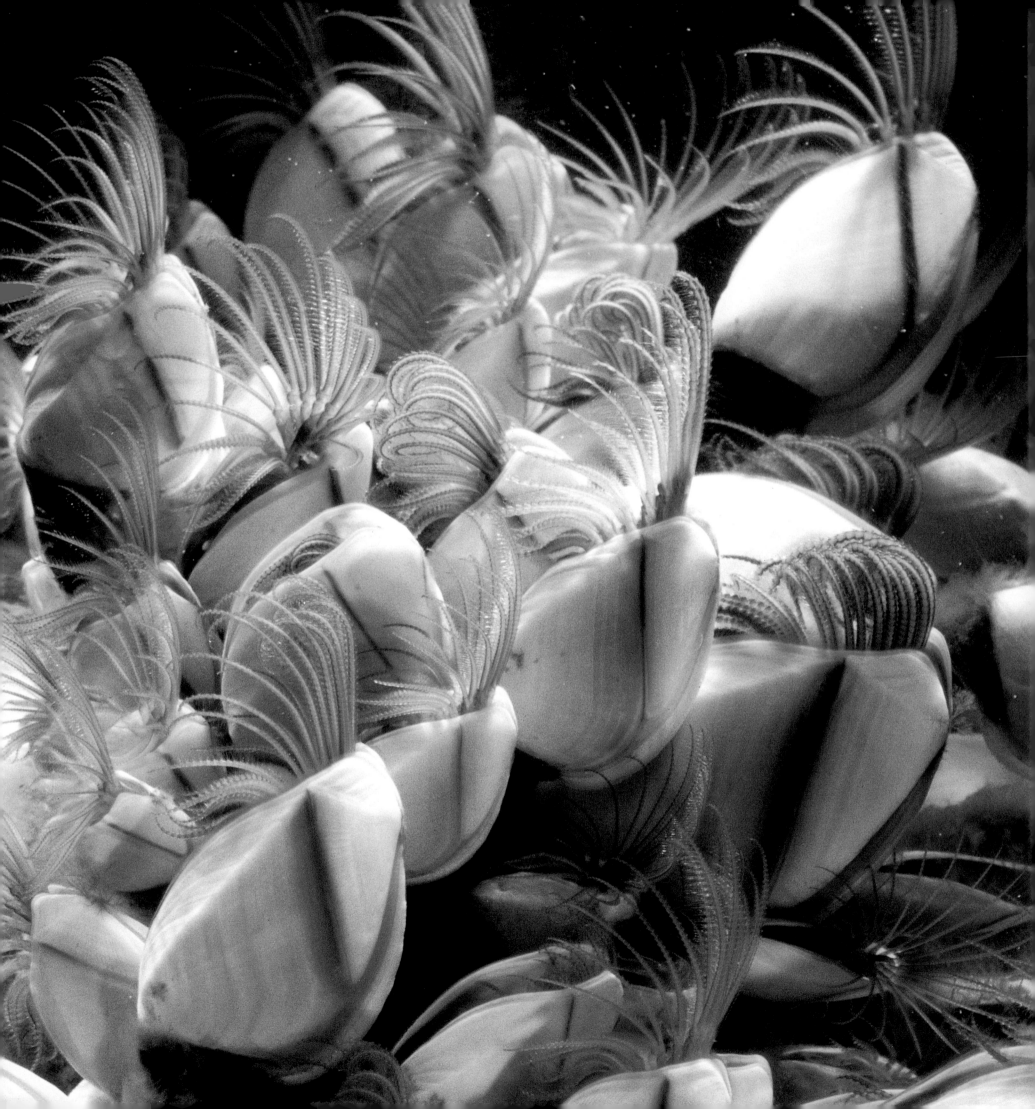

THE OPEN OCEAN

In the clear waters of the open ocean near the equator, a young green sea turtle finally pauses in his frantic paddling, an activity he has kept up day and night for days. He has found a large raft of sargassum weed, and as he makes his way into the tangled mass of blades and gas-filled bulbs of the algae, a profound sense of peace overcomes him. The young turtle has made it past an almost unbelievable series of obstacles. He started life four days ago on the pink sands of a remote coral island along with a hundred siblings. Half the clan were killed on or near the island by ghost crabs, which arose like apparitions from the sand; by monitor lizards, which tracked them down the beach; by seabirds, which plucked them from the water; and by snappers and groupers, which gulped them down as they passed through the coral reef. The remaining turtles were nearly all waylaid on their frantic passage to the equator by

Green sea turtles approach the island of their birth to mate and rest after a long migration. Most sea turtles are threatened and in danger of extinction. Sipadan Island, Borneo. / 24-25

Goose barnacles, attached to an abandoned fisherman's float, feed by filtering out food particles from the water with their fine-haired legs. Northern Pacific Gyre. / 26

petrels and albatross, skimming the surface from above, and by mahi-mahi, sharks, and tuna, coming from the waters below. Out of the entire nest, perhaps only this young turtle has survived. The size of a silver dollar, he has not grown during the days of his passage. He is awesomely tired, although fatigue is not a sensation that he is even aware of, so engrained is it in his consciousness. He will spend the next two years of his life ensconced in similar sargassum clumps, riding them with the equatorial currents. The turtle feeds at his leisure on the algae, and occasionally he swims out to feed on a passing comb jelly, which sparkles in the sunlight like an underwater rainbow.

Close to the surface, but so small as to be invisible, countless diatoms — tiny one-celled floating plants called phytoplankton — capture the light and turn its energy into food. At times, the water around the sargassum raft is so full of phytoplankton it looks like soup, a strange green vegetable broth filled with innumerable swarms of marine "insects" feeding on the phytoplankton and each other.

A multitude of animals are trying to trap, ensnare, filter out, and feed upon the plankton. Copepods — tiny crustaceans about the size of a grain of rice — swim about collecting the phytoplankton. A colony of barnacles, glued to a fisherman's abandoned glass float, throw out fine-haired nets to filter out plankton from the water. Comb jellies wave long, sticky tentacles, which look remarkably like copepods, to attract larger prey. One comb jelly manages to catch a krill — a crustacean much like a small shrimp — with its tentacles. It quickly whips its body around and stuffs the krill into its gut. The krill slowly disintegrates inside the comb jelly, visible all the while. Other types of jellies, ranging in size from tiny spheres to huge monstrosities thirty feet long, float through the water stinging food with their tentacles and drawing it up to their mouths in the center of their bells.

Almost every possible surface is covered with life. The raft of sargassum, only four feet across, harbors an entire community of animals. Small crabs and other marine crustaceans crawl busily over the sargassum. Juvenile fish of all kinds hover within the shelter the plant provides. A jellyfish is itself a floating world, sheltering an entire community of crabs, medusafish, and juvenile fish

A comb jelly, or ctenophore, (left and right) feeds on a krill that it has captured. Comb jellies are named for the rows of cilia which line their bodies. Greenland Sea.

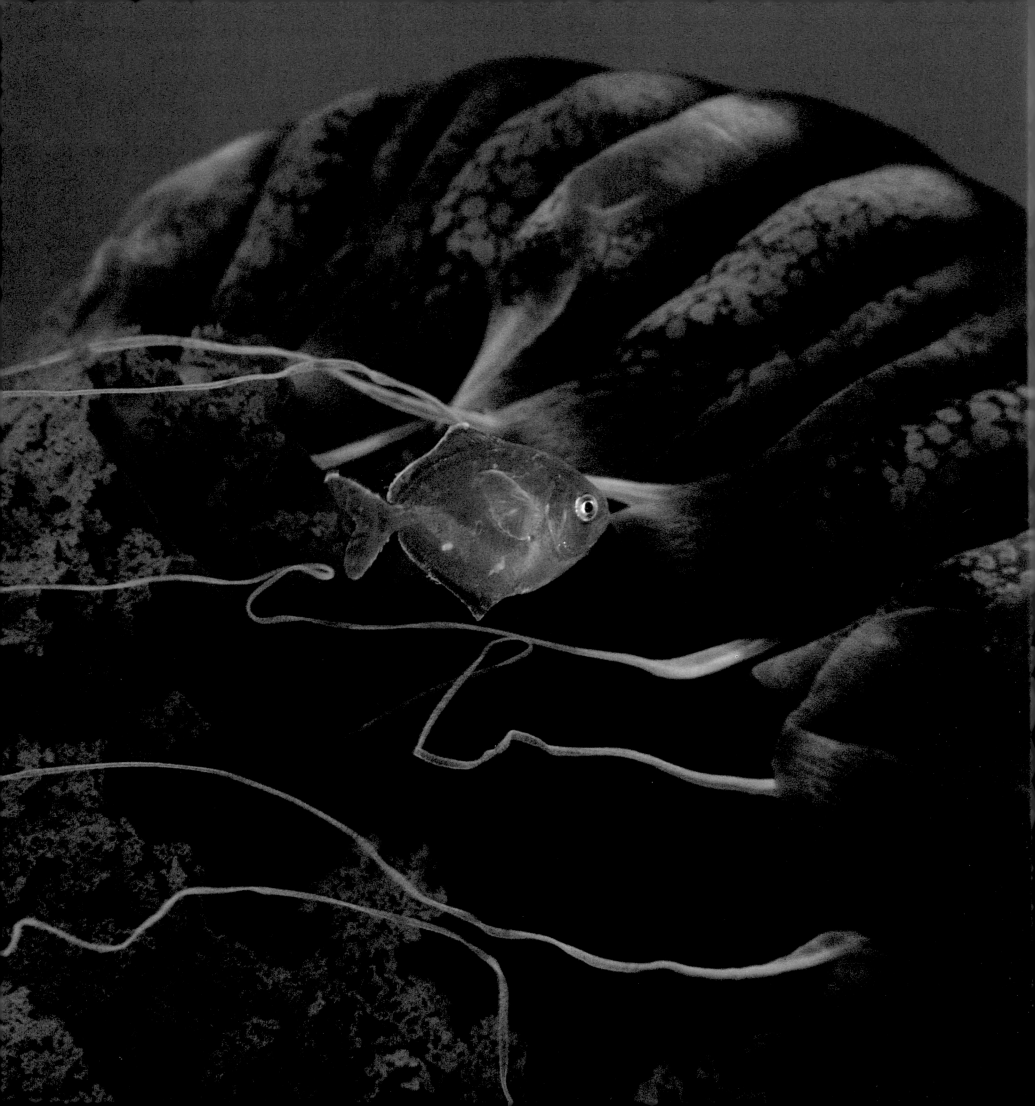

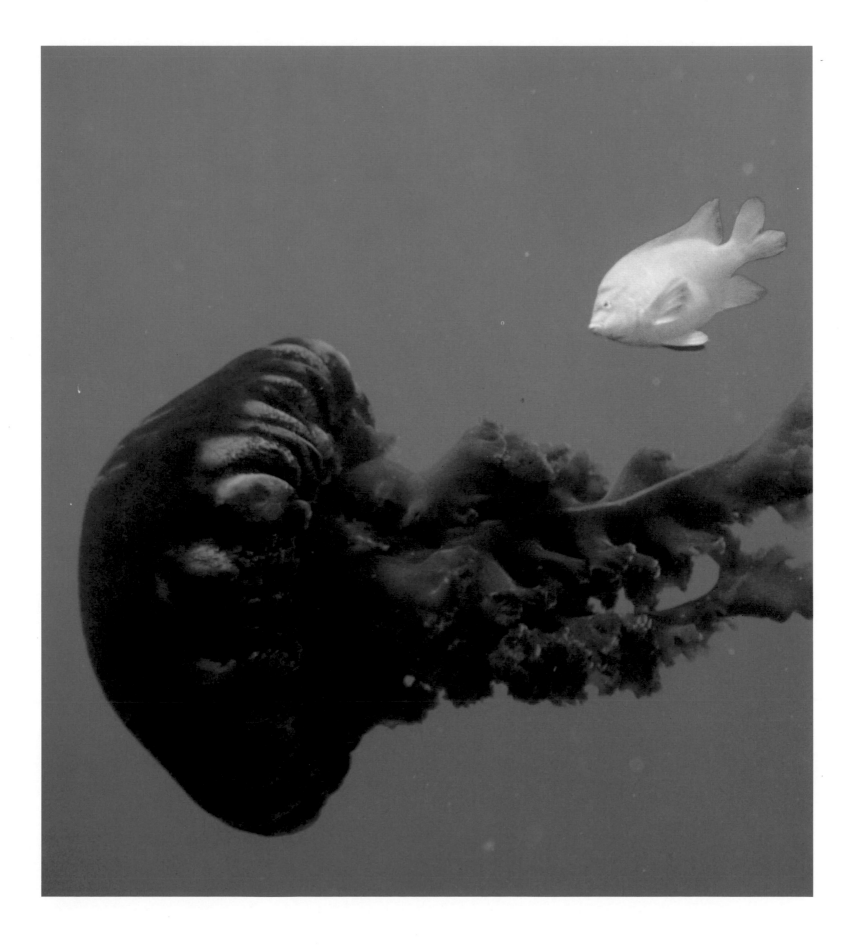

within the protective confines of its tentacles. Jacks — fast-swimming tropical fish — spend the first part of their lives within the protective confines of a jellyfish canopy, gaining protection from the voracious predators that have not developed the agility or immunity to elude the jelly's stinging tentacles.

The plankton bloom feeds a food chain in which everything eats everything else with a furious exuberance. Great schools of fish ruffle the water surface like a quick breeze. A school of anchovies, moving through the water with their mouths wide open as they feed on plankton, is pursued by a school of jacks, and then by a pod of dolphins. Calling to each other with high-pitched squeaks and whistles, the dolphins circle the large school. The frightened fish on the edges of the school try to escape, and the school becomes smaller and denser. Taking turns, each dolphin makes a pass through the tight, confused mass of fish, gaining several mouthfuls each time. Then, as quickly as they came, the dolphins are gone and the anchovies regroup, once again filtering plankton from the rich waters.

The sun glitters for a moment on a flying fish as it throws itself clear of the water, gliding in the air for a hundred yards before passing back beneath the waves. Underwater, a mahi-mahi follows the flying fish's path, registering its excitement in pulsating colors of aquamarine, green, and yellow. A group of sailfish — fast, elegant, six-foot hunters — works together to round up a school of silvery baitfish. A sailfish is able to move quickly through the water, using its powerful sickle-shaped tail. It raises its big sail-like dorsal fin to herd prey, or when it feels threatened. It is one of the fastest animals in the ocean and can reach speeds of fifty miles per hour. Circling the school ever tighter, the sailfish gather the fish into a tight ball. With a burst of speed, the sailfish plunge into the mass of baitfish, stunning them with their long beaks and turning back to feed.

Drawn by the sounds of feeding, two blue sharks appear out of the deep blue waters. The blue sharks move past the sargassum raft in languid, easy strokes and examine the scene before them. In the distance, a mako shark swims by quickly. On its dorsal fin trail long strings of copepod eggs, laid by parasitic copepods that have embedded themselves in the shark's skin. The

A juvenile slender crab crawls among the bell of a purple oceanic jelly. A jelly can harbor hundreds of these small crabs, which drop off in shallow waters to develop into larger, heavily armored adults. Monterey, California.

A single sea jelly may harbor dozens of juvenile fish within the protective confines of its stinging tentacles, such as this Pacific pompano, also known as a butterfish. Coronados Islands, Mexico. / 30

A garibaldi feeds on the tentacles and oral arms of a jelly in the Pacific Ocean. Jellies rarely feed on large prey such as fish; the reverse often occurs. Coronados Islands, Mexico. / 31

Flying fish use large fins to glide through the air and elude predators. They are marvelously adapted to their lifestyle at the surface of the water. Poor Knights Islands, New Zealand.

Stripe tail aholehole swim among the huge waves which build up over many miles of the Pacific Ocean and crash upon the tiny rock of Roca Partida. Revillagigedo Islands, Mexico. / 36-37

mako shark is different from the blue sharks. Long, sharp teeth protrude from its mouth, and it is a much faster swimmer. With a quick burst of its tail, the mako shark speeds off into the distance at an average pace of thirty miles an hour. The fastest human swimmers clock in at only four miles per hour!

A huge whale shark, all fifty feet of it, passes by like a locomotive. Over thirty remoras, or "sharksuckers," swim in front of it or hang off the shark's rough skin like hangnails. The largest fish in the world, the whale shark is a sluggish strainer of plankton, a placid cow of the sea. The largest ocean animals survive by grazing on the swarming lower organisms of the food chain — the tiny zooplankton and microscopic phytoplankton. Of the great whales, only the toothed whales are carnivorous; the rest are "baleen" whales, so named for the bristly material within their mouths that filters out the miniscule food particles collected with tremendous gulps of seawater.

A few miles away, a fleet of Japanese fishing boats searching for squid readies hundreds of miles of driftnets for the night. The sounds of their engines and generators come through the water clearly, ominously. Oceanic driftnets are one of the most insidious and dangerous threats to marine life, with the potential of completely wiping out most life in the open ocean. Every night these Japanese vessels, along with Taiwanese and Korean counterparts, lay out an estimated 25,000 to 30,000 miles of driftnet in the Pacific Ocean — enough net to completely encircle the globe. This method of fishing is incredibly wasteful and the practice is like strip-mining the ocean. By the end of the night, countless dolphins, turtles, sharks, and seabirds lay dying in the nets. All of these animals are simply thrown back into the sea as waste. Meanwhile, the young turtle, oblivious to his narrow escape, dozes on his raft of sargassum as it drifts further down the equatorial current.

Sailfish can reach speeds of 50 miles per hour. Their large sail-like dorsal fin is probably used in territoriality, mating, and even to herd schools of fish. Sea of Cortez, Baja Mexico.

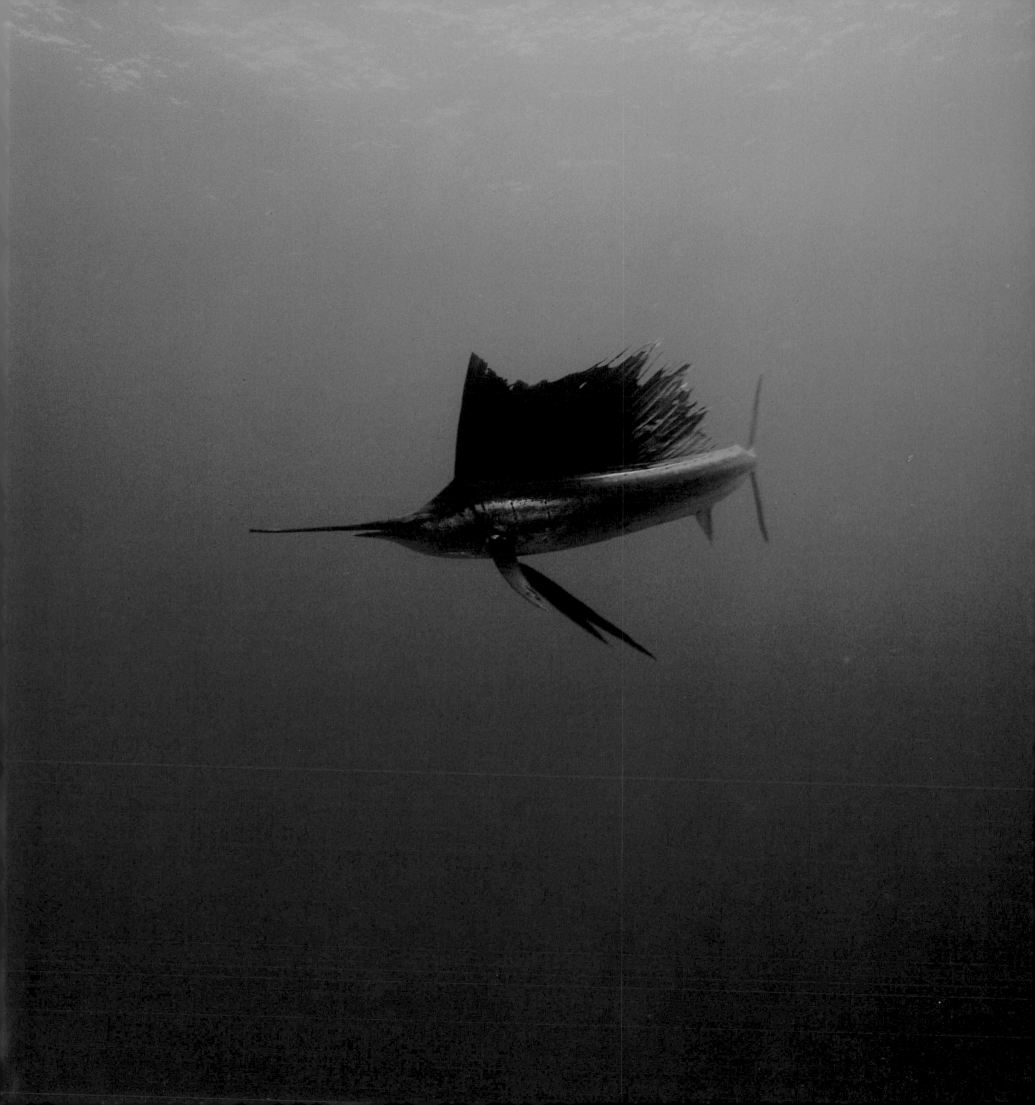

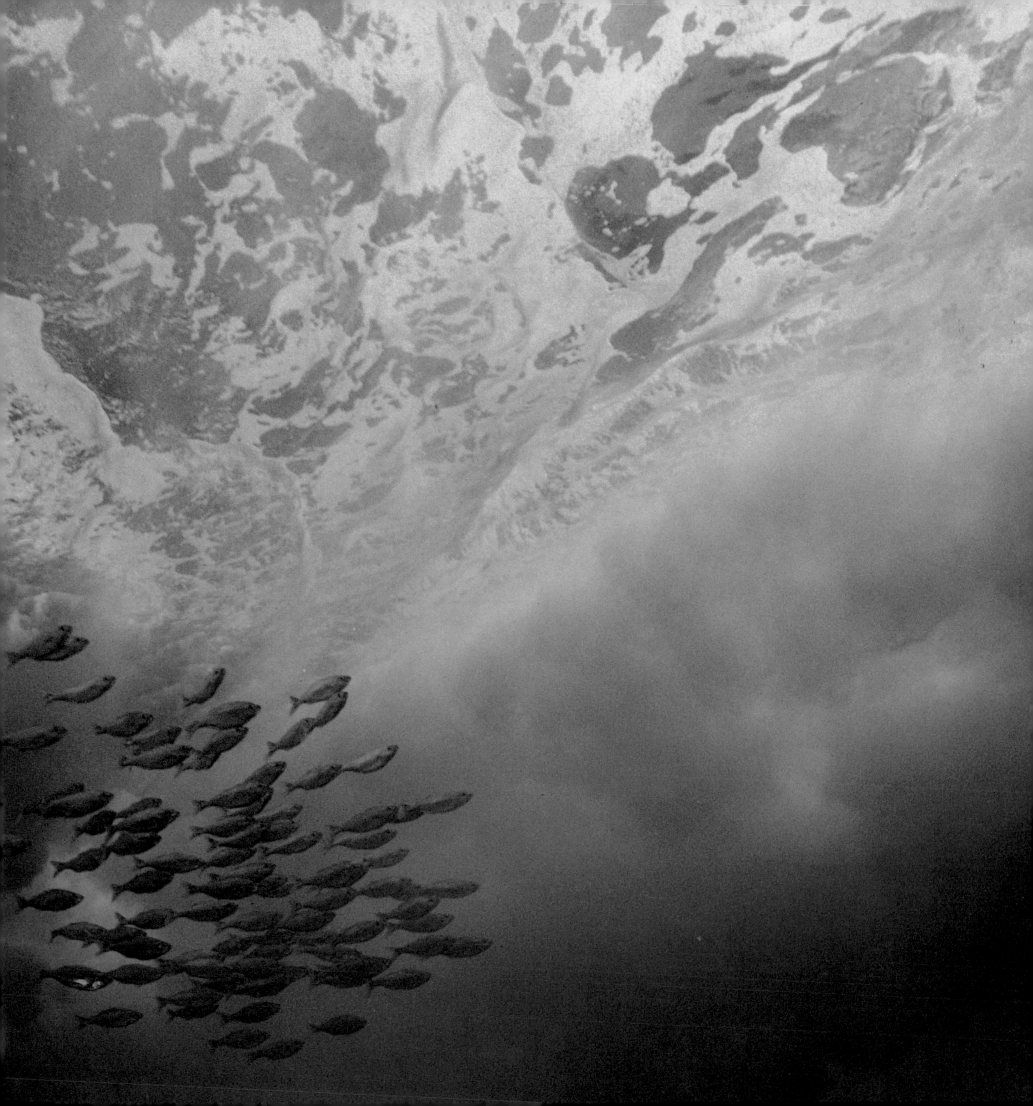

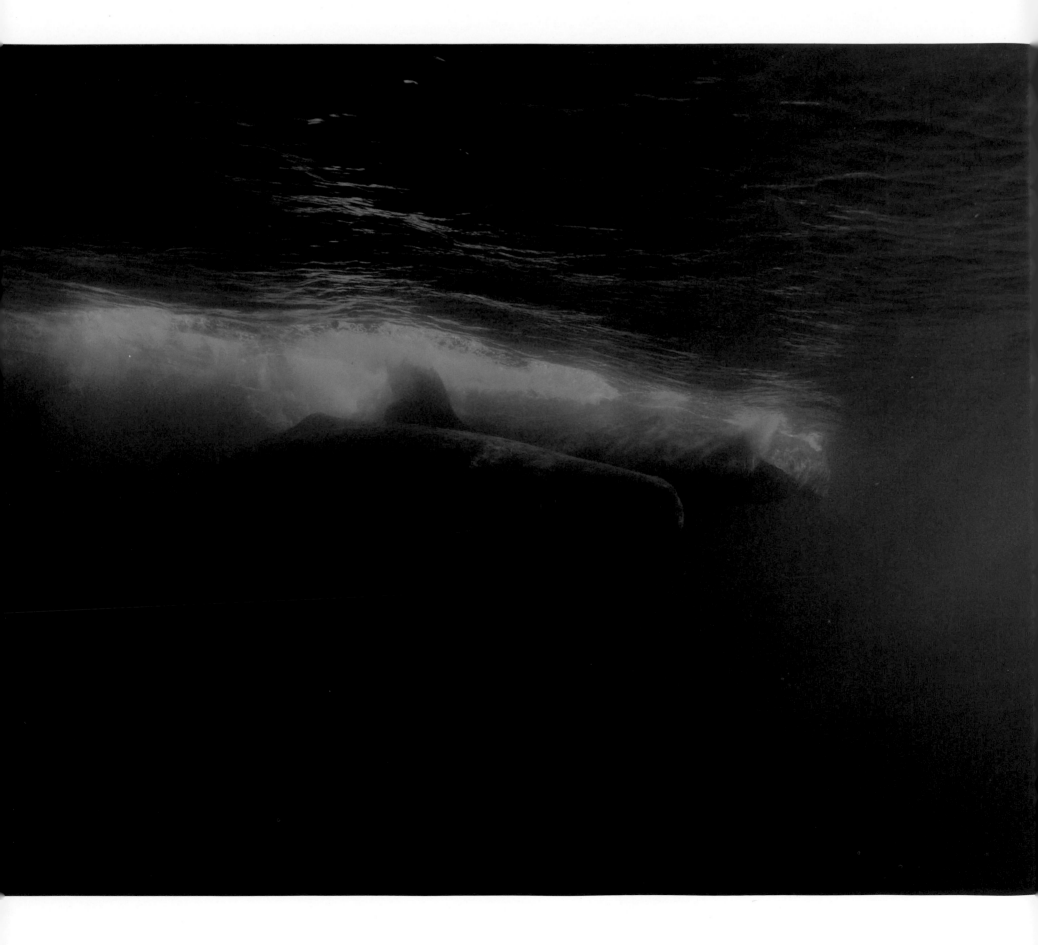

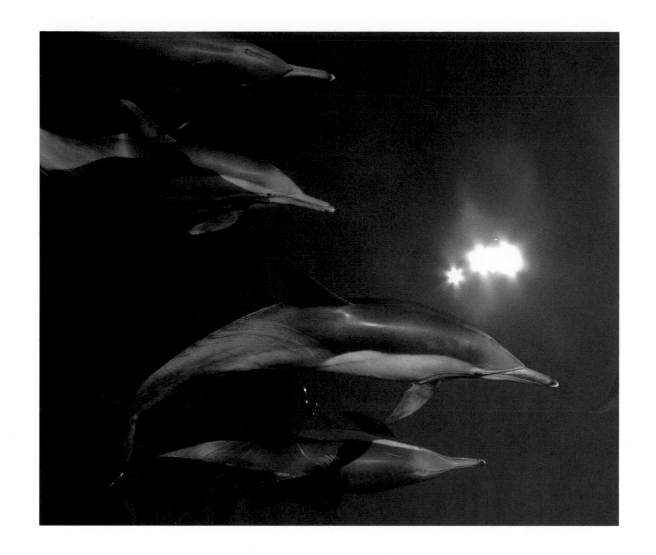

Highly social common dolphins form herds of tens to many hundreds. They often ride the pressure wave in front of a moving boat. Sea of Cortez, Baja Mexico.

Sperm whales (left) are the world's largest predator, routinely diving to 2,400 feet to prey on giant deep-water squid. They can dive to 9,000 feet. Revillagigedo Islands, Mexico.

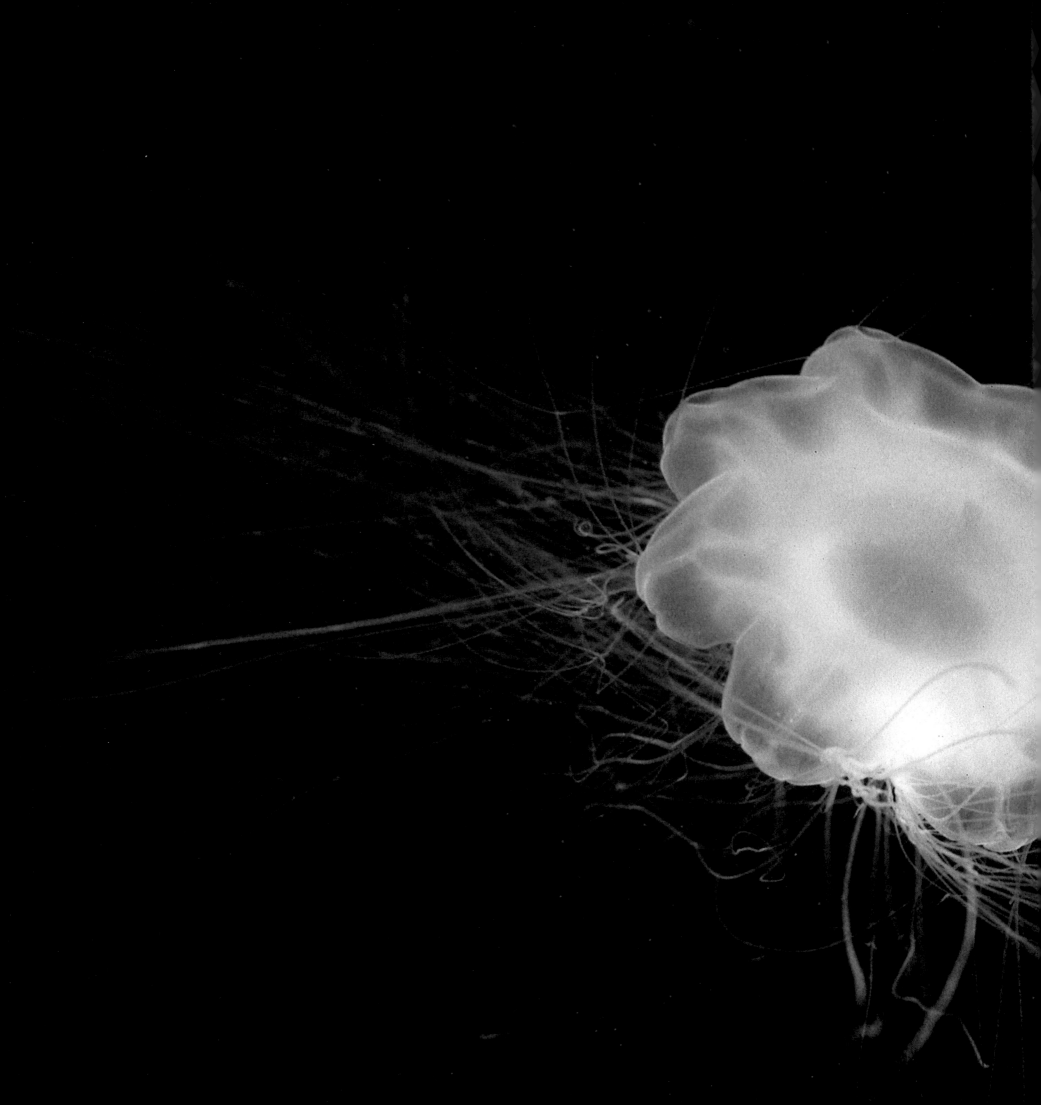

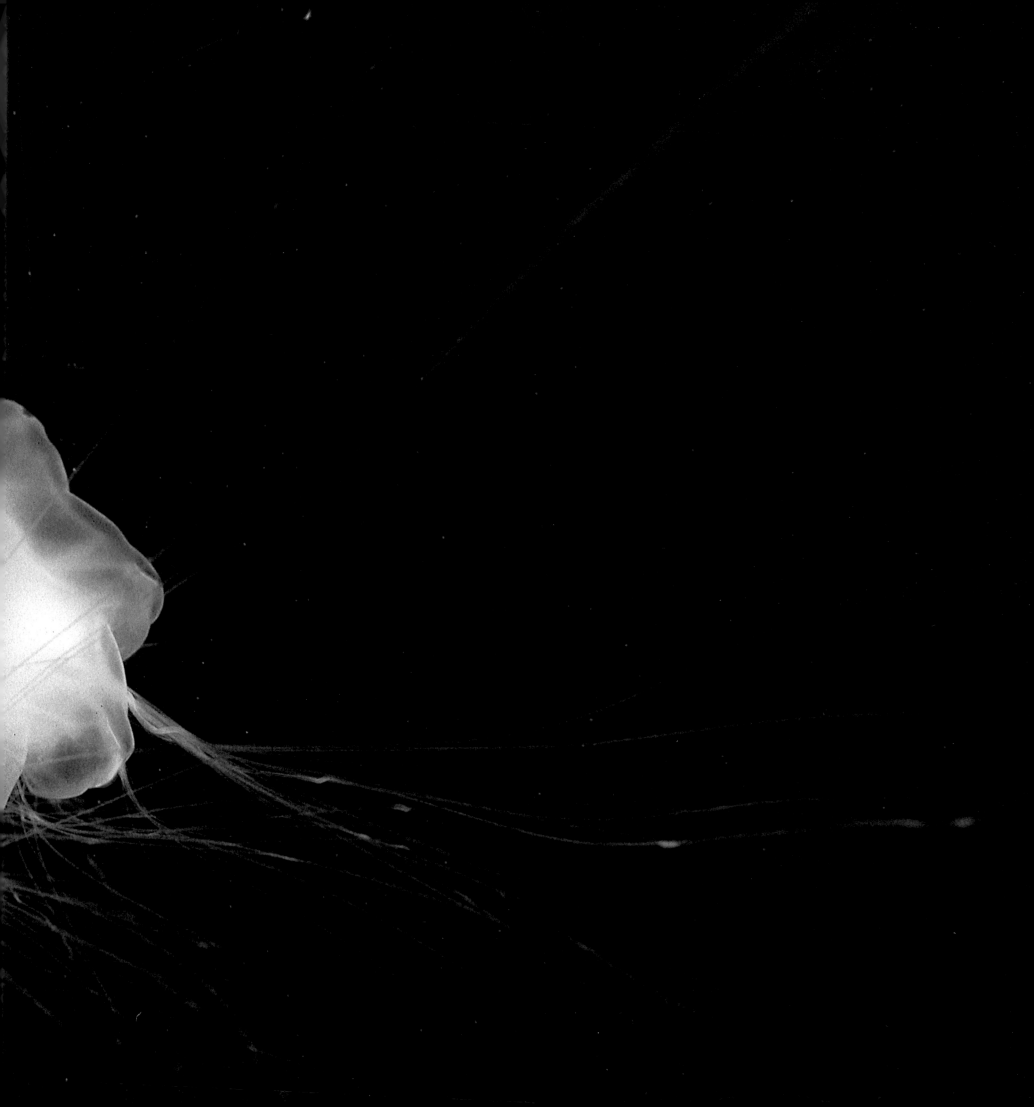

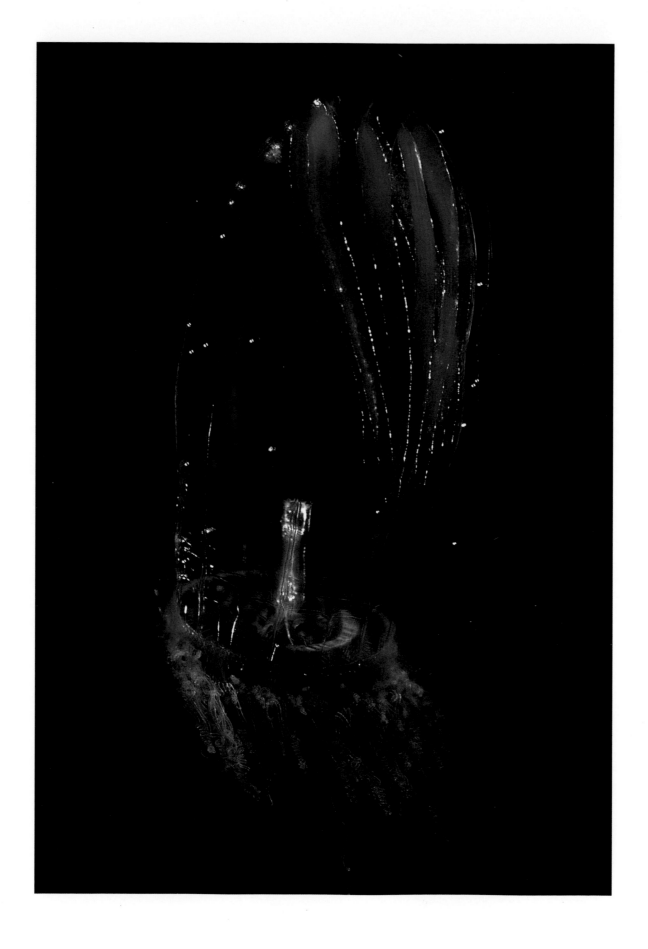

RUN OVER BY AN ICEBERG

The tiny glass jellyfish (left), has become entirely planktonic, unlike most jellies. Instead of a polyp stage, which is tied to land, their larvae bud off new medusae at once. Greenland Sea.

What happens if you are run over by an iceberg? If the iceberg is too big, you might find yourself trapped underneath a moving mountain, bumped and towed along with less and less choice of where to go. Following the safety line up to your guide boat seems to be the best possibility, but only if the line has not been cut on the sharp edges of the ice, or if the boat tender has not had to release the safety line to keep his boat from being capsized or dragged under the iceberg. Icebergs are notoriously unstable and may flip over at the touch of a careless finger or the thump of a careless boot.

A team of divers including myself experienced just such a dangerous situation. We entered the water with enthusiasm, as a previous dive had shown the waters to be filled with life. Since the days are long during the Arctic summer, we had opted to do one more dive before the night, but it was getting dark as we suited up for the dive. We were using a system of safety lines attached to a ring that was manned by a safety diver. The main line, thirty feet long, was attached to the inflatable boat above. A steel ring attached to the end of the main line held three long tethers, which were in turn attached to divers. The tethers prevented divers from ranging too deep or drifting too far away from the boat. The safety diver's job was to keep the other three divers' lines from tangling and to keep the lines attached to the steel ring.

The sea was flat as we entered the water, and the

The moon jelly can be found worldwide. Like most jellyfish, it has two life stages: the free-swimming medusa stage and the polyp form, which is attached to a substrate. Greenland Sea.

The lion's mane jellyfish is the largest jelly in the world. Its bell can reach up to 6 feet in diameter, and it can weigh as much as a grown man. Greenland Sea. / 40-41

NOTES FROM THE FIELD

This isopod rides inside the bell of a small jelly. It makes its living by stealing food from its host. Isopods are crustaceans related to terrestrial pillbugs. Greenland Sea.

RUN OVER BY AN ICEBERG

scientists began collecting animals at once, ranging to eighty feet below the surface. Suddenly, a tremendously dark, large shape blocked out what little light remained at depth. We all looked up to see the safety diver, Dr. Richard Harbison, frantically untangling himself from suddenly treacherous lines before being bumped by this moving mountain. He swam upwards, away from the tangle of lines, and disappeared on the other side of the iceberg. Greg was with Judy, an inexperienced diver, and I was only on my fifth dive using these types of safety lines and procedures.

Greg and Judy unhooked from the safety line and disappeared in the current. They swam even deeper as I looked back, probably to get below the iceberg. I decided to make my way up the safety line, past the tangle of tethers, to the surface where the boat tender, Bob, was frantically pulling in all the lines. The other divers were nowhere to be seen at this time, making for an extremely dangerous situation.

Bob and I collected all the safety lines and quickly motored around to the other side of the iceberg. In order to signal his presence in the deepening gloom, Richard had clambered onto the iceberg, risking a tear in his suit and the possibility of flipping the iceberg. A heavy fog had descended upon us, and both Bob and I realized that finding Greg and Judy had to be the immediate priority. Finding unattached divers amid open ocean is doubtful in

This tiny hydromedusan jellyfish was found in the open ocean in the freezing waters of the Arctic. Greenland Sea.

NOTES FROM THE FIELD

RUN OVER BY AN ICEBERG

Sea butterflies, or pteropods, are shell-less snails that look angelic, but are actually voracious predators. They capture their prey by throwing out a set of orange tentacles. Greenland Sea.

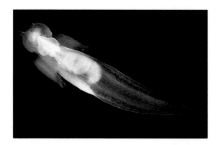

the best of times, and we had just been through the densest fog bank either one of us had ever experienced. We motored around, attempting to follow the current the two divers had followed. We finally found them and quickly picked them up. They had drifted much farther than I would have thought possible.

Richard was almost blue with cold, having to scramble up the iceberg with 100 pounds of scuba gear, and then left for several minutes all by himself. He was the chief scientist on board the boat. It was his $250,000 grant paying for this month-long expedition (this research vessel cost $7,000 a day to run), and he was getting a little nervous out there, getting colder, drifting away on a little piece of ice. Fortunately, it had been a small iceberg, as icebergs go — small enough to swim under and around, large enough to support a man, and big enough to teach all of us a lesson.

Siphonophores like this PHYSOPHORA HYDROSTATICA *exist in colonies made up of smaller members living and working to perform a specific function. Their tentacles sting powerfully. Greenland Sea. / 46*

This large scyphozoan jelly drifted past a coral reef. Like most jellyfish, this has a medusa and a polyp stage. Viti Levu Island, Fiji. / 47

NOTES FROM THE FIELD

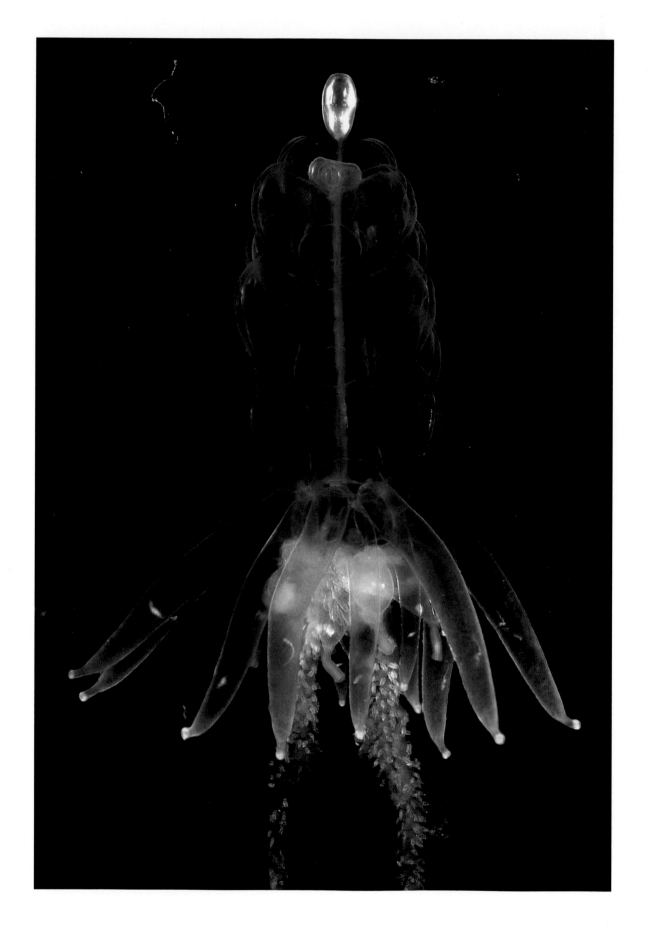

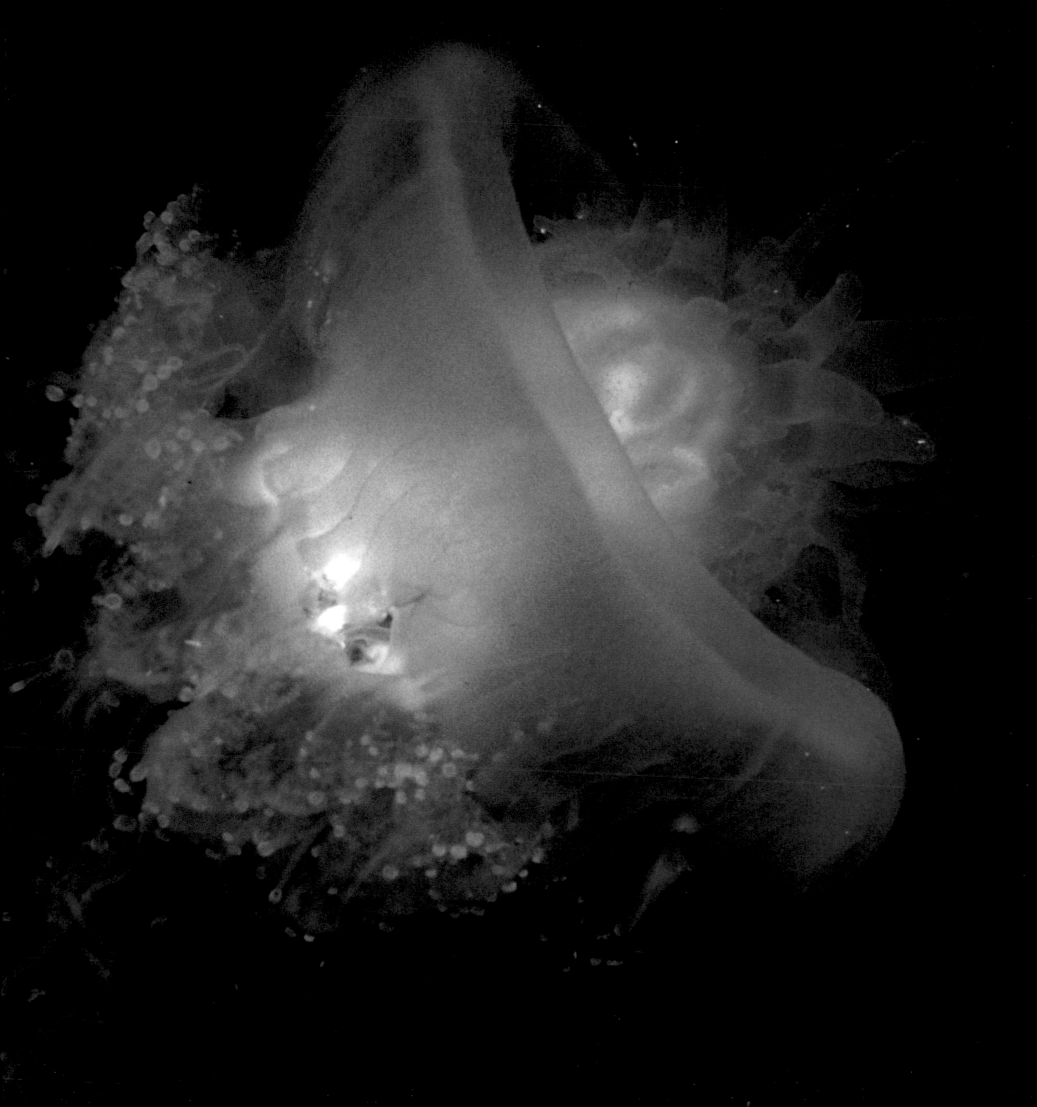

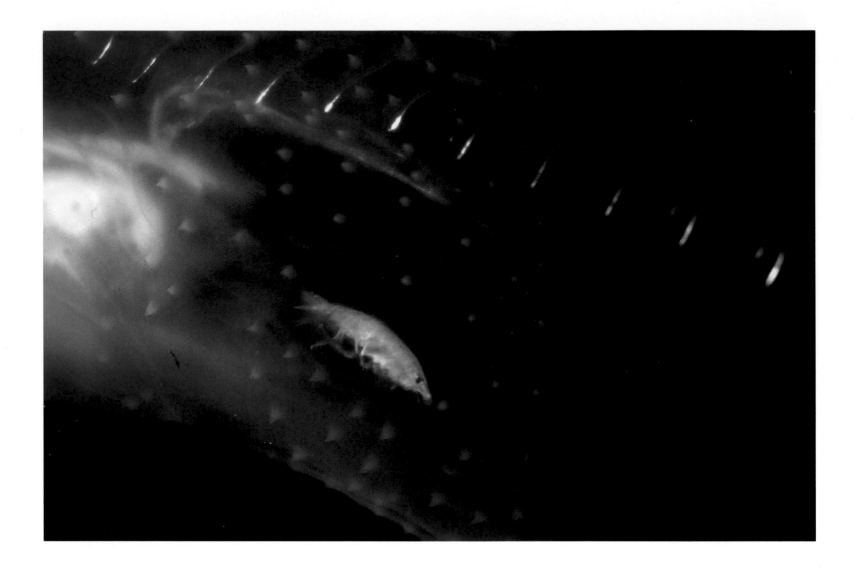

*This tiny amphipod (above), a
marine crustacean, lives within
the body of a pelagic salp. It
feeds on plankton brought in by
its host. This six-inch pelagic
solitary salp (right) floats in
the open ocean, gulping down
quantities of water. Although
they are invertebrates, all
tunicates possess a notochord
and a nerve chord. Monterey,
California.*

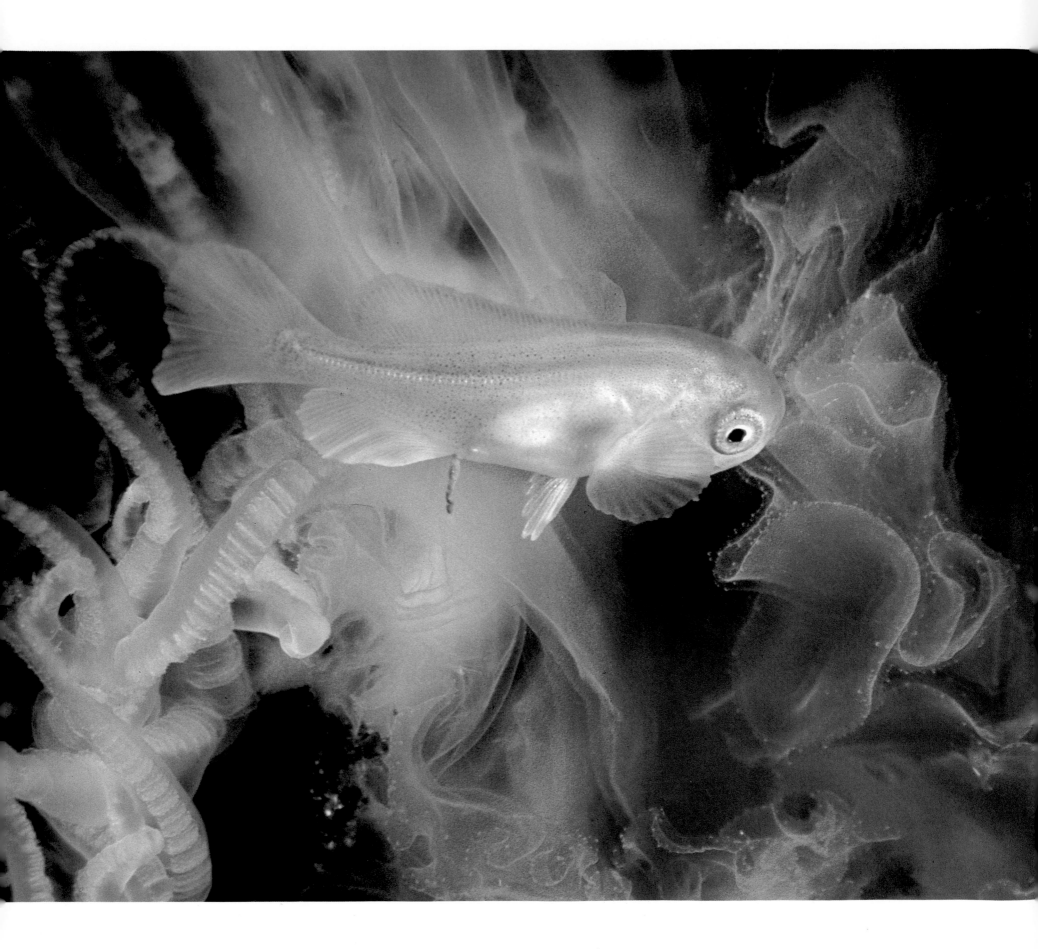

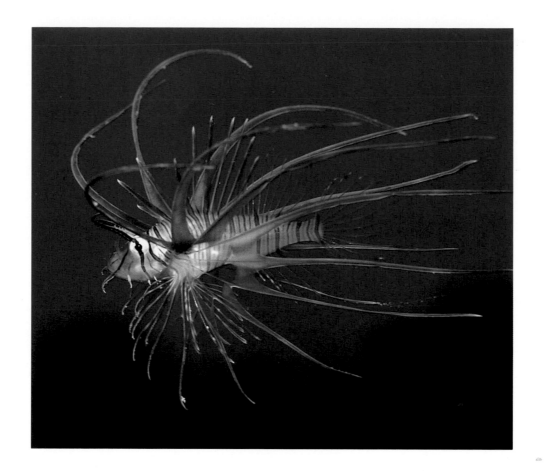

The larvae of many reef fishes
are planktonic, with unusual
shapes. When they settle onto a
reef, they mature into recog-
nizable fish. This juvenile
lionfish has long fins relative to
its body size. Red Sea.

The juvenile medusafish (left)
lives around jellies, protected by
the stinging tentacles of its host.
It may be immune to the jelly's
sting or simply adept at avoiding
the tentacles. Monterey,
California.

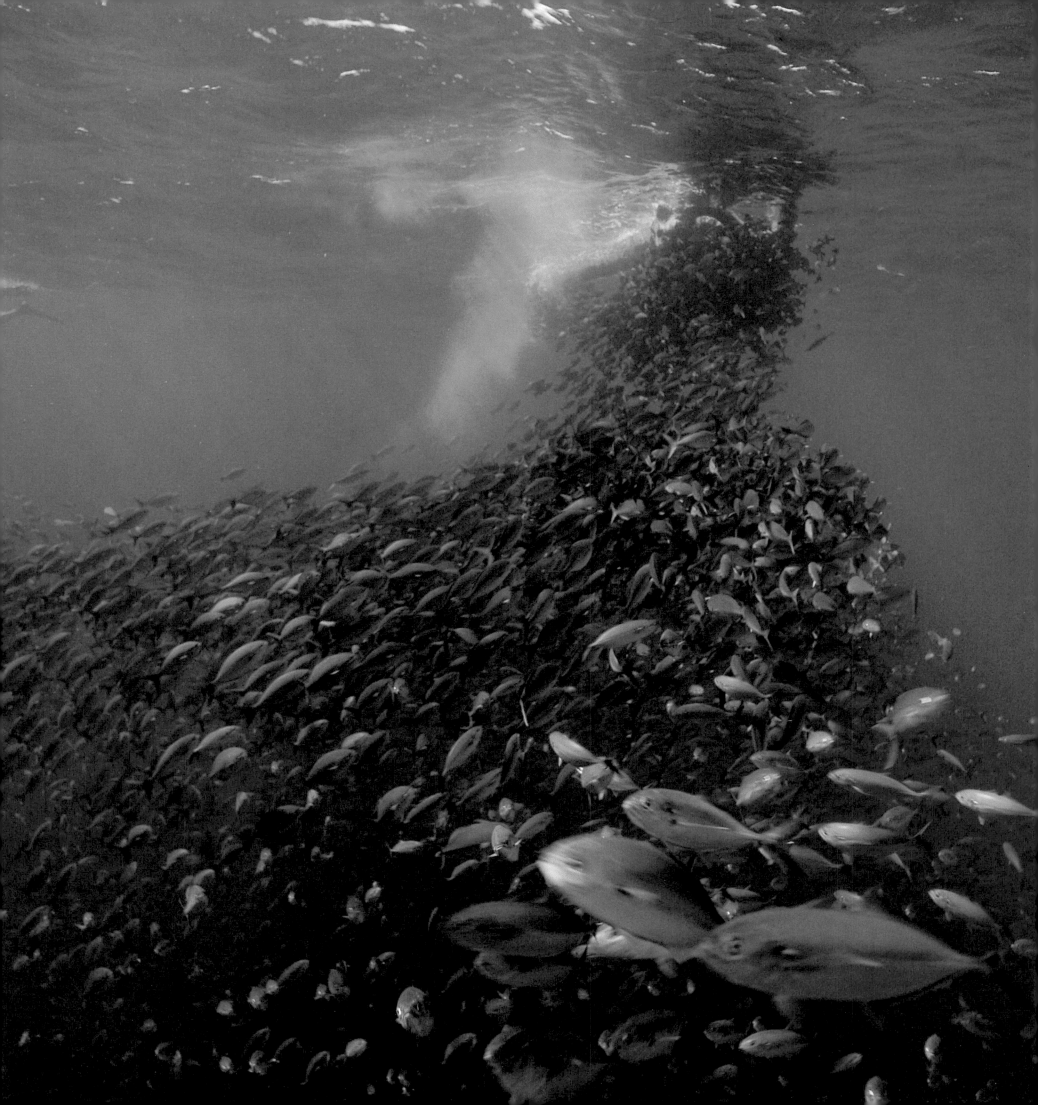

FLOATING OBJECTS:
LURES IN THE OPEN OCEAN

I was on a scientific expedition from the Scripps Institution of Oceanography to the Northern Pacific, 600 miles north of Hawaii. I had come to document life that gathers around floating objects in the open ocean. We had built a floating array with a radio tag we could track in order to document the life that accumulated and settled around this device during the next five weeks. The array was simply a few hundred feet of line with plastic buoys and pipes attached every thirty feet. We planned to track this large floating object and dive on it every two or three days.

A floating log attracted this huge school of baitfish that we encountered in the Pacific Ocean. Floating objects are a magical attraction to fish. Revillagigedo Islands, Mexico.

We had made four dives in the past seven days and had seen absolutely nothing in the way of marine life other than a few small masses of diatoms floating in the clear blue water. This was "extremely unproductive water," as one scientist put it, and I was beginning to regret my commitment to this cruise. We were to spend the next five weeks in this same area, and I had yet to see anything worth photographing. Besides, I am exceptionally prone to seasickness, and the *R/V Thomas Washington* rolled and pitched like no boat I had ever been on. It was only the chance to document Dr. Ken Smith's floating array that brought me to this heaving prison of steel and diesel fumes.

My regrets soon vanished, however, when we checked on the array that we had set out three days earlier. Even in this unproductive water, several large

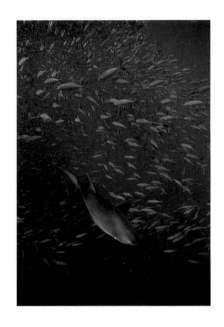

Hundreds of Galapagos sharks, splashing at the surface in a frenzy, were attracted to the school of baitfish underneath this floating log. Revillagigedo Islands, Mexico.

NOTES FROM THE FIELD

FLOATING OBJECTS

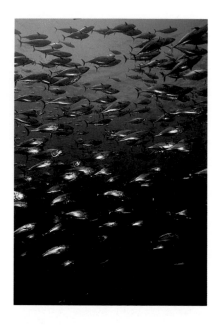

A school of skipjack tuna patrols a seamount in the Pacific Ocean. Tuna are swimming machines, their bodies designed to maximize speed in the water. Revillagigedo Islands, Mexico.

animals had gathered around this floating object in a short time — a four-foot wahoo (a gamefish shaped like a torpedo), schools of small fish, and pilotfish. The next day, two dolphinfish (mahi-mahi) made an appearance.

Unfortunately, my plans for a serious long-term observation of this array were dashed when the next storm came upon us. Our floating array was lost, and I spent the next two days in the bowels of the ship building a replacement. Upon deploying that new object, the buoyancy was misjudged by the crew and the entire apparatus, along with a valuable radio transmitter and other scientific gear, slowly sank out of sight beneath the clear blue water. With it sank my hopes for an eventful five weeks out at sea, for as I found during the rest of those long weeks in my imprisoned, seasick state, these waters were extremely unproductive, and nothing larger than a small jelly was seen. The floating object was clearly the attractant, and an extremely effective one at that.

The amount and diversity of life that gathers around floating objects in the open ocean is astounding. In the Revillagigedo Islands off Baja Mexico, I dove with sharks thrashing about near small pieces of old nets and logs, chasing the schools of jacks and juvenile fish that frequently hovered beneath. Literally hundreds of sharks were attracted to the site and patrolled the waters nearby. One small log the size of a door may have a school of 1,500 tuna underneath it. Floating masses of living kelp,

These oceanic triggerfish prefer the open ocean, and were found around a fish attracting device (FAD) set out at great cost to attract fish in deep water. Kona, Hawaii.

NOTES FROM THE FIELD

FLOATING OBJECTS

uprooted by winter storms and carried far offshore, may have innumerable crabs, fish, and other invertebrates living, feeding, and reproducing among the surfaces provided by the plant. Fishermen have long used this knowledge to their advantage in tracking congregations of fish. In Hawaii, I dove on fish aggregating devices (FADs) — long buoys attached to the bottom 2,000 feet below — that were set at tremendous expense to attract fish. Similar buoys have been set off the California coast and in other seas.

Steven Callahan, a sailor who was marooned on a small life raft for seventy-six days, reports that a school of mahi-mahi, sharks, and numerous pilotfish followed his raft for days on end. He was eventually rescued by South Pacific islanders who boated out to investigate a floating object they knew would harbor good fishing. The floating object turned out to be Callahan's raft, and much as they were surprised to find a man in his emaciated condition, they still stayed long enough to take advantage of the good fishing around the raft. Thor Heyerdahl, in his trans-Pacific voyage on a balsa wood raft, reported similar congregations of marine life around his raft:

The fish which most of all attached themselves to the raft were dolphins and pilotfish there was not a day on the whole voyage on which we had not large dolphins

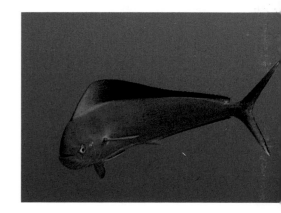

The mahi-mahi, also called the dorado or dolphinfish, is a beautiful, excitable fish that is immensely popular with sportfishermen. Northern Pacific Gyre.

NOTES FROM THE FIELD

FLOATING OBJECTS

wriggling around us. What drew them to the raft we do not know, but, either there was a magical attraction in being able to swim in the shade with a moving roof above them, or there was food to be found in our kitchen garden of seaweed and barnacles that hung like garlands from all the logs and from the steering oar. . . . we often wondered whether the whole ocean current was full of fish, or whether those down in the depths had intentionally assembled under the Kon-Tiki to keep us company for a few days.

Why fish tend to gather around floating objects remains a mystery to scientists. Although various small forage fishes congregate under these objects, it seems unlikely that their presence attracts the larger fish. The few small fish sheltering under a small log could hardly satisfy the appetite of a school of tuna. Regardless of the reason, any object floating at the surface or in mid-water attracts whole communities of animals, serving as both a refuge and attractant. One thing is for sure: floating objects make my work easier by serving as a beacon for my subjects.

Galapagos sharks attracted to a school of baitfish kept their distance as long as two or more people were in the water. Diving alone, however, I was immediately surrounded by sharks. Revillagigedo Islands, Mexico.

NOTES FROM THE FIELD

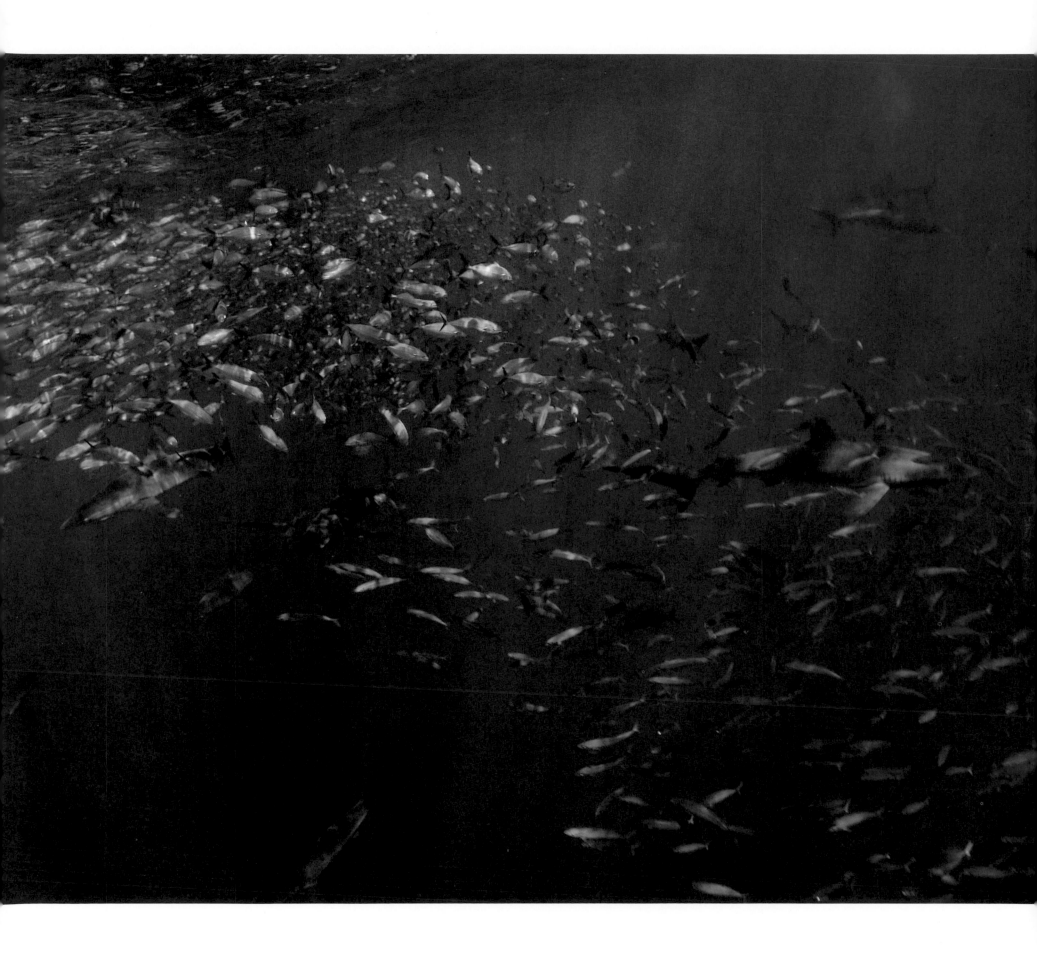

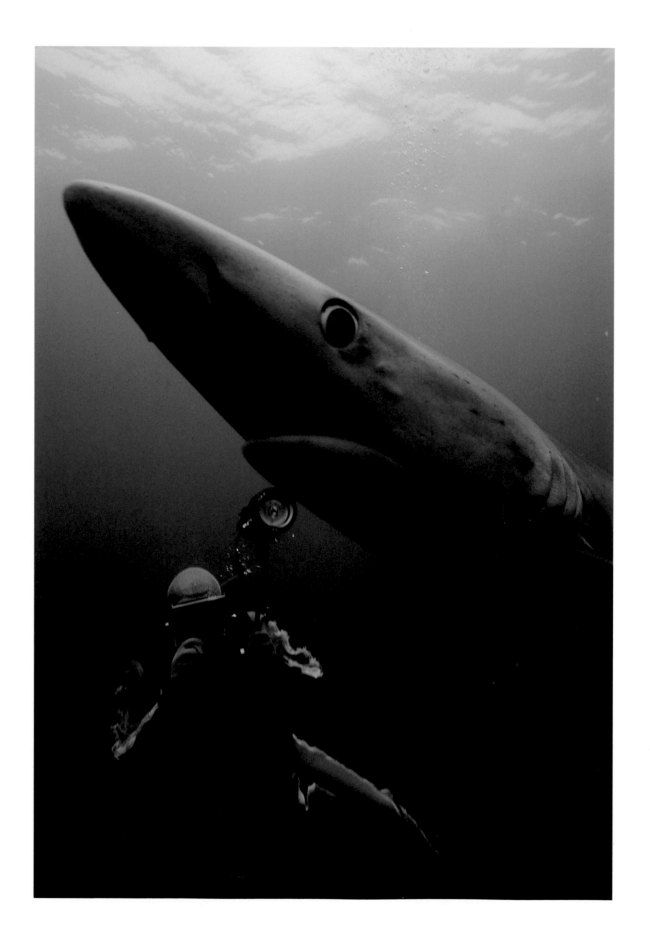

SWIMMING WITH SHARKS

There is nothing like seeing a blue shark, sleek and silvery, coming out of the deep blue of the open ocean. Blue sharks are fairly predictable animals. Though they are certainly dangerous, they don't get quite large enough to crush a man in their jaws, and their teeth, while razor sharp, are short and stubby. In contrast, a mako shark has long, slender teeth. Mako sharks are not as common as blue sharks. They move faster and they are much harder to photograph.

There are shark suits made specifically to protect against attacks by blue sharks. Only a few of these suits have ever been made, at a cost of thousands of dollars each. The suits are made of stainless steel links woven together electronically into a tight mesh. The mesh covers the diver's entire body and allows enough flexibility to swim and move around. The stainless steel mesh works by spreading the point of impact of a shark's tooth into a more generalized area. I've been bitten several times since first trying on a suit, and it does work. Even a large, eight-foot blue shark could bite my arm with nary a bruise or ache afterward. A mako shark's teeth, however, would probably tear right through the steel mesh. Fortunately, mako sharks are wary animals, and it is hard to get them to come close to divers.

To find blue sharks, we must take a boat twenty miles out into the open ocean off the coast of California The bottom here is over two miles deep, and a novice diver

A blue shark approaches a diver wearing a steel-mesh shark suit. The impact from a shark bite is spread out by the steel-mesh links in the suit, preventing injury. San Diego, California.

The blue shark is an open ocean predator. It has been implicated in attacks on shipwrecked humans. San Diego, California.

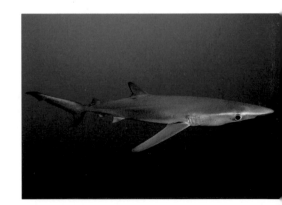

NOTES FROM THE FIELD

SWIMMING WITH SHARKS

The mako shark has a reputation for speed. The strings on this shark's dorsal fin are egg strings laid by copepod parasites embedded in the shark's fin. San Diego, California.

The largest fish in the world, whale sharks appear almost every spring off the coast of Baja Mexico, above the Gorda Banks near La Paz. Sea of Cortez, Baja Mexico. / 62-63

might easily become disoriented by the endless three-dimensional blue space all around him. Diving in the open ocean can be disorienting. There are no visual clues to indicate where or how fast a diver might be sinking. The neoprene of a wetsuit compresses at depth, making a diver even heavier relative to the water around him, and so the deeper a diver sinks the faster he goes. This is an exceedingly dangerous situation. Add the weight and stiffness of a shark suit to the inherent problems of blue water diving, and small problems can quickly become dangerous situations.

Divers use a piece of equipment to adjust their buoyancy. This is called a buoyancy compensating device (BCD), and it is a bag into which air is pumped to keep the diver neutrally buoyant. Unfortunately, the BCD is easily punctured by frenzied sharks, and a diver could easily find himself sinking out of control to the bottom two miles down, with a twenty-five-pound, $6,000 stainless steel anchor that is impossible to take off underwater. This is not a glorious prospect. We shark divers have learned to pay constant attention to our surroundings, our depth, and the location of our buddies. Ironically, as with most things in the ocean, it is not the sharks, but rather a diver's carelessness that leads to dangerous situations.

Blue sharks are among the most abundant of temperate-water sharks. San Diego, California.

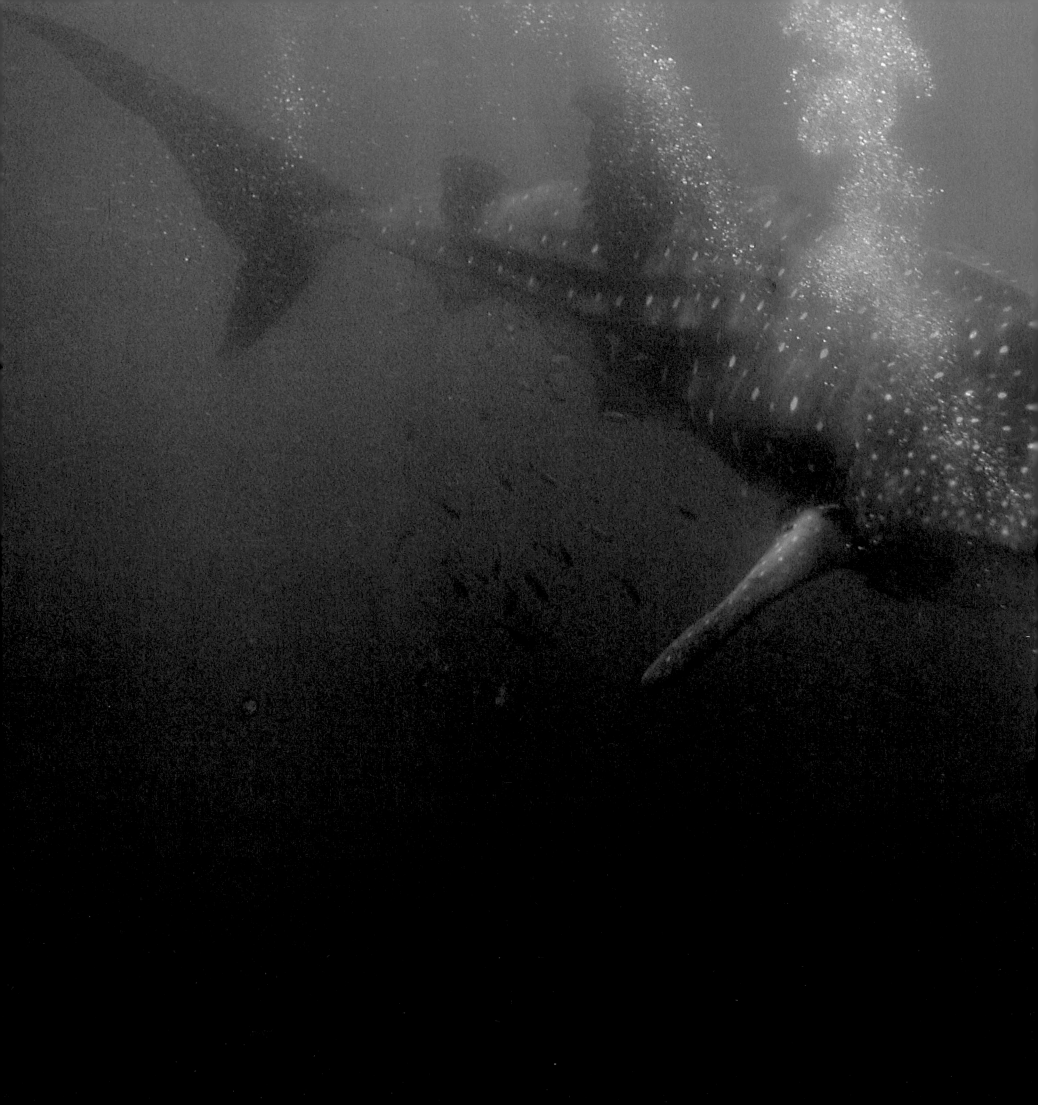

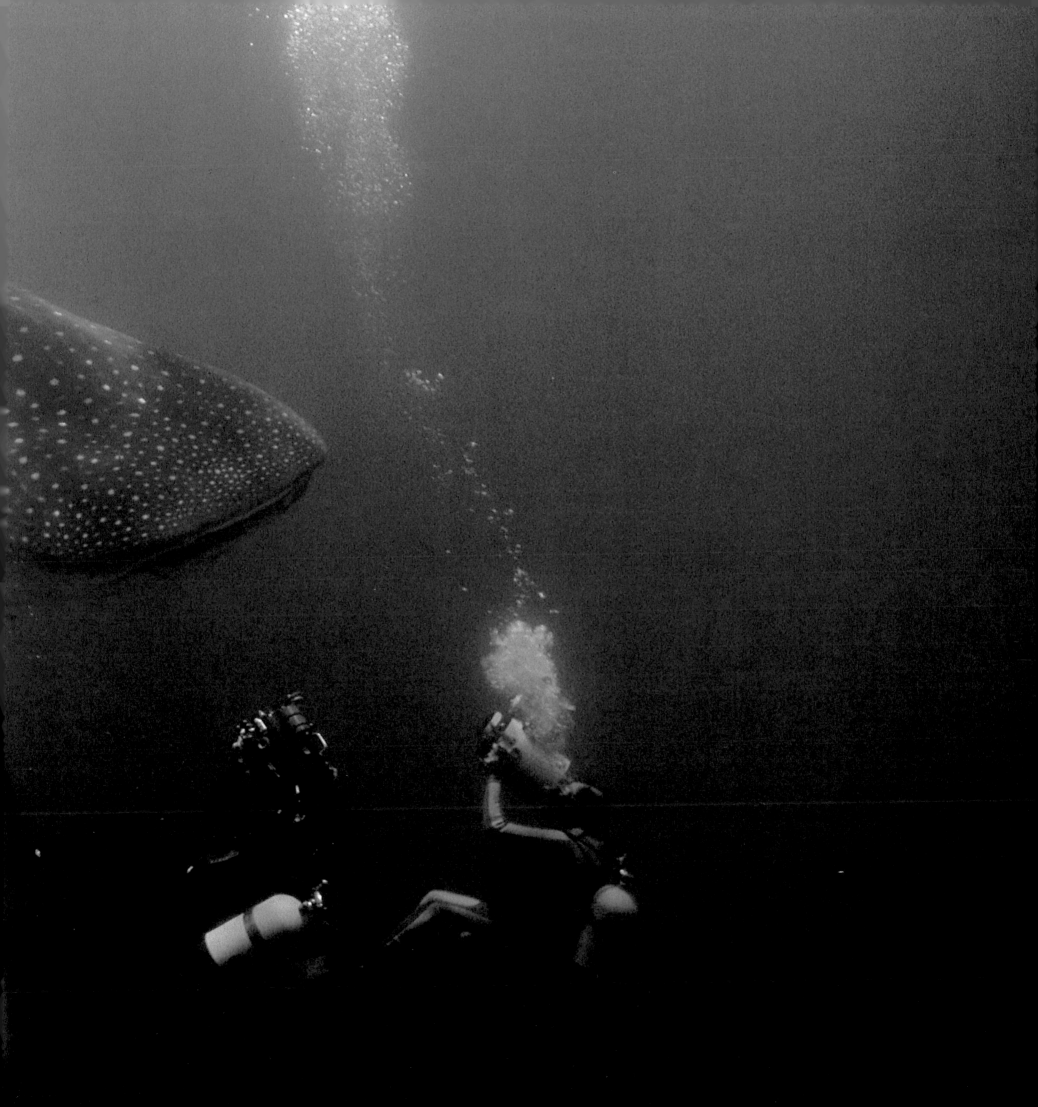

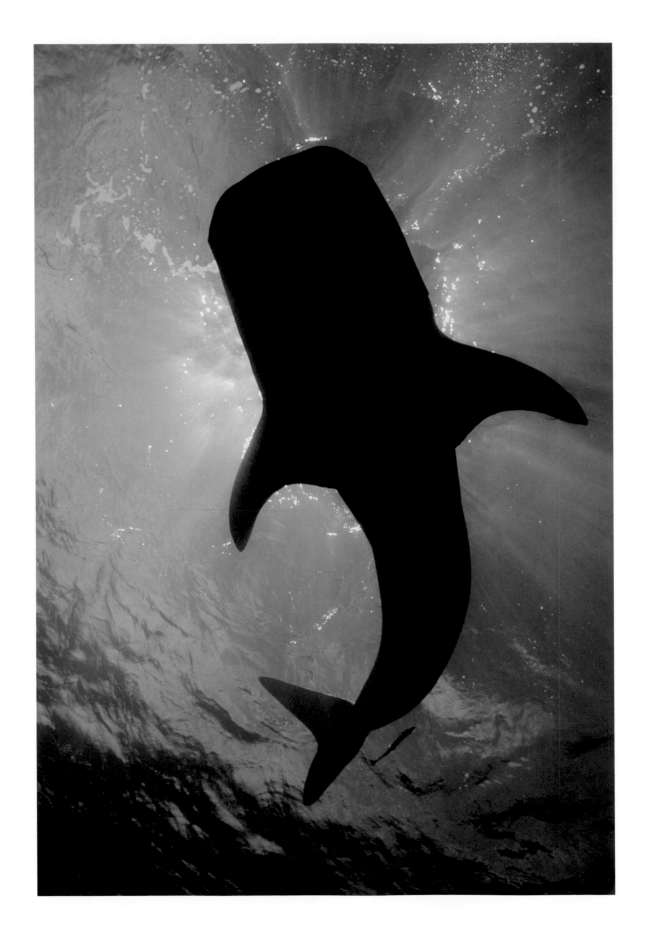

THE LARGEST FISH
IN THE WORLD

The dorsal fin, as tall as a man, slices through the water toward our boat. As we swim toward the fin, the monster suddenly appears out of the blue. It's even bigger than I had imagined, at least forty feet from tip to tail, and it moves FAST. The big shark sweeps by with a flick of its tail, spinning me over in the backwash. Howard Hall, the filmmaker in charge of this expedition, was actually pushed in front of this huge shark by a pressure wave flowing in front of the animal.

We were filming the largest fish in the world — whale sharks. They appear almost every spring off the coast of Baja California, in the Sea of Cortez above the Gorda Banks. I have seen whale sharks all over the world. These huge creatures are unmistakable with their broad, flat head and checkerboard pattern of white spots on a dark body. Like most sharks, the bottom of its body is lighter in color than the top — an effect called countershading, which may serve to hide the animal from view in the open ocean. This is by far the largest fish known. Maximum size has been reported to be fifty-nine feet, but the largest accurately measured whale shark was forty feet long.

Swimming with a whale shark is a dream fulfilled, a Holy Grail for a diver. Divers have come to recognize the whale shark not as a sea monster, but instead as a gentle, endearing beast. While whale sharks are powerful animals, they are not aggressive. Large as they are, whale

While whale sharks are powerful animals, they are not aggressive. Large as they are, whale sharks are cautious around divers. Seychelles Islands.

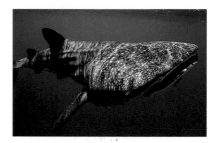

Not much is known about the whale shark's natural history. We know little about its migratory patterns, breeding behavior, or even precisely what species it eats. Seychelles Islands.

NOTES FROM THE FIELD

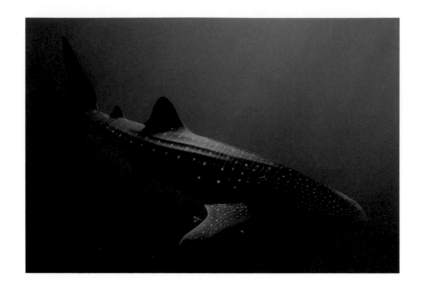

Like most sharks, the bottom of a whale shark's body is lighter in color than the top. This "countershading" may serve to hide the animal from view in the open ocean. Seychelles Islands.

Schools of hundreds of hammerhead sharks can be encountered off seamounts. Swimming in the midst of a school of hammerheads is exciting, and fortunately not dangerous. Cocos Island, Costa Rica. / 68-69

THE LARGEST FISH IN THE WORLD

sharks are somewhat shy. It has always surprised me that large animals in the ocean, such as whale sharks and whales, prefer to avoid you rather than simply run you over. I've ridden small whale sharks on the order of twenty feet long. Some of them tolerate your presence on their fins for a while, but most of them will sound (dive abruptly) when they feel you on their body.

Very little is known about the whale shark's population or behavior. There is almost no scientific information on their migratory patterns, breeding behavior, or even precisely what species they eat. Only three juvenile whale sharks have ever been found. In these days of open ocean driftnets, coastal gill nets, pollution, and overfishing, it is heartening that whale sharks of all sizes can still be found.

Each year nearly 20,000 once-endangered gray whales migrate from their feeding grounds in the Bering Sea to the warm lagoons of Baja Mexico to mate and give birth. San Ignacio Lagoon, Baja Mexico.

NOTES FROM THE FIELD

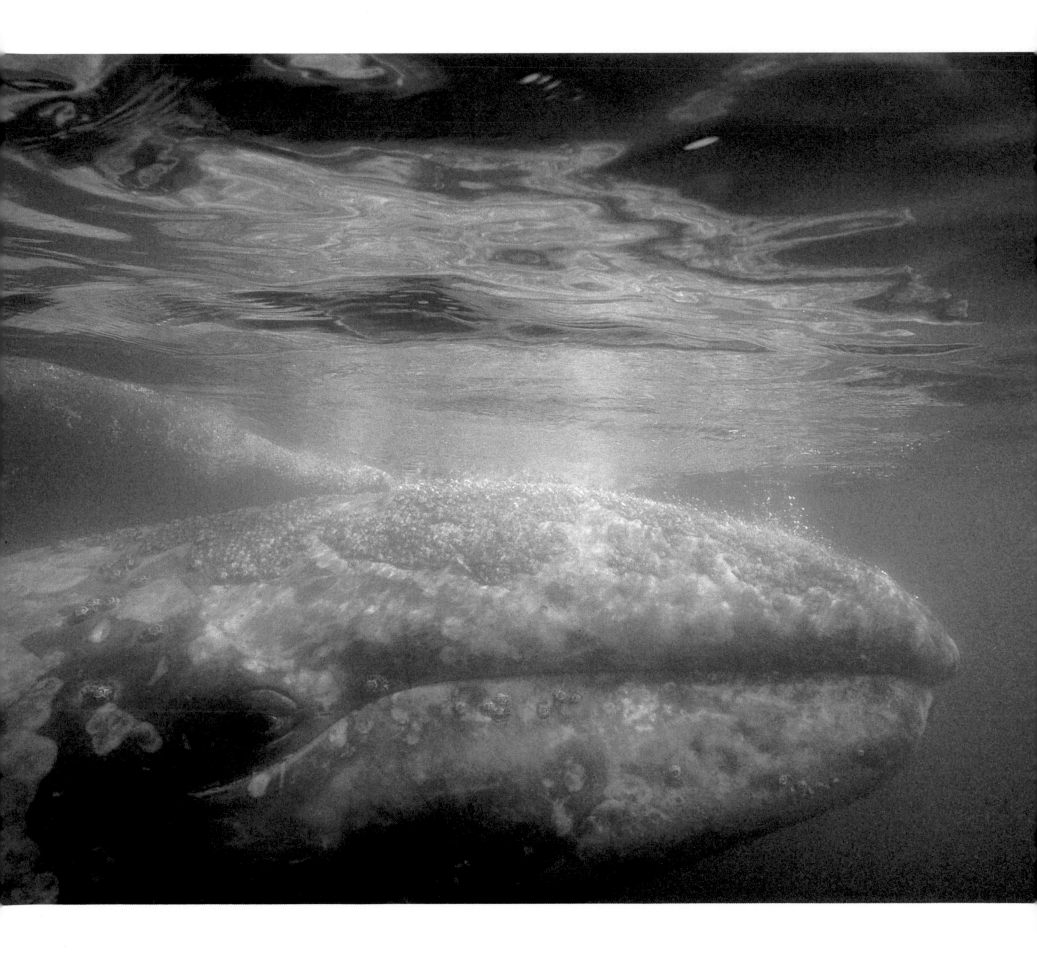

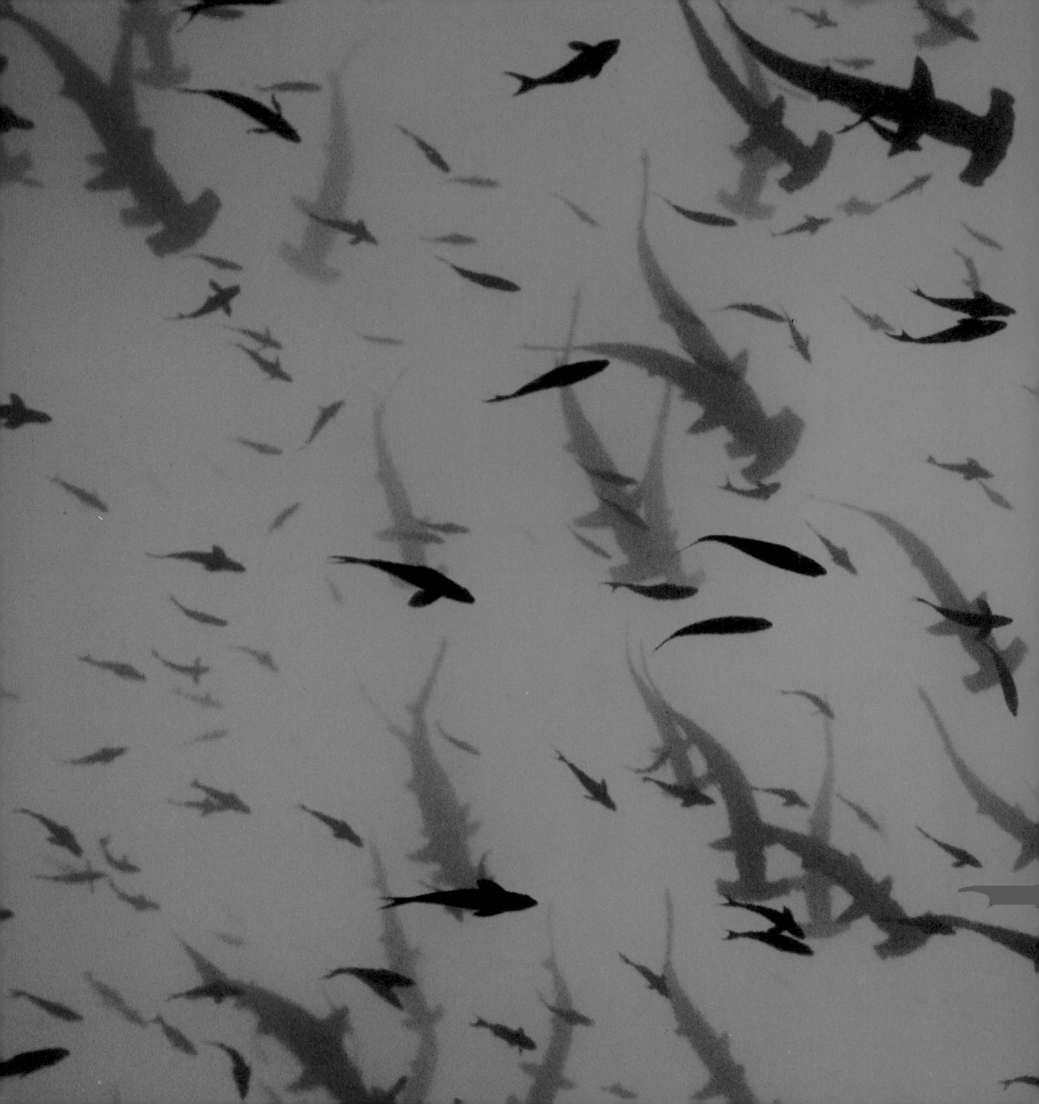

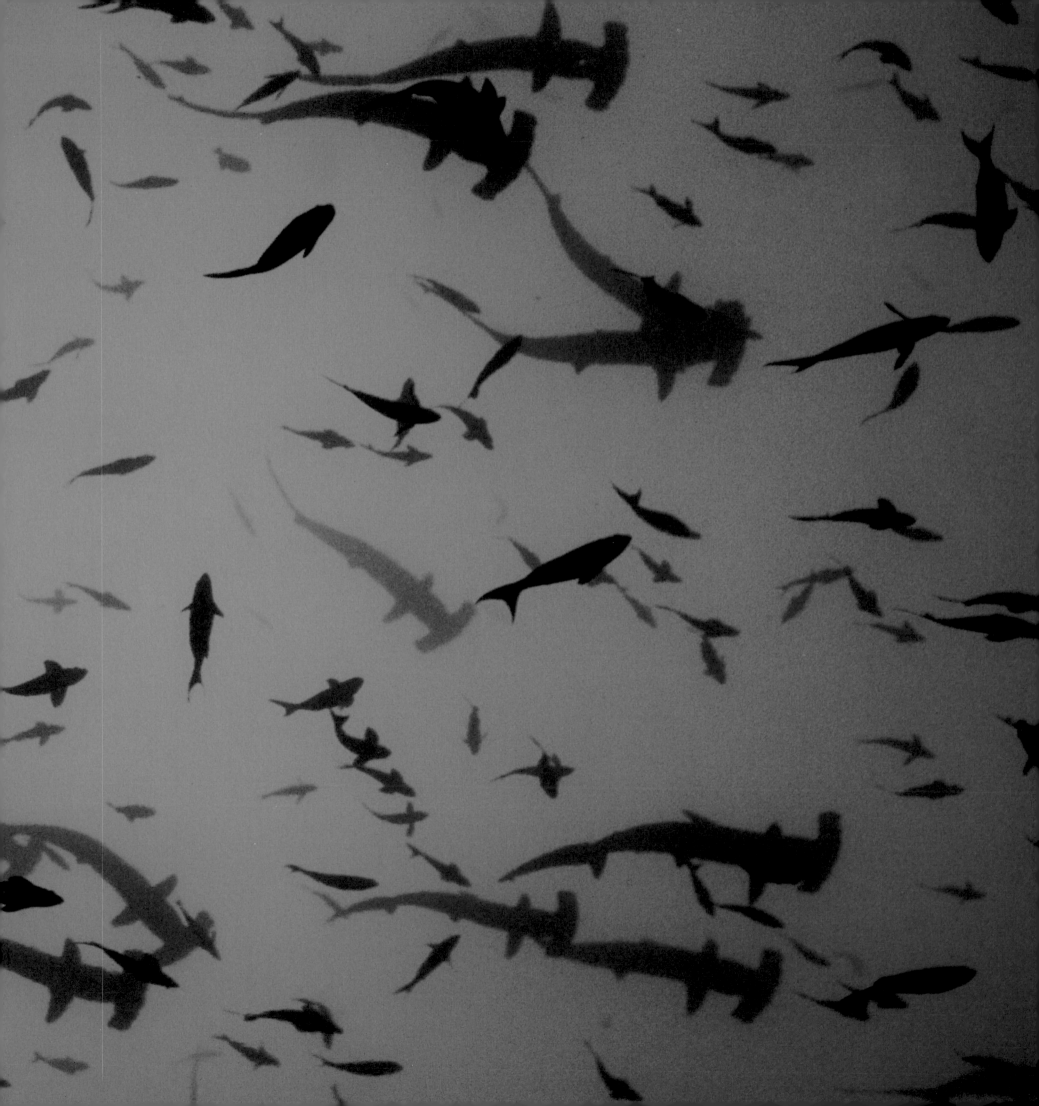

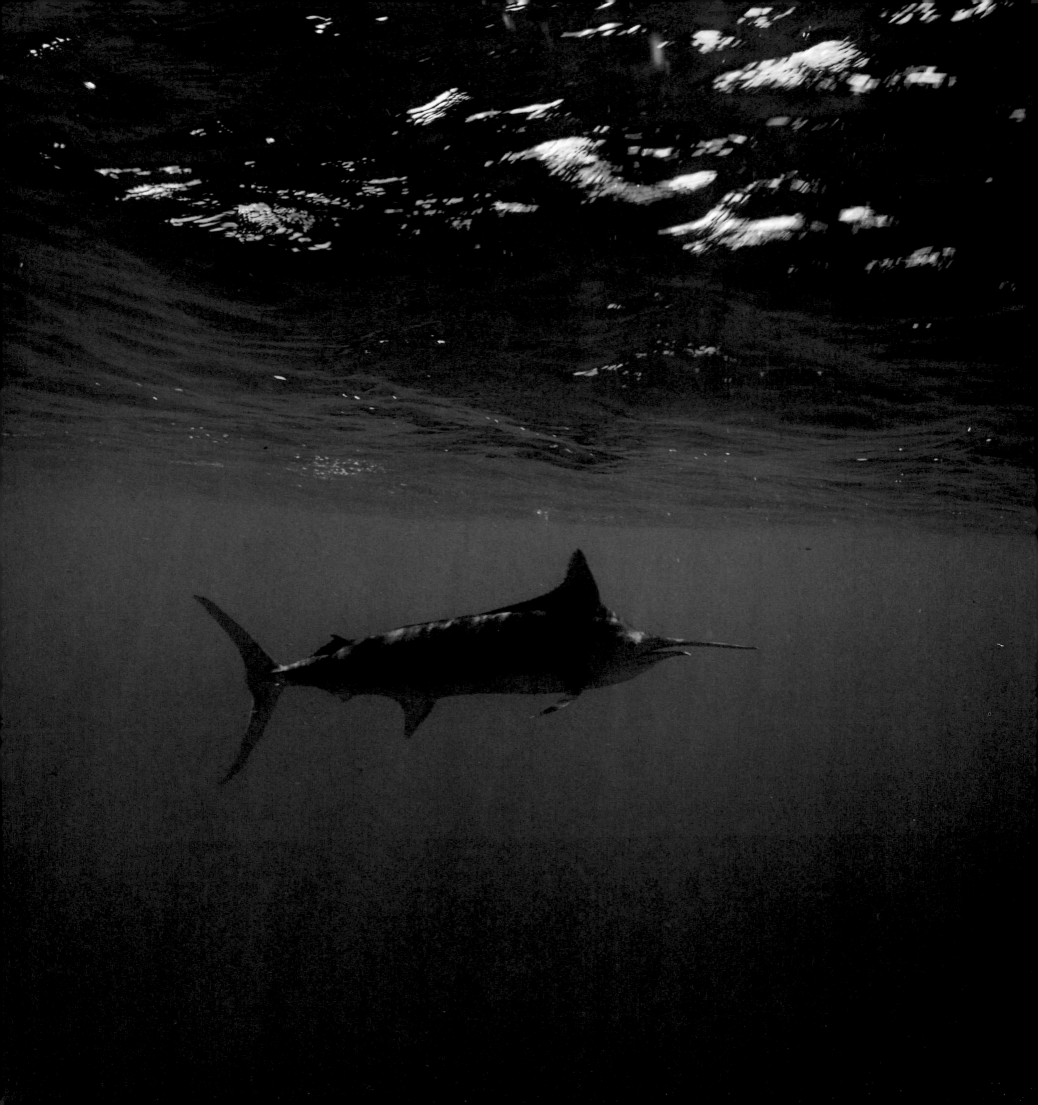

UNDERWATER CROSSROADS

The blue marlin grows to 12 feet. A powerful, aggressive fighter, the blue marlin is a prized gamefish. Sea of Cortez, Baja Mexico.

I've been kicking steadily in the blue water for five minutes, my heart pounding with the exertion and my lungs hard-pressed to get enough oxygen. Suddenly they are all around me, eight-foot hammerhead sharks, and I fight to hold my breath while concentrating on getting the picture. Finally I can't take it anymore and I have to exhale. The sharks bolt in an instant, forty to fifty of them moving simultaneously, disappearing into the blue. I don't know where I am in the open ocean; I only know that I am crossing over a seamount when I pass through schools of creolefish, triggerfish, and jacks. The hammerhead sharks hover on the edge of my vision, gathering in huge schools.

Seamounts are undersea pinnacles that serve as gathering places for marine life, attracting the ocean's largest and most exciting animals. I have had my most memorable dives around these magical places — in the Galapagos Islands; the Revillagigedo Islands off Baja Mexico; Cocos Island, Costa Rica; and Sipadan Island, Borneo. They are famous for their concentrations of sailfish, marlin, hammerhead sharks, tuna, and manta rays. Seamounts form in areas of volcanic action, where the ocean floor abruptly rises to the surface. These volcanic "hotspots" can be close to the coast or hundreds of miles offshore.

Later in the day, a school of bait is whipping the water ahead of us, and Mike McGettigan, the captain of

Undersea pinnacles are gathering places for marine life. This small pinnacle in the Pacific Ocean had schools of squirrelfish and snapper surrounding an underwater arch. Cocos Island, Costa Rica.

NOTES FROM THE FIELD

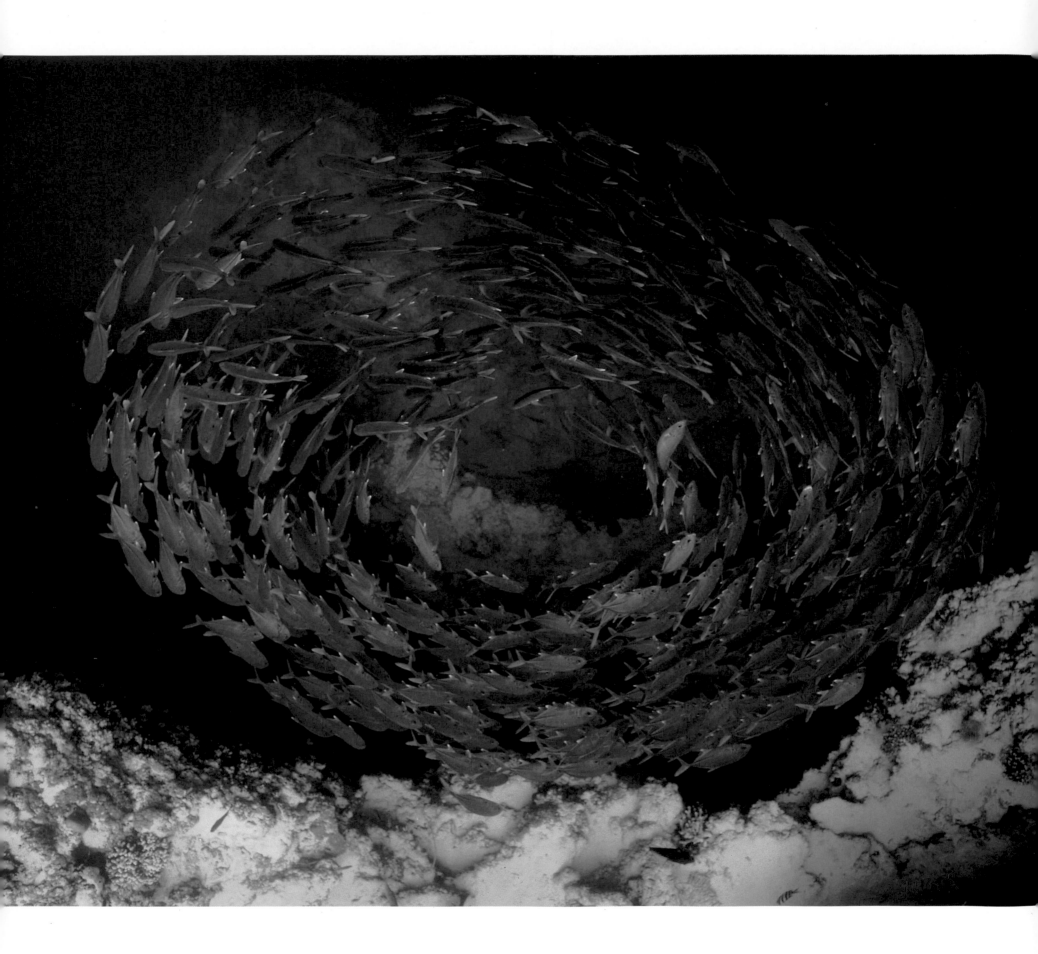

UNDERWATER CROSSROADS

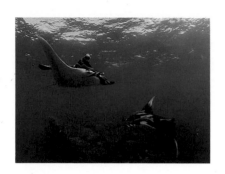

Huge manta rays gather at a seamount in the Pacific Ocean. If approached quietly and with respect, mantas may allow divers to hitch rides on their backs. Revillagigedo Islands, Mexico.

A hammerhead shark approaches a cleaning station in the Pacific Ocean. These sharks are often cleaned by adult king angelfish and barberfish at sites on a seamount. Cocos Island, Costa Rica.

our boat, pulls alongside and we jump in with our cameras. Striped marlin are everywhere, working together to keep the baitfish in a tight ball. Their eyes are on us, and their stripes flash in a threat display. They are gone too quickly to film, but the memory of these sleek shapes stays bright. Later in the summer, I am swimming on the surface after a dive near the Marisla seamount. Suddenly, out of the corner of my eye, I see a grey shape which I mistake for a large shark, until the fish turns and I see a thick, powerful bill. It is a blue marlin — the largest I have ever seen — and it passes within four feet of me, curiosity in its eyes. The next day, around the seamount again, sailfish are everywhere. We see them in schools of four, and on one occasion, which I film, in a group of twelve. They raise their large dorsal sails in alarm when we kick toward them, but we are merely a small threat and they easily outswim us.

A few years later, on my first trip to the Revillagigedo Islands, I encounter the famous manta rays of Baja. Like giant flying carpets (the name "manta" is Spanish for "blanket"), these mantas swim about a seamount called Boiler Rock. They are astoundingly docile. We spend hours with these fish which reach sixteen feet from wingtip to wingtip. Henry Kaiser and Ken Richards, the only two non-photographers on the boat and thus the only divers who truly enjoy the experience, hitch a ride on a manta for almost half an

A school of squirrelfish gathers around a seamount, seeking shelter in caves during the day. Their large eyes enable them to hunt for plankton at night. Cocos Island, Costa Rica.

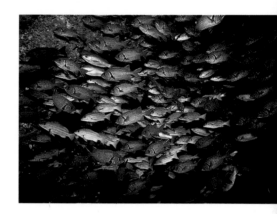

A school of bigeye trevally forms a moving circle off the steep dropoff of an oceanic island. Sipadan Island, Borneo. / 72

NOTES FROM THE FIELD

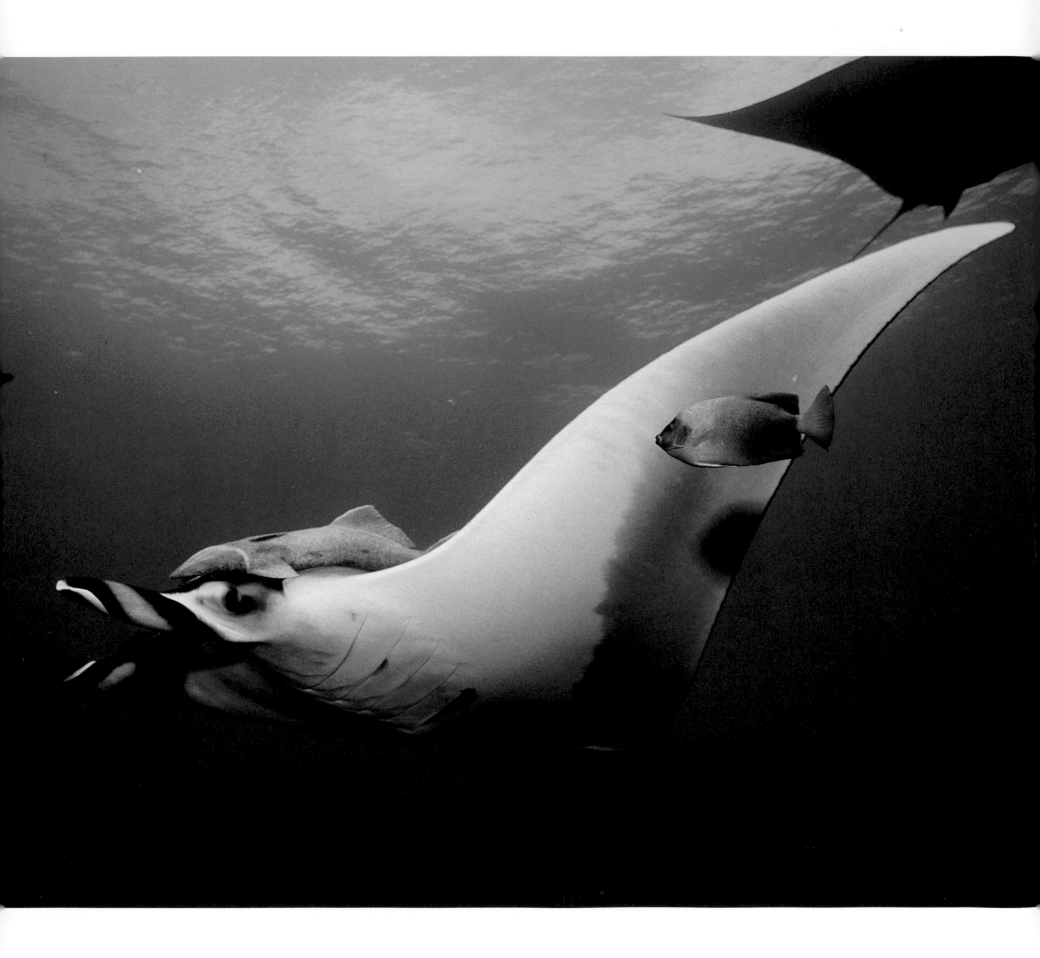

A clarion angelfish approaches a manta ray to clean it at this seamount in the Pacific Ocean (left). The mantas are apparently drawn to the site by the prospect of a cleaning. Revillagigedo Islands, Mexico.

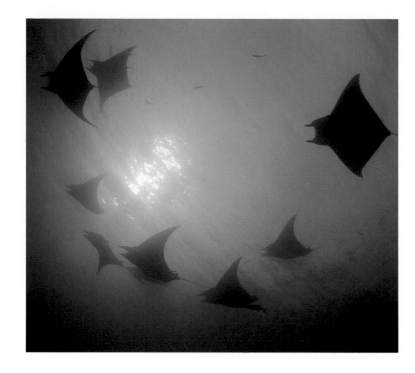

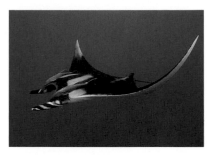

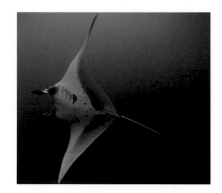

UNDERWATER CROSSROADS

hour! The mantas tolerate the divers amazingly well, and they circle back to the seamount time after time. As I leave, four of them appear out of the blue in formation and tip their wings at me as if in a salute, their sad, watery eyes imploring me to remember and protect this magical place, these magical beings.

Most manta rays encountered in the waters around the Baja California peninsula have two large remoras attached to them. The remoras attach to the mantas with suckers on the top of their heads. The suckers attach so strongly that they often leave marks on the manta's rough skin. Revillagigedo Islands, Mexico.

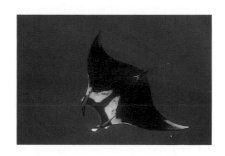

NOTES FROM THE FIELD

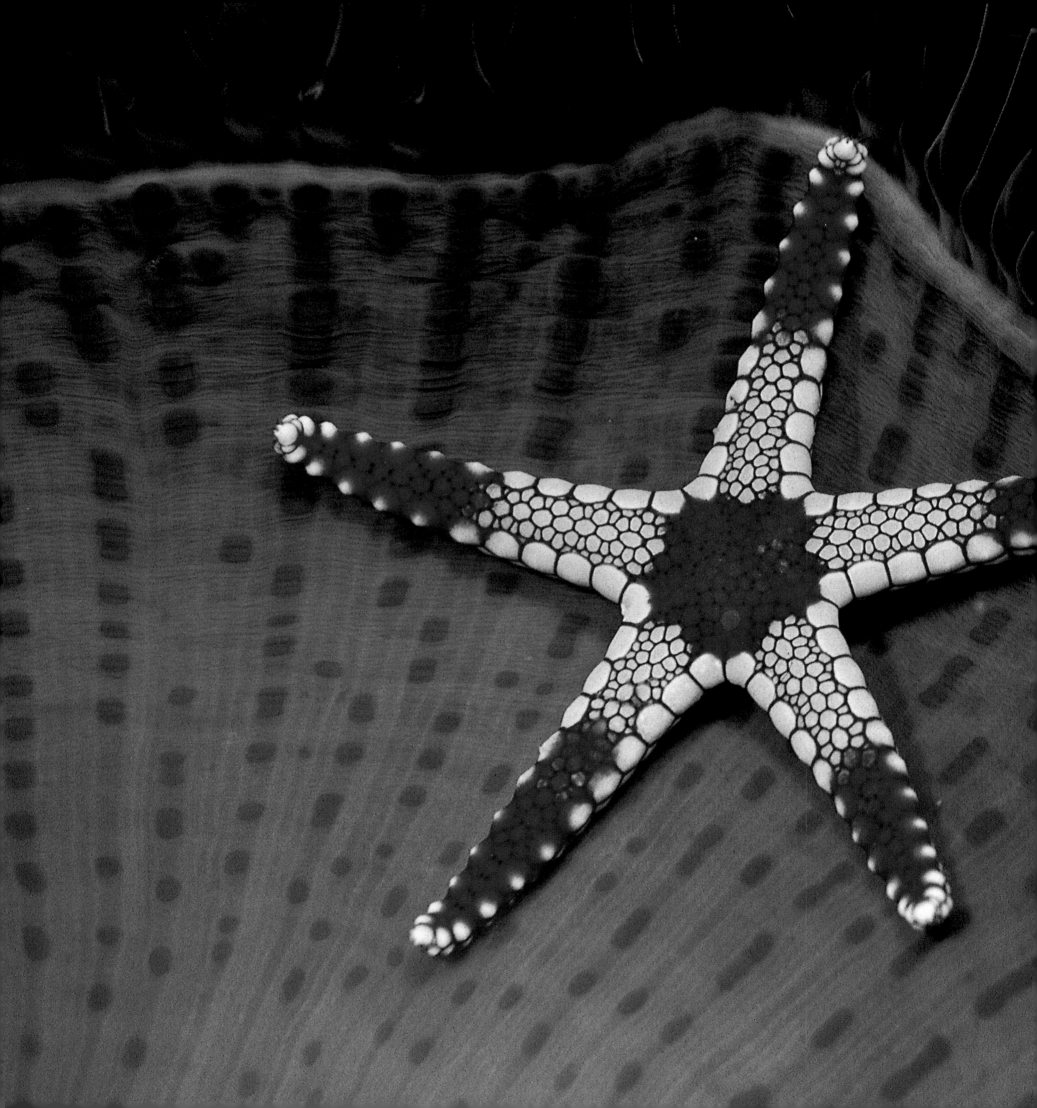

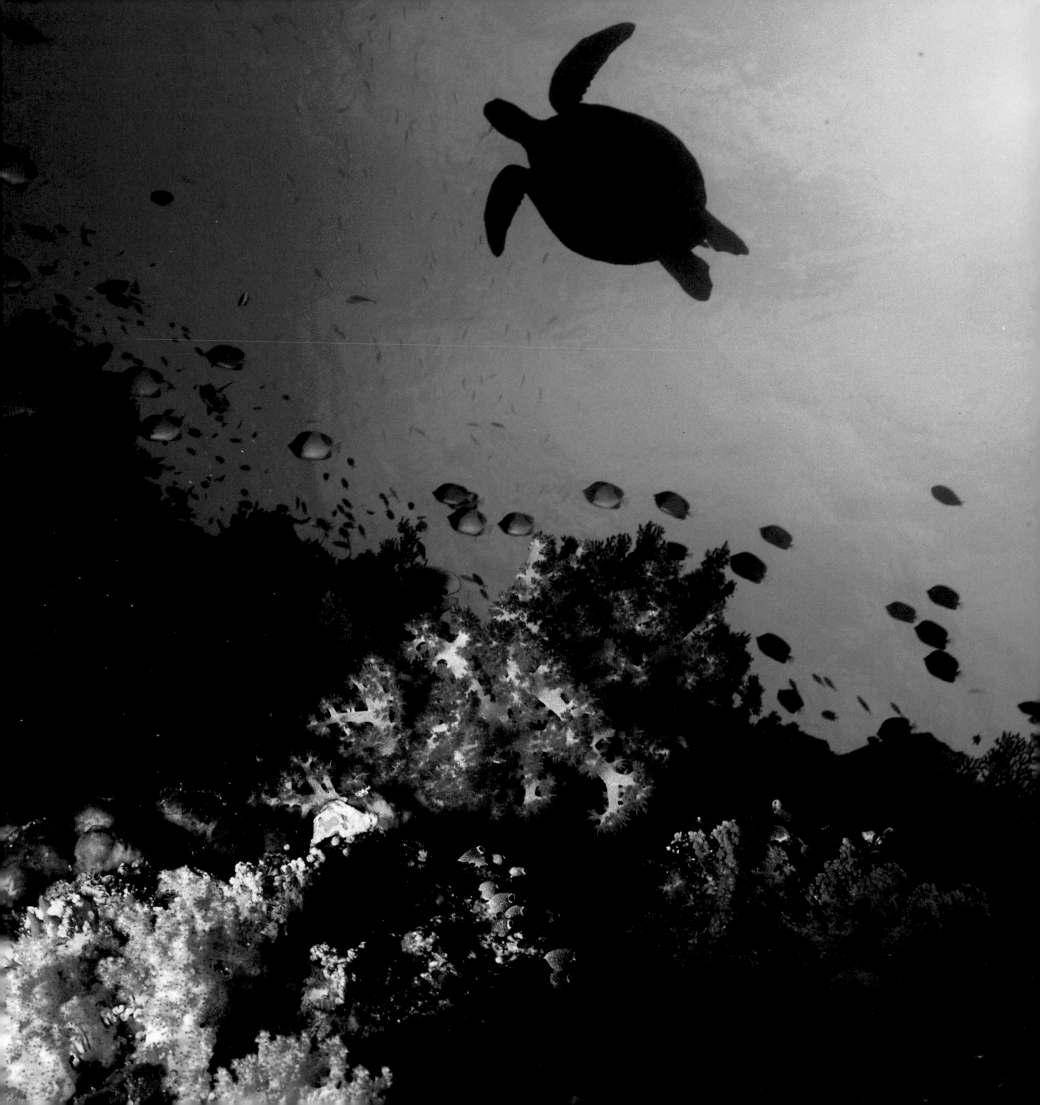

THE CORAL REEF

A green sea turtle pokes her head above the water to peer at the island of her birth. She has returned here regularly for the past forty years to mate and lay her eggs in the warm pink sand of this tropical island. She is old, and she is tired from her long journey through the Pacific Ocean. She is waiting for night to fall so that she can return to the island under the cover of darkness to dig a nest and lay her eggs. It is the middle of the day now, and the turtle looks at the route she must take tonight — over the coral wall that drops steeply down below her, past the surf foaming over the shallow barrier reef, through the shallow sandy lagoon behind the reef wall, and finally up the beach. She picks out a nice shady spot far up the beach, beneath some pandanus trees, where her eggs will be kept warm, but not too hot. Ever patient, the turtle takes a deep breath, sinks below the surface, and finds a dark coral cave to sleep in as

she waits for sunset. All around her teems the hustle and bustle of the coral reef. A coral reef is very much like a city, with a great deal of activity during the day, and quieter residents making their appearance at night. Like a neighborhood or community, the coral reef has its apartment houses, places for socializing, and even barbershops. The walls of the city are actually made of limestone cement that has been built up over generations and generations. Although they look like rock, the walls are actually alive, formed by millions of tiny animals — the corals. Each coral polyp surrounds itself with a limestone skeleton, and colonies of these animals work together to build structures of distinct shapes and sizes. Over thousands and thousands of years, these polyps gradually erect the huge, intricate limestone reefs that exist off tropical coasts and islands.

All around the coral reef, brightly colored fish parade about in pairs and schools. Above the sleeping turtle, a school of jacks circles in an endless dance. A large solitary barracuda keeps its distance, waiting for a chance to dart in and seize a careless individual from the school, but its body is scarred from past encounters with the jacks, which together can defend themselves against a barracuda attack. Parrotfish wander about from coral head to coral head, gnawing off chunks of coral and crushing them with their strong teeth. They create sand by crushing the limestone skeletons of the coral. Butterflyfish and angelfish, paired off in couples, patrol established territories, delicately browsing on sponges, corals, and other invertebrates. Sponges grow on reef walls, drawing in water through numerous small holes on their body and filtering out food particles. Water is expelled through a large central opening. Sea fans grow in areas of current, where plankton is brought within reach of their numerous stinging polyps. Almost every available surface on the reef is covered with corals or sea fans, which in turn serve as the home for dozens of fish, shrimp, and other creatures. On the top of a sea fan several crinoids, also called feather stars, comb the waters for small food particles. Looking closer one can see tiny shrimp, crabs, and even pairs of clingfish, all of which make their homes within the crinoids' waving arms and steal food that their host has collected.

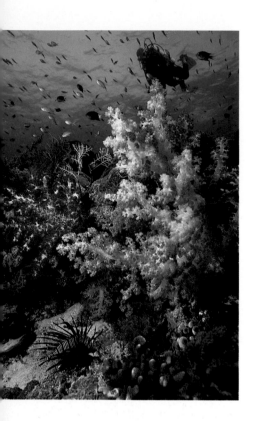

A lionfish rests amid a forest of colorful soft coral trees. These brilliantly hued soft coral trees inflate with water during periods of food-bearing current. Sipadan Island, Borneo.

Individual polyps make up a stand of reef-building ACROPORA corals. Corals of the genus ACROPORA adopt more forms than any other. Solomon Islands.

The brilliant hues of a candy-cane sea star form a startling contrast to the purple base of a sea anemone crowned with stinging tentacles. Sipadan Island, Borneo. / 76-77

A green sea turtle circles overhead after taking a breath at the surface. Green sea turtles come to this island by the hundreds to mate and lay eggs. Sipadan Island, Borneo. / 78

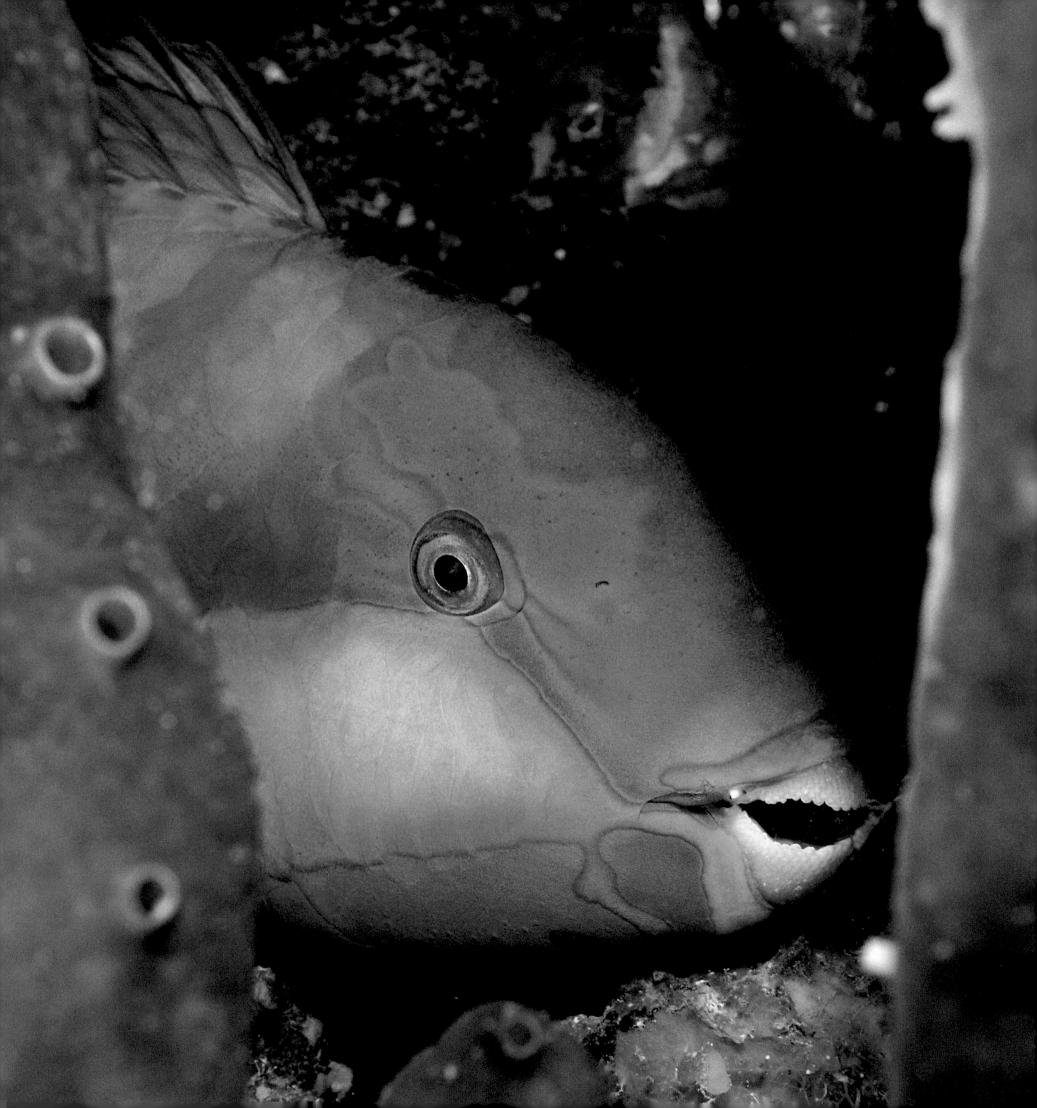

A large male parrotfish sleeps in a coral reef. Parrotfish, named for their beaklike mouths, use their strong jaws for crunching coral. Sipadan Island, Borneo.

In the distance, an albatross soars in the trade winds and catches its first sight of land in three months. The sun is setting and its rays illuminate the tropical thunderclouds above. The still waters of the lagoon are shattered here and there by the splashes of schools of small fish jumping out of the water in unison. They are being pursued by a school of larger needlefish — long, thin fish shaped like arrows, and moving almost as fast. Further out, a school of even larger barracudas patrols the edges of the barrier reef, looking for unwary prey in the dim light. As the light fades all around the coral reef, the creatures of the day find holes and crevices where they will spend the night. The brightly colored angelfish and butterflyfish find beds of sponge and sand, and they mute the fine colors of their bodies, turning into dull reflections of their daytime selves. In the deepening dark, a brilliantly colored parrotfish settles down in a coral cave. He begins spitting out a cocoon of mucus that slowly covers his entire body. This cocoon serves to mask his smell to the predatory and frightening-looking moray eels that hunt by smell at night.

Numerous other animals make their way up from their daytime resting places to use the night's cover to feed. A basket star unfurls itself from its base at the bottom of a sea fan, climbs to the top of the sea fan, and spreads its hundreds upon hundreds of finely branched arms. With these arms, it combs the passing currents for tiny food particles. Brittle and feather starfish also climb on top of sea fans to take advantage of stronger currents. Most of these "filter-feeding" invertebrates keep their sticky arms to themselves during the day, to prevent them from being nipped off by butterflyfish. At night, crabs, shrimp, and small cardinalfish also come out of hiding to forage under the cover of darkness.

Big-eyed soldierfish are everywhere, using their large eyes to spot tiny shrimp and krill. Winking lights belong to flashlight fish, which use a patch of light underneath their eyes to signal each other for mating or to find food. They cover their light organ with a patch of skin to turn it on or off. A reef octopus makes its way across the reef bottom, pausing to examine new territory, and pulsating with excitement as it locates a tasty snack — a half-buried clam. The entire face of the coral reef is changing, as the corals

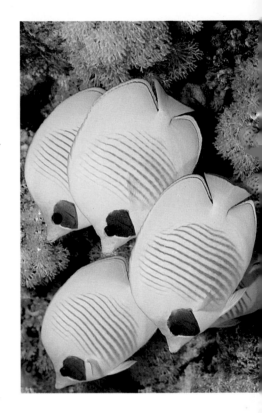

A group of masked butterflyfish, endemic to the Red Sea, rests around a coral head. More active in the late afternoon, they feed on soft and hard corals. Red Sea.

A polyclad flatworm (left) rests on a gorgonian, or sea fan. Flatworms are small, simple animals often found under rocks and in crevices. Sea of Cortez, Baja Mexico.

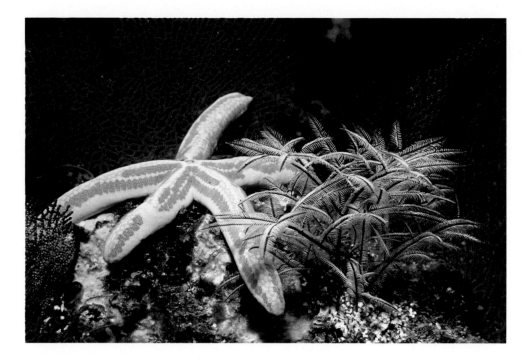

themselves burst out of their limestone skeletons to join in the activity and feeding of the night.

The turtle awakens from her dreams of childhood. She makes her way through the nighttime reef that sparkles with light from brittle stars, shrimp, and the phosphorescence of her splashes. She passes over the reef wall, through the breaking surf, and into the still waters of the lagoon. From here she swims to the pink coral sand and makes her way arduously up the beach. Her size makes it hard for her to move about on land. She is so heavy, and her flat shell drags in the sand. She slowly pulls herself with her flippers, grunting all the while with the strain, and leaving a heavy trail in the sand. After her long trek, she digs a hole and lays her eggs. She may repeat this for the next few nights before leaving to wander once again through the world's oceans. Her passage through the reef is marked by a dim glow of phosphorescence, disappearing in her wake.

Stinging hydroids and a tan sea star rest on a rock in front of a Panamic sea fan (above). Hydroids are cnidarians, related to jellyfish and sea anemones. Sea of Cortez, Baja Mexico.

A tiny coral goby, so small that it is almost invisible, watches for passing food particles while resting on a colony of star coral. Sipadan Island, Borneo. / 86-87

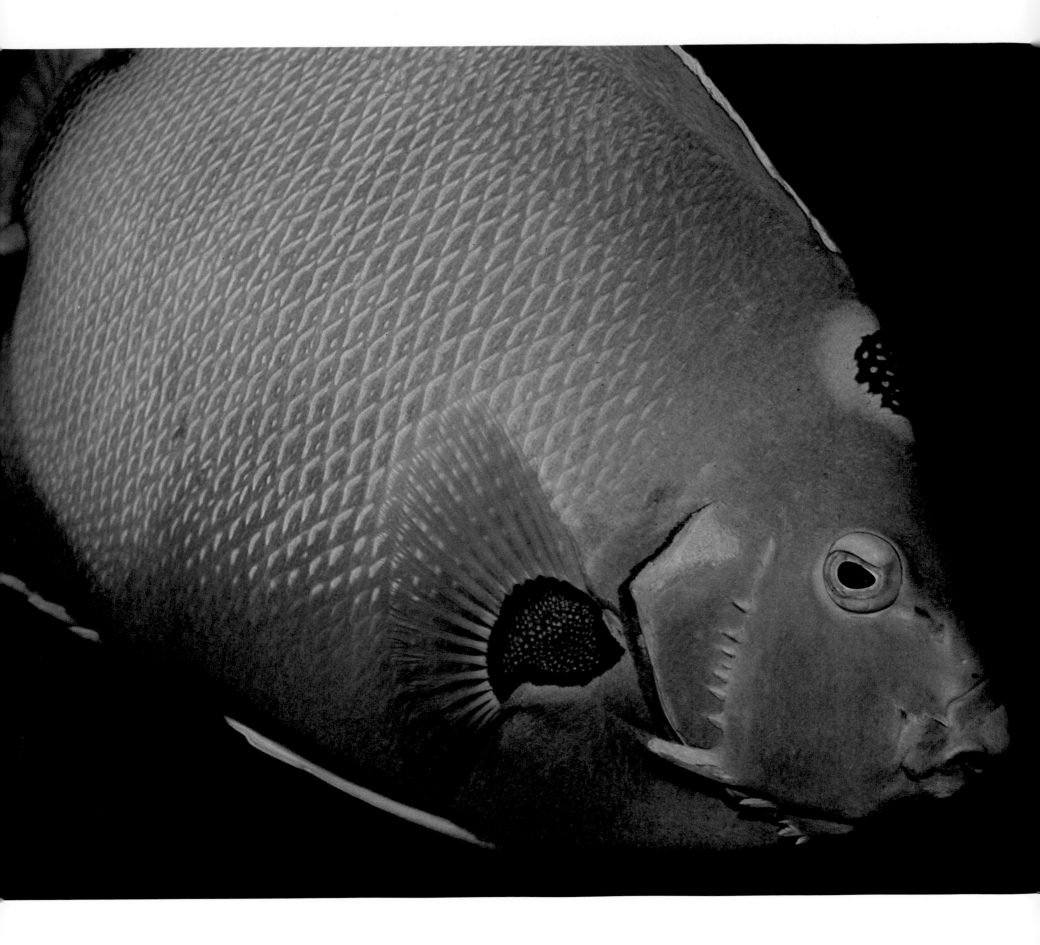

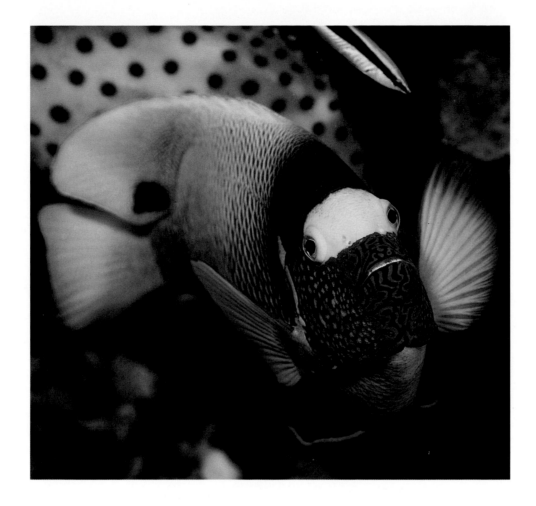

Under the cover of darkness, a sponge spider crab makes its way across a sea fan. It has covered itself with sponges to camouflage itself during the day. Roatan, Honduras. / 90-91

A cleaner wrasse services a blue-faced angelfish at a "cleaning station," which operates much like a neighborhood barbershop. Sipadan Island, Borneo.

The shimmering colors of a queen angelfish (left) jump out against its muted surroundings. Angelfish patrol established territories among the coral reef, feeding on sponges, algae, and invertebrates. Roatan, Honduras.

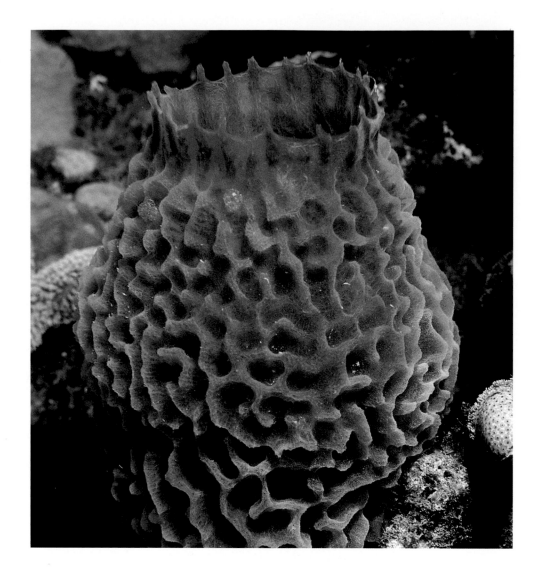

These commensal shrimp live among the rough surface of a Panamic cushion star, avoiding predators by keeping to the underside of the sea star. Sea of Cortez, Baja Mexico. / 94-95

An azure vase sponge glows with a soft fluorescence in the Caribbean Sea. Sponges filter water for food particles through a network of canals within the body. Saba, Netherland Antilles.

Soft corals come in all colors of the rainbow. This close-up (right) shows stinging polyps and silicon spicules embedded in the calcareous skeleton. Solomon Islands.

A school of Anthias, or fairy basslets (right), crowds a coral wall lined with soft corals. Explosions of color like this characterize Red Sea reefs. Red Sea.

·The spectacular foot-long Spanish dancer—a shell-less snail called a nudibranch— swims by undulating its body. It is nocturnal, generally coming out at night to feed. Red Sea. / 98

A crinoid, or feather star, catches food particles in the current at the top of a sea fan. Crinoids catch food particles in their bristly arms. Fiji. / 99

A school of amethyst Anthias swims above a patch of lettuce corals. These are mostly females and juveniles. Sangalakki Island, Borneo. / 100-101

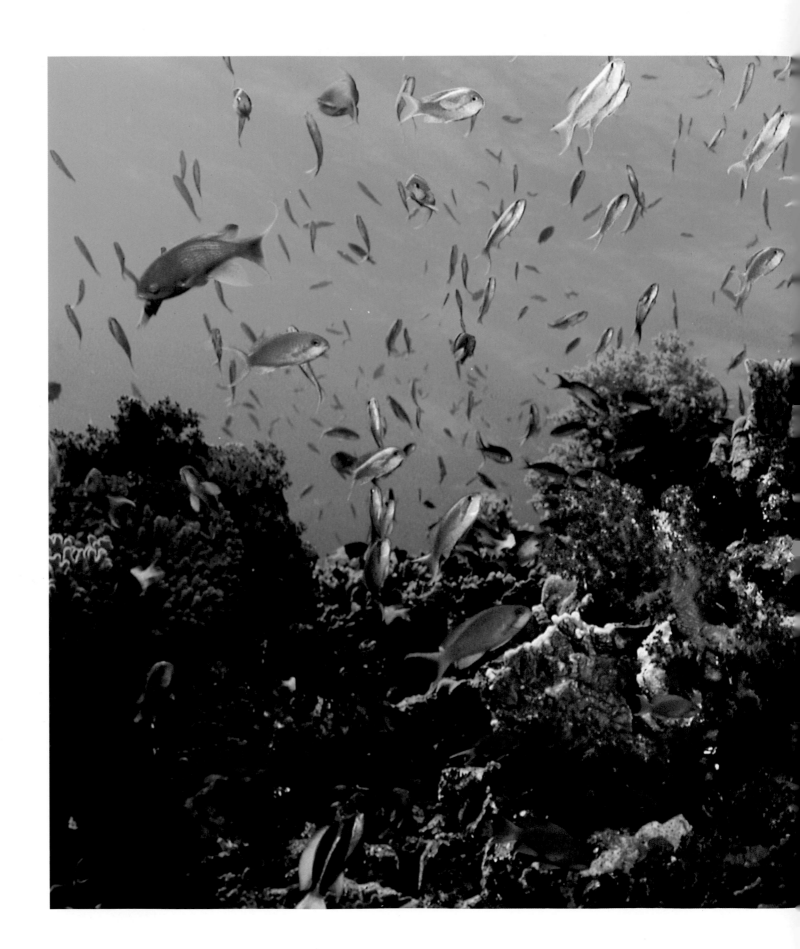

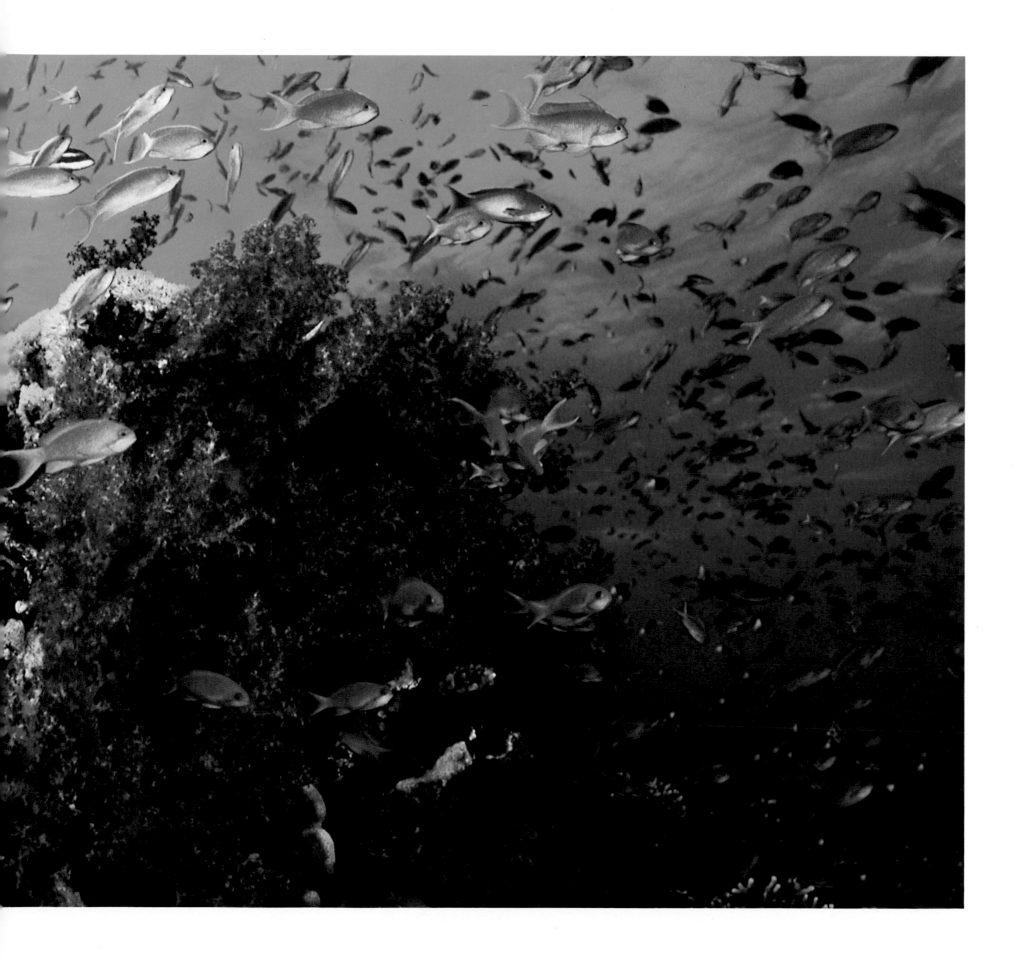

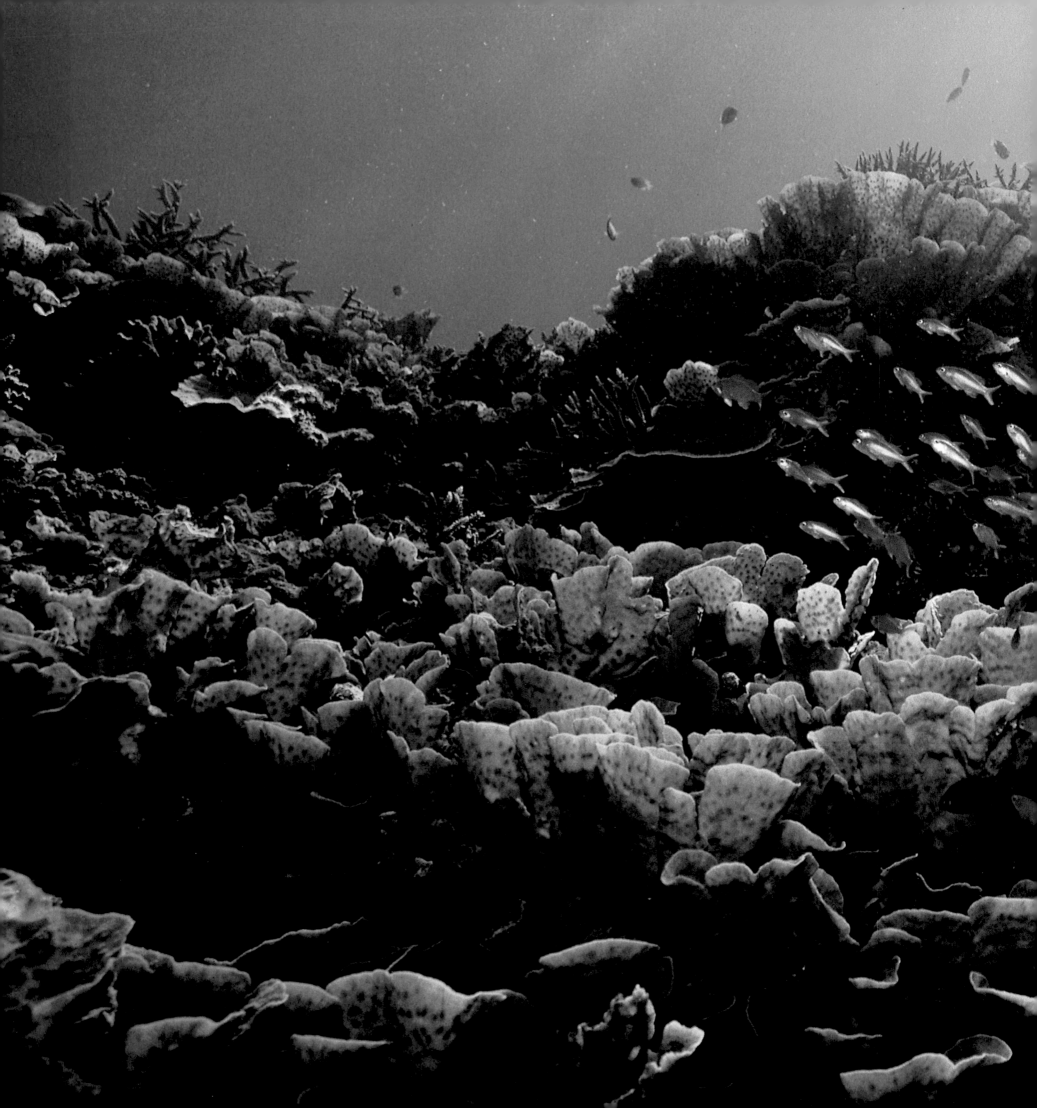

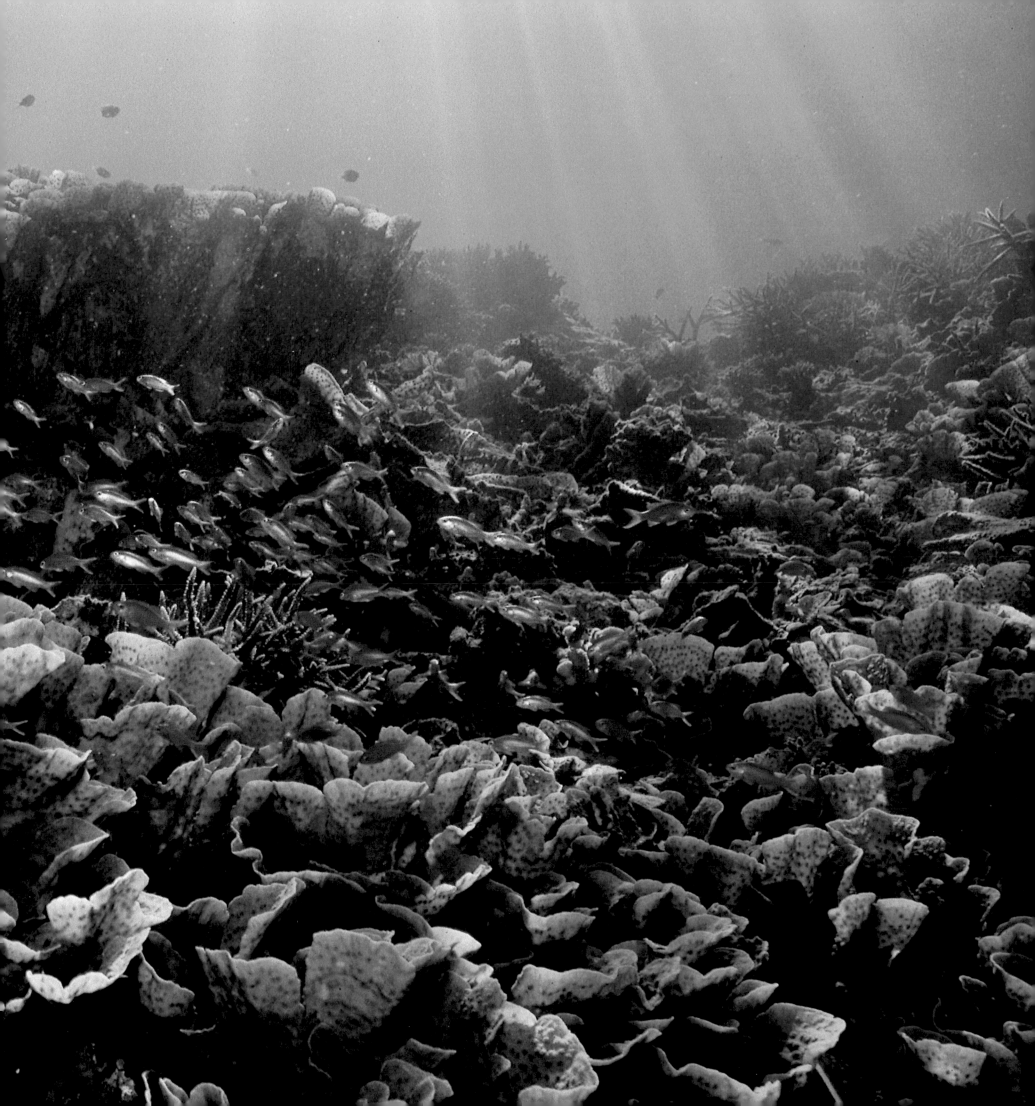

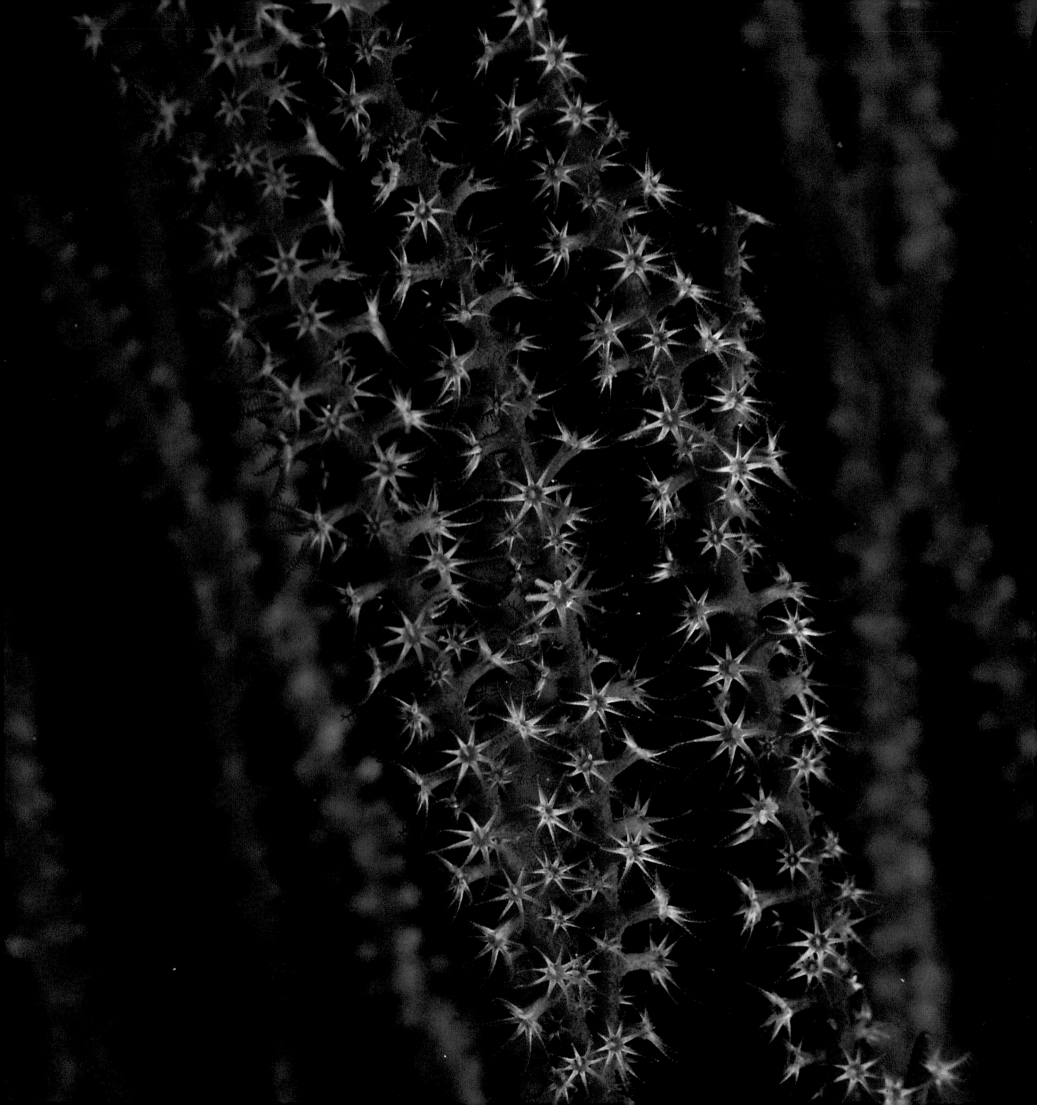

NATURAL RECYCLING

Individual polyps of a chalice, or cabbage, coral live within limestone skeletons that they have secreted. Each polyp has stinging tentacles which capture plankton. Fiji.

An arrow blenny swims near a colony of dotted line coral. This tiny blenny drifts with a cocked tail, ready to shoot forward to capture prey. Roatan, Honduras.

When I die, I want my ashes to be scattered over a coral reef. I could achieve a kind of immortality there, among the shallow waters of the tropics. The creatures of the reef would keep the minerals of my body there for eons, recycling my essential elements endlessly. I'd end up making some of the wonderful abstract patterns in the mantle of a giant *Tridacna* clam, my nutrients helping the symbiotic algae to create food within the clam's mantle. My ashes would become embedded in the polyps of corals, made into elegant limestone tabletops, whorls, flowing branches, delicate spirals, and fingers. Green sea turtles would incorporate my nitrogen into their tough muscles and take me along on their endless journeys. Parrotfish would munch me up from my home of coral, pass me through their bodies, and eject me as grains of sand to float onto a pink coral sand beach.

The abundant life of a coral reef is a tribute to the recycling powers of the community. Coral reefs grow in nutrient-poor, tropical waters — an oasis of life in a desert, a community of animals which recycles all available nutrients to near-perfection. Corals reefs are the most immense structures ever built by living things. The corals catch food with stinging tentacles, and they give rise to large colonies by splitting apart asexually. They can also reproduce sexually and give rise to young that are carried by ocean currents to new areas, where they form new coral colonies. By working together with algae

The individual polyps of star coral are surrounded by limestone skeletons, looking here like tiny volcanoes. Fiji.

The polyps of red sea whips open and close for feeding. Sea whips and sea fans are colonies of stinging invertebrates with polyps that catch plankton in currents. Roatan, Honduras. /
102

NOTES FROM THE FIELD

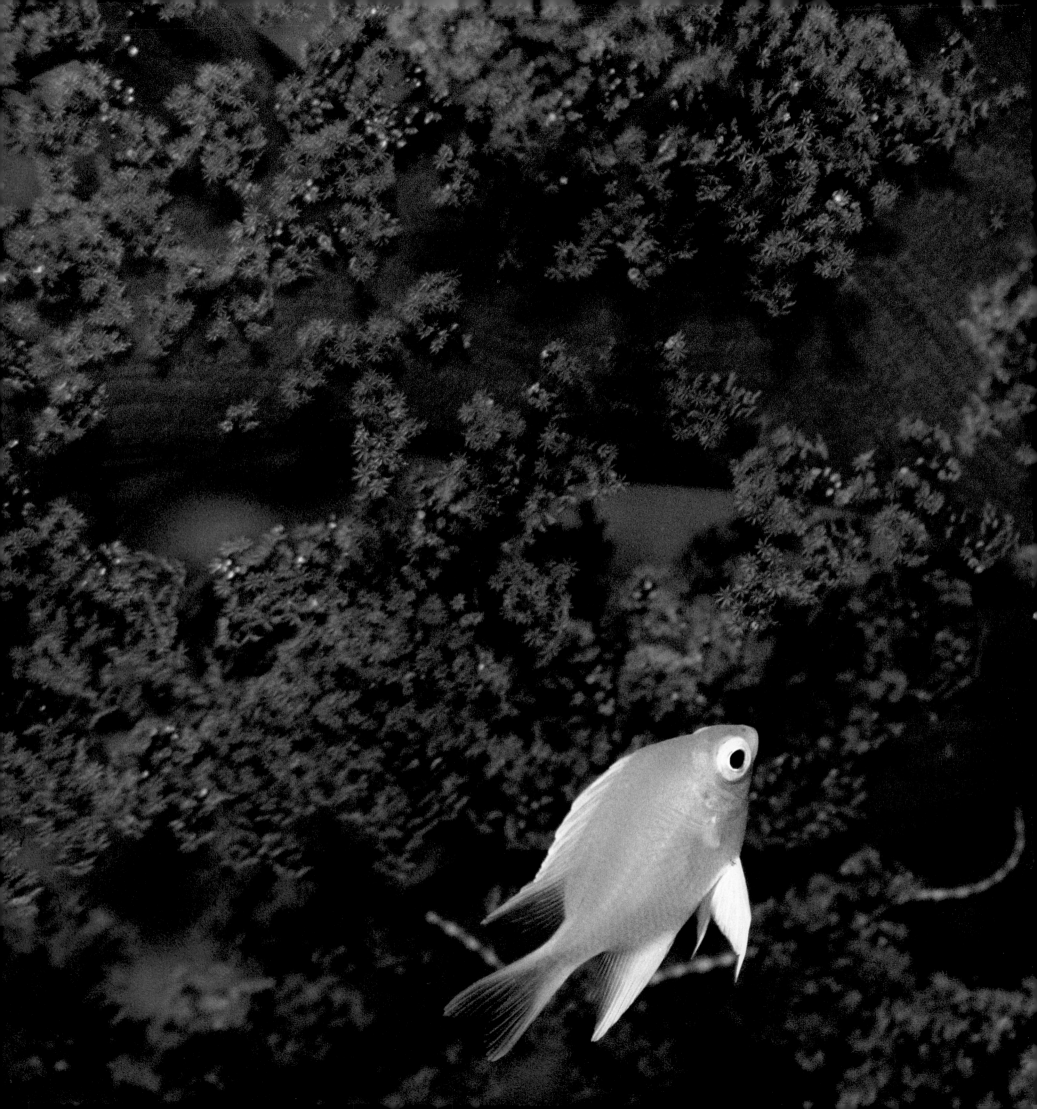

NATURAL RECYCLING

in their tissues, corals produce their own food from the energy of the sun.

It has been my privilege to see the many coral reefs of the world. I started in the Caribbean, snorkeling the reefs of the Florida Keys. The Caribbean is a young sea, so it has relatively few species of coral and fish compared to the Indo-Pacific. Caribbean reefs are better known for their variety and color of sponges. I had to wait years before being able to see the fabulous reefs of the Indo-Pacific region. The diversity there is unrivalled, with hundreds of species of coral and fish in every reef.

Coral colonies take on a great many shapes and forms. Brain corals form massive, solid boulders, while staghorn corals form elaborate branching colonies that provide shelter for a multitude of shrimp, crabs, and fishes. Fire coral, so named for the burning sensation it causes on contact, can cover other corals or form ridges and spires. Soft corals and sea fans, closely related to stony corals, do not form hard limestone skeletons, and so they are not reef-building corals. Soft corals can come in all colors of the rainbow. I have seen entire walls of soft corals puffed up in times of current, creating spectacular displays of color. I have seen soft corals the size of bushes, and sea fans fifteen feet tall.

There are three major types of coral reefs. Fringing reefs grow in shallow water close to the coast. Barrier reefs are larger, farther away from the coast, and continue

A chromis, a type of damselfish, swims near the protective confines of a pink sea fan. Fiji.

A golden damselfish (left) keeps close to the shelter of a soft coral tree, feeding on plankton passing in the current. Fiji.

A damselfish sleeps within the polyps of a sea fan. Like many fishes, this damsel has muted its body colors as it sleeps at night. Fiji.

NATURAL RECYCLING

Symbiotic algae within the mantle of the giant clam form wondrous displays of swirling colors. The clams use food and waste gases produced by the algae in their tissues. Great Barrier Reef, Australia.

Two lei triggerfish swim past a coral reef. A large spine on their dorsal fin allows them to lock themselves into a coral crevice if threatened. Kona, Hawaii. / 108-109

on for long distances. Australia's Great Barrier Reef is the most famous example. Atolls are volcanic islands which have sunk slowly enough for corals to build upon them. They have a ring of corals surrounding a central lagoon, the crater of the old volcano. As the volcano sinks, the ring of corals keeps growing to the surface.

Diving any type of reef is a magical experience. Typically, there is a wall that may drop down from the surface sixty feet or more — sometimes up to two thousand feet! Currents that wash along these coral walls may be the basis for a drift dive, in which you simply go with the flow and are picked up by the boat at the end of the dive. If you're unlucky, however, you will have to fight the current to get back to the boat. Divers quickly learn to watch for currents and plan their dives accordingly, depending on whether the boat is anchored or drifting.

As corals grow together and over each other, caves and large tunnels form. Worms, oysters, and other animals burrow deep into coral heads, leaving the interior of a coral head full of holes and tunnels. All of these spaces provide homes for a multitude of animals. A large sea fan at first glance appears empty, but a closer inspection reveals that it is home to a number of animals. Spider crabs, with colors matching those of the sea fan, hide and feed among its branches. Long-nosed hawkfish dart about along the surface of the fan, and tiny gobies

A school of jacks swims above a forest of sea fans. Red Sea.

NOTES FROM THE FIELD

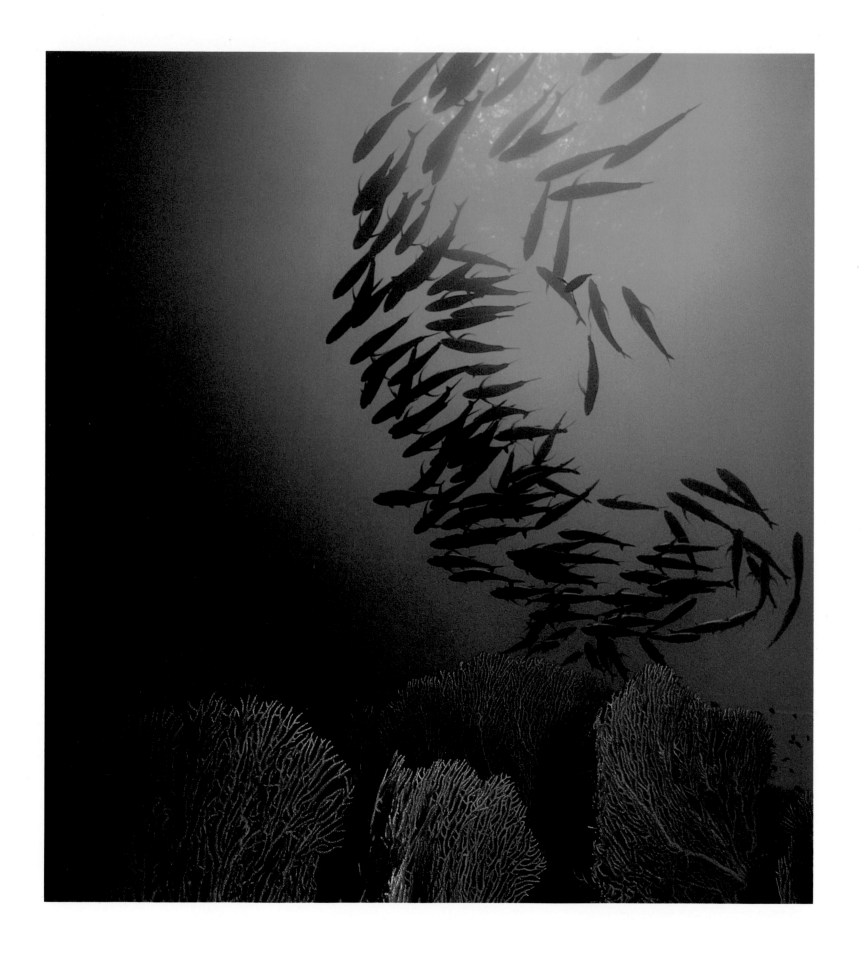

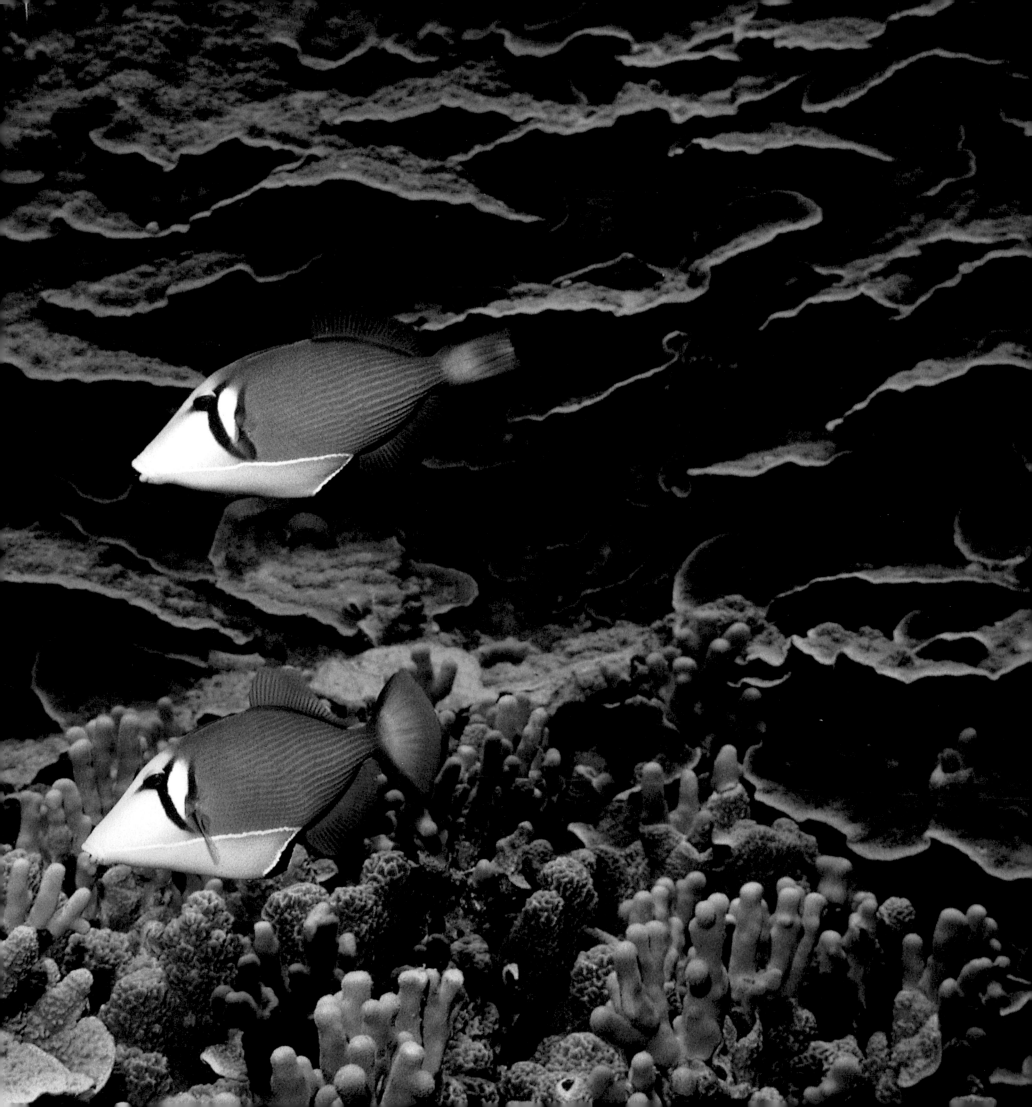

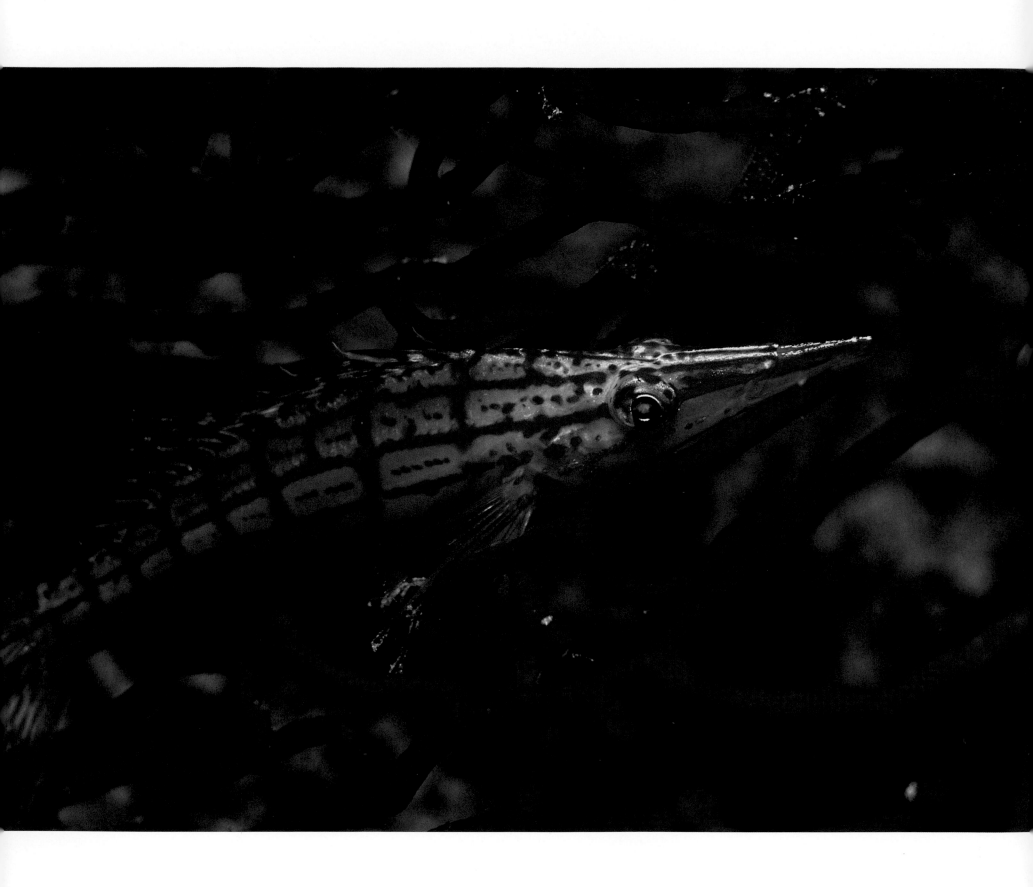

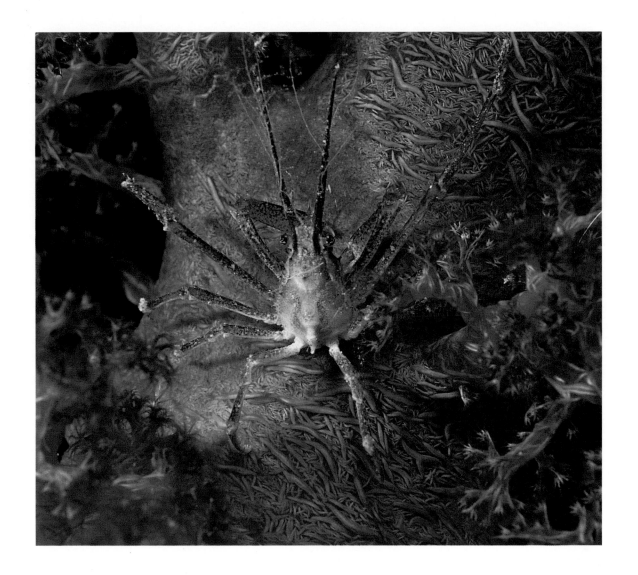

NATURAL RECYCLING

The color pattern of the longnose hawkfish (left) may help to hide it in the red sea fan in which it perches. Fiji.

A spider, or icicle, crab (above) feeds at night among the polyps of a soft coral tree. Red Sea.

blend in with the branches. Cowries, brittle starfish, fireworms, shrimp, and small fish all use the sea fan for shelter and food. Like the open ocean, almost every available surface on the reef and on its animals is colonized and used.

A clown anemonefish rushes out to assert his territory. He is careful not to leave his protective area—the stinging tentacles of an anemone. Sipadan Island, Borneo. / 112-113

NOTES FROM THE FIELD

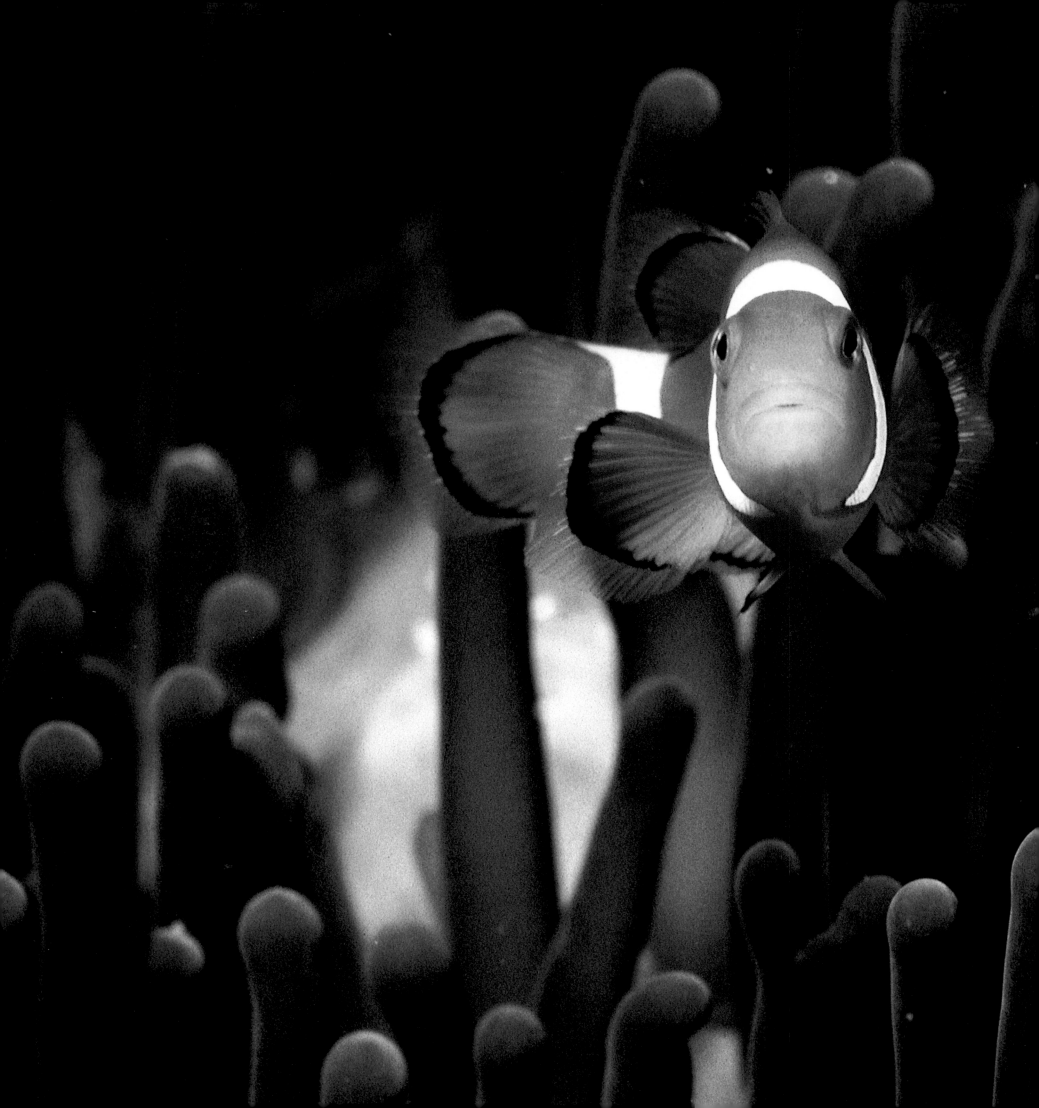

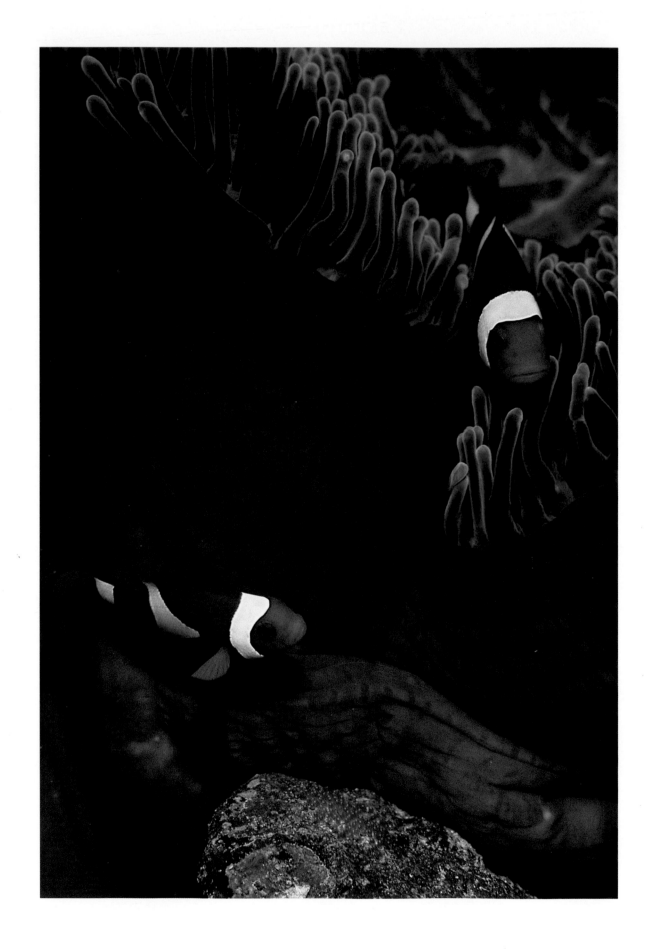

SYMBIOSIS: WORKING TOGETHER

I have always been fascinated by how different reef residents work together in relationships that benefit both parties. In fact, the entire structure of the coral reef depends on animals working together in symbiotic, or mutually helpful, relationships. Coral polyps and giant clams hold algae within their tissues. During the day, the algae gathers in sunlight to produce food, like any other plant. The coral polyps and giant clams depend on the algae's by-products — oxygen, sugars, starch — to live.

Perhaps the best known example of symbiosis is the relationship between the anemonefish and the anemone. Anemones are animals closely related to corals. They come in all colors of the rainbow and have a big muscular foot, stinging tentacles on top of the foot, and a mouth in the middle of the ring of tentacles. They feed by stinging prey with their tentacles. Some of these anemones have potent stings; I have seen anemones in the Philippines that could send a person into shock. I was stung repeatedly by a supposedly "harmless" anemone once, and all the skin on my hand fell off over a period of days after the sting.

Despite their stinging tentacles, each anemone on the reef has a small community of fish and shrimp living within its tentacles. One particular type of fish, called anemonefish or clownfish, spend their entire lives within the protection of the stinging tentacles of the anemone. They even lay their eggs beneath the anemone's tentacles.

An anemone usually contains a pair of mature anemonefish and a few immature juveniles. The female is the largest and most dominant. If she is removed, the male will change sex to take her place. Batangas, Philippines.

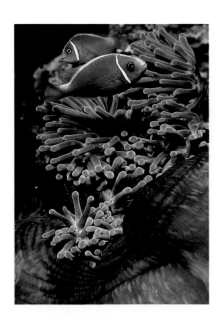

Two pink anemonefish keep company with their orange anemone host. Fiji.

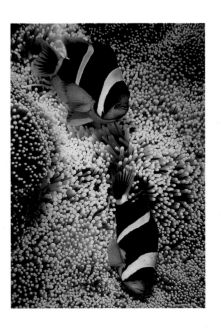

A pair of Seychelles anemonefish within their host, a Merten's sea anemone. This species is endemic to the Seychelles Islands and Aldabra Atoll. Seychelles Islands.

A pair of clown anemonefish, immune to the stinging tentacles of their host, guard a nest of orange eggs they have laid at the base of the anemone. Solomon Islands. / 114

NOTES FROM THE FIELD

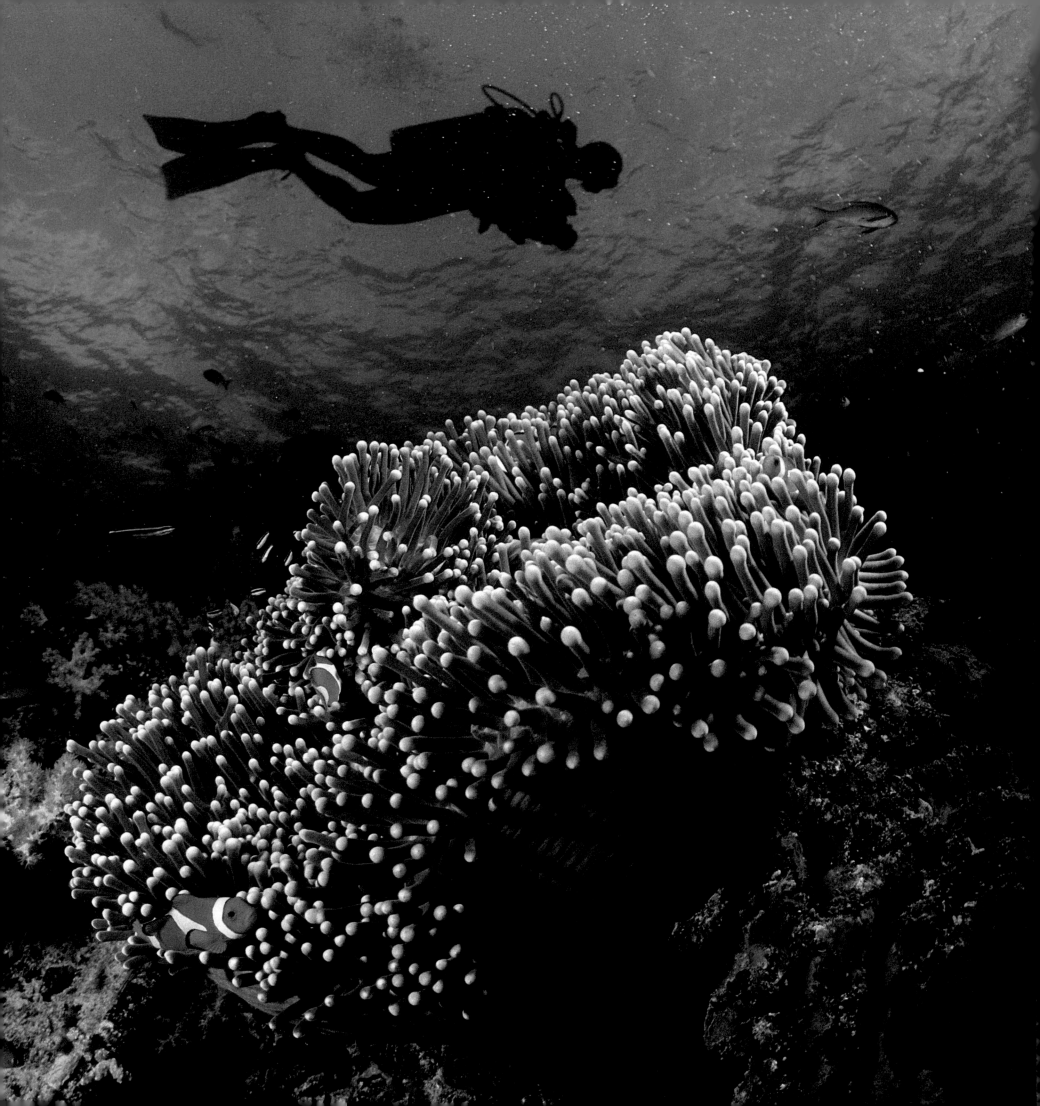

SYMBIOSIS: WORKING TOGETHER

Anemonefish will often nip at their host anemone, possibly to cause the anemone to spread its tentacles to cover the fishes' nests. Sipadan Island, Borneo.

Anemones typically contain several juvenile anemonefish which hatch from a nest under the anemone's body, drift in the ocean current for about two weeks, and then seek a new host anemone. Sipadan Island, Borneo.

They check on their nests constantly, cleaning them by flushing water over them. I've seen anemonefish nipping their host anemone to keep the folds of its foot over their eggs. It seems that the anemonefish is not actually immune to the anemone's sting, but somehow becomes familiar to the anemone so that it is not stung. As juveniles, these small fish pick out a host anemone and repeatedly brush up and wriggle against the stinging tentacles. Gradually the anemonefish is able to dart right into the stinging tentacles without harm. The anemonefish thereby gains protection from predators, and in return it may pick up debris and attract prey fish for the anemone to eat.

I constantly see other examples of symbiosis when diving on coral reefs. The phenomenon of cleaning stations is everywhere. Small, brightly colored shrimp and fish dot the surface of large sponges and brain corals. These animals serve as neighborhood barbers, cleaning the surfaces and mouths of larger fishes such as groupers and snappers. Normally eager to snap up such tasty morsels, the larger fishes allow the cleaners to swim all over their bodies and even within their mouths. One small fish, called the sabertooth or false cleaner blenny, takes advantage of this mutually beneficial truce. Its colors resemble that of a cleaning wrasse, and it takes up a position near a cleaning station. When an unsuspecting customer comes in for a cleaning, the sabertooth blenny

A family of clown anemonefish lives within an anemone. When the dominant male changes to female, a juvenile will mature into a male. Sipadan Island, Borneo.

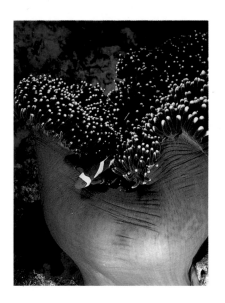

NOTES FROM THE FIELD

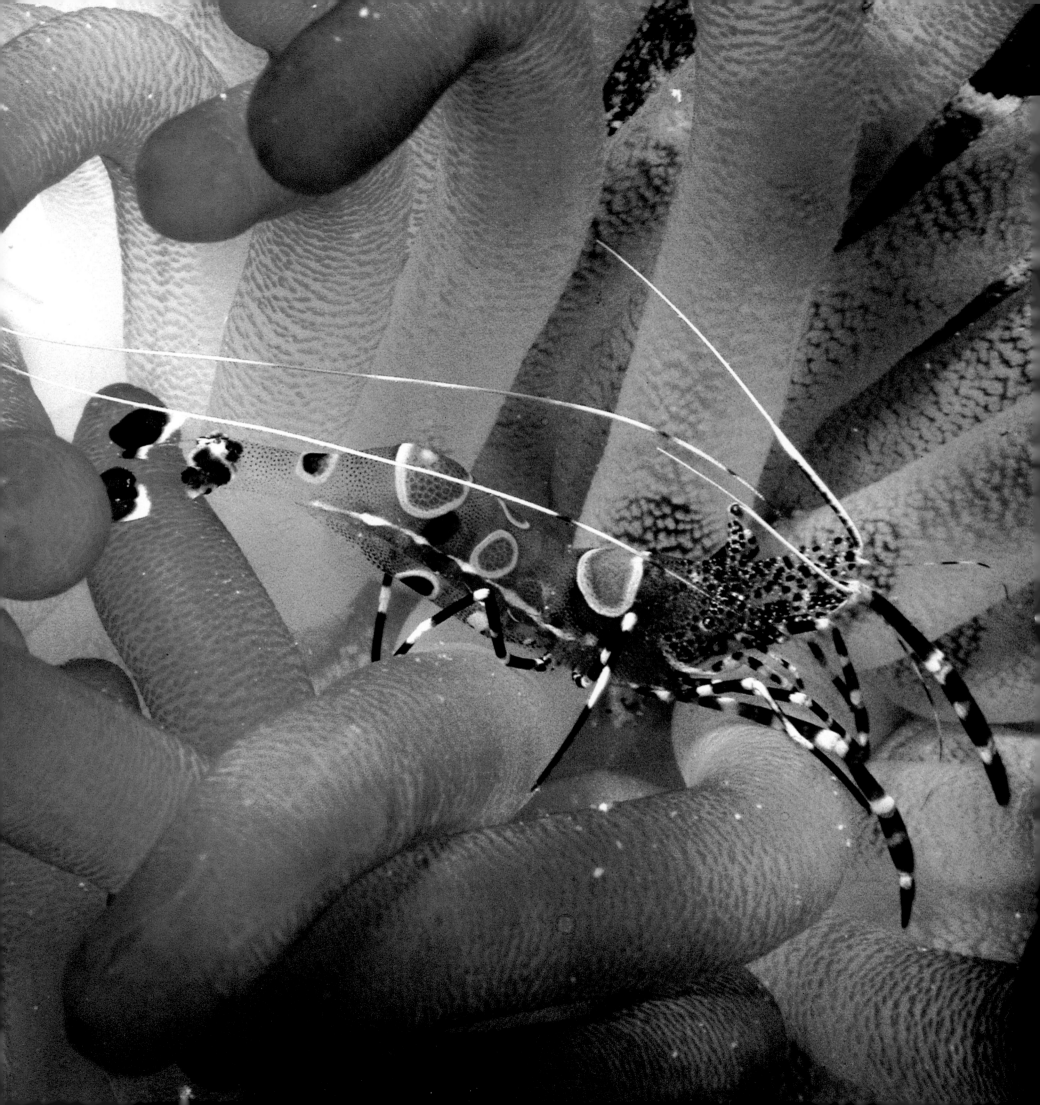

SYMBIOSIS: WORKING TOGETHER

Tiny shrimp within a bubble coral dance and wave their tentacles about to attract the attention of a client fish. They will leave their host anemone to clean their client of parasites. Sipadan Island, Borneo.

This spotted cleaning shrimp is ensconced within the pink tentacles of a giant Caribbean anemone. It may only mimic true cleaning shrimp. St. Croix, U.S. Virgin Islands.

darts in, bites off a chunk of flesh, and then speeds away to safety. I often see the sabertooth blenny swimming around a reef. It usually hangs around a specific area and may dart into an abandoned worm hole for safety.

I often encounter hermit crabs along the reef, carrying the shells they have picked up in their travels. Hermit crabs have a soft abdomen, and they protect themselves by adopting empty shells they find on the reef. As they get larger and outgrow their current homes, they begin looking for new shells to inhabit. I often see two hermit crabs fighting each other for the right to a shell. Once in a while I come across a hermit crab that has covered its shell with stinging anemones. The anemones provide an additional defense. When the crab decides to move into a larger shell, it will gently stroke the anemones and convince them to move over onto the new shell! A few species of small crabs even cultivate anemones on their claws. These boxer crabs will thrust out the anemones at predators, presenting a mass of stinging tentacles to any fish that dares to threaten them.

The banded coral shrimp can often be seen waving its antennae about and dancing on top of a coral head in an attempt to attract a client to a cleaning. Roatan, Honduras.

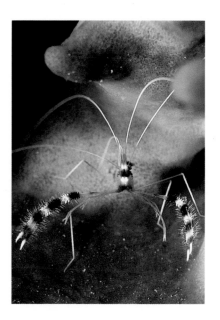

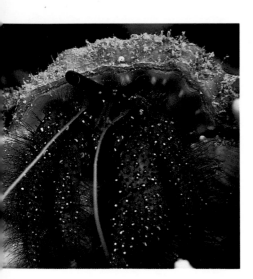

A hermit crab (above) finds or fights other crabs for empty shells, which it inhabits. The shell protects the crab's soft abdomen. Great Barrier Reef, Australia.

These porcelain crabs in an anemone use the fine nets around their mouths to sift water for food particles. Sipadan Island, Borneo.

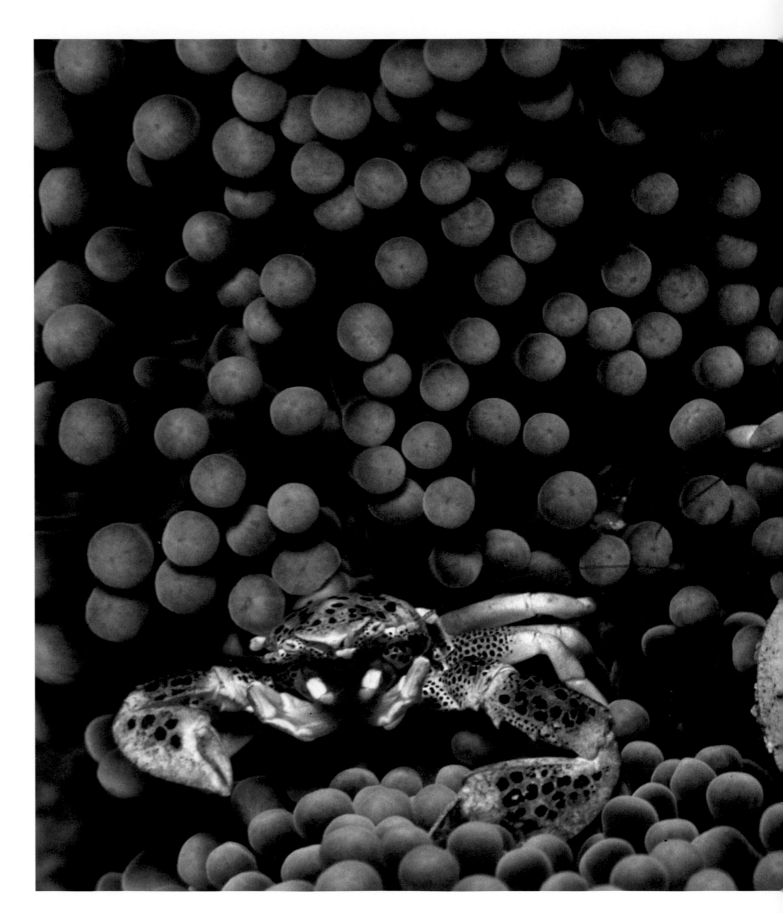

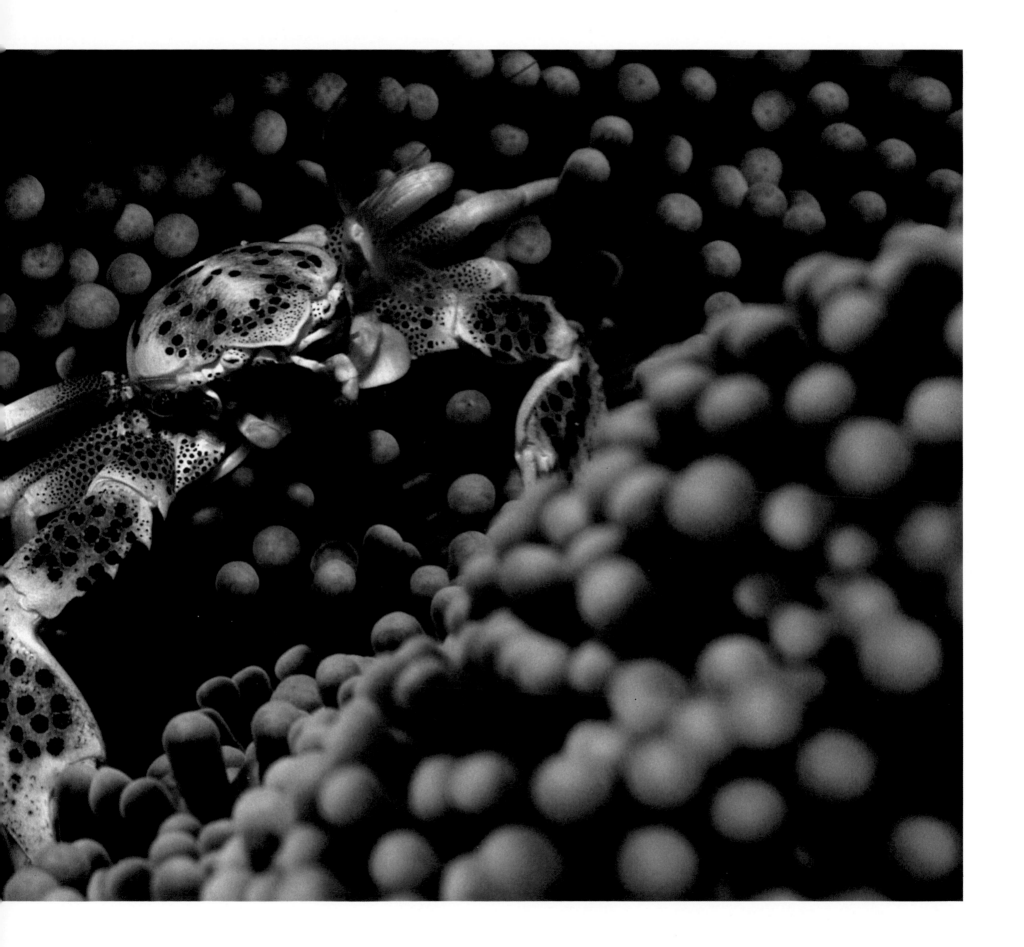

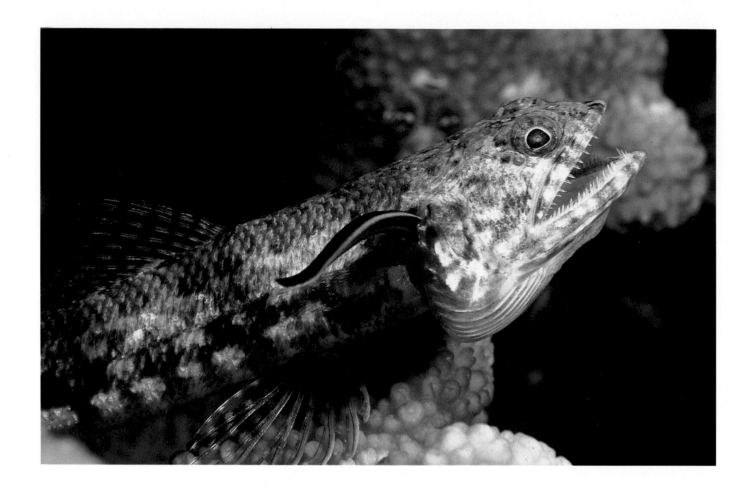

*A normally voracious lizardfish
is being cleaned by a wrasse in
this age-old symbiotic
relationship. The wrasse has
gone into the lizardfish's gills in
search of parasites. Sangalakki
Island, Borneo.*

*A parrotfish being cleaned by a
wrasse (right) has a peculiar
understanding. It allows the
cleaner to go all over its body,
even within its mouth and gills.
Sipadan Island, Borneo.*

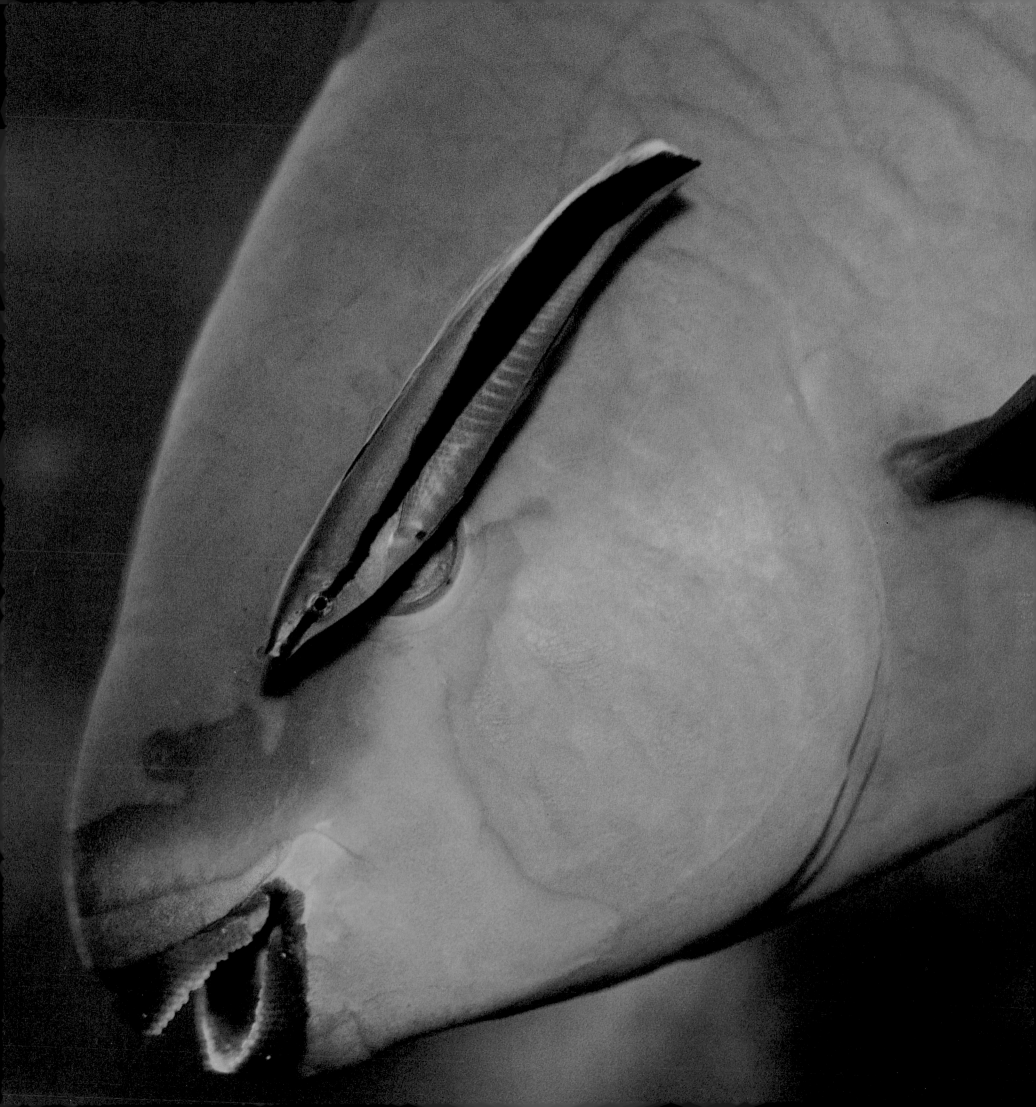

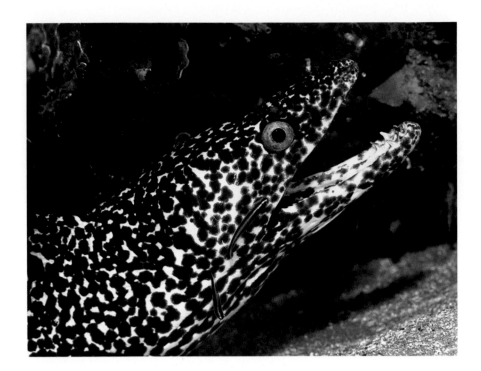

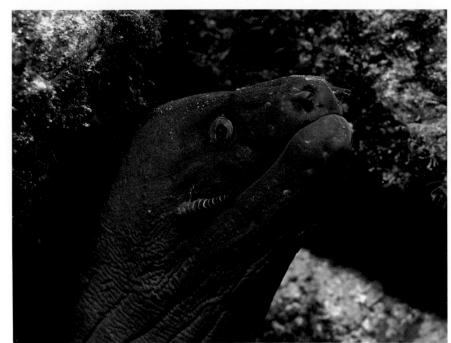

Two sharknose gobies service a spotted moray, cleaning the eel of parasites. Saba, Netherland Antilles.

A banded cleaner goby services a Panamic green moray eel. Sea of Cortez, Baja Mexico.

A giant moray eel (right) opens its mouth to breathe. This is probably the world's largest, but not longest, moray eel. Morays have an undeserved reputation for ferocity. They may bite if provoked, but are otherwise docile. Great Barrier Reef, Australia.

An angel shark swims through the only coral reef on North America's west coast. Angel sharks are flattened, bottom-dwelling sharks that ambush prey. Sea of Cortez, Baja Mexico. / 126-127

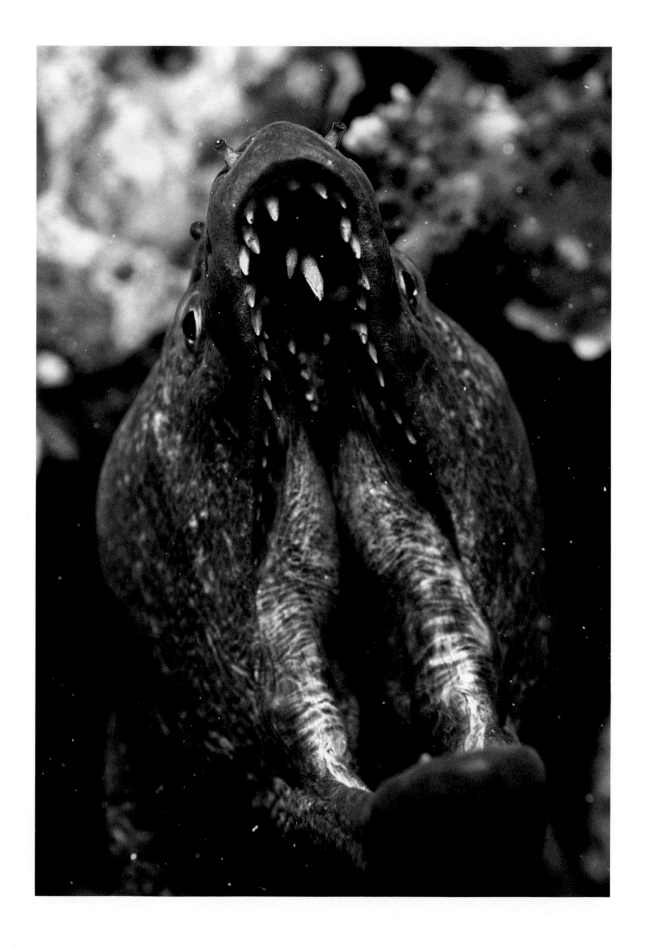

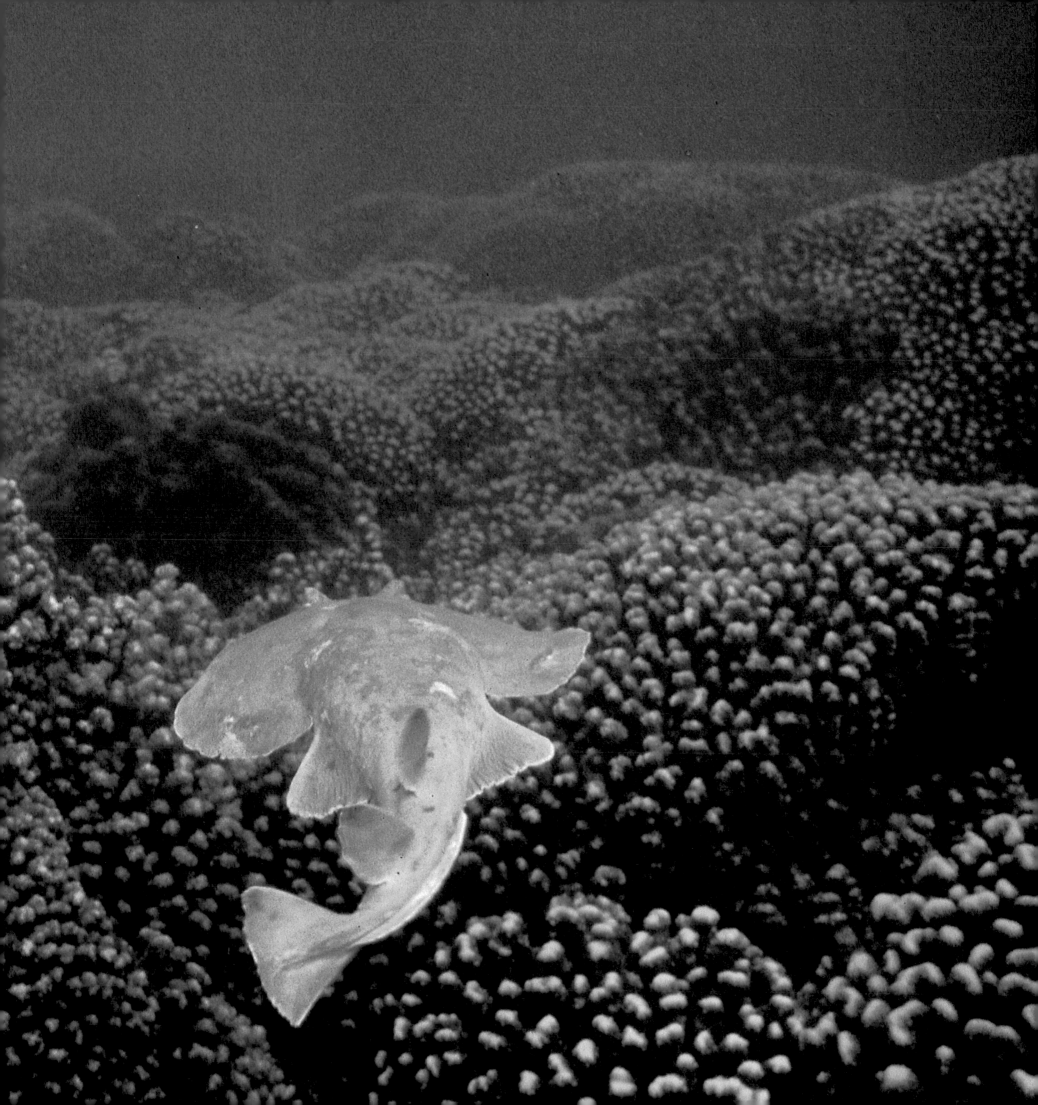

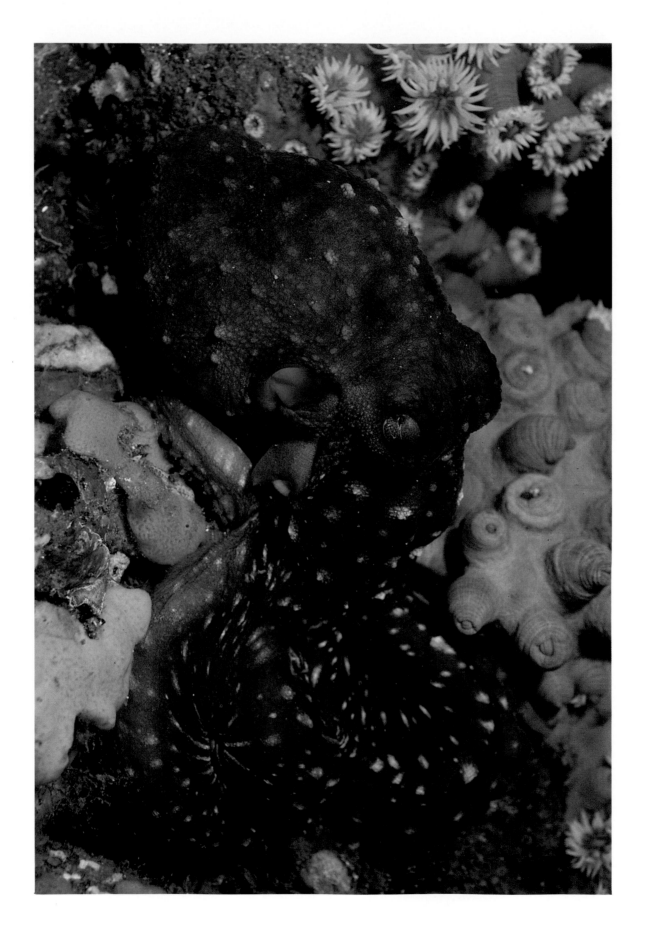

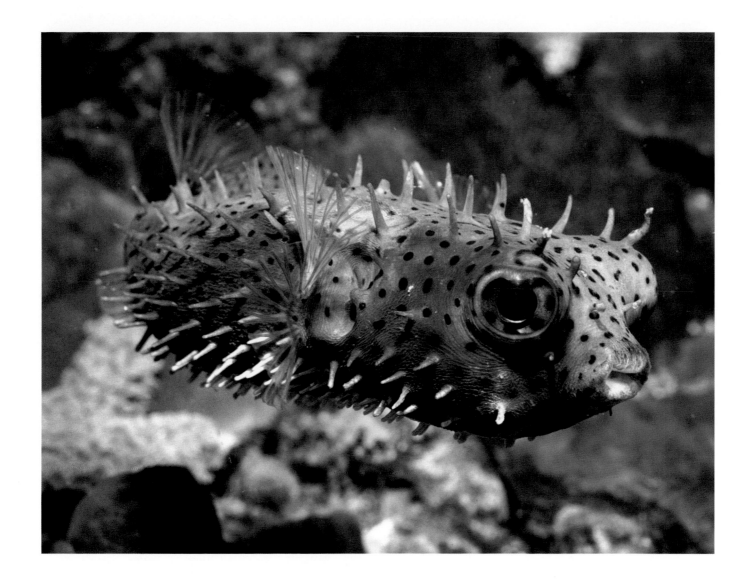

A porcupinefish can swallow air or water to swell up as a defense. Inflated, it looks like a pincushion, as it presents a mass of spines to a potential predator. Saba, Netherland Antilles.

An octopus hunting at night (left) pauses among brilliant orange clump corals. Batangas, Philippines.

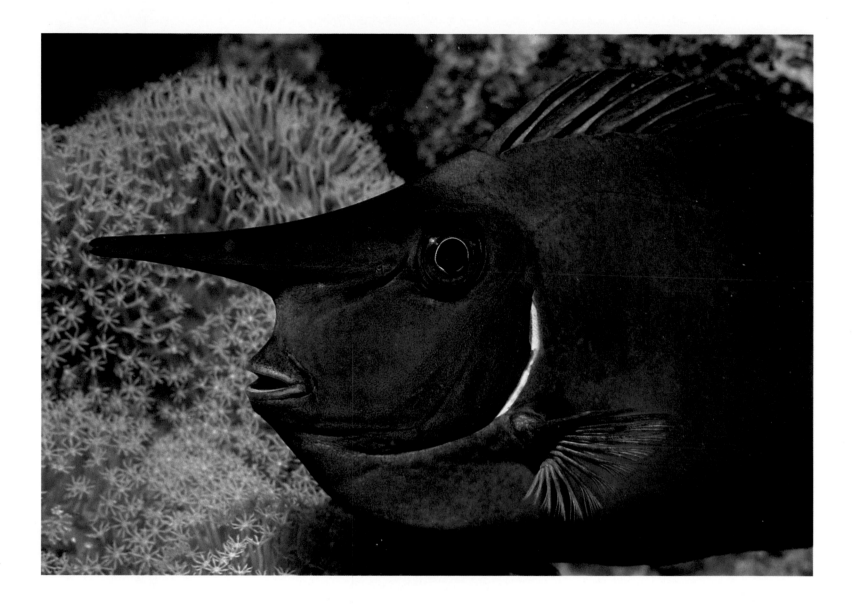

The whitemargin unicornfish is
a member of the surgeonfish
family. Its long horn is probably
used in territorial displays. Fiji.

This white-spot puffer (left) has
inflated itself with water as a
defense. Puffers possess one of
nature's most potent neurotoxins,
known to kill a human within
five minutes. Hilo, Hawaii.

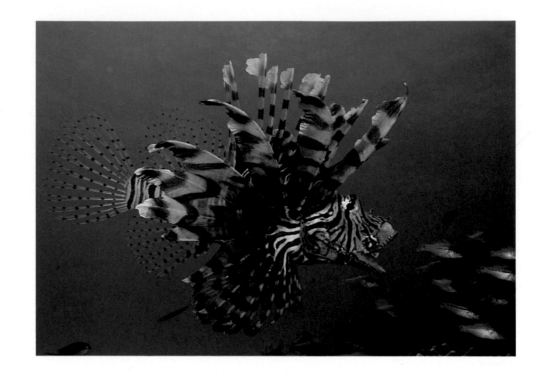

A school of four-foot-long humphead parrotfish travels through a coral reef, reputedly using their large foreheads to bump coral apart into smaller pieces. Sipadan Island, Borneo. / 134-135

A lionfish pauses to yawn during its hunt over a coral head. Sangalakki Island, Borneo.

A tiny juvenile clinging crab (right) crawls among the branches of a Venus sea fan. Grand Cayman Island.

A tiny clingfish (below) steals food from its host while gaining shelter at the same time. Solomon Islands.

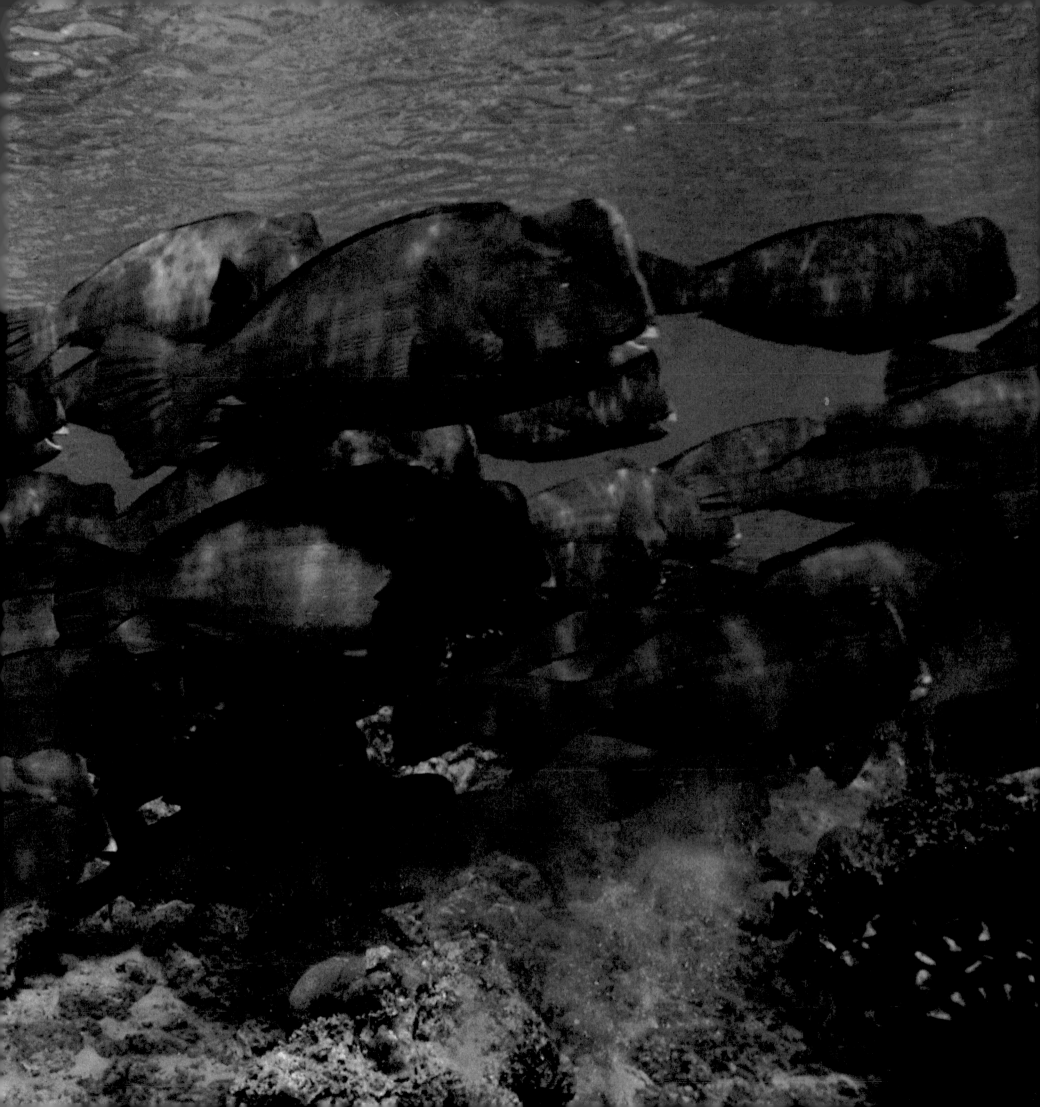

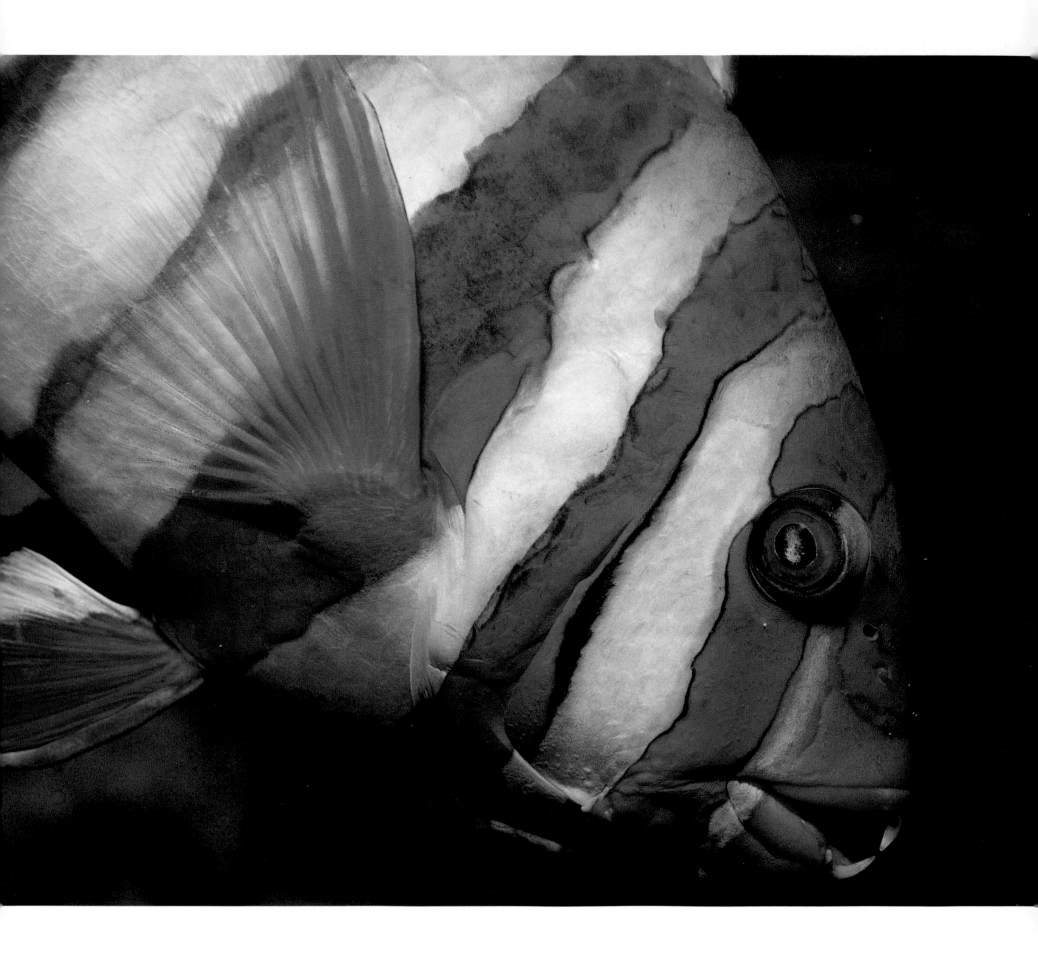

ALL ABOUT FISH

The harlequin tuskfish (above and left) is a wrasse with typically large teeth, used for snagging invertebrate prey that it digs up from beneath rocks, sand, and coral. Great Barrier Reef, Australia.

The emperor angelfish is found throughout the tropical Pacific. In many angelfish species the colors and patterns of juveniles differ markedly from the adults. Red Sea.

I am fascinated with fish, with their colors and grace, their habits, even their taste. In a coral reef, all the animals of the land seem to be reincarnated into these fantastic creatures which fly, glide, and soar underwater, their brilliant colors radiating. I see butterflyfish swimming around, in all their vibrant yellows, reds, blues, and oranges. Parrotfish flit about the reef in hues of aquamarine, red, and purple, crunching up morsels of food with their mouths that are fused together like beaks. Cowfish carelessly loll about, lionfish sit around in wait for an ambush opportunity, and leaf fish flip and flop in the current, like leaves in a wind.

Fish come in all sizes, from the tiny gobies and blennies which make their homes within corals and sea fans, to giant whale sharks sixty feet long. One goby has the distinction of being the tiniest vertebrate in the world. Small fishes can live just about anywhere: in a worm-tube, within the arms of a feather star, and on other fishes.

Many fishes change their colors during their lifetime. Often, male fishes will change colors to attract females. In some species, males may turn into females, or females into males. In either case, the change of sex may be accompanied by a radical change in color. Bright, gaudy, poster-like colors can advertise the dangerous nature of a fish, while cryptic colors can serve to hide an animal within its environment.

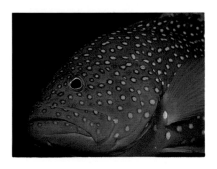

A coral grouper shows its brilliant colors. Like many fishes, this small grouper can mute its hues to match its mood or surroundings. Red Sea.

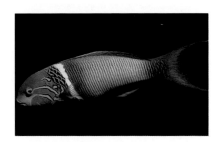

A goldbar wrasse hunts for food in the sand around a coral reef. It often follows goatfish around, which dig up invertebrates in the sand. Seychelles Islands.

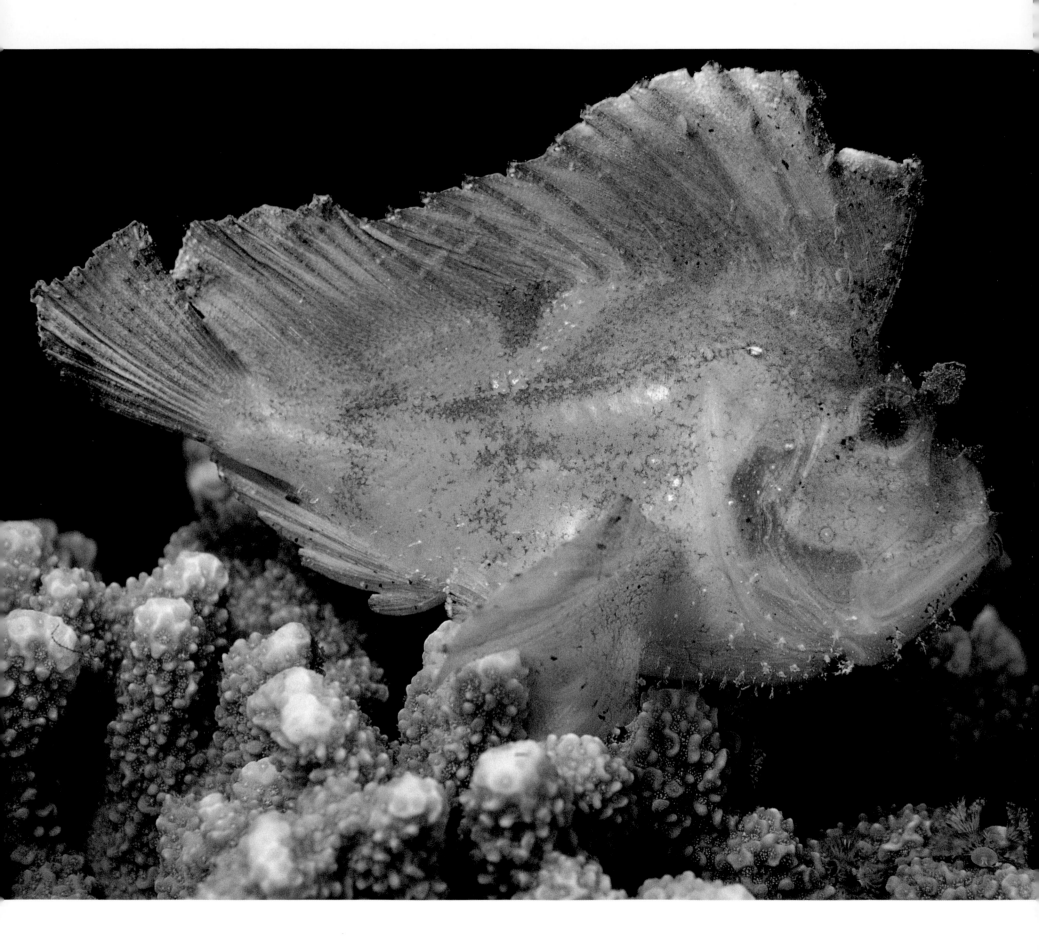

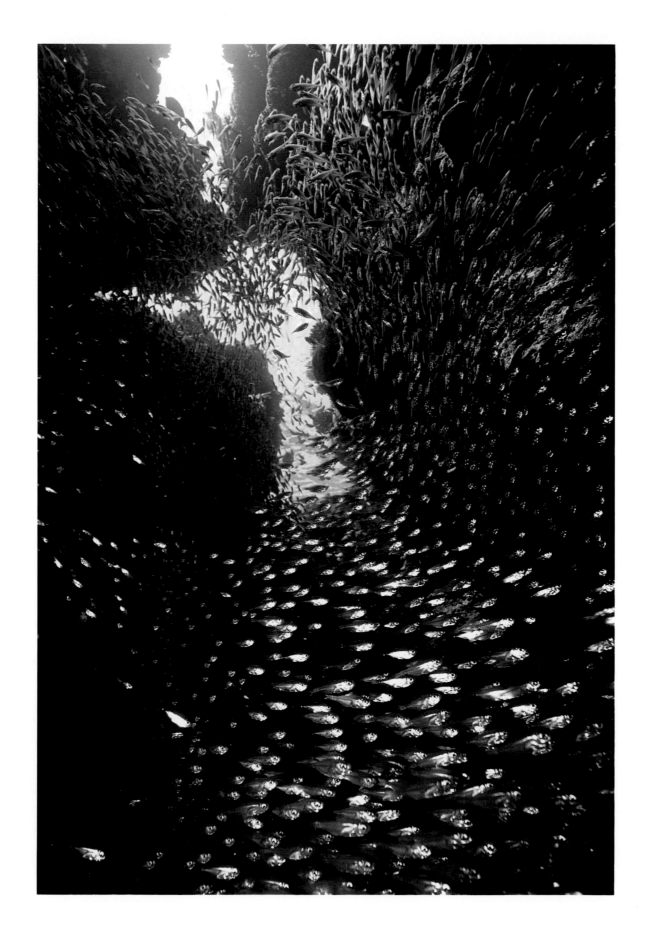

Yellowtail snappers (above) are among the most successful feeders in areas where fish-feeding is allowed. Ambergris Caye, Belize.

A school of Caesar grunts and snappers (right) frequent a channel in a marine reserve. Sanctuaries where fish are protected offer rare views of undisturbed populations of fish. Ambergris Caye, Belize.

The body of a leaf fish is so thin it is almost invisible when viewed face-on. It looks like a blade of algae as it sways from side to side with the surge. Sipadan Island, Borneo. / 138

By day, schools of dwarf sweepers hover in coral caves. Red Sea. / 139

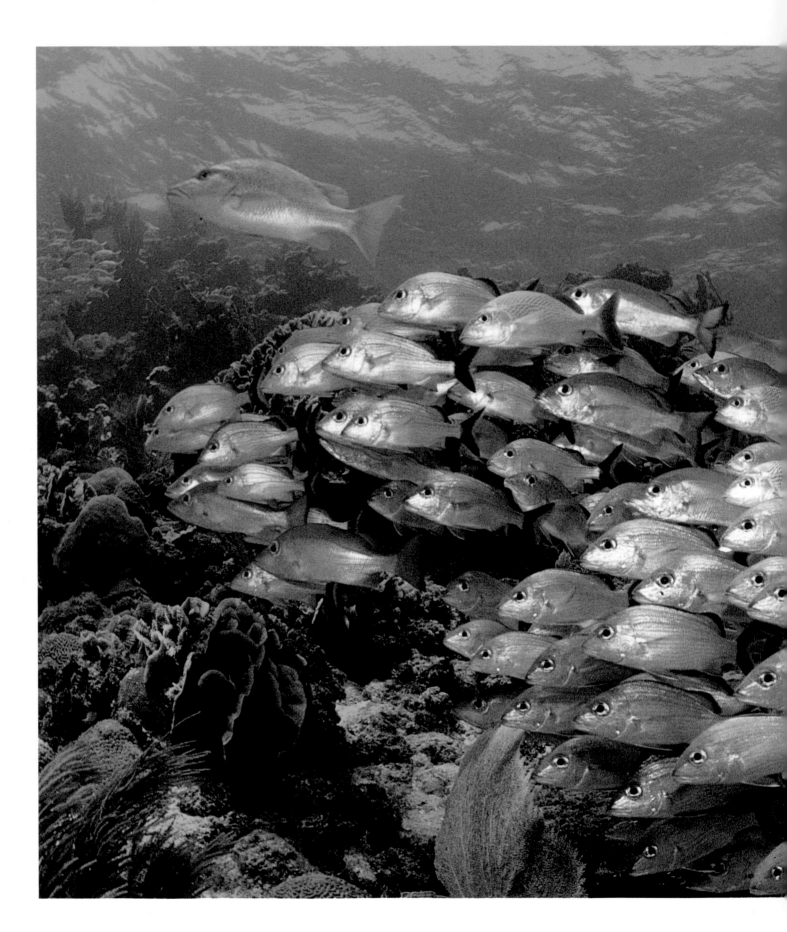

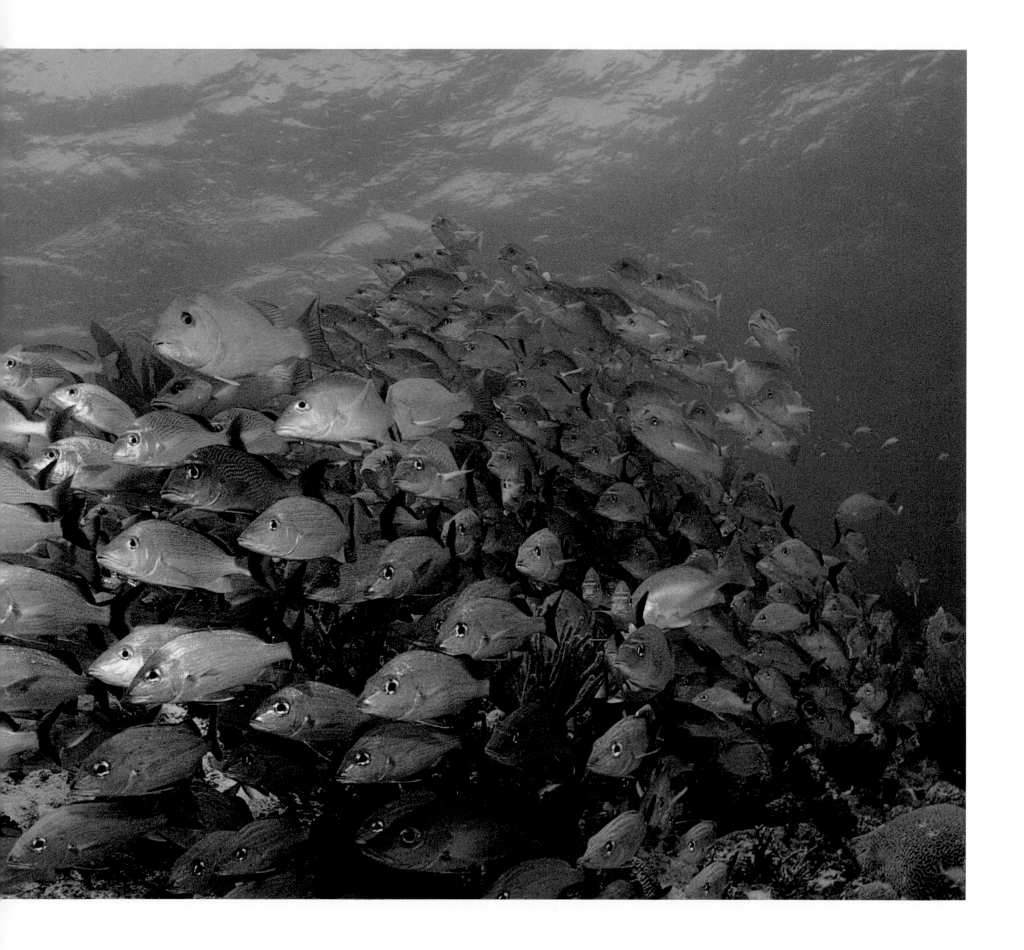

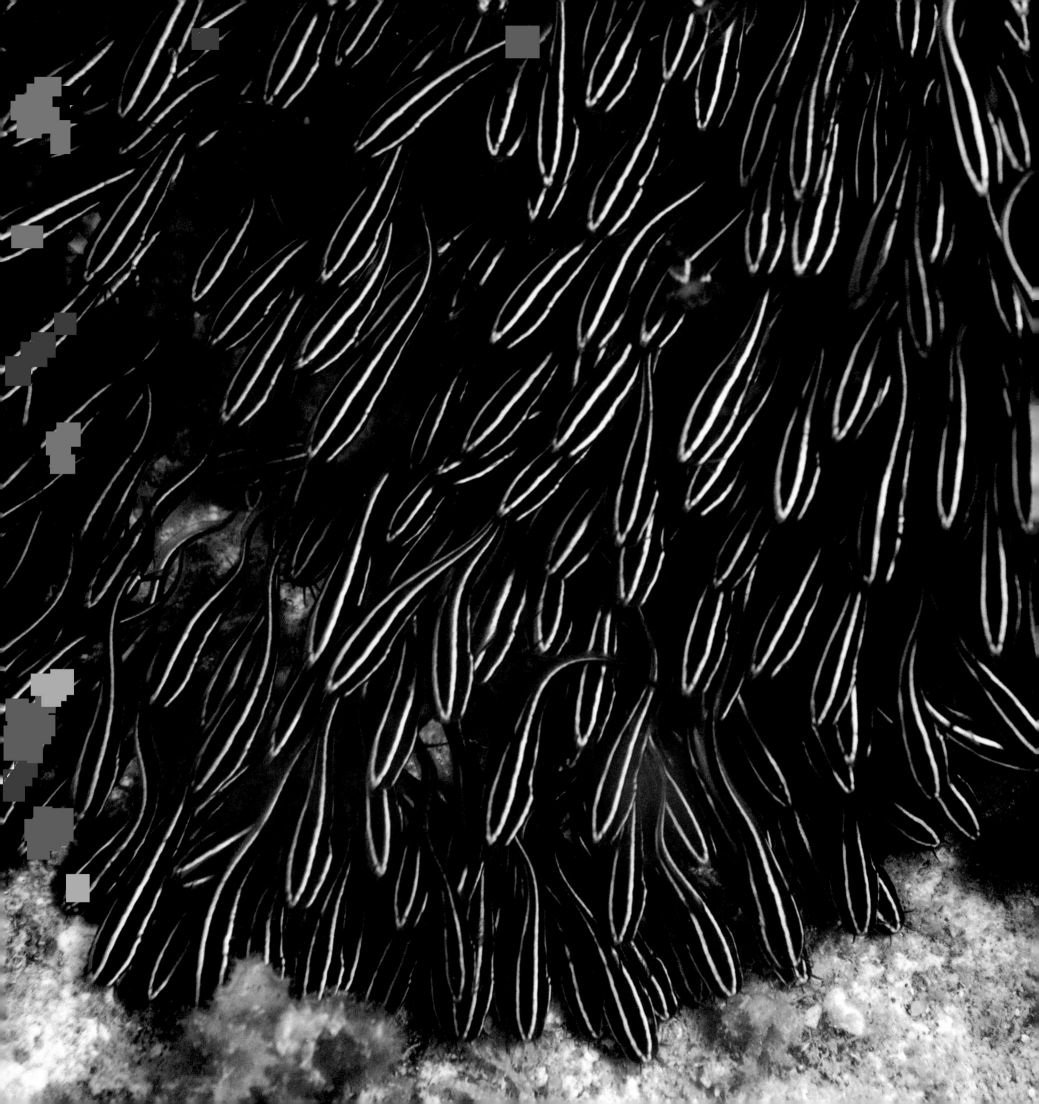

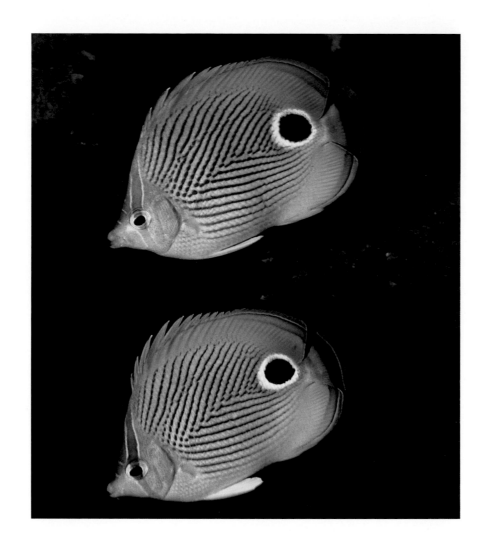

Black lines cover the four-spot butterflyfish's real eyes, and the false eyespots may confuse predators into thinking they are the eyes of a much larger fish. Saba, Netherland Antilles.

A school of juvenile striped catfish swarms a reef (left). A one-inch juvenile catfish can produce a sting like a wasp. Batangas, Philippines.

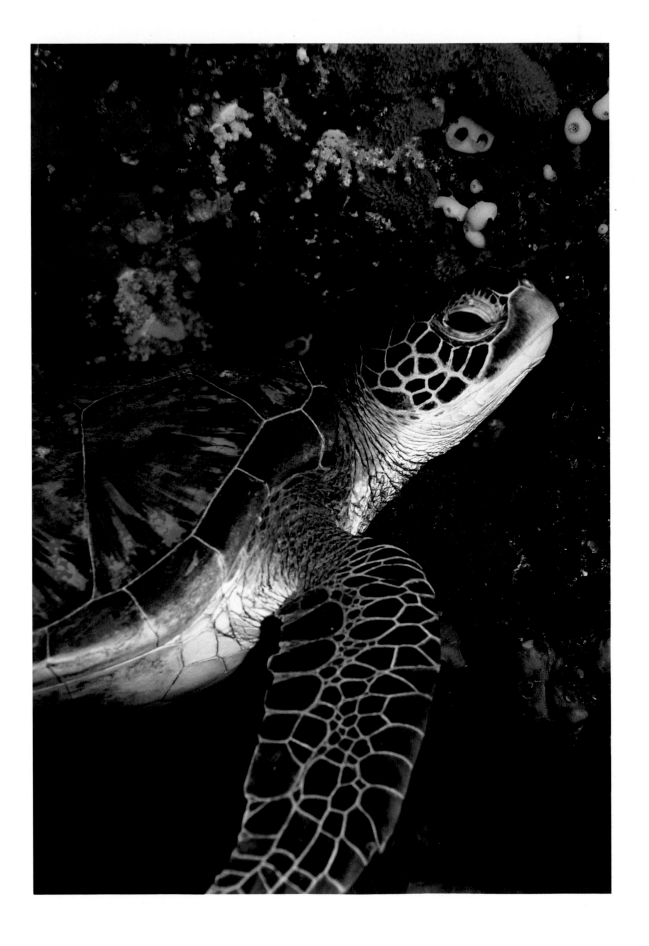

SEA TURTLES

I had often caught glimpses of sea turtles in my travels through the coral reefs of the world, but it wasn't until my visit to Sipadan and Sangalakki, islands off the coast of Borneo, that I was able to spend time with these wanderers of the oceans. Sea turtles carry an aura of age and mystery. Their eyes, set in folds of wrinkled skin, see much of the world during their 100-year lifespan.

Today, the green sea turtle is the most common sea turtle. I have seen them in the cool waters of Hawaii, in eelgrass beds of the Caribbean, and most frequently, sleeping and swimming all around the tiny island of Sipadan. On Sangalakki Island, I watched dozens of turtles hauling out each night to lay their eggs. To witness this spectacle, it is necessary to know the habits of the green turtle. At high tide in the black of night, the female will scan the beach for dangers. At this time she can be frightened off by any movement or light on the beach. Once she has determined that the beach is safe, she will lumber out of the waters and make her way up the slope of the beach. As she heads for the vegetation beyond the beach, the turtle feels especially vulnerable and will move from her chosen site if disturbed. Only once she has begun digging her nest is it safe to come close. While digging, neither lights, movement, noise, nor large groups of people will stop her from her task.

Despite years of study, the basic natural history of sea turtles still remains a mystery. Even such simple

Sipadan Island is a magical place, a gathering spot for hundreds of green sea turtles. Here, a green sea turtle sleeps in a small coral crevice. Sipadan Island, Borneo.

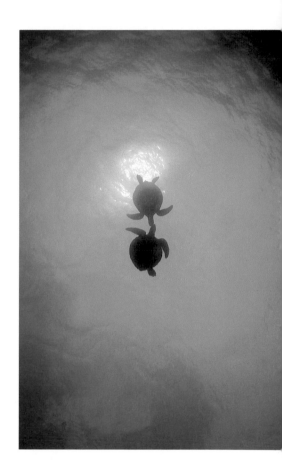

Two green sea turtles meet off a coral wall. One of these turtles has lost a foot to a shark or a fisherman. Sipadan Island, Borneo.

NOTES FROM THE FIELD

Groups of male sea turtles will pursue a female vigorously during mating. Because turtles will mate for hours, their meat and eggs are rumored to be aphrodisiacs. Sangalakki Island, Borneo.

SEA TURTLES

hypotheses that female turtles return to the place of their birth to lay eggs have been enormously difficult to prove. Their long lifespans make tagging-and-releasing studies logistically difficult and expensive, and it has been impossible to tag and track a turtle as it grows from juvenile to adult. It is a mystery how turtles find their way through the world's great oceans. Although the juveniles respond to light (they are confused by the lights of buildings, which leads to a great many deaths), it is not known whether this is the only stimulus they use to navigate directly toward the open sea immediately upon hatching. In a world without artificial lights, the turtles may orient themselves by swimming toward the area of greatest light, usually the horizon of the open ocean.

One thing is for sure, however. Sea turtles are animals in danger of extinction. There are many groups who are working to help save sea turtles. I've experienced firsthand the results of a conservation effort by Borneo Divers on Sangalakki Island. Sangalakki is an island in Indonesia, a good forty miles from the southeast coast of Borneo. Since 1937, a man named Bapak Tamboli has worked as a collector of turtle eggs for a government concession. Bapak Tamboli harvested the turtle eggs every morning. The tracks of the female turtles gave away the location of the nests. The only nests that escaped his harvest were those that were hidden when tracks were obliterated by rainfall or tides. The

A green sea turtle swims off the 2,000-foot wall of Sipadan Island, Borneo.

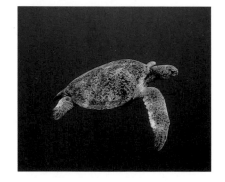

NOTES FROM THE FIELD

SEA TURTLES

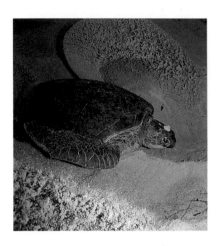

On rare occasions when high tide occurs just before dawn, female turtles can be found digging their nests at daybreak. They usually complete this arduous task under the cover of darkness. Sangalakki Island, Borneo.

interesting thing is that green turtles continue to lay on Sangalakki Island, even after fifty years of almost-total harvesting. It is quite probable that few young females have come out of Sangalakki since World War II, and that the entire population of nesting females is comprised of older females which reached sexual maturity prior to the 1940s.

When Borneo Divers and the Dewata Group decided to develop Sangalakki as a diving resort, they wanted to stop the turtle egg harvesting and allow the nests to hatch naturally. Borneo Divers bought the turtle egg concession from the Indonesian government for a significant annual fee. Bapak Tamboli became the guardian of the turtles, resuming his patrols down the beach, but this time to guard against poachers. Local political problems soon arose. Islanders from miles away, missing their daily meal of turtle eggs, simply could not understand why the new owners were letting all those eggs go to waste. Unfounded rumors about eggs rotting on the beach or being eaten by monitor lizards, and hatchlings dying by the thousands, fed upon by hawks, lizards, and crabs, did not help matters. In the meantime, after a single year of protection, turtle nests were hatching out by the hundreds. Thirty to forty turtle nests were being laid each night.

The plight of the sea turtle is improving, but is far from over. I think of those old females, laboring up the

Green sea turtle hatchlings, just emerged from a nest, scramble madly to the ocean. They must avoid numerous predators to make it to the open sea. Sangalakki Island, Borneo.

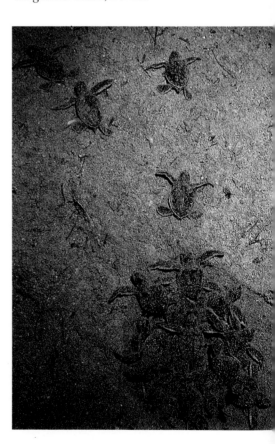

NOTES FROM THE FIELD

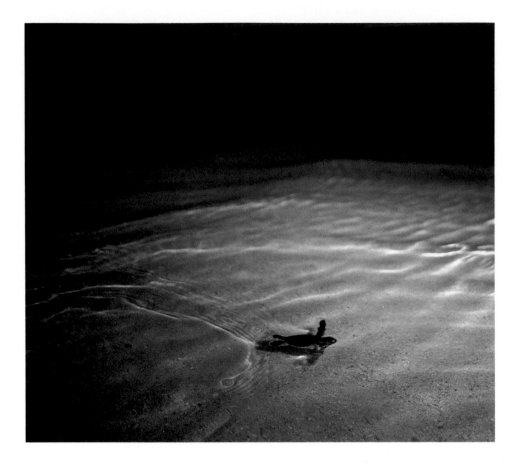

A juvenile green sea turtle swims above a coral reef. Juveniles are thought to drift in equatorial currents the first two years of their lives. Sipadan Island, Borneo./ 150-151

Most turtle hatchings occur at night. Hatchlings will rush to the region of greatest light. On a deserted island, this is the horizon and the open ocean. In developed areas, street lights and house lights confuse the hatchlings, who may mistakenly travel inland toward the lights rather than toward the open sea. Sangalakki Island, Borneo.

SEA TURTLES

beach to bring forth new blood. I think of all the old green sea turtles, now dwindling in numbers, dying in nets, speared for food, disappearing from the sea, and I feel a great loss. The female turtle sheds salt tears as she labors to bring forth her eggs, and I suspect this is one of the reasons she cries.

NOTES FROM THE FIELD

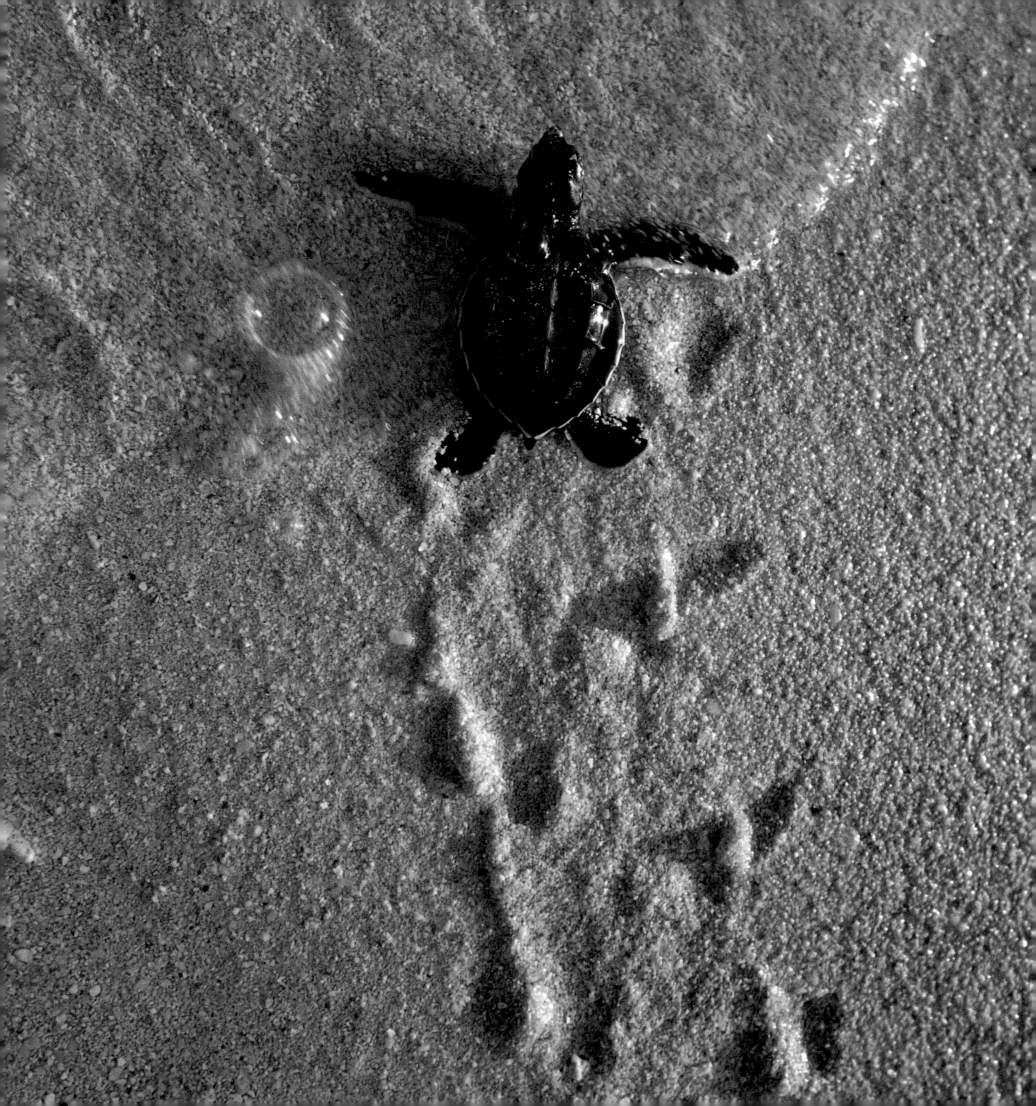

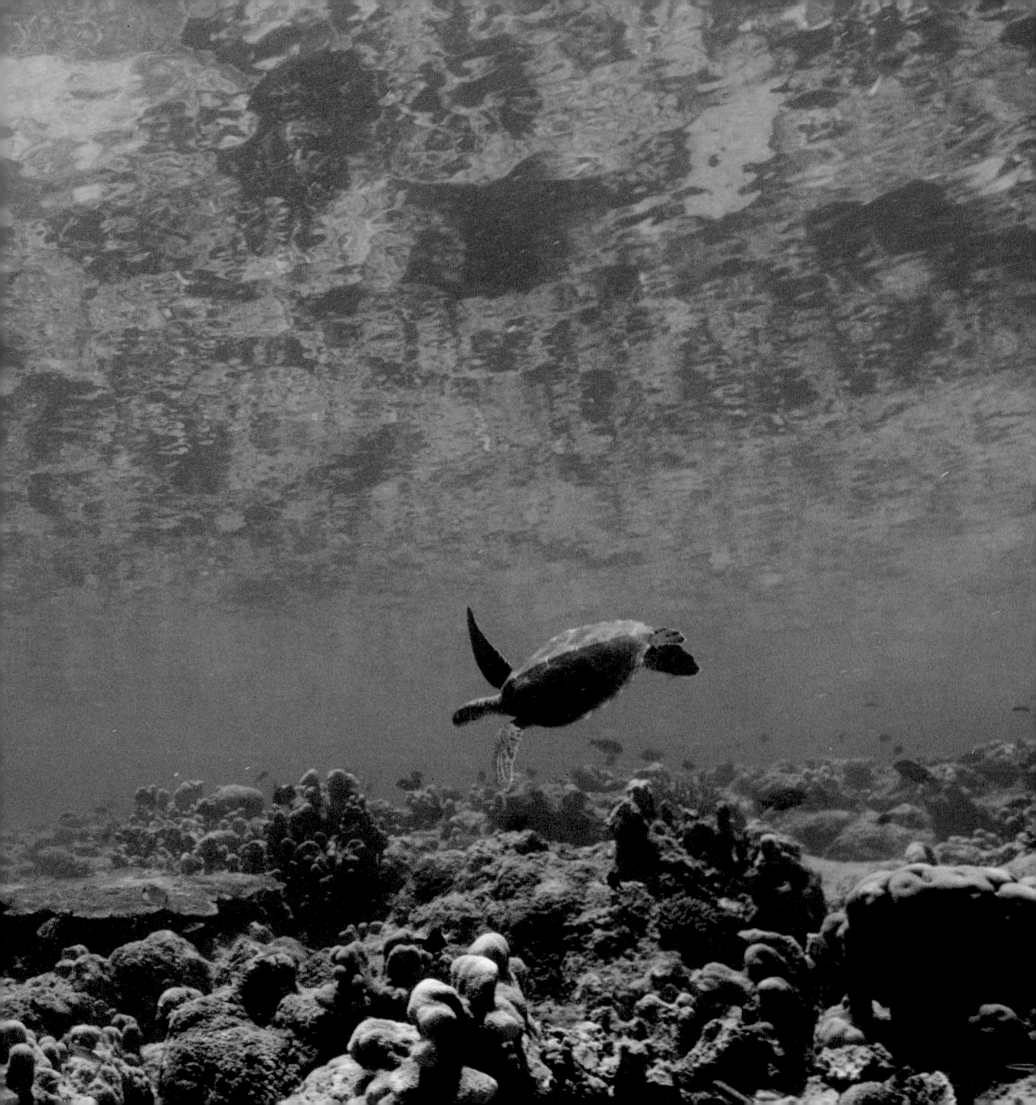

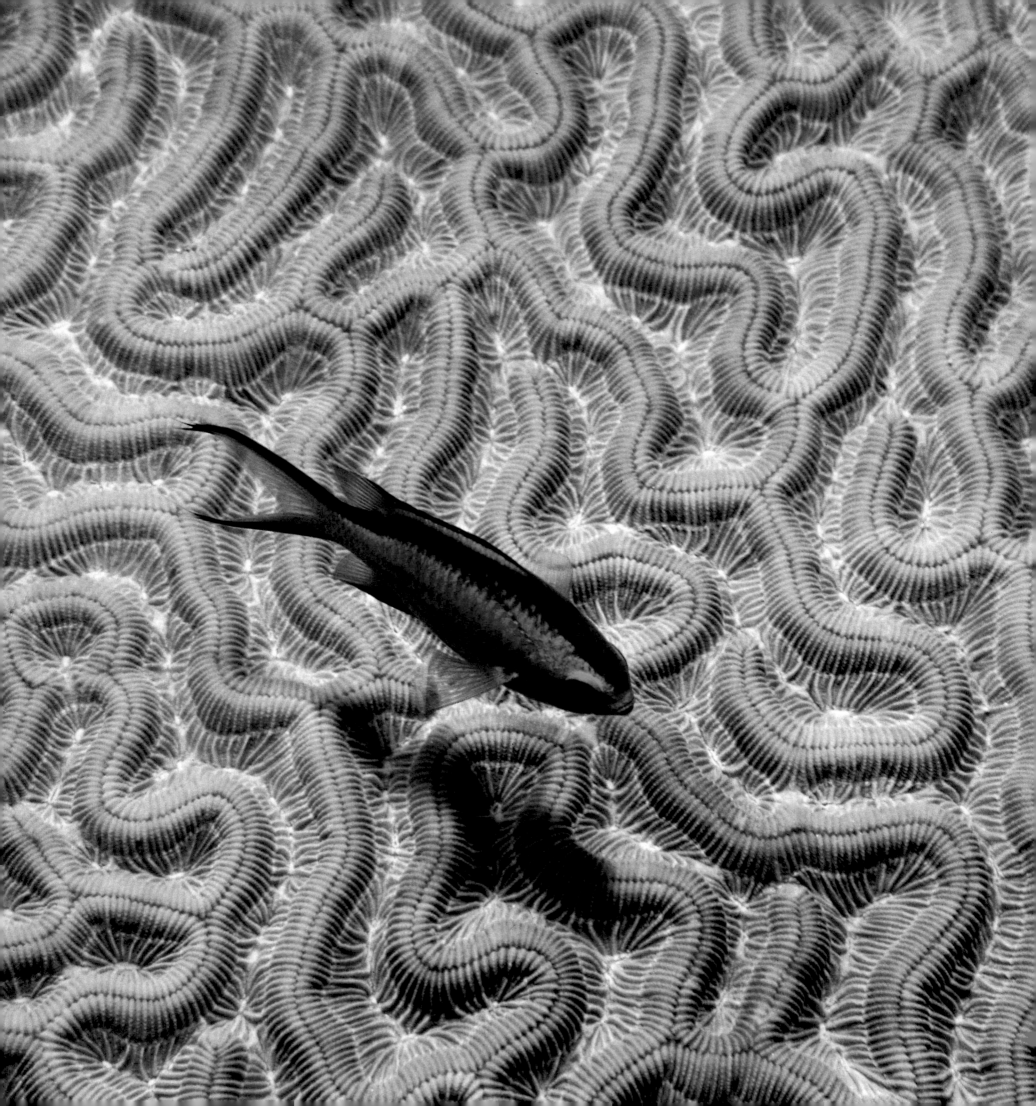

A healthy brain coral forms a convoluted pattern. Symbiotic algae living within the coral polyps produce food. Roatan, Honduras.

A blue chromis (left), a member of the damselfish family, swims over the convoluted pattern formed by a brain coral colony. Saba, Netherland Antilles.

THE FRAGILE REEF

Golf courses are one of the most serious causes of coral reef damage in the world. I recently visited the island of Maui after a hiatus of four years, and I was astonished at how quickly conditions had changed in such a short time. One of the more popular snorkeling spots off the island was almost completely buried under a thin layer of silt, washed down from neighboring golf courses. The pristine Molokini Crater, two miles offshore, had also been affected. Large patches of coral were dead or dying, with telltale streaks of algae growing throughout the reef.

Corals are extremely delicate. They require clear, warm water to stay healthy. Large temperature changes, wave action, or sediment kill them quickly. Polyps can be smothered by sand or dirt, killed by heat or cold, and destroyed by storms and waves. Hurricanes produce huge waves that reduce reefs to rubble. However, this natural process may actually be beneficial in the long run. The rubble and coral debris from a storm-ravaged reef becomes compacted and is cemented together by coralline algae and other plants and animals. Eventually this process produces a strong foundation for another generation of coral polyps.

There is no question that divers also damage coral reefs. Just the touch of a diver's hand will damage the polyp. However, divers' damage is far less than that produced by natural storms; the problem is that divers affect the same places year after year, and just one

Coral polyps are delicate animals. They are easily killed by sediment. Here, a twig lying on a patch of brain coral has killed the surrounding polyps. Roatan, Honduras.

A harem of Anthias crowds a coral wall of a remote atoll in the Indian Ocean. Desrouches, Seychelles Islands.

THE FRAGILE REEF

careless kick can knock off a fragile stand of staghorn or table coral.

Many coral reefs are in danger of dying or disappearing. Reef deaths are due mainly to silt wash-downs from neighboring golf courses, sewage runoff from area development, and excessive amounts of phosphates and nitrates from nearby agricultural developments. In addition, poor coastline management may destroy such important filters as wetlands and mangrove swamps, which keep waters clear of sediments that may otherwise smother a reef. Resort developments and cities built on the reef's edge often produce a great deal of sediment. Hotels which change the shoreline may cause new currents to form. These currents may bring with them large amounts of sand. Coral reefs are even being paved over to make room for airports and piers.

Natives on many islands are fishing out all manner of fish for food, and the removal of these fish from the ecosystem can lead to algae overgrowth on the corals. In the Philippines, extremely destructive methods are used to take fish for food and aquariums. Sometimes, entire reefs are dynamited for fish, and some fish collectors may kill entire reefs by injecting bleach or cyanide into coral to stun and collect aquarium fish.

A coral grouper sleeps among clump corals, which usually open at night to feed. Many groupers start life as females, changing sex later to become males. Sipadan Island, Borneo.

NOTES FROM THE FIELD

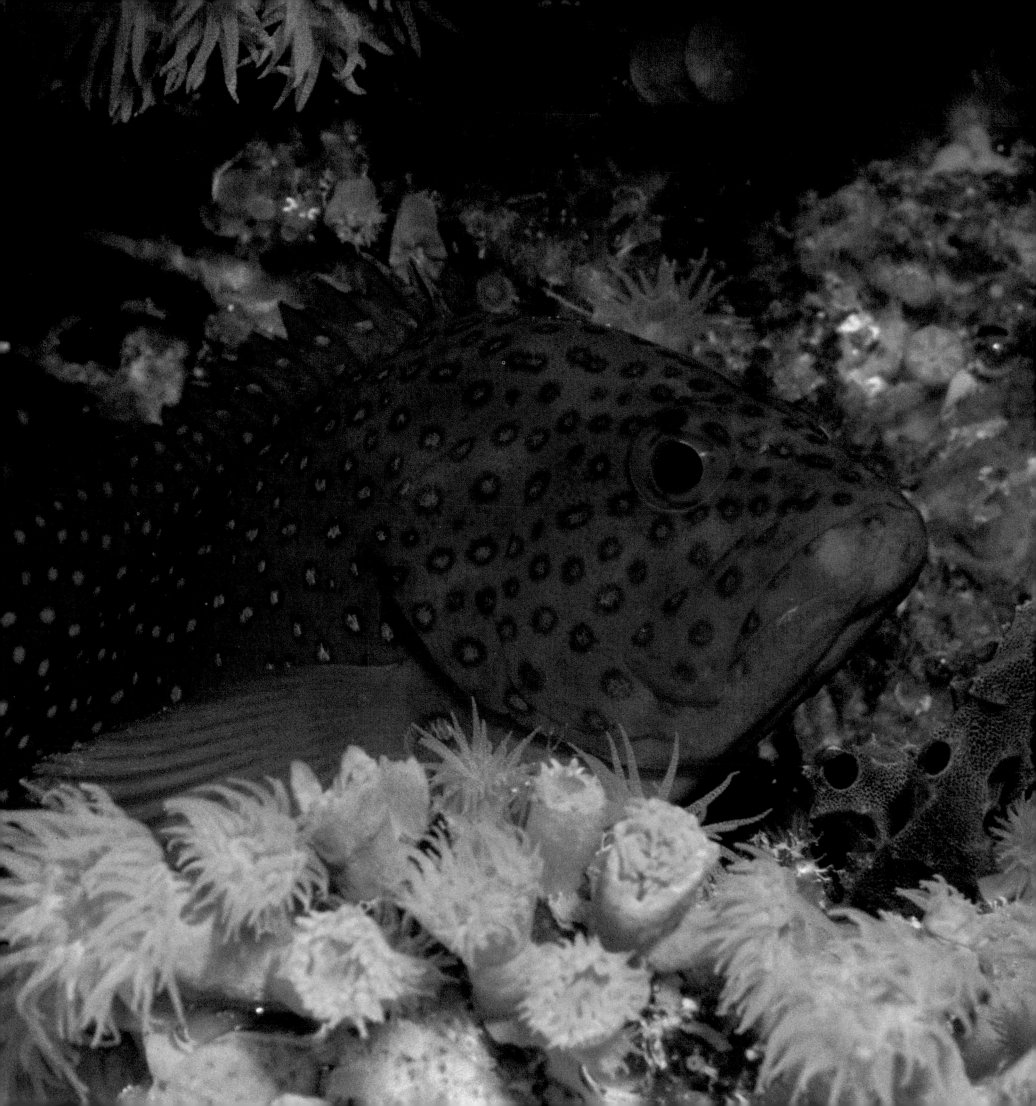

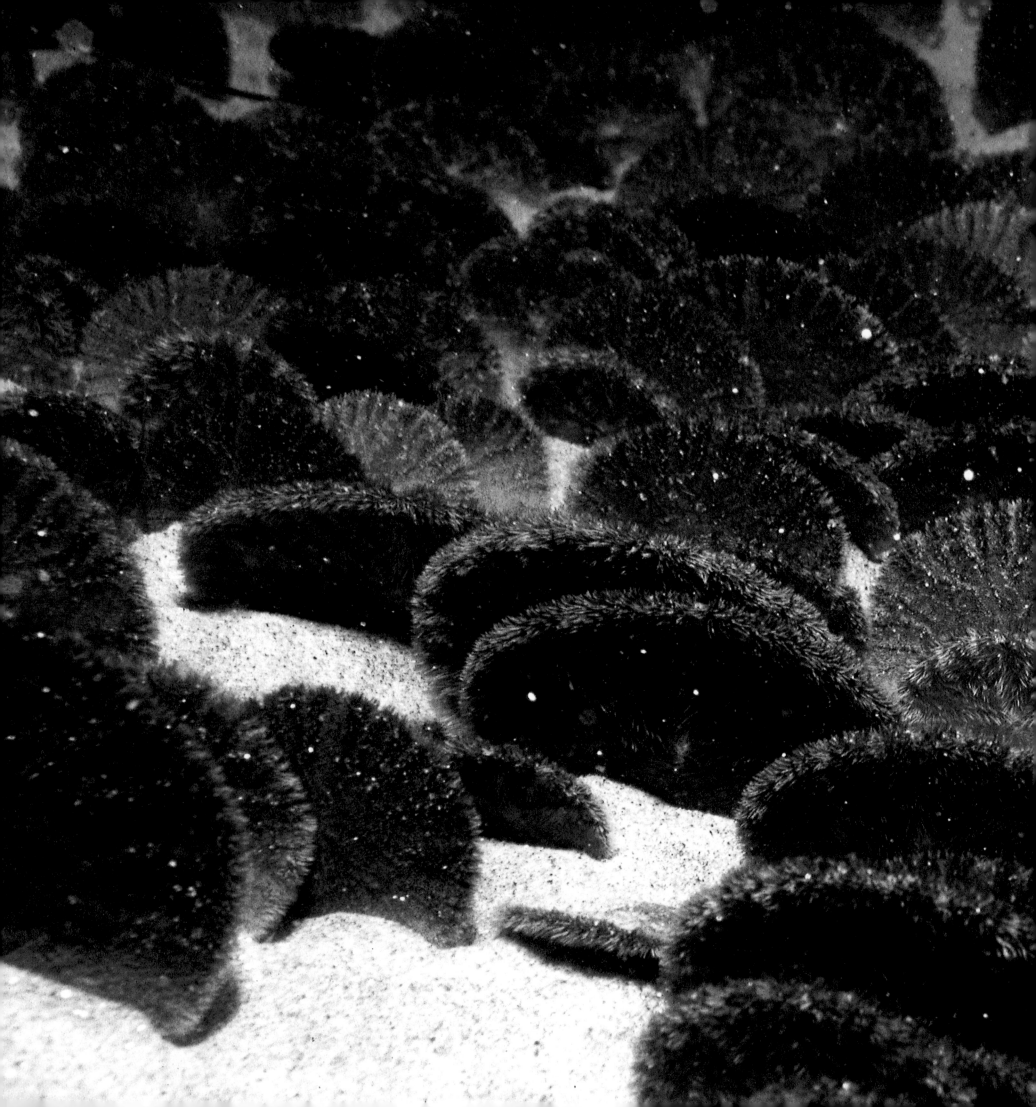

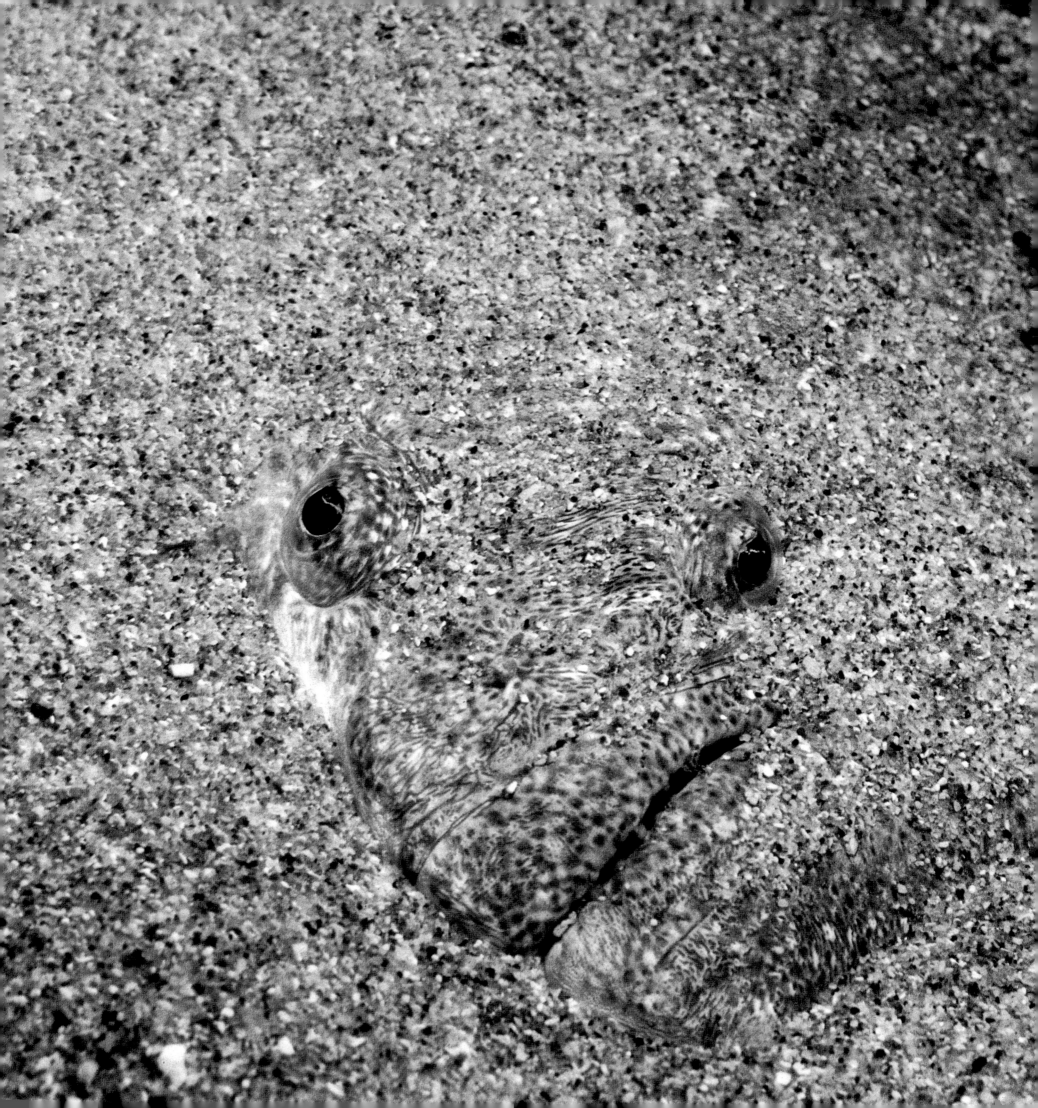

THE SAND COMMUNITY

A C A R P E T O F C A M O U F L A G E

A peacock flounder makes its way down the highway of sand near an island. Flat as a pancake, it swims in an undulating motion over the sand, looking much like a magic flying carpet. As it passes from white sand to darker coral, its entire body darkens to match the background. Back on the sand, the flounder wiggles into the bottom so that it is completely covered with sand. Only its two eyes protrude like tiny periscopes. The flounder begins life as a normal-looking fish, swimming with side-to-side thrusts of its tail. As it gets older, however, a hideous but quite natural transformation begins. Its left eye moves over its head to its present position, right alongside the right eye. The flounder begins swimming on its side, left side facing the bottom. It is just one of the many nearly invisible animals that inhabit the sand community. The channel of sand that the flounder has settled on is like a highway. At

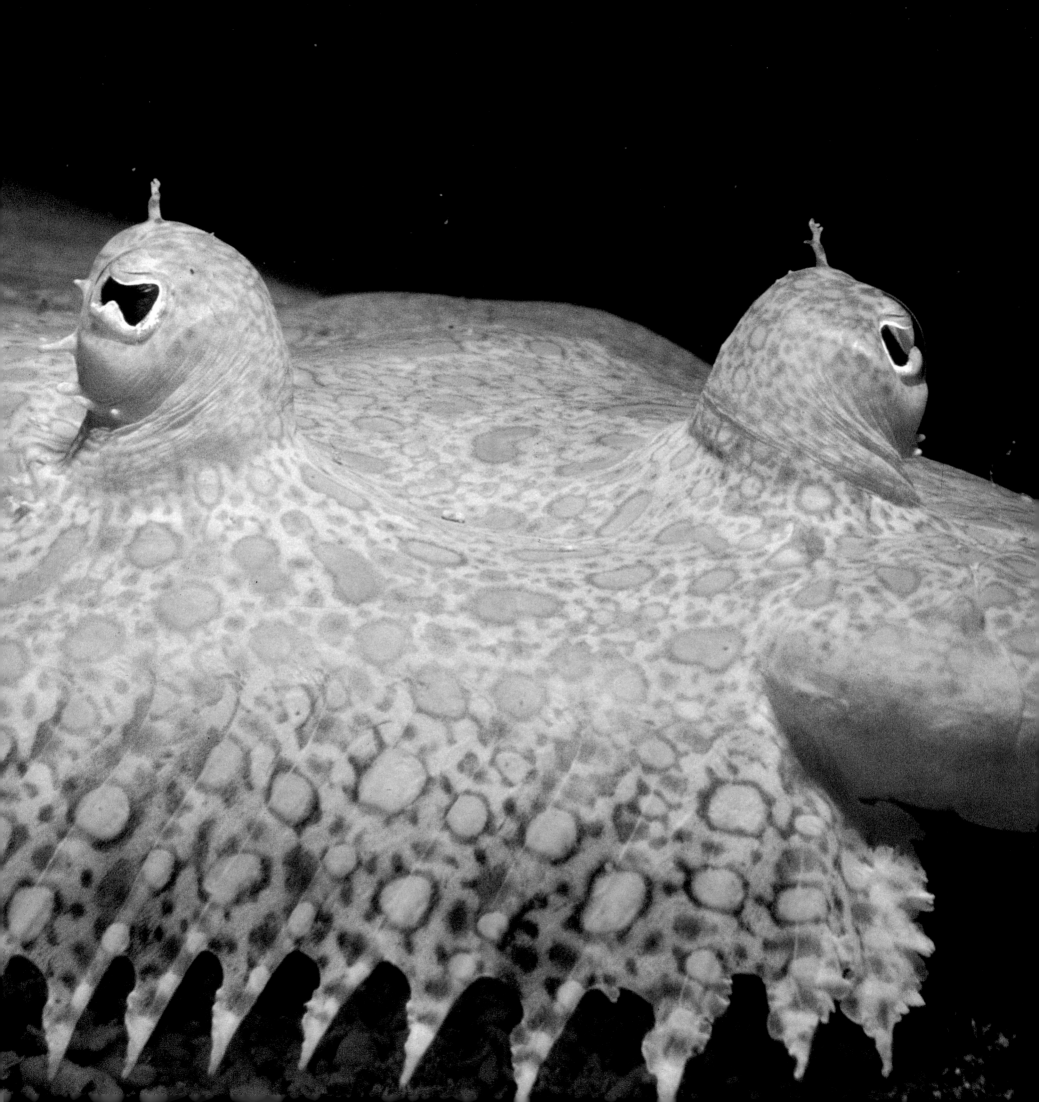

certain periods of the day, the current of water flowing through the area reaches tremendous speeds. During these times, a flotilla of manta rays often travels the highway, flying with ease against the current, mouths open to collect the plankton that the current carries.

In a sandy patch between two coral heads, a striped goby stands watch at the entrance to its burrow, a hole in the sand lined with shells and bits of dead coral skeletons. Two shrimp within the burrow are busily and endlessly cleaning house, excavating the burrow and dumping debris outside. Looking like miniature bulldozers, the shrimp push piles and piles of sand and shell out of the burrow. Startled by a manta's passing shadow, the goby flicks its tail to warn the blind shrimp of danger. The shrimp wait patiently inside the burrow until the goby removes its tail from the entrance. This, along with a small flick of the tail, signals that all is clear once again.

Nearby, a sea cucumber, with a mouth that looks like a flower, is busy sifting the sand for small food particles. A few feet away, a large Titan triggerfish blows sand away from the bottom, searching for the small crabs, shrimp, and brittle stars that live there. With surprising strength, the triggerfish flips over large pieces of dead coral and rock to find the animals underneath. Its large, strong jaws are suited to crunching pieces of coral. Finding a pincushion sea star, it flips it over to reveal the small shrimp that live on the starfish's body. The shrimp, however, elude the triggerfish by constantly scurrying to the other side of their host. Spotting the sea cucumber, the triggerfish flips it over also, looking for similar shrimp that live around the sea cucumber. It quickly snatches one off, but is then suddenly sprayed by hundreds of sticky white threads from the sea cucumber. Sea cucumbers have no defense other than to eviscerate their insides if disturbed too much. The triggerfish, alarmed and unable to get the white threads off its head, darts off in a commotion, shaking itself violently.

The sand highway ends a few hundred yards away, where the bottom abruptly drops down to deeper waters. At the slope's edge, a bed of garden eels sways like charmed cobras above their burrows. Almost six feet long, the thin eels only keep the upper two feet of their bodies above the sand. As a

Flounders start out life looking like normal fish, but as they grow they change dramatically. One eye migrates to the other side of the head, and the fish starts swimming on its side with the eyes topmost. This peacock flounder's eyes act as periscopes as the fish lays covered in sand. British West Indies.

The peacock flounder can change the color of its body to match the surface that it lies on. Saba, Netherland Antilles.

Sand dollars are echinoderms related to sea stars. They collect food particles being swept by in water currents. Monterey, California. / 156-157

The California halibut is an ambush predator that burrows into the sand so that only its eyes show. Channel Islands, California. / 158

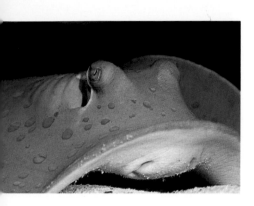

The blue-spot stingray uses its round pectoral fins to dig for food. Its mouth, on the underside of its body, crushes the invertebrates that it finds in the sand. Red Sea.

manta swoops down toward them, the eels retreat into their burrows one by one. A crocodilefish on the edge of the bed waits patiently. Its eyes and body are amazingly adapted for camouflage and ambush. Its eyes are covered with fringes of skin that look like algae, and its flat body is mottled and colored so that it looks like a rock. Only on close inspection can its shape and its large narrow mouth be discerned.

The crocodilefish has painstakingly inched closer and closer to its prey, a pair of razorfish hovering over the sand. The razorfish, mindful of their appeal to predators, nervously scan the horizon, as they poise themselves above a special bed of sand that they have prepared. When the crocodilefish moves a bit too quickly, the razorfish stop in their pursuit of passing plankton. Suddenly sensing the nearness of the predator, both dart headfirst into the sand and completely disappear from view. Disappointed, the crocodilefish swims off to take up a station further down the slope.

Conchs in their beautiful shells, their eyes floating on long stalks above their bodies, make their way slowly across the sand, seeking the eelgrass beds that lay in shallow water ahead. Two flying gurnards walk across the sand, dipping their strange fingerlike fins into the sand, searching for invertebrates. When alarmed, they spread their brightly colored fins that make them look like huge butterflies.

A pod of dolphins passes in the distance, swimming languidly toward the sand banks where they will rest during the day. They have spent the night diving in deep water for squid. Tired now but sated, the dolphins chatter to one another in high-pitched squeaks. A young calf stays close to his mother, nuzzling her in search of milk. Trying to wean her baby, the mother refuses his requests and instead guides it to the shallow sand bottom where she has seen another pair of razorfish. Pointing her nose to the sand, the mother dolphin emits a series of loud sonar clicks at the sand, then probes the sand with her nose. As the startled razorfish leap out, the mother quickly snatches one in her teeth. She allows the other fish to escape in the sand again and waits for her calf to follow her example. The calf is unsuccessful, however, and the pair moves off to join the rest of the pod.

This photograph shows the underside of a southern stingray, where its mouth and gills are located. Grand Cayman Island.

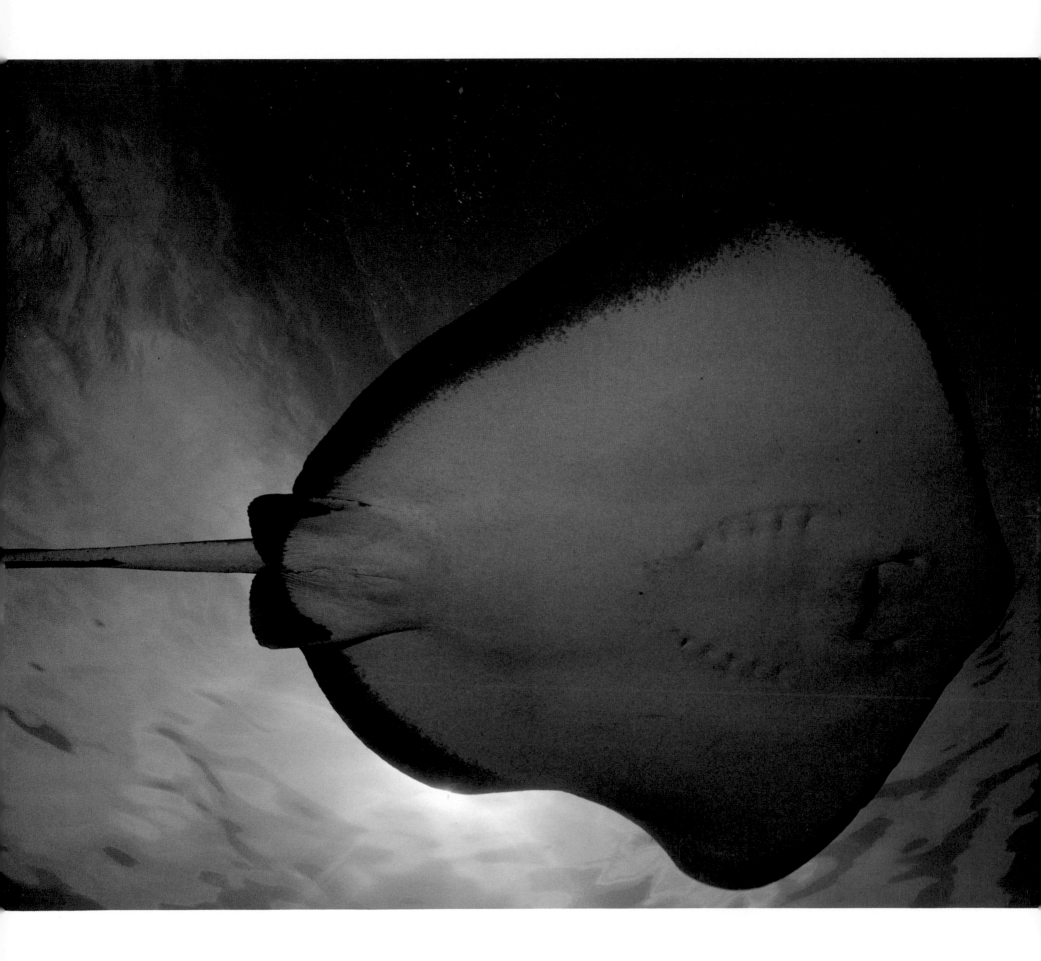

A giant yellowmargin triggerfish blows away sand to find the invertebrates living there. Sipadan Island, Borneo.

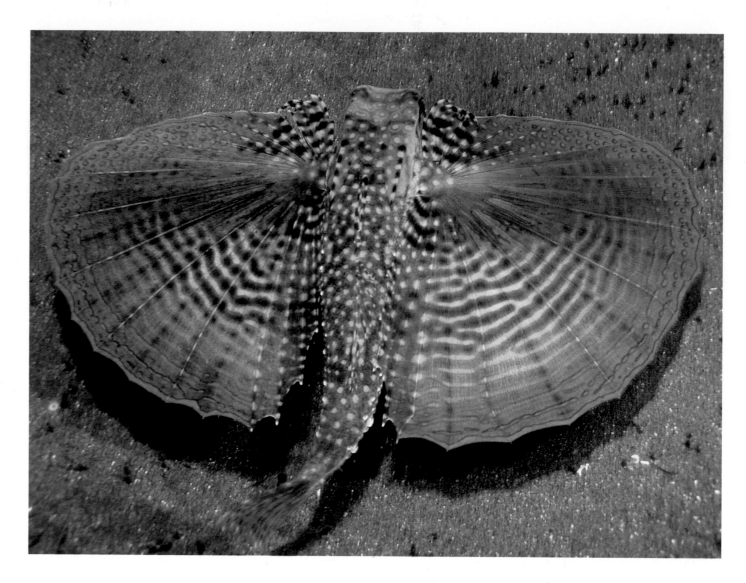

Flying gurnards walk across the sea floor on fingerlike fins, rarely leaving the bottom. They unfold large, bright, winglike fins to confuse and threaten predators. Saba, Netherland Antilles.

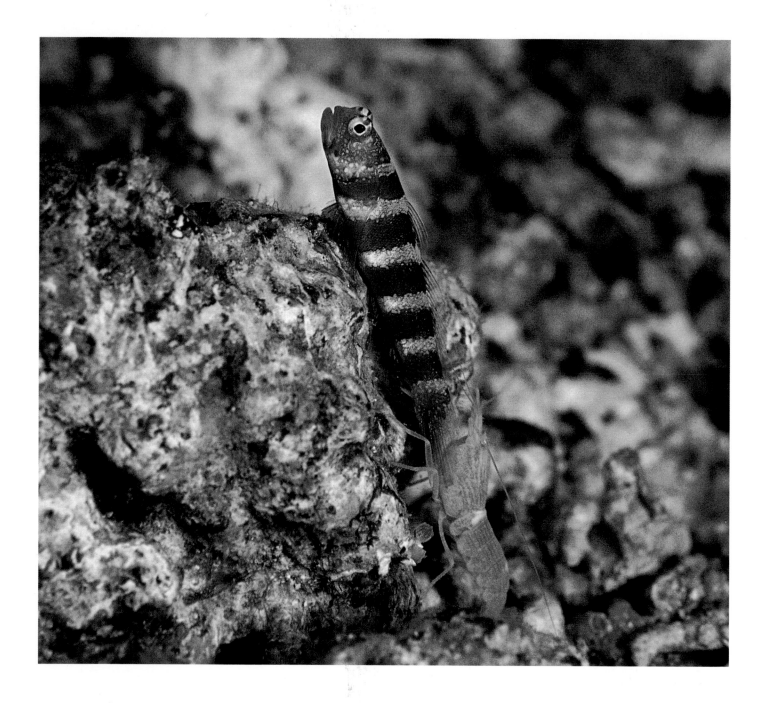

The eyes of a queen conch are on the end of long stalks that can be quickly retracted beneath the conch's heavy shell if the animal is disturbed. St. Croix, U.S. Virgin Islands.

Many types of gobies have developed partnerships with blind shrimp. The gobies stand guard while the shrimp maintain the shared burrow. Sipadan Island, Borneo.

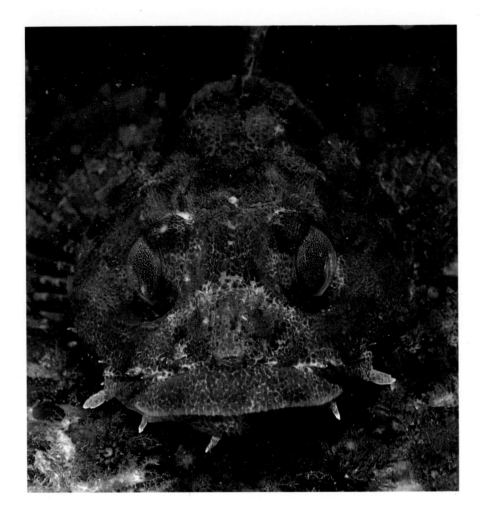

The Irish lord (top left) is a sculpin whose coloration closely matches the sandy bottom on which it is found. San Juan Islands, Washington.

The scorpionfish (top right) is an ambush predator with cryptic coloration that helps it blend into the background. Scorpionfish have venomous spines. Sea of Cortez, Baja Mexico.

A master of camouflage, the flattened crocodilefish (right) can hardly be distinguished from its habitat. Its flat shape and mottled coloring make it an effective ambush predator. Solomon Islands.

Underwater sand flats seem as barren as a desert. Upon closer inspection, however, the sand flats harbor many varieties of animals. Grand Cayman Island. / 168-169

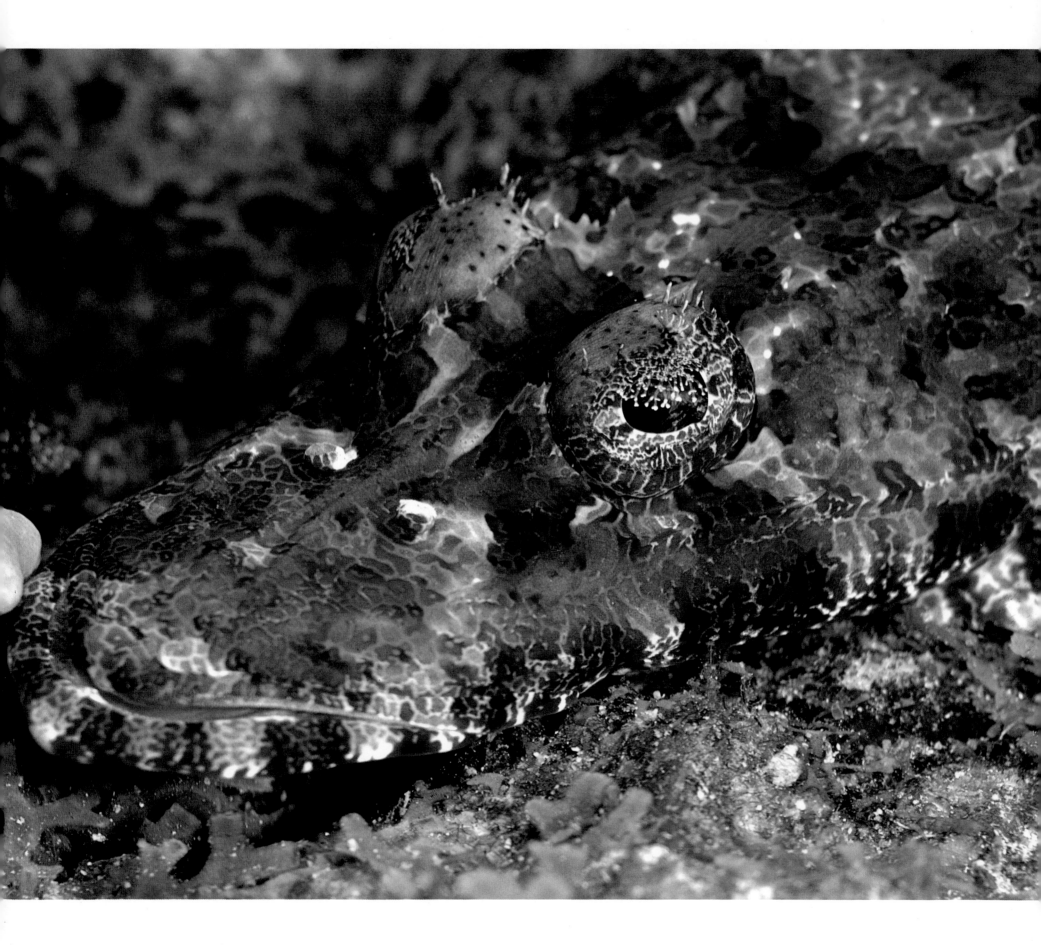

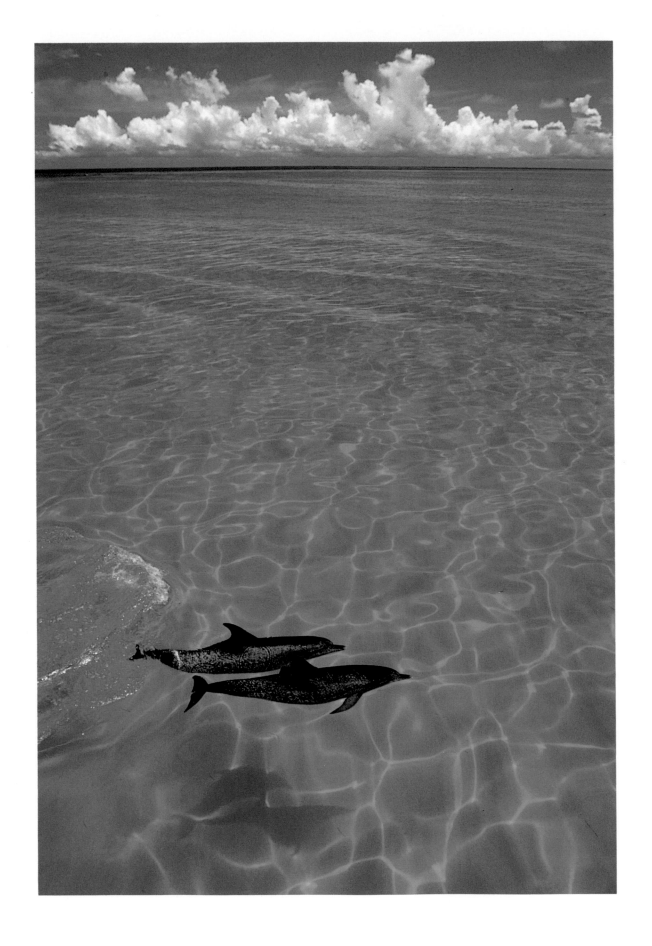

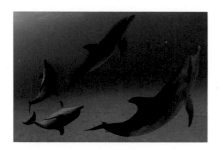

A mating pair of dolphins is assisted by several male "helpers," which warn off intruders. These helpers may assist the mating pair by helping them to the surface. Bahama Banks.

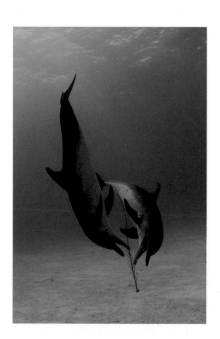

Eternally playful, two Atlantic spotted dolphins pass a sea fan back and forth. Bahama Banks.

THE SPOTTED DOLPHINS OF THE BAHAMAS

In all the world, there are few places where wild dolphins come of their own free will to interact and play with humans. These wild dolphins have not been fed or otherwise lured. They are apparently drawn to humans for the sheer enjoyment of this inter-species play. One of these magical places is the Bahama Banks, a shallow sand bank off the island of Grand Bahama. These dolphins were first discovered by treasure hunters searching for sunken Spanish galleons. The men would take time off from their labors and play with their new friends.

Dolphins have always held a special fascination for humans. Stories of their intelligence, altruism, and physical abilities abound as myths of the sea. Swimming with dolphins is exhilarating, refreshing in every sense of the word. Since dolphins love to play, the best way to hold their interest is to snorkel with them, twisting and turning, interacting with them at their level. They will often approach divers closely, mimicking their actions.

These dolphins do most of their hunting at night, when they pursue squid in the deep waters off the bank. They rest during the day on a warm, clear, shallow sand bank. These dolphins are the only known successful predator of the elusive razorfish, which dive headfirst into the sand to escape danger. Dolphins, unlike other predators, use their sophisticated sonar capabilities and high intelligence to track the razorfish, then dig up and capture them with a quick snap of their beaks.

NOTES FROM THE FIELD

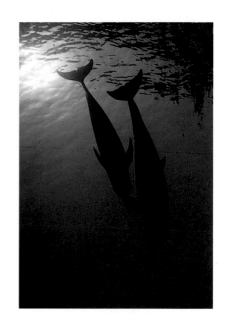

An Atlantic spotted dolphin pair rests on a shallow sand bank during the day, after a busy night of hunting. Bahama Banks. / 170

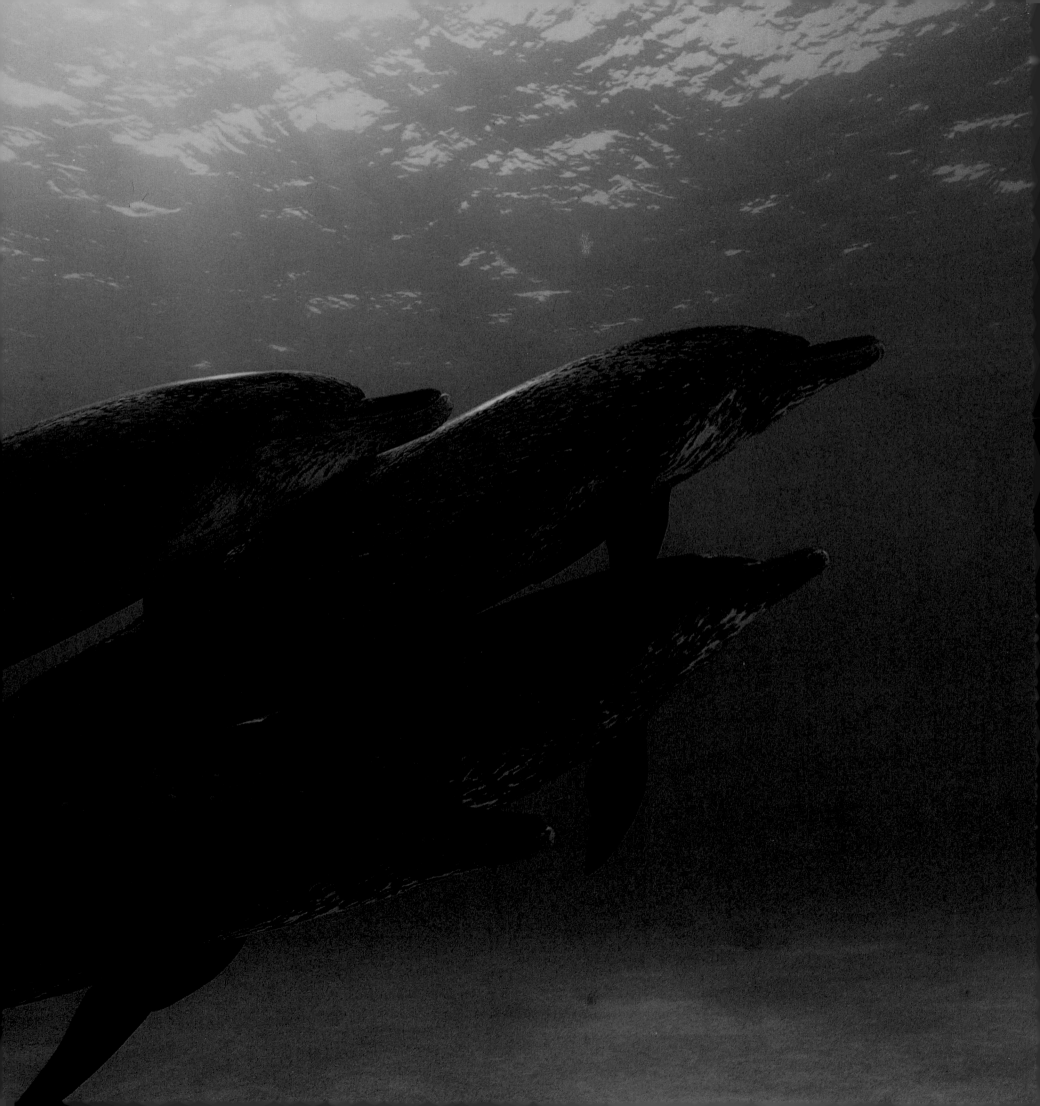

SPOTTED DOLPHINS

By spending time with these animals, I have observed their mating habits. Dolphins are quite passionate animals, and they spend almost as much time engaged in sex and foreplay as humans do. In fact, one of the first things I learned about dolphins in captivity is that males often come on to human females in the water. When mating, the male swims upside down, directly under the female. Up to six other males, called "helpers," will swim with the couple, supporting them and warning off intruders. It is an interesting spectacle.

Although the dolphins off Grand Bahama love to swim with humans, they don't like to be touched. They will swim closely until you put a hand out. Mimicking a fin by extending an elbow is fine. Sometimes the dolphins are not in the mood to accept a human intruder. If you swim into their midst, they will move off and give you a clear signal of displeasure by expelling excrement.

Spotted dolphins love to play underwater. I have seen them grab objects and pass them to and from each other at high speeds. Like many species of dolphins, they will often come up to the front of a moving vessel and ride the pressure wave created by the boat, similar to bodysurfing. Many scientists have written papers and spent hours observing this phenomenon, only to come to the conclusion that there is no logical reason for this dolphin behavior. It's pretty obvious to all but the most detached observers that dolphins ride waves for fun.

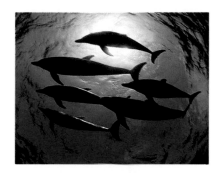

A group of wild Atlantic spotted dolphins have interacted with humans in their home range for over 20 years, after their initial discovery by treasure hunters. They will often approach swimmers in the water. Bahama Banks.

NOTES FROM THE FIELD

The mantle of a cowrie (above) covers its smooth shell at night, as the cowrie emerges from its shelter or sand cover to feed. Red Sea.

A four-inch-long shrimp (right) hides in the sand bottom of California's cold waters. Channel Islands, California.

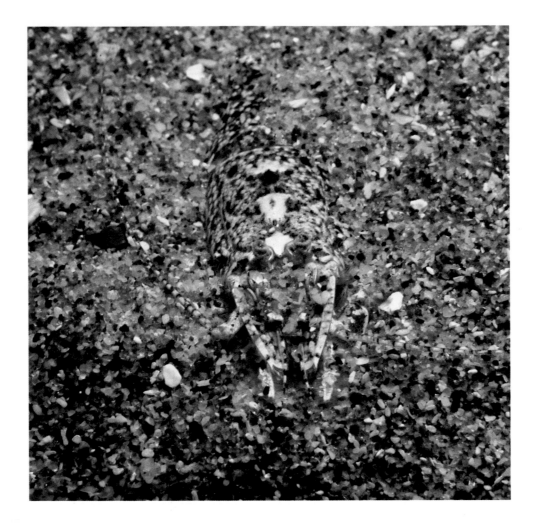

The wobbegong shark (below) has fringes and coloring to help it blend into its preferred background of sand and rubble. Unwary fish passing in front of it will be engulfed with a quick lunge. Great Barrier Reef, Australia.

The spawning of many marine animals is rarely seen and occurs only at certain times of the year and lunar cycle. Here, a pyramid sea star releases sperm and eggs into a strong nighttime current. Sea of Cortez, Baja Mexico.

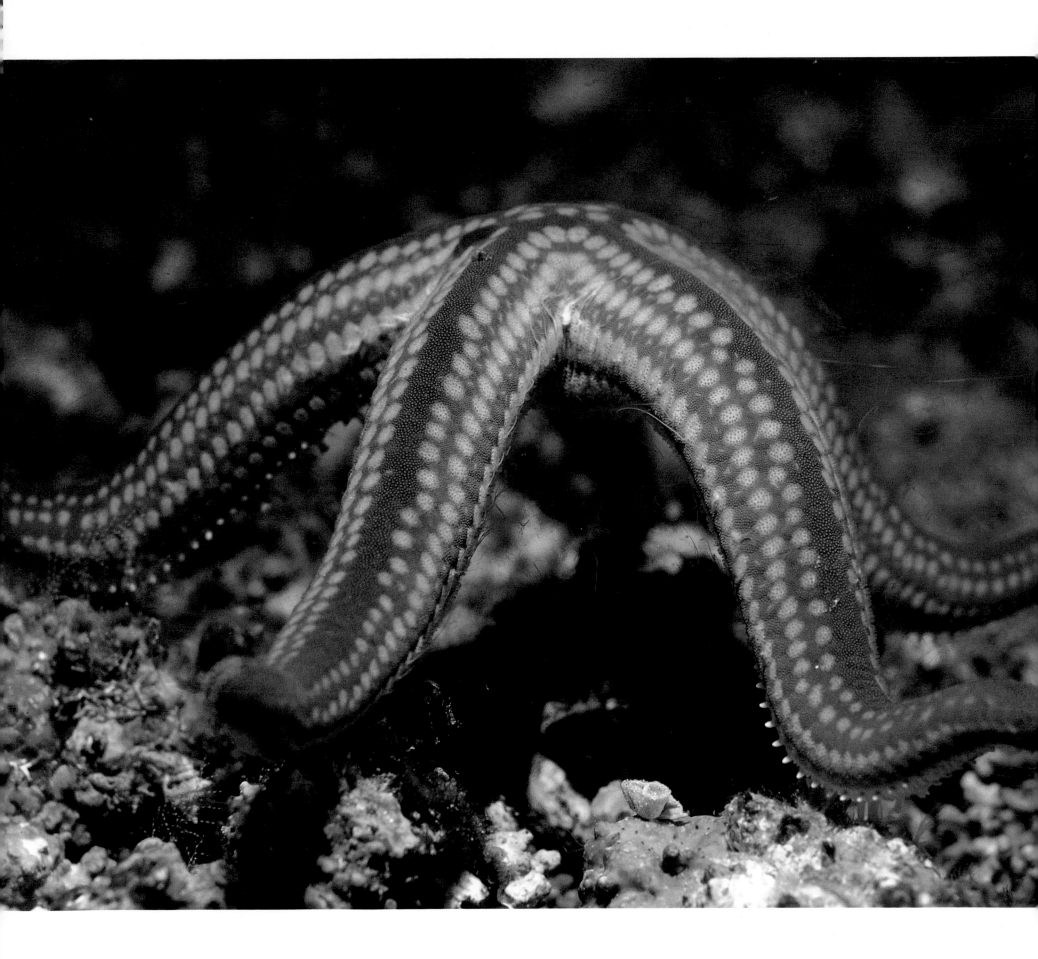

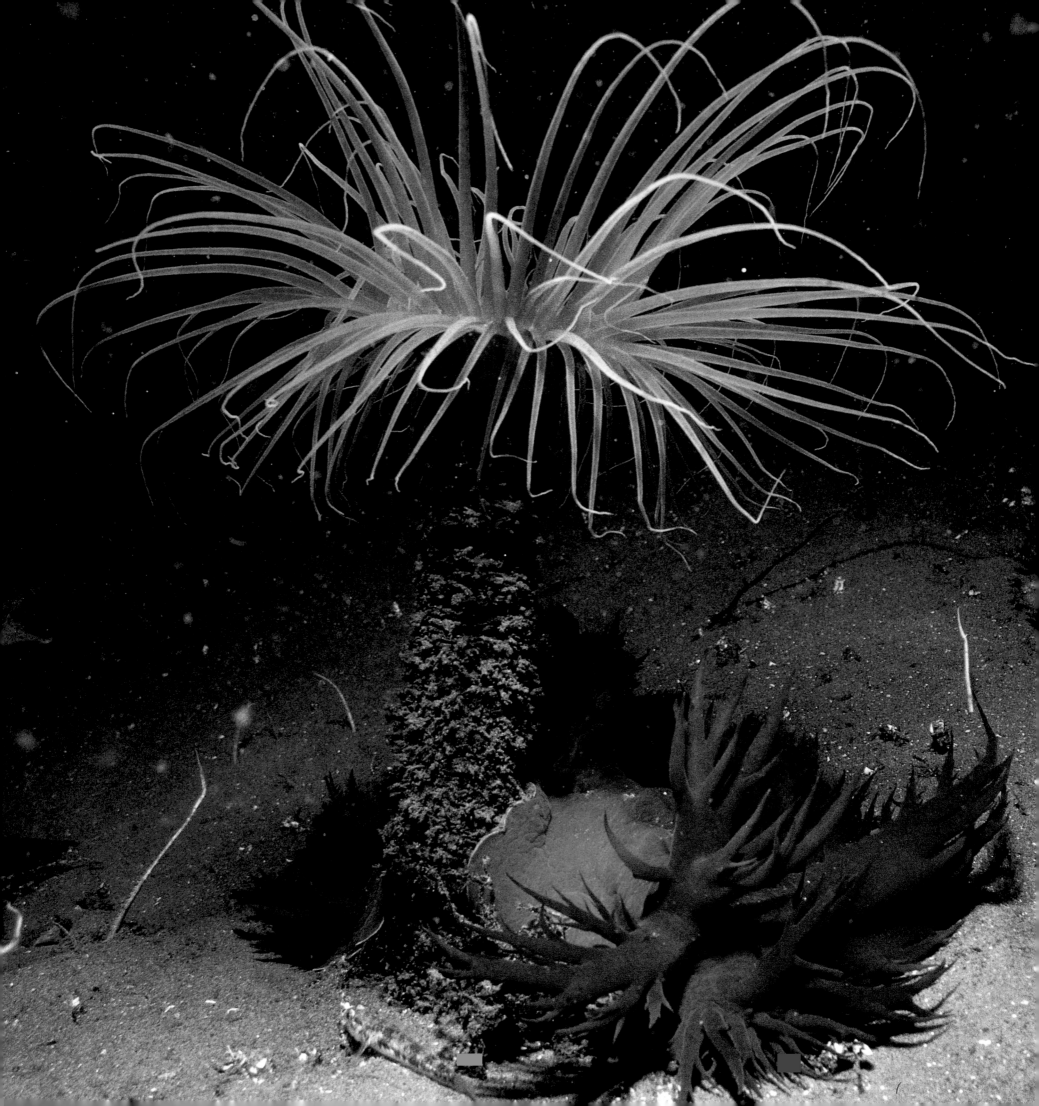

A NUDIBRANCH ATTACK

SEQUENCE: A rainbow nudibranch attacks and feeds on an anemone, and then lays its eggs beneath the anemone's tentacles, thereby gaining protection for the eggs. Monterey, California.

Anchored to the sandy sea floor between the rocks of a kelp forest, a group of tube anemones feeds on plankton, plucking food particles out of the water with long, thin tentacles. Sea anemones may resemble flowers, but they are invertebrate animals closely related to jellyfish. Their living, colorful "petals" are actually stinging tentacles containing thousands of poisonous harpoons that repel most predators and paralyze small prey.

Along the edge of this group wanders a large, bright orange sea slug called a rainbow nudibranch. A nudibranch is a snail that has no shell. It breathes through the brightly colored gills on its back. The nudibranch's bright colors advertise the fact that it is poisonous and untasty.

The rainbow nudibranch specializes in feeding on the tentacles of live tube anemones. Upon detecting the anemones around it, the nudibranch moves into position. It rears back and exposes its radula, a sawlike organ with rows of "teeth." With a sudden strike, the nudibranch leaps upon the anemone and bites off the tentacles. The anemone draws back into its tube, and the rainbow nudibranch goes with it, feeding as it goes. The nudibranch doesn't eat the entire anemone, just a few tentacles. As the nudibranch eats, it stores the stinging cells from the anemone on its back. Afterwards, any fish that attacks the nudibranch will be stung by these cells.

NOTES FROM THE FIELD

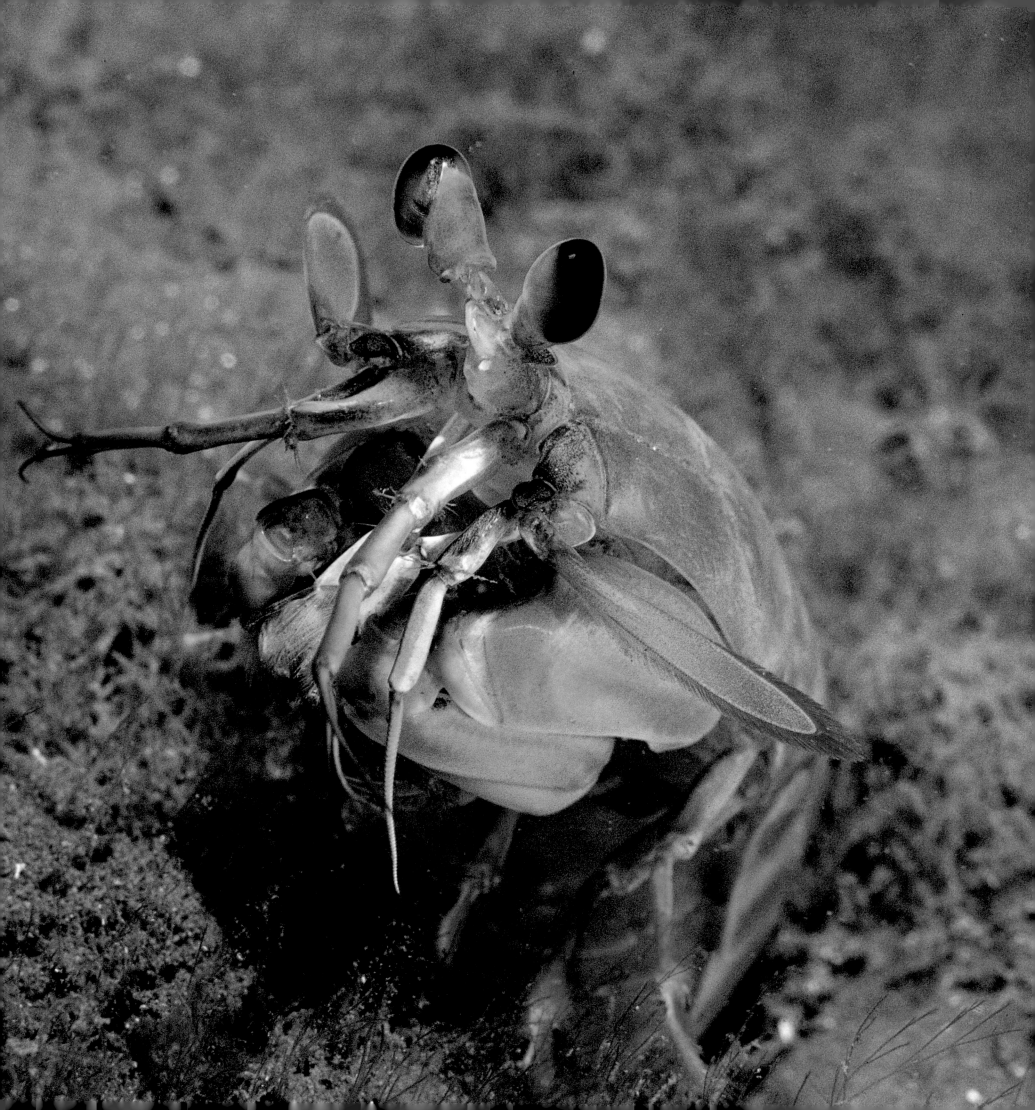

THE MANTIS SHRIMP:
THE FASTEST CLAW IN THE WEST

SEQUENCE: The mantis shrimp is a primitive crustacean. In this sequence of photographs, two male mantis shrimp fight for a burrow by exchanging blows on each other's hard tail. By striking the tail rather than more vulnerable body parts, males can test their physical dominance without being seriously injured. Santa Catalina Island, California.

The mantis shrimp is a crustacean that digs burrows in sandy bottoms, lines the burrow with shells, and uses a particularly well-sized shell to seal up the burrow during periods of inactivity. Its main claim to fame is the ability to strike out with stiletto-shaped front claws, one of the fastest movements in the animal kingdom. It uses this striking movement to stab, slice, or bash clams and mussels that it finds within the sandy bottom. The eight-inch-long, colorful males also use these claws to assert their dominance, and both sexes use the claws to defend themselves from predators. Aquarists have reported cases where their aquariums have been shattered by the rapping of these front claws against the glass.

When two males encounter each other, they may fight over possession of a burrow. If this happens, the male already inside a burrow may rush out and strike out at the intruding male. The intruder will often present his thick tail, rather than more vulnerable parts of his body, to be rapped upon by the angry resident. After a while, the resident may turn tail; that is, it will disappear into his burrow and present only his tail to the outside world. This presents a barrier to the intruder, who may retaliate by striking the resident's tail. This behavior may allow male mantis shrimp to assert dominance without doing physical harm. The strikes land on the thick tails, doing little or no damage while allowing the males to "take their punches like a man."

NOTES FROM THE FIELD

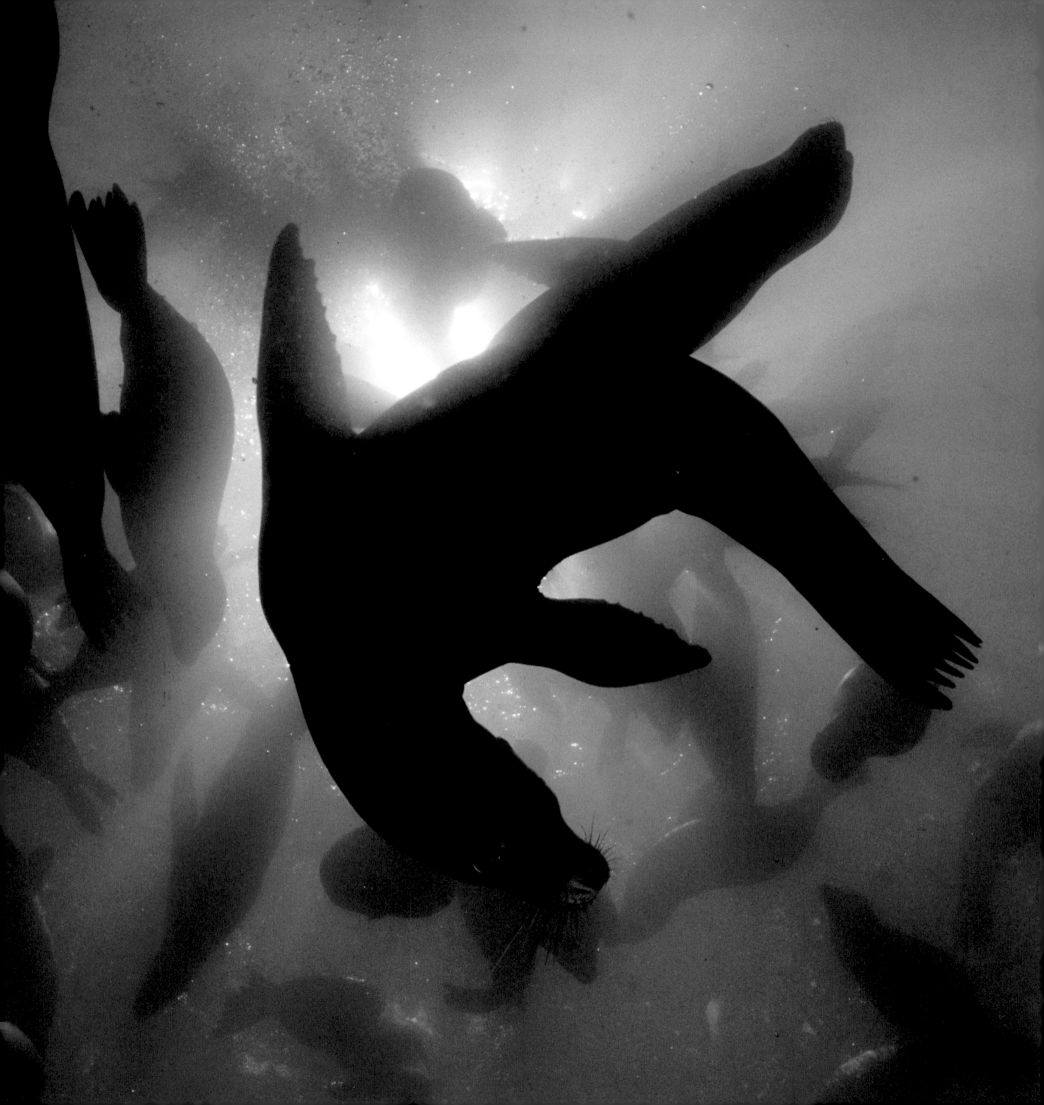

THE KELP FOREST

The day is starting off the coast of California. The rising sun reveals dark masses of kelp below the steep cliffs bordering the cold, rough Pacific. A sea otter splashes in the shallow water near the cliffs, diving up and down, fishing for its breakfast. Eventually it comes up with a kelp crab, which it quickly devours. Then it floats on the surface, rolling in the kelp, and grooming itself by combing its fur with its paws. It does this after every meal, and it is this constant grooming that keeps the otter's fur clean, fluffy, and full of air. The air in the fur helps the otter stay warm. A sudden snort startles the otter, and it looks up from its grooming to see a pair of large, black eyes in the dark water. The eyes belong to a harbor seal, who snorts in fear or playfulness and then sinks quickly below the surface. Unlike the sea otter, the harbor seal has a thick layer of blubber to protect it from the cold water. In the

background, a contingent of sea lions brays in the distance, arguing among themselves as they have all through the night. A dozen sea lions loll about at the surface of the water just beyond the kelp forest, lying on their backs with their fins in the air. Clumsy and loud on land, the sea lions become graceful, playful swimmers in the water.

The sea otter dives into the water again, and this time it finds one of its favorite foods, a large red sea urchin. The otter lies on its back in the water and uses its flat stomach as a dinner table. With nimble paws, it pries open the sea urchin. Careful to avoid the urchin's long, sharp spines, the sea otter digs for the meat. Then, with a twist, the otter drops the urchin's shell into the sea. A school of señorita fish, patrolling the waters beneath the kelp canopy, follows the shell's path, nibbling on the remains of the urchin as the shell twists and turns its way to the rocky ocean bottom forty feet below. Different fishes — bright orange garibaldi, large California sheephead, and rockfish — all drawn to a free meal, fight over the urchin. Even bat stars, attracted by the smell, glide on water-filled tube feet over the rocks and sand to see what remains of the feast.

It is dark underneath the kelp canopy, like a golden forest with shafts of light shimmering through the branches. Kelp forests are as grand as any redwood stand, and they boast a great diversity of species. The kelp plant is not a tree, but a type of algae, and its "roots" and "leaves" are very different from its terrestrial counterparts. The rootlike structures are called the holdfast, and instead of being planted in the ground, they are spread out on top of rocks, anchoring the plant to the ocean floor with a natural glue. Without the holdfast, the plant would be washed ashore to die in a tangled mass. The "leaves" are called blades. They are rubbery and the bottom of the blade ends in a hollow sac filled with gases. These bulbs help to keep the top of the kelp plant at the surface, where the blades can convert sunlight into food. What looks like the trunk of the kelp plant is called the stipes. Unlike the thick, rigid trunk of a tree, the stipes are a mass of supple intertwined cords. These hollow tubes transport food from the blades down to the rest of the plant, all the way to the holdfast. When the fronds of giant kelp plants

Two jeweled top snails meet on a kelp bulb. They feed on bryozoans, hydroids, and other invertebrates that cover the kelp. They can even digest the kelp plant itself. Monterey, California. / 180-181

Clumsy on land, sea lions move like rockets underwater. They are highly social and noisy animals, and dominant males may gather harems of twenty or more females. The males are conspicuous for their larger size and their crested foreheads. Monterey, California. / 182

A group of bat stars has slowly made its way to this jellyfish entangled within the kelp forest. The bat stars will feed by everting their stomachs and digesting the jelly from the outside. Monterey, California.

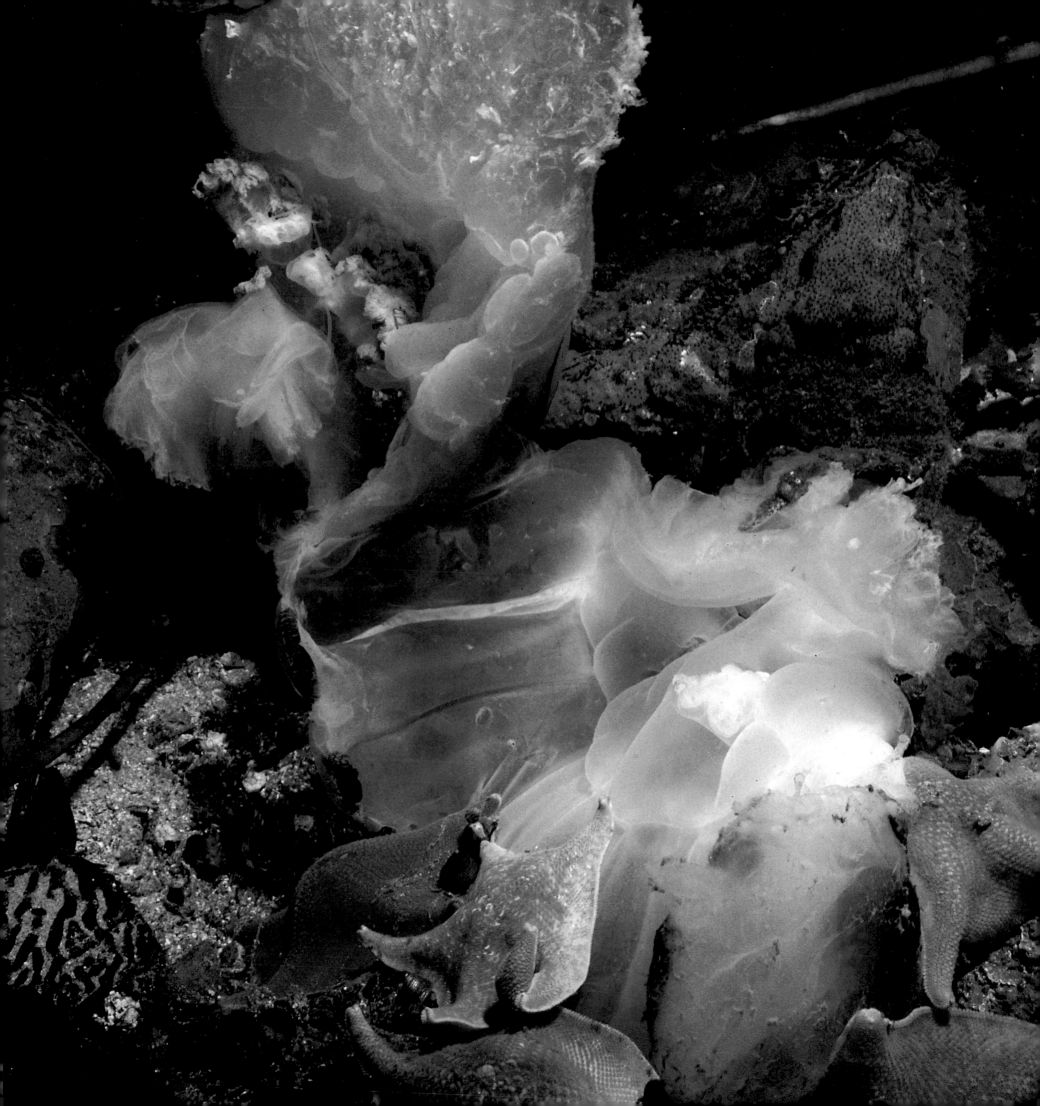

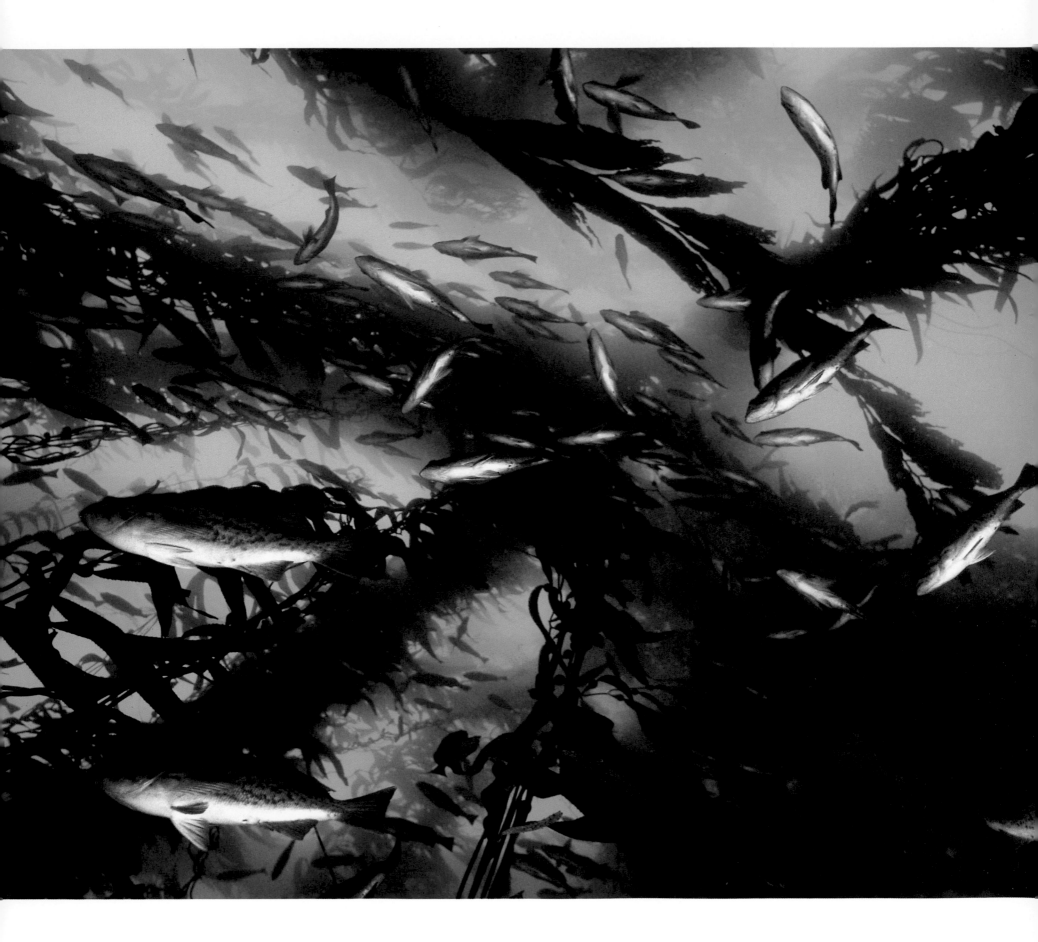

reach the surface, they continue to grow horizontally, forming a canopy through which the sun's rays filter.

The kelp forest extends just a short distance from the coast. The plant grows only in depths of twenty to ninety feet. In shallow water, the plant is torn up from its holdfast by wave action. In waters that are too deep, the young plant cannot gather enough sunlight to grow. During the summer, the waves and surf are calm, and the sun shines brightly. The kelp grows quickly — as much as a foot a day — forming a dense canopy that herons and seagulls can actually walk on. During winter storms, however, big waves can tear up the kelp forest. Once a kelp plant has been uprooted, it may become entangled with other plants, dragging them off their holdfasts as well. The kelp forest may seem barren after winter storms, but new kelp plants quickly find a surface to grow on, and summer finds the kelp forest back to its previous lushness.

A school of blue rockfish swims beneath the fronds of a kelp forest canopy. Monterey, California.

All varieties of life are mating, feeding, crawling, waiting, and hiding within this dark underwater forest. The kelp plants themselves harbor a community of animals. Turban and top snails crawl among the stipes, feeding on the dead and rotting parts of the plant. Their rasping, filelike teeth cannot pierce the wall of a healthy kelp plant. Kelp crabs, gold in color like the kelp, rest within the stipes, waiting for night to make their appearance. Kelpfish and juvenile rockfish peer out from behind the blades and stipes, camouflaged by their resemblance to the golden blades of the plant. A shy, tiny clingfish holds tightly to the stipe with a small suction cup on its belly. It looks remarkably like the stipe and, like the kelpfish, it uses this camouflage for safety. In the tangled mass of the holdfasts, tiny octopus search for crabs, their favorite food. Brittle stars thrust their supple arms up into the water to catch passing food particles, keeping their bodies within the shelter of the holdfast.

On the rocks below, a giant-spined sea star has found a limpet — a snail with a shell like a straw hat. Sea stars are slow but voracious predators, with many arms that they use to grasp their prey, and a stomach which comes out of their body to digest their meals. The sea star slowly reaches forth an arm to cover the snail and grabs hold of it with the many tube feet found on the

underpart of its arm. Quickly, the limpet releases a slippery white mantle from underneath its shell. The mantle is so slippery that the sea star can't hold on, and the limpet glides away to safety. A tiny worm that lives within the limpet's mantle also helped in the escape. It bit the sea star's tube feet, causing them to loosen their hold on the limpet's shell!

Suddenly, the sea otter is back again, digging through the rocks looking for another favorite food — abalone. A small octopus hiding under a rock is surprised, and it quickly shoots a spurt of ink, which hangs in the water and tricks the otter into grabbing the inky shape instead of the octopus. Instead of jetting away, the octopus stays very still, changes its color, and spreads out its arms to look like a piece of drift kelp. The sea otter can't find the octopus, even though the octopus is right in front of it. When the otter leaves, the octopus glides under another rock, seeking the safety of a dark cave. However, it is quickly chased away by an angry female octopus who has been brooding her eggs in the cave for four weeks. The octopus is one of the world's most devoted parents. She stays with the eggs for the entire six weeks that it takes them to hatch, never eating and dying soon after.

The sun is setting. With a whoosh, a gray whale passes by on her way to the warm, protected lagoons of Baja Mexico to give birth. She is a huge, gray-colored animal almost fifty feet long, and her entire body is covered with barnacles, whale lice, and barnacle scars. She has come from the Chukchi and Bering Seas, where most gray whales spend their summers living off the rich waters of the Arctic. During the short Arctic summer, she feeds and builds up a layer of blubber, which supports her and the calf she carries in the long months of travel ahead. She moves quickly on in her urgent desire to reach the warm waters of Baja.

Once again, the otter rolls in the kelp, making its bed for the night. Rocked to sleep by the gently rolling waves, the otter sleeps entwined in the kelp to keep from drifting away. This way the otter will awake in the same place ready to start another day.

The Spanish shawl nudibranch's bright colors probably warn of its bad taste. Many nudibranchs retain noxious compounds from their food and store these chemicals in their bodies. Monterey, California.

A group of strawberry anemones covers a rock wall. These are probably all clones from a common ancestor that has reproduced by splitting apart asexually. Monterey, California.
190-191

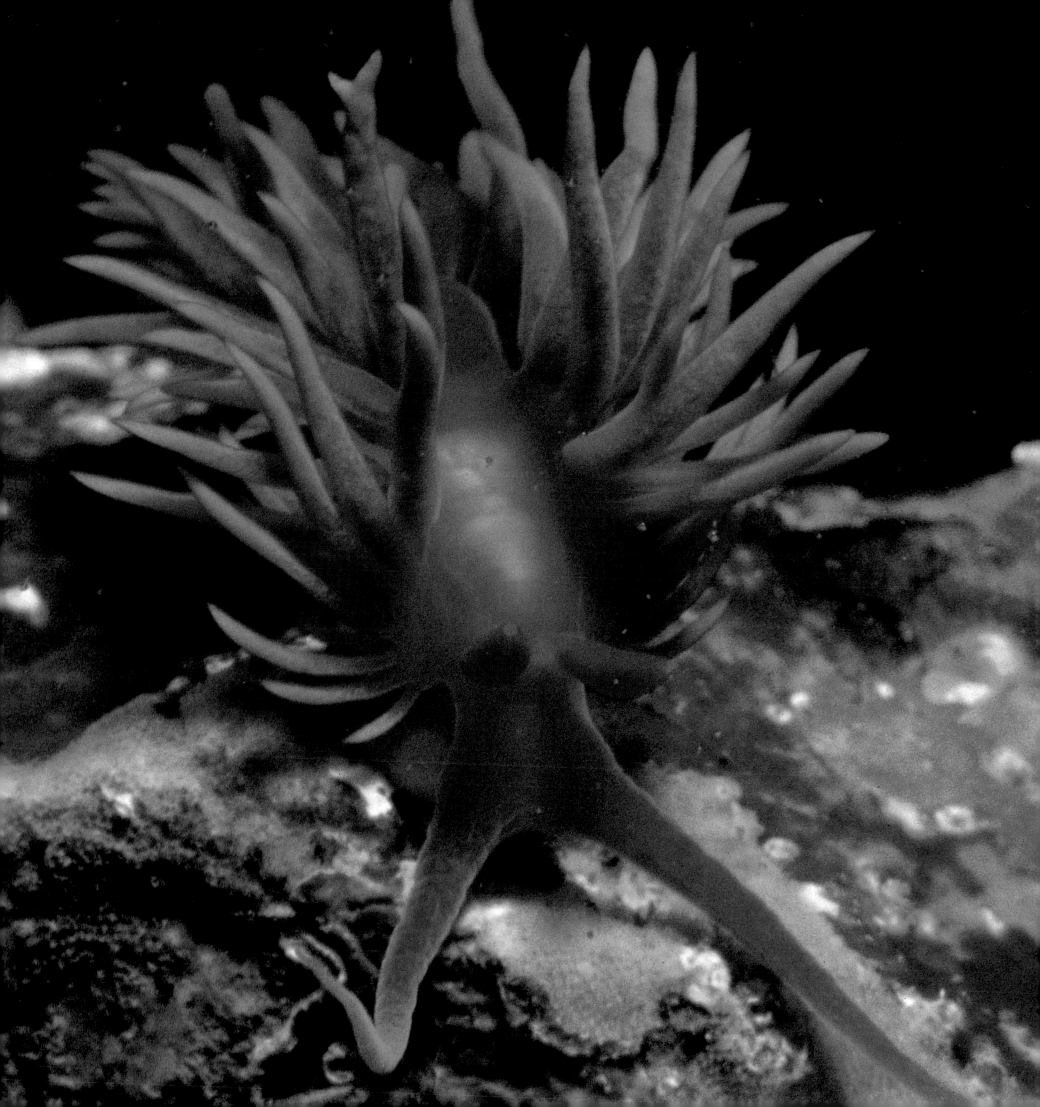

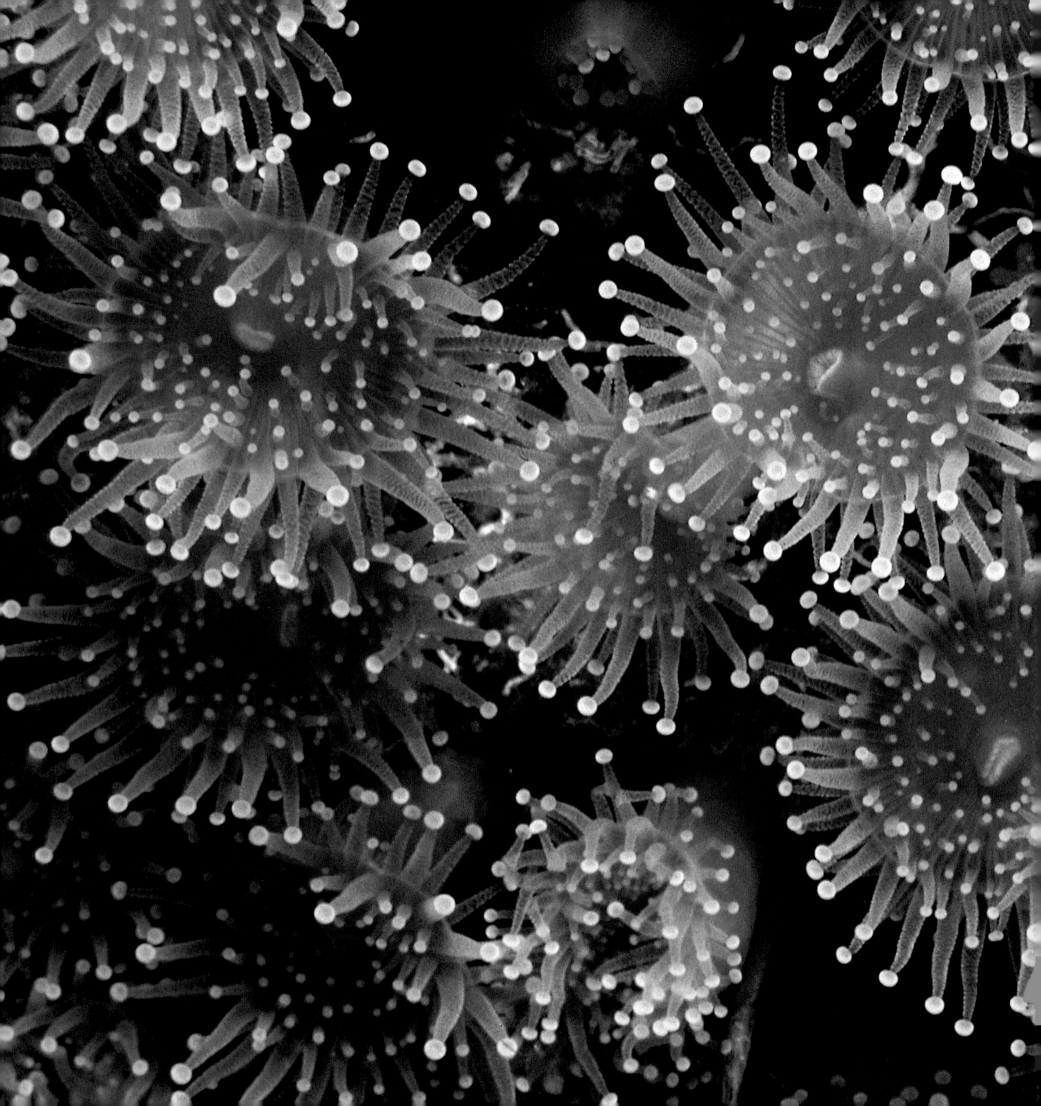

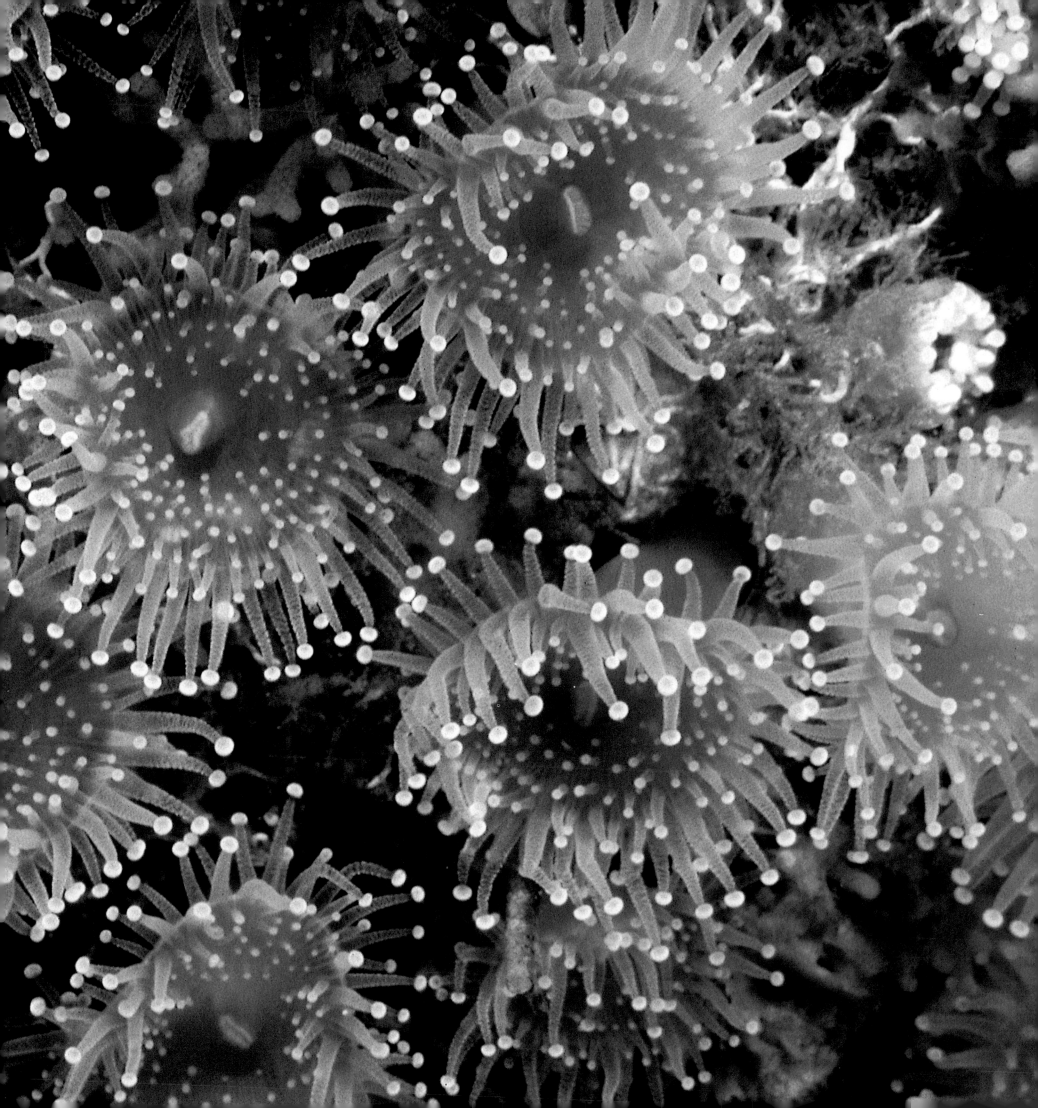

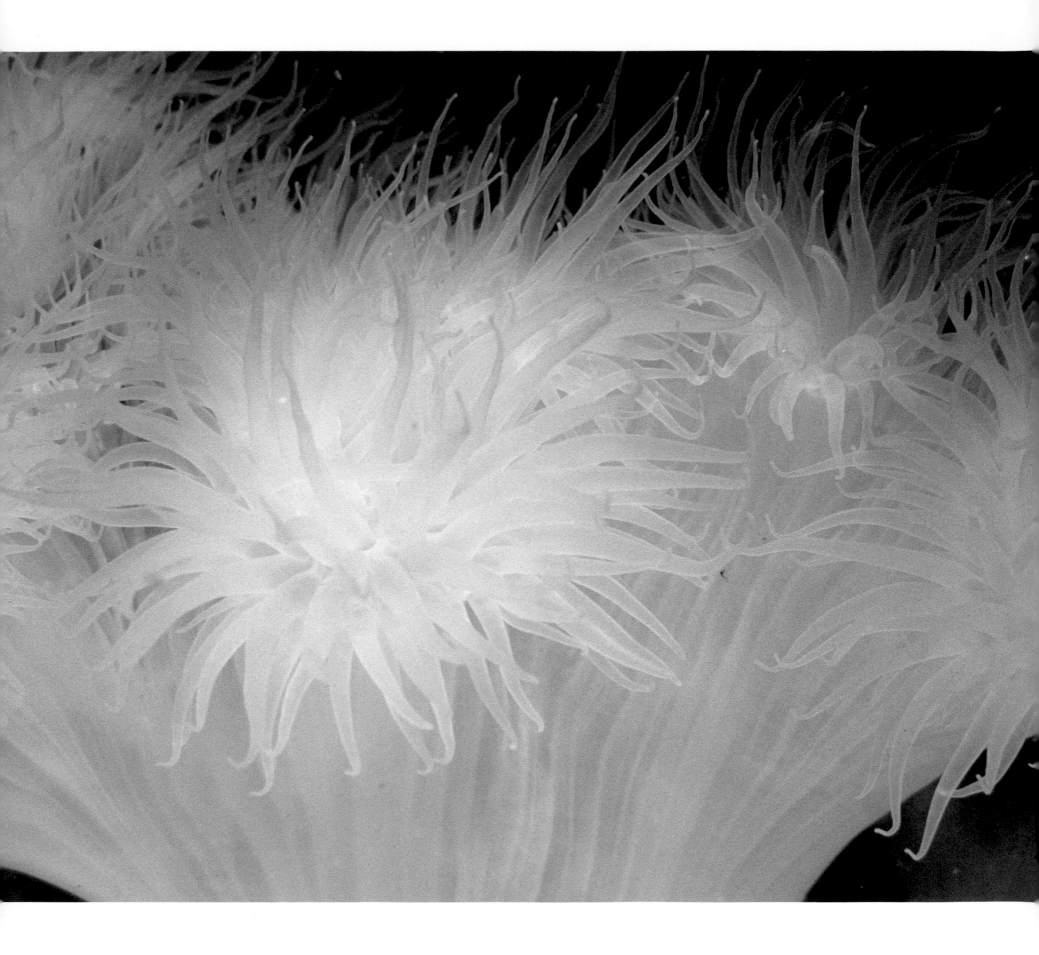

The tentacles of this tube anemone have curled into spirals, indicating where the stinging cells have fired. Monterey, California.

The plumose anemone (left) can reproduce by simply leaving part of its foot behind. The fragments develop into dense colonies, all from a single ancestor. Monterey, California.

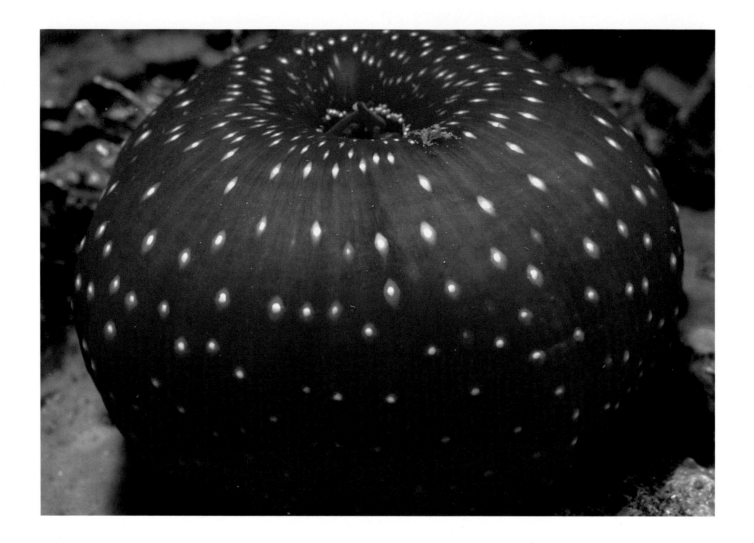

This striking design appeared on
a white-spotted rose anemone's
base. The tentacles of this large
anemone can subdue and hold on
to larger prey such as crabs and
sea stars. Monterey, California.

An anemone's mouth is located
in the center of a ring of stinging
tentacles (right). These tentacles
capture prey that falls, drifts, or
wanders into them. Queen
Charlotte Islands, Canada.

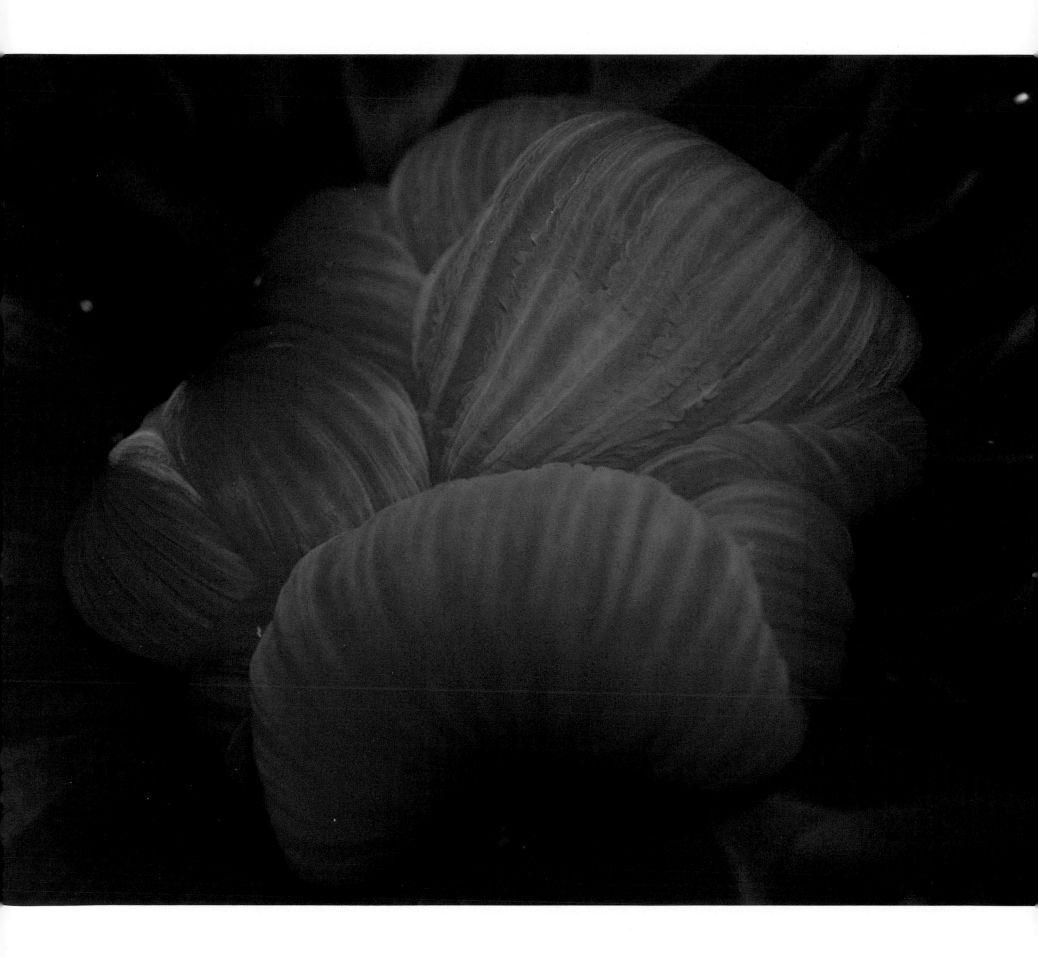

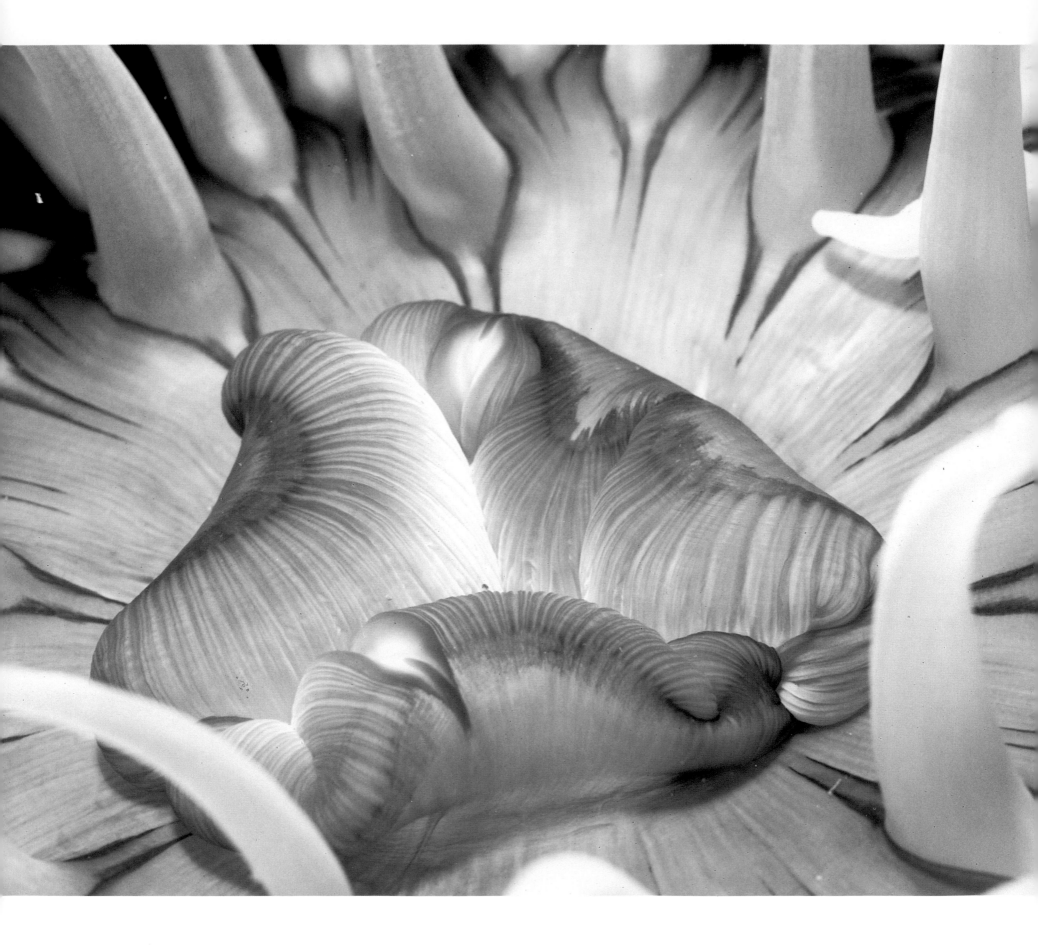

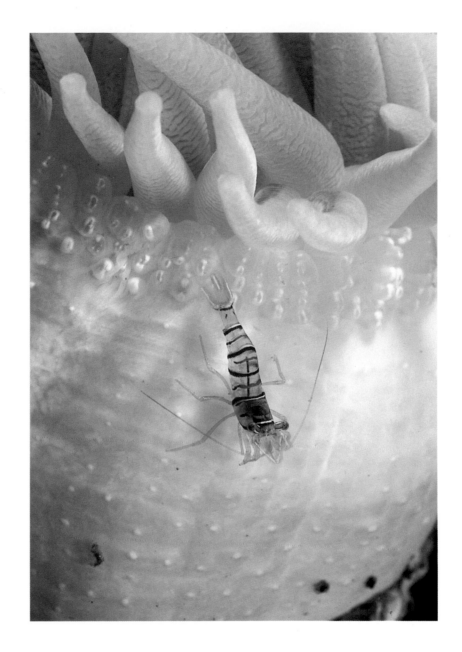

This clown shrimp lives among the tentacles of a crimson anemone. San Juan Islands, Washington.

The stinging tentacles of the fish-eating anemone (left) usually only pick up tiny plankton particles. Monterey, California.

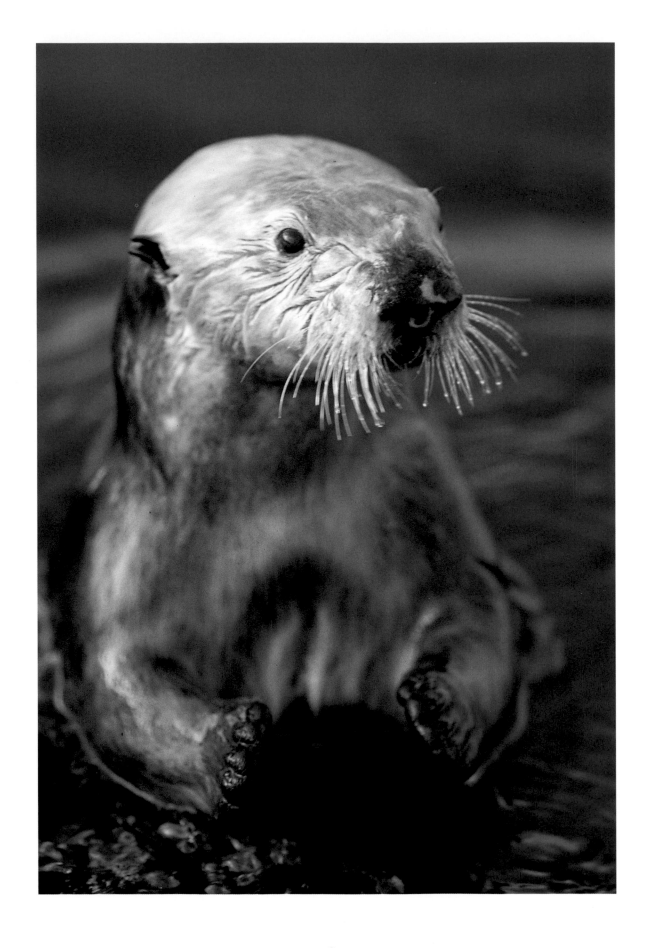

SEA OTTERS

I remember the first time I saw a sea otter. Once quite abundant, there are now just 2,000 otters gathered in a few colonies along the central California coast. The sea otter once ranged all along the Pacific coast, from the Aleutian Islands to Baja California, as well as the northern coast of Japan. However, a demand for the otter's dense fur during much of the nineteenth century nearly decimated their population in California. The sea otter was thought extinct in California waters until 1938, when a small pod was discovered off Big Sur.

Because California otters are limited to such a small range of coastline, many people are concerned that a disaster, like an oil spill, could wipe out this small population. To protect this vulnerable subspecies, a program to set up a second, backup population on isolated San Nicolas Island in Southern California was begun in 1987. Over one hundred sea otters were transplanted to this small island full of sea urchins and abalone. Unfortunately, the transplant project failed miserably, with no otters staying. Some were recovered trying to swim the 200 miles back to their home near Monterey. Others have simply disappeared, and one was found dead near San Diego. Rumors abound of fishermen shooting the animals.

The sea otter is a member of the weasel family, which also includes terrestrial relatives such as skunks, minks, and badgers. The North American river otter is

This female otter's nose has been rubbed raw by the male's habit of biting and pulling her head back when mating. A pink nose identifies an otter as female. Monterey, California.

The sea otter's main food items— sea urchins and abalone— are kelp grazers. The sea otter's voracious appetite controls these populations, thereby creating larger and healthier kelp beds, and thus, larger fish populations. Monterey, California.

NOTES FROM THE FIELD

SEA OTTERS

Sea otters wrap themselves in kelp strands every night, preparing for sleep. The kelp anchors them in place, and passing swells may rock a mother and pup like a cradle. Monterey, California.

also a close cousin. The smallest marine mammal, sea otters have a problem maintaining their internal body temperature in the cold waters of the kelp forests. A dense coat of fur and a high body metabolism are their only means of protection. The result is that sea otters are eating machines. An adult otter may consume up to twenty or more pounds of food per day — 25 percent of its total body weight and nearly three times the calories a human would eat. To catch the required amounts of food, the sea otter must spend most of the day hunting. Its typical menu consists of crabs, clams, sea urchins, and abalone, supplemented by snails and fish.

Sea otters are the only marine mammal without an insulating layer of blubber. By constant grooming and cleaning, the otter keeps its dense coat meticulously clean. I've felt sea otter pelts, and they are simply luxurious — soft, thick, and warm. Air bubbles which the otter rubs into its fur during grooming form an insulating layer that keeps the animal warm. Foreign matter can prevent the fur from holding air and will cause the otter to die. This is why otters are so susceptible to oil spills. The oil coats the fur, and the otters succumb to hypothermia. The Exxon Valdez tanker oil spill in 1989 killed more than a thousand Alaskan otters. Fortunately, the Alaskan otters have recovered substantially from the fur trade days. They now number over 100,000 — a healthy population.

A raft of sea otters rests in a kelp bed. Monterey, California.

NOTES FROM THE FIELD

SEA OTTERS

Purple sea urchins are active and voracious algae grazers. They feed on kelp plants at the base, uprooting and killing entire 100-foot plants. San Diego, California.

Because sea otters are such voracious hunters of sea urchins and abalone, scientists believe that sea otters may serve to keep urchin populations in check, preventing the problem of "urchin barrens," undersea deserts where entire kelp forests have been destroyed by population explosions of feeding urchins. From studies in Alaska where healthy populations of otters have existed for decades, scientists have found that these mammals contribute to larger, healthier kelp forests. In turn, abundant kelp means larger fish populations as well as a healthy community of marine mammals, invertebrates, and other algae.

Unfortunately, sea otters compete with commercial fishermen for some of their favorite foods. Because the otter is also an active predator of urchins, abalone, and crab, commercial fishermen oppose the otter's introduction into its former habitats. Organizations such as Friends of the Sea Otter, scientists, and environmentalists believe differently. They are well aware of the otter's key role in maintaining diversity in the kelp forest community and seek to preserve this healthy balance.

A population explosion of sea urchins has created an "urchin barrens" where a once lush kelp forest thrived. Urchin barrens may be due to the absence of predators, such as sea otters. San Diego, California.

NOTES FROM THE FIELD

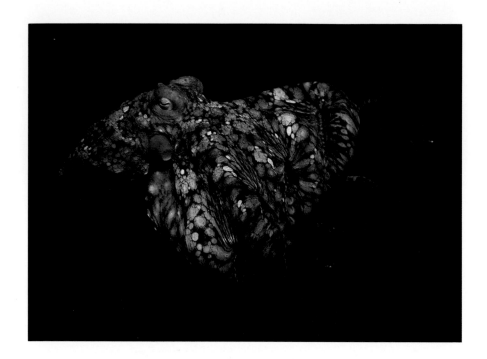

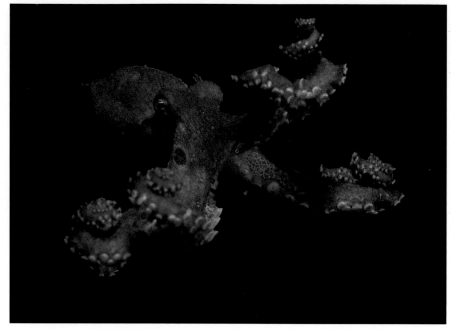

A two-spotted octopus attempts to blend into its surroundings by mimicking a piece of kelp. Santa Catalina Island, California.

Octopi have complex brains, eyes that resemble our own, and the ability to alter their shape and color at will. This two-spotted octopus is swimming, and it has a body color that mimics a piece of kelp. Santa Catalina Island, California. / 202-203

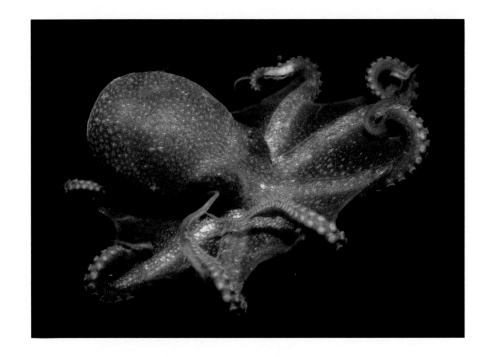

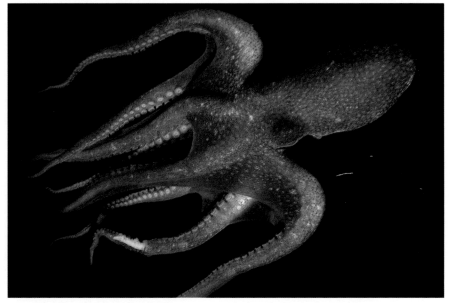

This deepwater octopus swims in a characteristic position using jet propulsion, where water is forced from the mantle cavity out through a siphon. Santa Catalina Island, California.

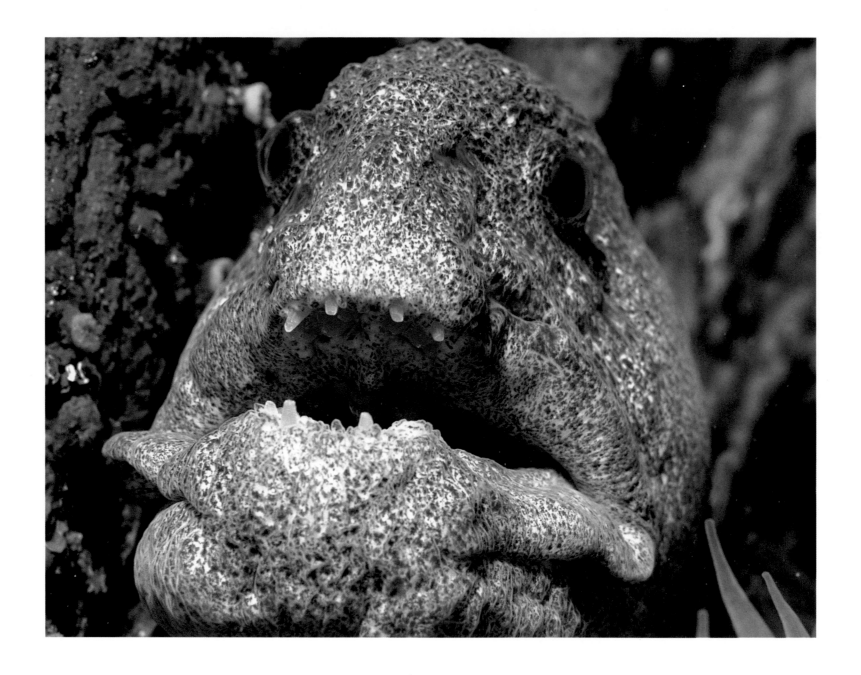

A CLOSE ENCOUNTER WITH
A WOLF EEL

Dr. Leon Hallacher, the burly research scientist who led me to his secret spot that day, quickly swam over and scribbled on his slate (you can't talk underwater!), "Want to see a wolf eel?" "Sure," I signed back, thinking nothing of encountering an animal over six feet long, thinking nothing of the wolf eel's teeth — formidable, massive tusks. After all, I had seen these eels in the Monterey Bay Aquarium dozens of times.

Leon quickly led me to a sheer wall covered with strawberry anemones, with a small crevice in the corner of two giant boulders. He pointed to it and swam off to do his research. I looked closer and suddenly my eyes locked with two small, beady black eyes. They became larger, and suddenly I realized that six feet of wolf eel was coming toward me like a derailed train. The wolf eel slithered right up to my face mask, stared me straight in the eyes with a look of righteous indignation, encircled my body, and then sped like an arrow back to its lair in the rocks.

Leon returned, pried a sea urchin from beneath a rock, and offered it to the eel on the tip of his knife. The eel immediately retrieved it like a well-trained puppy. Later I discovered that another diver had tamed this eel after three months of visiting it and offering it its favorite food. This eel turned out to be a most friendly animal, its ugliness even endearing.

Wolf eels can grow to a length of 6 feet. Their large, strong teeth are adapted to crushing their diet of clams, sea urchins, and crustaceans. Monterey, California.

NOTES FROM THE FIELD

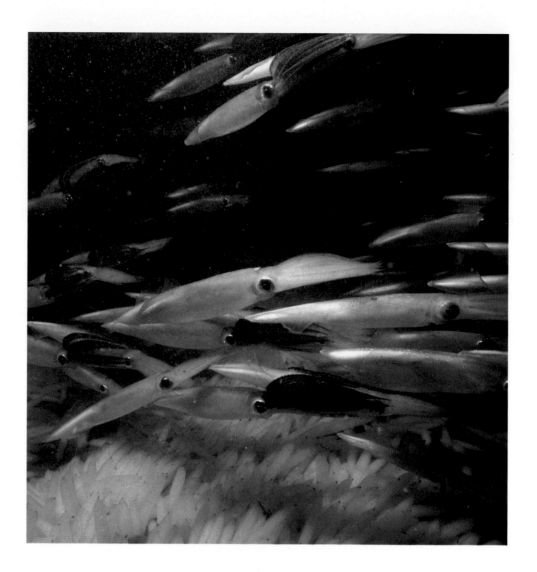

At certain times of the year in California, millions of market squid return from the open ocean to spawn on shallow sand bottoms around the kelp forest. Santa Catalina Island, California.

A female squid is courted aggressively by a crowd of males (left). Santa Catalina Island, California.

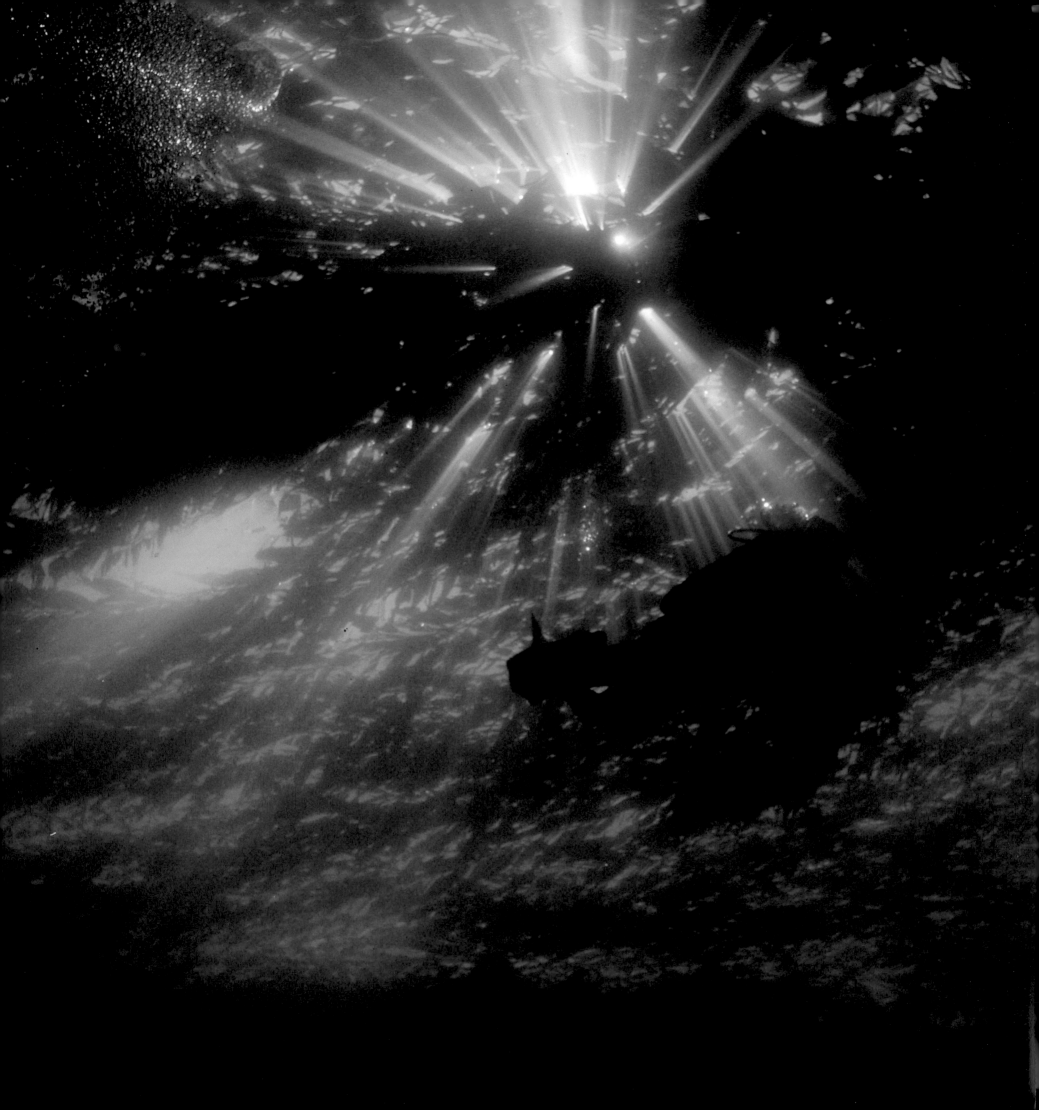

MONTEREY

Once you learn to dive in the cold waters and tough conditions of a kelp forest, you can dive anywhere. To protect against hypothermia you must use gloves and thick wetsuits or drysuits. The kelp forest itself is dark, and it can seem ominous. My first few dives in Monterey, where I have done most of my kelp diving, were not like my joyous, easy experiences in warm water. It still takes a few days of diving for me to become accustomed to the bulk of the gear, the restrictiveness of the wetsuits, and the frigid temperatures. Most divers, myself included, are also aware that the California coast is a prime area for great white sharks, the most feared and awesome predator of the underwater world. The kelp itself can present problems. It can clump up under your boat in thick masses which make it hard to get in without becoming entangled. However, experienced divers never get tangled seriously, as they learn to move slowly and deliberately through the kelp, to work with the kelp rather than against it.

Even though it is more difficult to take photographs in the cold, dark, and frequently murky waters off California, my efforts have usually been amply rewarded. Monterey has shown me dozens of surprises in the ten years that I have been diving its waters. I've played for hours with the sea lions that bark by the hundreds off the tip of the breakwater, and I've spent days filming the behaviors, the acts of life and death, the different time

Shifting sun rays penetrate the canopy of this giant kelp forest. The majority of plant life in the ocean consists of floating microscopic plants, not large forests. Monterey, California.

The single large bulb of the bull kelp holds a mixture of gases, including carbon monoxide. This gas-filled bladder holds the plant upright. Monterey, California.

NOTES FROM THE FIELD

MONTEREY

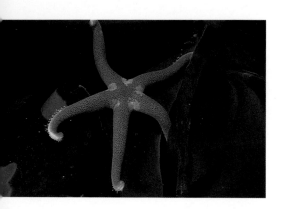

A blood star makes its way among fronds of giant kelp. It feeds by applying its stomach to bryozoan colonies attached to the blades of kelp. Queen Charlotte Islands, Canada.

and size scales of the underwater wilderness. It is a true wilderness, its inhabitants scarcely affected by man.

For years the underwater richness of Monterey Bay was a secret known only to the local diving community, its waters too cold for all but the most hardy (or foolhardy) of underwater explorers. However, the higher nutrient levels sustained in cold waters like these support an astounding richness and variety of life off Monterey's coast. Great thirty-foot basking sharks cruise its nutrient-rich waters. These sharks are harmless relatives of the notorious great white shark, which also visits these waters frequently. Point Lobos, protected as an underwater reserve for many years, is a magical place boasting lush kelp forests and sheer granite cliffs underwater.

The coast of Monterey is also unique for its steepness. In fact, its waters cover an underwater canyon system equal in size and depth to the Grand Canyon. The kelp forests cover the tops of sheer cliffs that plunge down into the abyss, nearly two miles below. Diving in the kelp forests is almost a religious experience; the forests grow up from depths of one hundred feet to form underwater cathedrals, harboring all manner of invertebrate and larger animal life. I've dived all over the world, and I am still surprised by the sunken treasures found in Monterey. Yet, I have only seen the tip of the proverbial iceberg. Divers can only explore the canyon rims, less than two percent of the 2,000-meter drop.

The giant kelp plant can grow over a foot a day. The bulbs serve to keep the photosynthesizing parts of the plant at the water's surface. Monterey, California.

A tiny clingfish uses a suction cup on the bottom of its body to hold tight to the kelp plant, moving only to take cover or to seek food. Monterey, California.

NOTES FROM THE FIELD

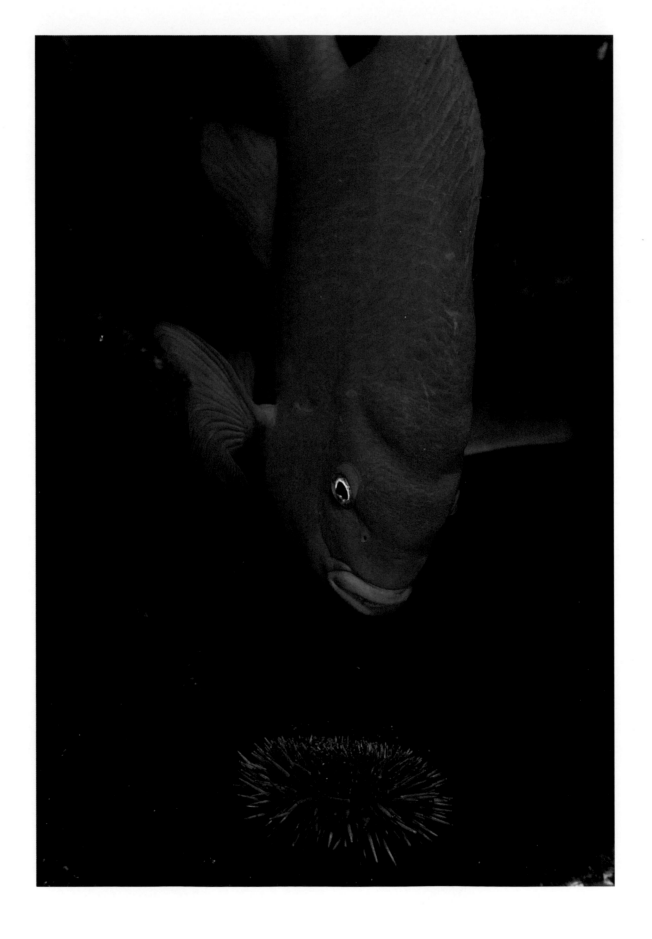

THE GARIBALDI

The garibaldi is an unmistakable fish, with a garish orange body that jumps out against the muted hues of the kelp forest. Most fishes in the kelp forest are cryptically colored, and have habits to match. Not so the garibaldi, a member of the pugnacious damselfish family that also includes anemonefish.

The bright orange garibaldi of southern California farms a patch of rock, making sure that only a particular kind of red algae grows there. The site is usually on a flat face of a large boulder. The male cleans the surface of all debris except for the red algae, and he also brings algae from other sites to grow. If intruders such as sea urchins find their way to the nest, the garibaldi will remove them with his mouth and drop them a few yards away.

In the spring, the male entices a female to lay her eggs in his nest. He does this by rising off the bottom into the water column and spreading out his fins to appear larger. His colors brighten during the mating season, the better to attract attention, and he will also make grunts and clicks by using his teeth. It is quite a scene to see a female swimming through a kelp forest in the spring. Dozens of males will rise up and frantically try to attract her attention. If the male is successful, a willing female will lay her eggs in his nest, which he fertilizes by wriggling with her in a side-by-side motion. It is the male that keeps the nest clean and tidy, defending it vigorously against all intruders until the eggs hatch.

A lone garibaldi stands out against the muted background of a kelp forest. Channel Islands, California.

The male garibaldi (left) cultivates a nest of algae into which a female will lay eggs. It actively defends its nest against all intruders, including this purple sea urchin. The garibaldi will take this urchin a few yards from the nest and dump it. Channel Islands, California.

Two garibaldi engage in a mating ritual within a kelp forest. Channel Islands, California.

NOTES FROM THE FIELD

In the brilliantly colored shell of
a jeweled top snail, a small
hermit crab crawls among a
colony of purple stinging
hydrocoral. Monterey,
California.

Nudibranchs are small, shell-less
snails. These horned nudibranchs
(right) could be in the process of
mating. Monterey, California.

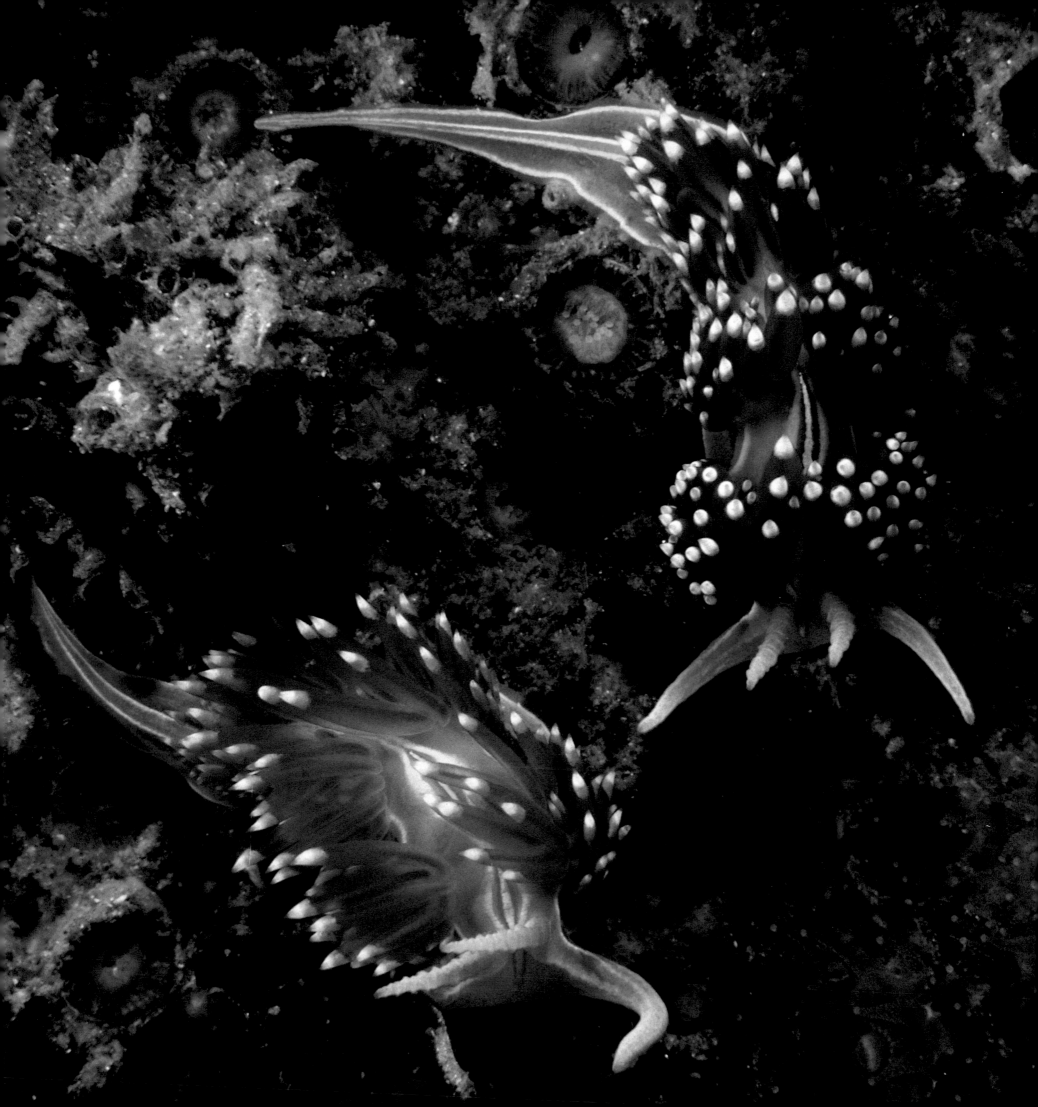

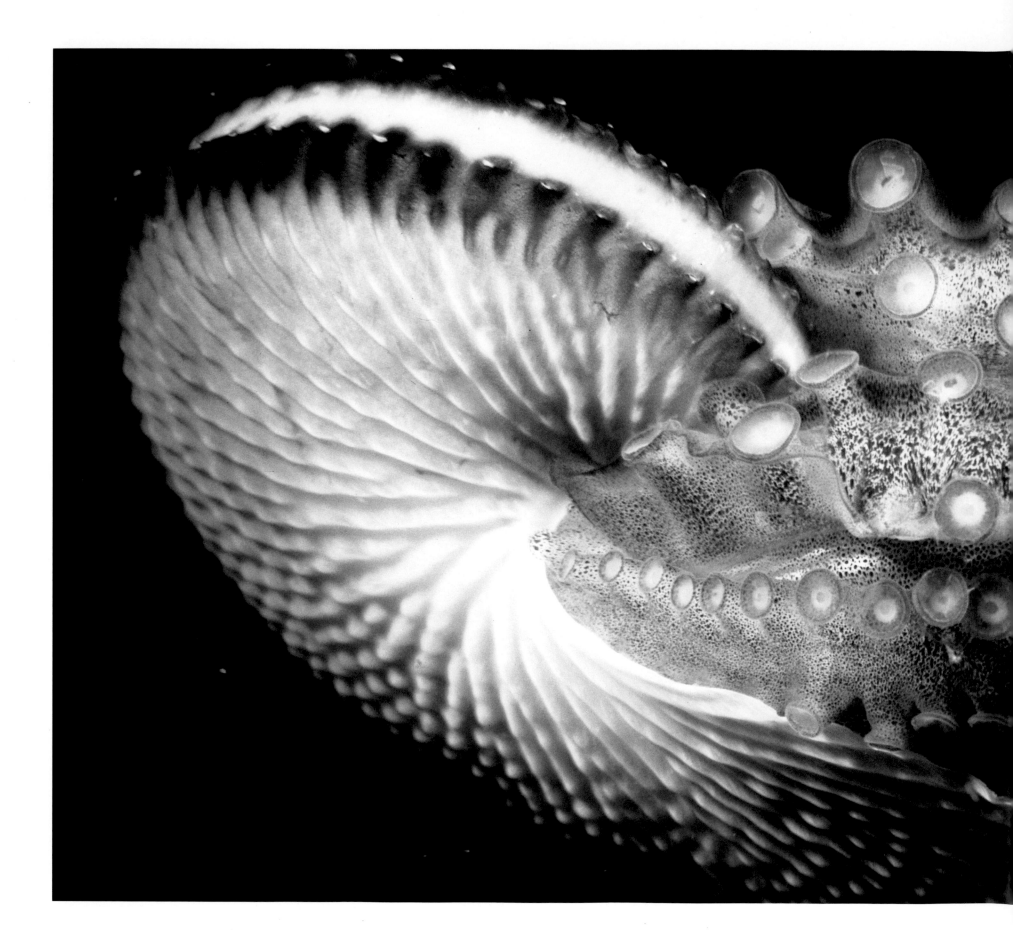

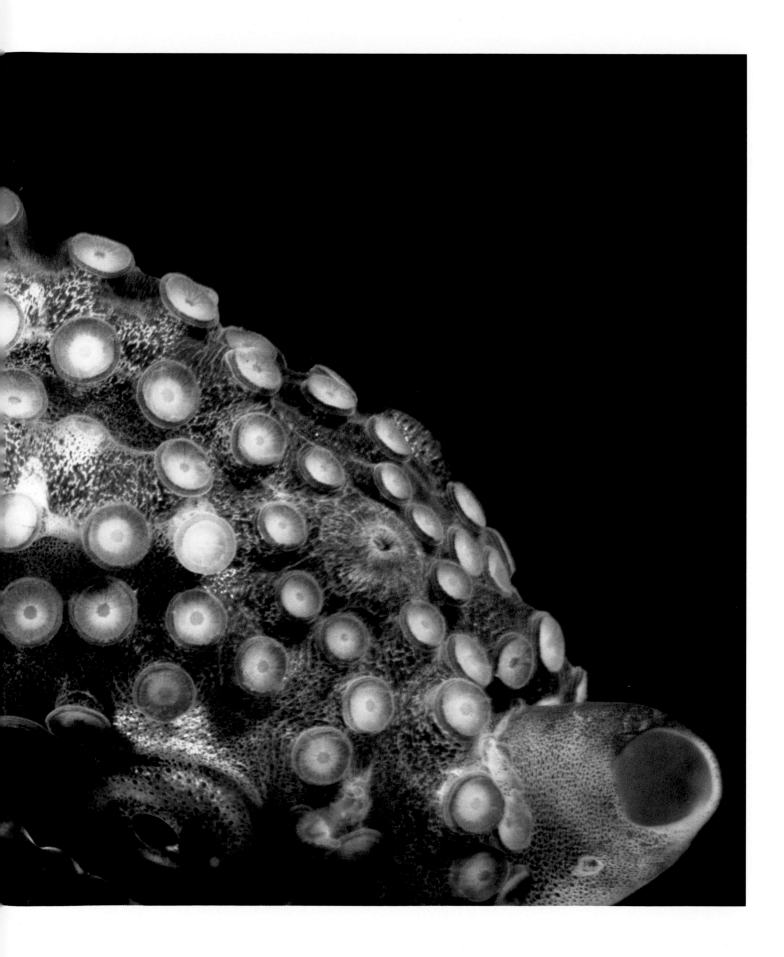

The paper nautilus, or argonaut, is named for its delicate, paper-thin shell which resembles the chambered nautilus in form. It is a pelagic octopod which is sometimes carried by currents into the kelp forest of New Zealand. The shell is secreted by the female and serves as a brooding chamber for her eggs. The shell itself is highly prized by collectors for its fragility and beauty. The female is not attached to her shell and holds it in place with her large dorsal arms, which are also very sensitive to passing plankton, upon which she feeds. Females are 10 to 20 times the size of males. Male argonauts, already dwarfed in size by the females, must suffer one final blow to their ego and physique. One of their arms, termed the hectocotylus, is specially adapted for transferring sperm. This arm is cast off when mating takes place, and the female carries it and its sperm contents around with her. Poor Knights Islands, New Zealand.

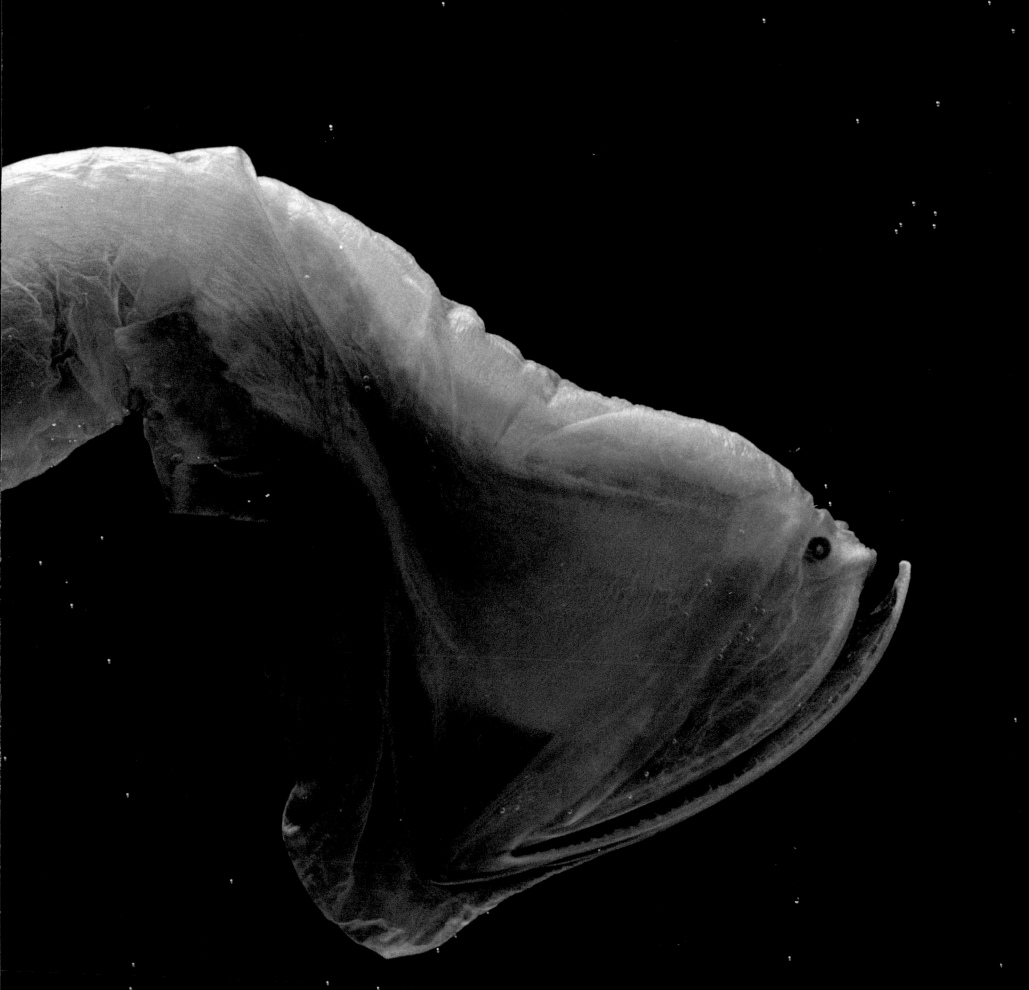

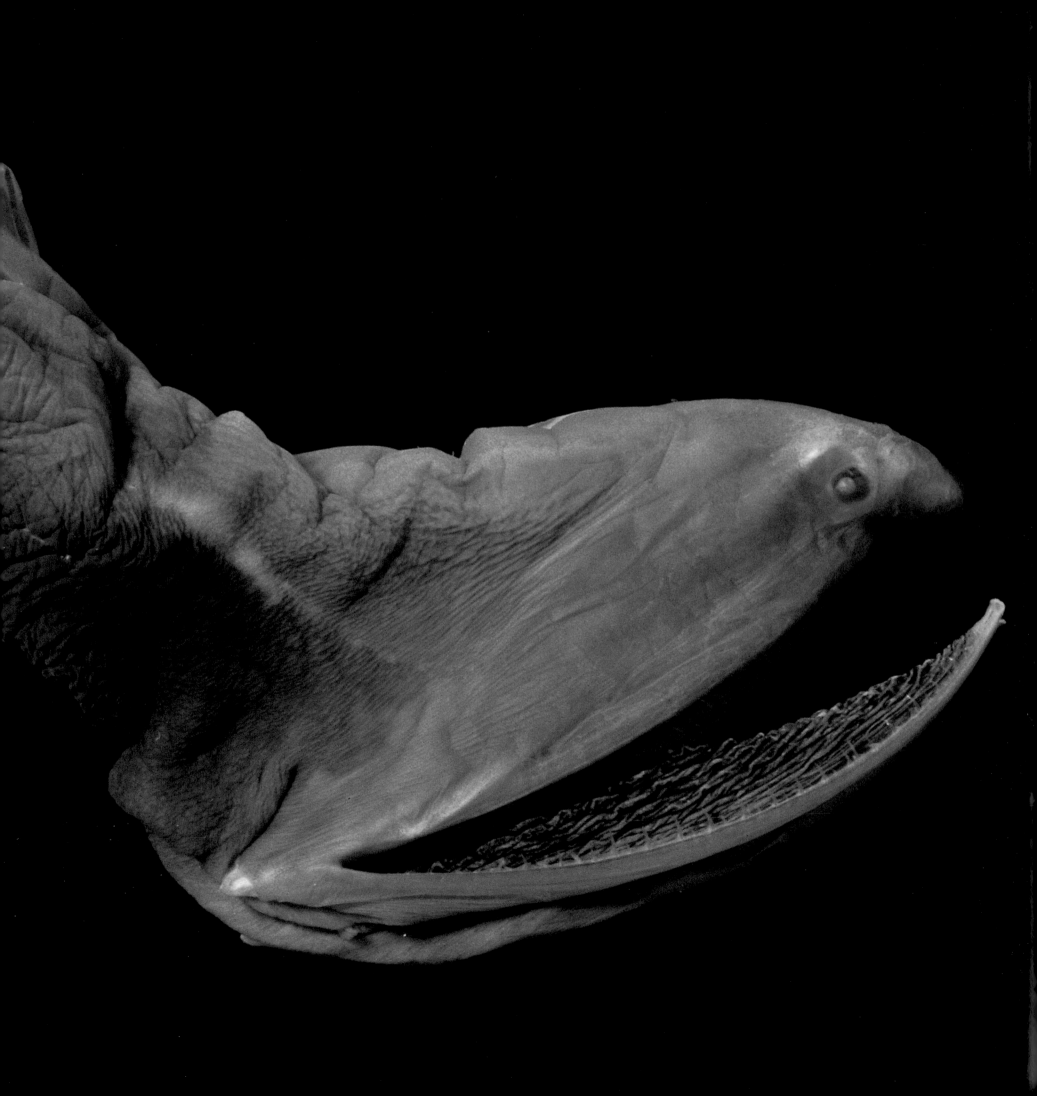

THE DEEP SEA

As night falls, a constellation of lights flickers on and off in the coral crevices and caves along a 2,000-foot coral wall. Soon a great cloud of lights darts about a few yards off the wall, one hundred feet down. The lights belong to lanterneye fish, small fish which have a light organ filled with luminous bacteria underneath each eye. Hiding in crevices and at greater depths during the day, these fish come out on dark nights to feed on plankton. Their light organ is mounted on a stalk, which flips over and fits into a socket below the eye, thus turning the light "on and off" at will. The lights signal to mates and help to attract and pinpoint the plankton. In the deep waters off the wall, a pod of dolphins is resting at the surface after a long dive. They inhale and exhale with great sighs, almost totally emptying their lungs with each breath. Refreshed and energetic, the dolphins are vibrant with the thrill of a chase. They

quickly dive again in unison, making their way to depths as great as 600 feet, where they chase after their favorite food, small squid. As they dive, their path through the water is marked by phosphorescence from plankton that lights up briefly in their wake.

At a depth of 140 feet, the dolphins encounter animals they have never seen before — giant Humboldt squid, flashing red and white in excitement as they pursue their prey of large fish. Five feet long and weighing up to sixty pounds, these giant squid are frighteningly efficient predators. Their tentacles are lined with suckers, which in turn are lined with razor-sharp teeth. Their mouth rasps away at flesh like a huge parrot's beak, and the squid will attack and feed on anything in their frenzy, even each other. The dolphins, communicating with each other by sonar clicks, keep their distance and descend deeper, searching for smaller squid.

A large male dolphin is suddenly set upon by a small, foot-long cookie-cutter shark. The cookie-cutter shark has the bizarre ability to extend its jaws far from its body. The shark bites the dolphin behind its dorsal fin, leaving a fist-sized wound that is almost perfectly circular. It twists away with a chunk of flesh and vanishes quickly into the darkness. Most other dolphins in the pod have semicircular scars from past encounters with these small sharks.

The water gets colder and colder further down. The dolphins pass thermoclines, layers of water with distinctly different temperatures, at depths of 80 feet, 140 feet, and 300 feet. A huge school of small, six-inch squid are found at a thermocline at 300 feet. The dolphins work in unison to circle the squid, then take turns slashing through the ball and gobbling up mouthfuls of confused prey. The water at this depth is pitch black, but the spectacle of the hunt can be seen because the squid in their panic spurt out great clouds of luminous green ink. After a few minutes the dolphins turn and head back to the surface to fill their lungs again with air. They will make over thirty dives like this tonight.

The remains of the squid slowly drop deeper and deeper through the water. Unlike the teeming waters of the surface, the deeper waters are cold and dark, and much less rich in life. At a depth of 1,500 feet the water is a cold

The deep-sea swallower has a hinged mouth which swings wide open to accommodate large prey. Guadalupe Island, Mexico. / 220-221, 222

The giant Humboldt squid reaches lengths up to 5 feet and may weigh up to 50 pounds. A voracious carnivore, it has rows of suckers lined with razor-sharp teeth, and a mouth shaped like a parrot's beak. Sea of Cortez, Baja Mexico.

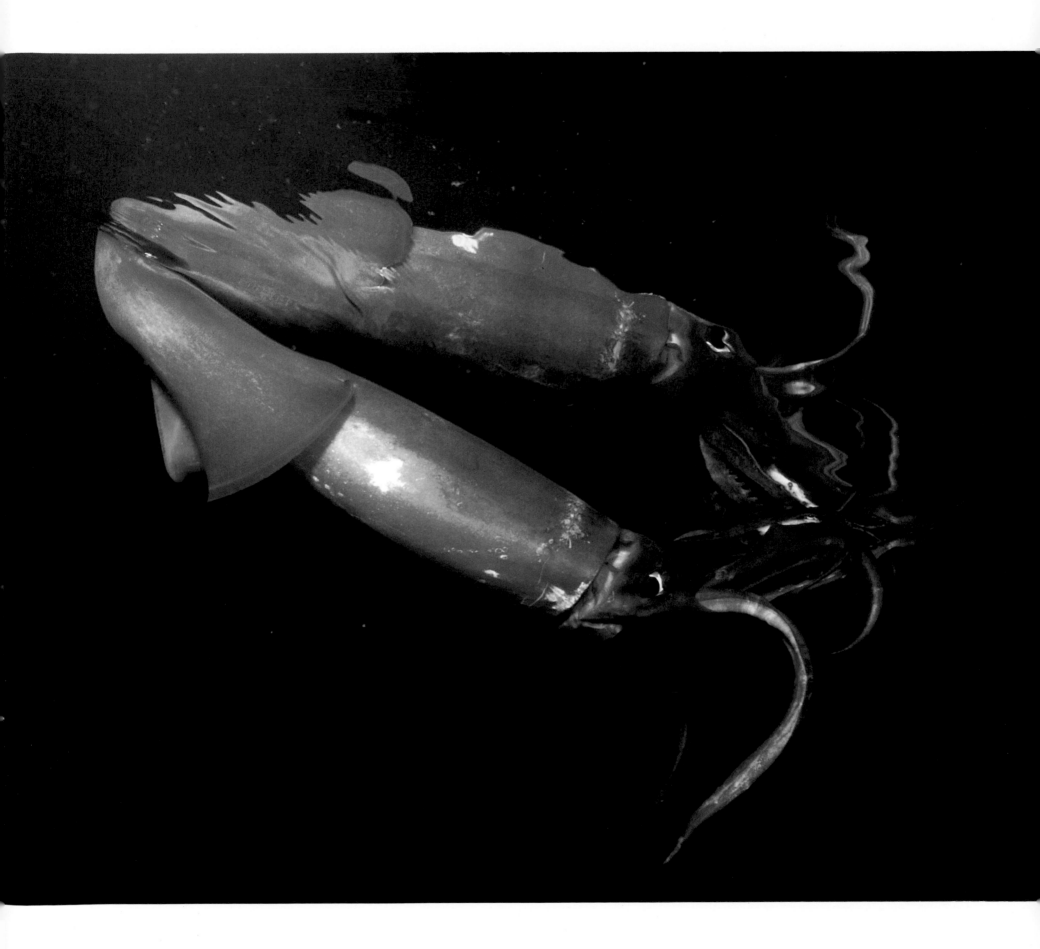

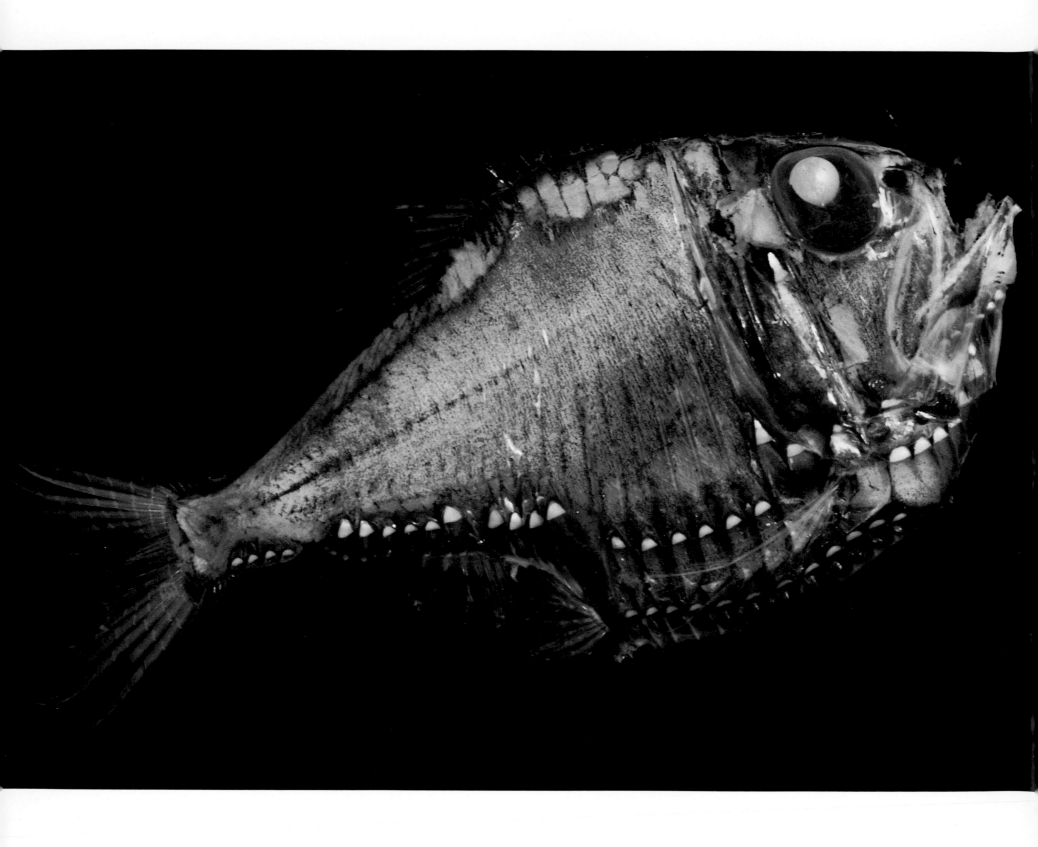

39 degrees Fahrenheit. At this depth the waters are seemingly pitch black, but lights twinkle on and off here and there. The lights belong to a host of animals, all of whom carry their own light sources used to hunt, attract mates, and even render themselves invisible. A viperfish swims by, eel-like in its movements, with rows and rows of lights glimmering along its long, serpentine body. It waves a barbel — a slender whisker like those found on catfish — in front of its mouth in a twitchy movement. At the tip of the barbel is a luminescent lure that looks exactly like a worm. A school of deep-sea hatchetfish swims above the viperfish. The color and intensity of the lights across their bellies match the very faint level of light that penetrates at this depth. Consequently, the school of hatchetfish is invisible to the sensitive eyes of the viperfish — they don't cast a shadow or create a silhouette!

The only sunlight at these great depths has been filtered by the water to a very faint, blue-green wavelength of color. The viperfish and hatchetfish all can see this particular wavelength of light very well. Unfortunately for the hatchetfish, a dragonfish has been stalking them. It has luminous patches beneath its eyes that emit a red light that is invisible to the hatchetfish, and which the dragonfish uses to hunt by. With a lunge, the dragonfish impales a hatchetfish with its long, needle-sharp teeth and quickly gobbles it down. The rest of the school darts away in fright, with a brief flash of light that blinds the predator with its intensity.

The trail of the dead squid through the water has attracted a multitude of predators in its wake. When the squid drop to the soft mud bottom at 4,000 feet, a feeding frenzy of hagfish — eel-like primitive fish — burrow into the squid and eat them from the inside out. A large sixgill shark soon appears. The squid are quickly devoured, and the predator leaves soon thereafter. All that remains are trails in the mud and sand, and a sea cucumber slowly sifting its way through the detritus.

The deep-sea hatchetfish's large eyes look upward to catch any available light from the surface. Rows of light plates on its body match the color and intensity of downwelling illumination, so that the hatchetfish is invisible when viewed from below. San Clemente Basin, California.

The scalloped ribbonfish may be responsible for many sea serpent stories. It only grows to 5 feet, but its close cousin, the oarfish, grows to 35 feet long. U.S. Virgin Islands.

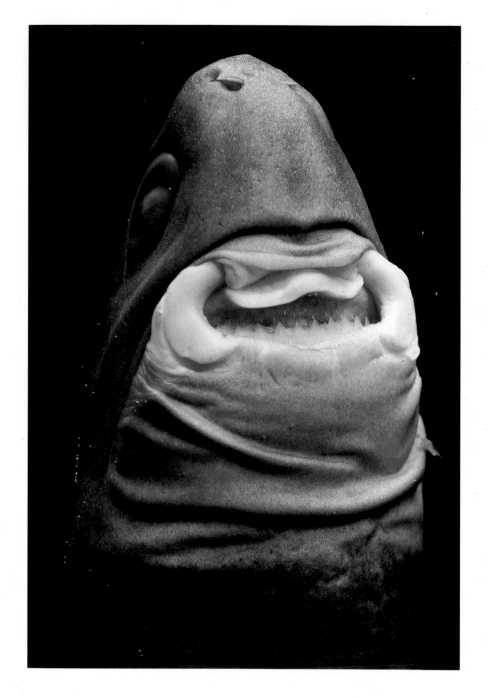

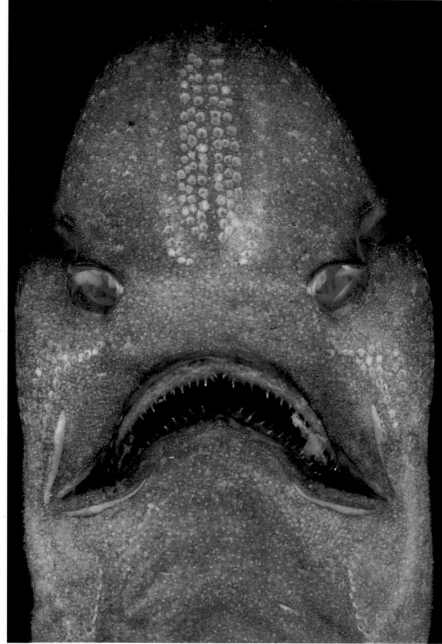

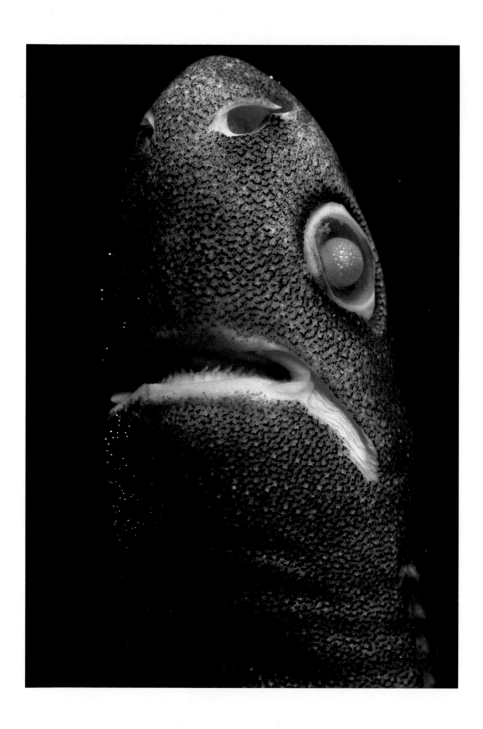

The cookie-cutter shark (far left), though measuring only 20 inches, is unique among its kind. This midwater fish bites cookie-sized chunks of flesh out of dolphins, whales, tunas, marlins, and other large fishes. French Polynesia.

The electrical field receptors in the snout of a deep-sea cat shark (center) allow it to detect electrical fields from its prey. Isla San Salvador, Galapagos Islands.

The second smallest shark in the world, the dwarf, or pygmy, shark (left) reaches a maximum size of 10 1/2 inches. South Atlantic Gyre.

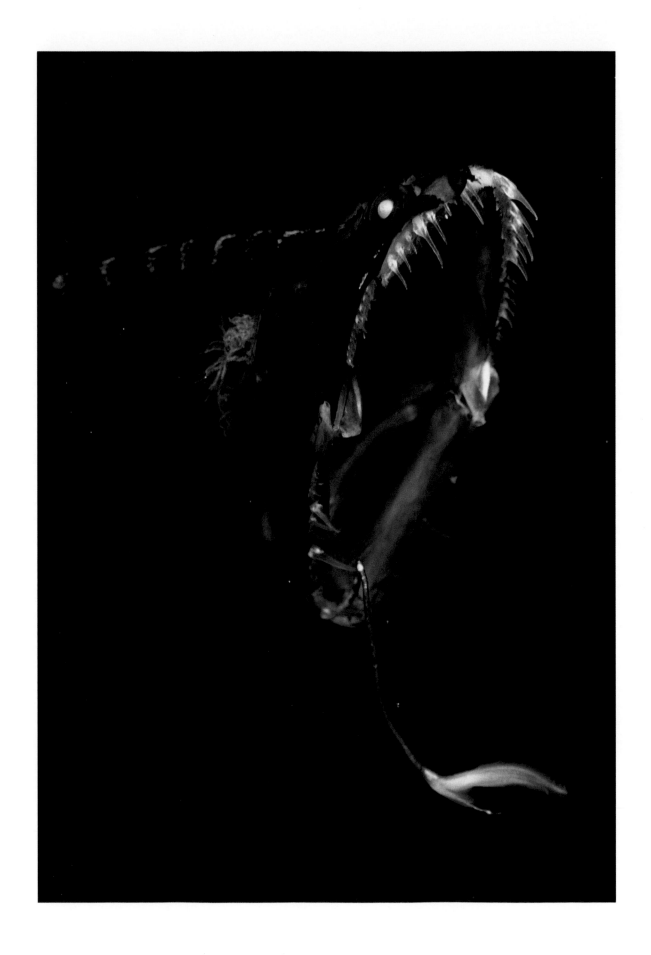

THE ABYSS

The deep sea is home to the last unexplored region of earth and a fantastic array of creatures that defy the imagination. This dark, mysterious region has withheld its secrets more obstinately than any other. Man, with all his ingenuity, has been able to venture only to its threshold. The rich, familiar top layer of our oceans is a thin cover to an enormously deep basin averaging two and a half miles in depth. This top, biologically productive layer represents only 2.5 percent of the ocean's capacity. The other 97.5 percent has only recently fallen under man's gaze through new robot and submersible technologies. Undersea canyons rivalling the grandeur of the Grand Canyon have been discovered at our doorsteps. Oceanographers have also discovered abyssal currents as strong as any surface currents, which run around the continents and connect all the major oceans of the world.

Sunlight reaches the upper 300 feet or less of the ocean, creating a productive layer of life called the euphotic zone. Below 300 feet, there is not enough sunlight to fuel the photosynthesis required for plant life. Since water filters out the warm colors of the light spectrum quickly, the light that reaches to the depth of 300 feet is blue-green in color. At depths past 3,000 feet, where the most bizarre deep-sea fish species are found, the environment is pitch black. The pressures at these depths are enormous. At 3,000 feet, water exerts a

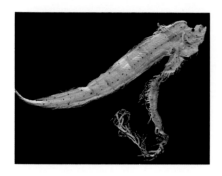

This bizarre, unidentified "exterilium larva" is thought to become a grouper as an adult. The trailing extension of the gut is thought to mimic sargassum weed or a jellyfish. New Guinea.

The black sea dragon (left) probably waves its barbel with bioluminescent lure, growing from the front of its mouth, to attract prey. San Clemente Basin, California.

These deep-sea toads show the typical oily, soft-bodied shape of deep sea fishes. Florida.

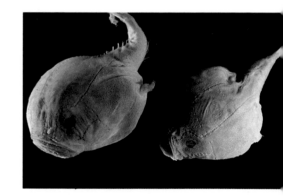

NOTES FROM THE FIELD

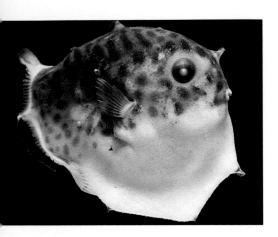

The tiny inch-long larva of the ocean sunfish (or mola mola) is little more than a head. It grows into a bizarre adult that swims the open ocean in search of jellyfish. Equatorial Pacific.

THE ABYSS

pressure of over half a ton per square inch! The temperature at these great depths is a uniform 39 degrees Fahrenheit, and the salinity and other characteristics of this water are also similar from one location to the next. Consequently, many of the bizarre fishes and invertebrates of the deep sea are found in every part of the world. For instance, sometimes the same species of deep-sea anglerfish can be found off California as well as South Africa.

All animals of the deep sea are predators or scavengers, relying on the productivity of surface waters for food. Rare falls of large animals such as sharks and whales may provide a bonanza for scavenging fishes, which can gather to a corpse at astonishing speed. Remotely operated camera systems and, more recently, manned submersibles have documented feeding frenzies at baited sites thousands of meters down.

The lack of food in the abyss causes animals to adopt feeding strategies that capitalize on rare good fortune. Should a fish encounter a potential meal, it will likely eat it regardless of the prey's size. Large female anglerfish, with teeth in the back of their throats to keep prey from escaping as it is being swallowed, have been recorded taking prey two or three times their own length. Another family of fish, the black swallowers, is well known for a tremendously extensible stomach that is frequently found filled with large prey equal in size to the predator itself.

Living in waters that can dip to 30 degrees F., the crocodile icefish has evolved unique features to survive. Its blood contains no red blood cells or hemoglobin. Anvers Island, Antarctica.

NOTES FROM THE FIELD

THE ABYSS

The serpentlike deep-sea swallower has an enormous head, and a hinged mouth that can open like a garbage truck to swallow prey.

Since food is so scarce, fish species have developed many ways to make themselves neutrally buoyant, wasting little energy on trying to keep afloat. Their skeletons and vicious-looking teeth are flimsy, muscles are weakly developed, and eyes, brains, gills, and kidneys are often very small. With few exceptions, deep-sea fishes develop little in the form of spiny or armored protection. These economies are forced upon them because they live in the poorest food-containing part of the ocean. To conserve energy, most midwater dwellers lure their prey rather than chase it.

The cutlassfish has an elongated, strongly compressed body and fanglike teeth. Pacific Ocean, Baja Mexico.

The black swallower has an enormously distensible mouth and expandable stomach to accommodate prey larger than itself. Central Pacific Ocean. / 234-235

NOTES FROM THE FIELD

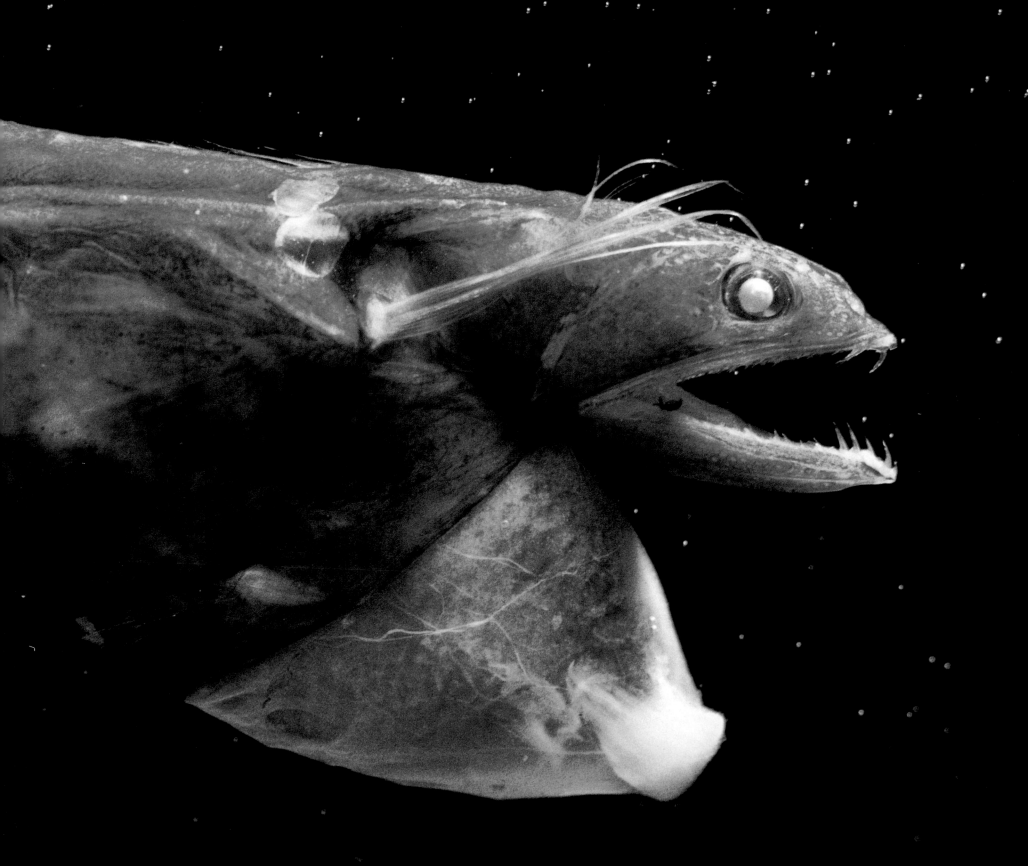

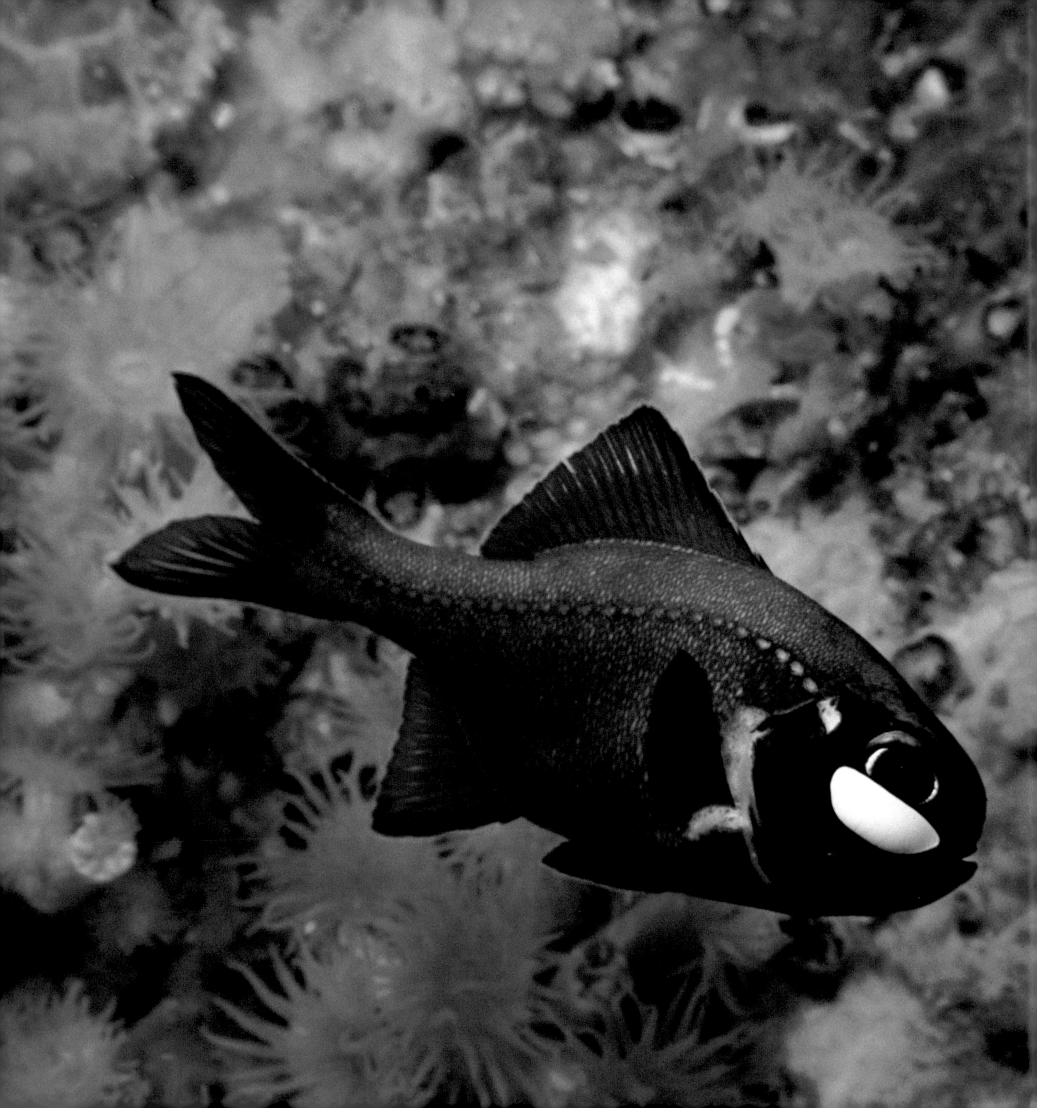

LIVING LIGHT

The flashlight, or lanterneye, fish has a light organ under its eye which is used in mating and finding prey. Different species have different ways of controlling the light. Sipadan Island, Borneo.

Many marine animals have developed their own light sources. Some corals and anemones in the tropics glow a strange orange or red color at depths where warm colors are usually not seen without the aid of a flashlight. At night, brittle sea stars and worms may give off flashes of light when disturbed. Tiny plankton in the water can cause surf to glow on dark nights, and dolphins riding the bow wave of a boat may gleam with phosphorescence.

Night diving is a popular activity now, but in the 1960s it was a novel experience. At Hydrolab, one of the first undersea habitats, scientists were surprised to discover bright lights hovering over the edge of a coral wall on moonless nights. The lights belonged to a previously undiscovered class of fish, the lanterneye or flashlight fish, which have a luminous patch below each eye. Since then, flashlight fish have been discovered in almost every tropical sea. One type of flashlight fish turns its light on and off by raising a flap of skin to alternately cover and expose it. Another type can rotate its light organ in its socket.

In tropical waters at 3,000 feet, only the faintest suggestion of light from the sun exists. The animals of the abyss have made numerous adaptations to see in even this faint amount of ambient light. Most fish have eyes particularly sensitive to the particular wavelength of blue-green light that filters though from the surface. Their eyes consist of pure rod retinas, which in humans are

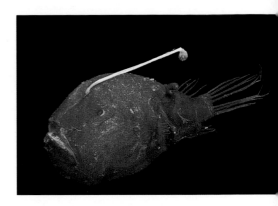

A seadevil shows its "fishing pole," complete with luminous lure. Southwest Indian Ocean.

LIVING LIGHT

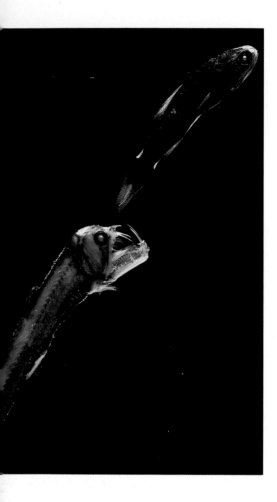

A viperfish is poised as if to attack a lanternfish. The lanternfish has light organs on its tail which may fool predators into attacking its tail rather than its more vulnerable head. Atlantic Ocean, Dominican Republic.

used in night vision. It has been estimated that these fish can see fifteen to thirty times better in dim light than humans can. Some fish have developed tubular eyes that look upward, catching all available light. Tubular eyes allow their owners to judge distance and detect prey silhouetted against the light from the surface. As a defense, fish such as the hatchetfish have rows of light plates along the underside of their bodies that emit light to match the color and intensity of light from the surface. They thus avoid casting a shadow!

Other uses of bioluminescence abound in the deep sea. Fish may use light sources to attract prey, signal mates, render the sender invisible, confound predators, and serve as invisible light beams. The pattern of light organs for a given fish distinguishes the species. Black dragonfish use muscles to pull a screen of black pigment cells down to hide the light organ below their eye, and they also have a row of light cells all along their body. Black dragonfish even have luminous barbels at the tip of the mouth, and viperfish have light organs within their mouths that lure prey right into a waiting stomach. With such elaborate capabilities of flashing lights, fish recognize each other by displaying an individual constellation of lights.

Less than a foot long, this fierce-looking viperfish specimen has light organs within its mouth to lure potential prey inside. Southeastern Pacific.

NOTES FROM THE FIELD

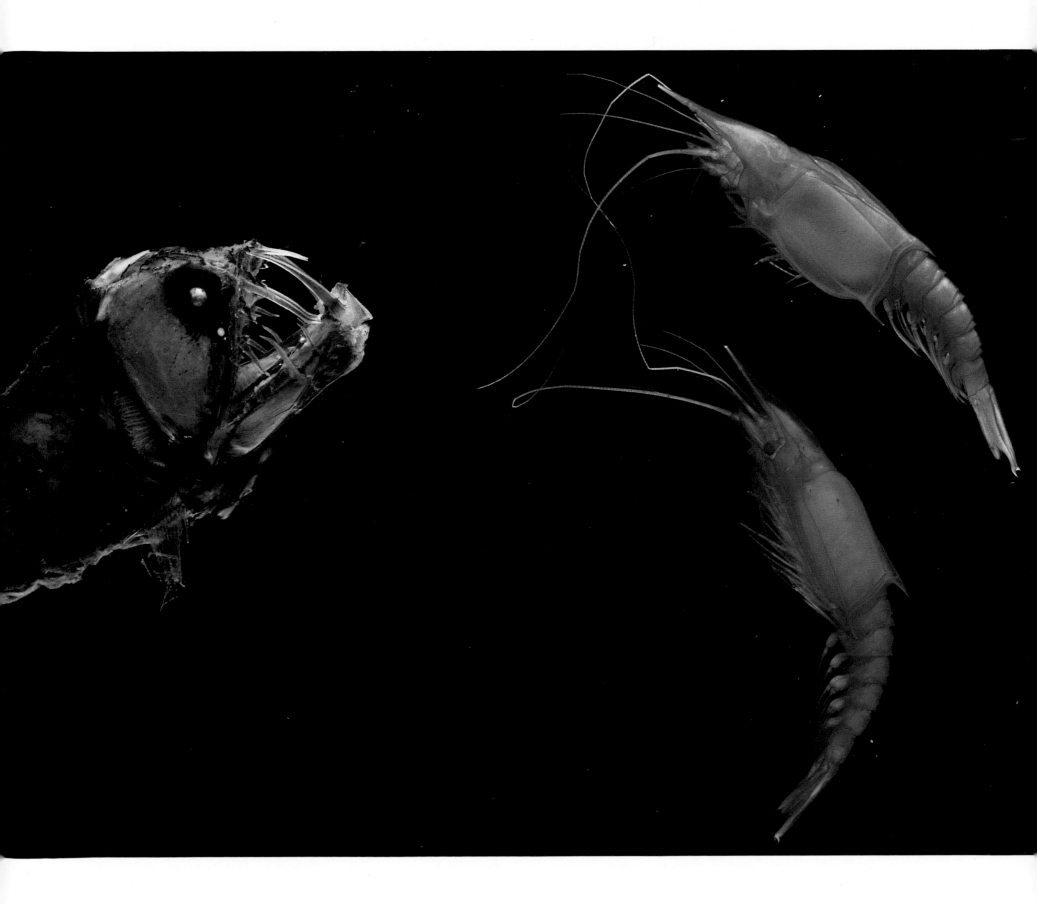

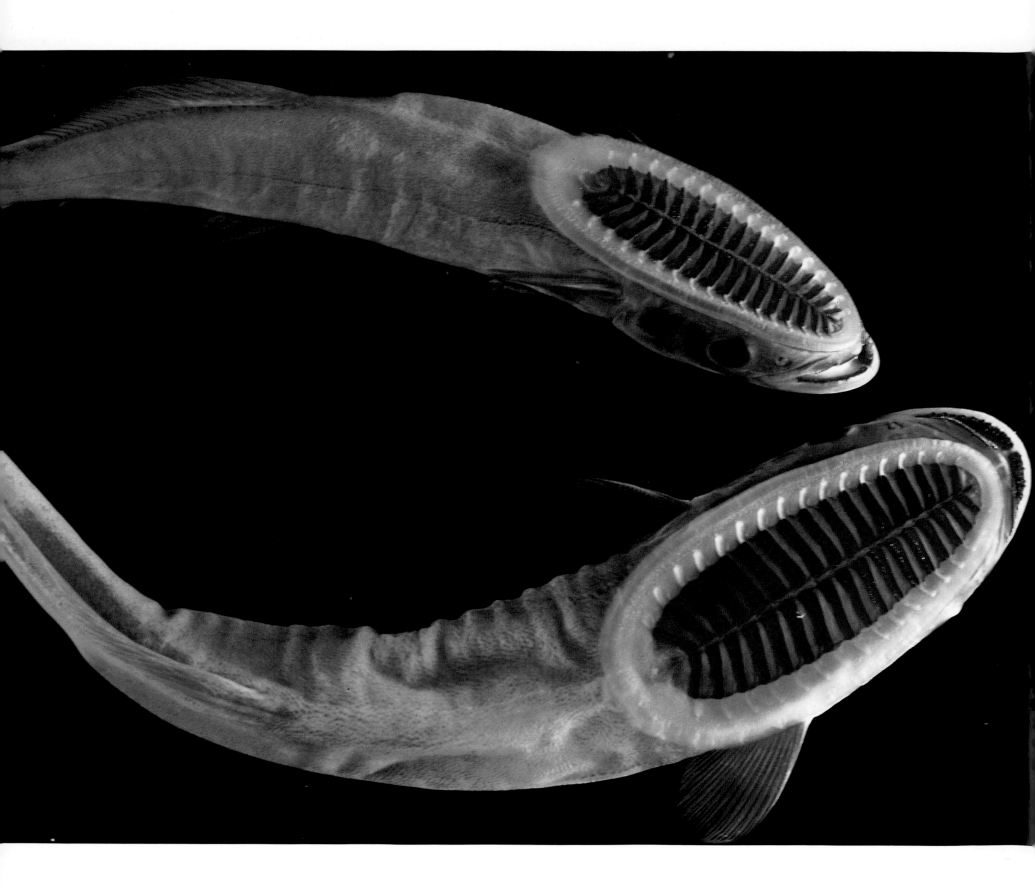

PHOTOGRAPHING
DEEP-SEA CREATURES

A black dragonfish.

A deep-sea anglerfish.

Remoras (left), also called
sharksuckers.

You learn to be patient on a boat that is trawling in the deep sea. A huge net, as wide as the side of a barn, is lowered overboard from a 200-foot-long steel-hulled research vessel. The vessel may cost $10,000 or more per day for the scientist whose grant is supporting the expedition. It may take days to lower the net to the depth being studied, to collect enough material, and to raise the net. After all of this work, and after sifting out miles and miles of water, the contents of this huge net may yield only a few globs of protoplasm. Jellyfish and soft-bodied animals are destroyed, as are most of the fish. If you are lucky, perhaps a single deep-sea fish is still in good shape. Very rarely does something like an anglerfish couple come to light.

These fishes were netted on a series of research expeditions. The photographs were taken as the fishes were brought up, in a shipboard tank, or later when they were preserved for the Marine Vertebrate Collection at Scripps. Very few were alive when photographed, and none were photographed in their natural habitat. It is the temperature difference more than anything else that kills deep-sea fish as they are brought to the surface. Although deep-sea fish experience an enormous change in pressure as they are brought to the surface, most don't possess a swim bladder. The expansion of the swim bladder, due to change in pressure, is the usual cause of death in fishes brought up from shallower depths. Most

A deep-sea anglerfish.

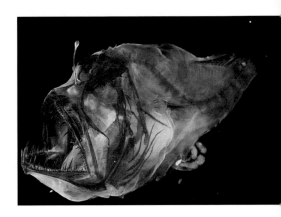

Note: The specimens in this section have been cleared and stained to show their internal structure. Bone, a feature of more advanced fishes, has been stained red. Cartilage, a feature common to more primitive bony fishes such as sharks and rays, has been stained blue.

NOTES FROM THE FIELD

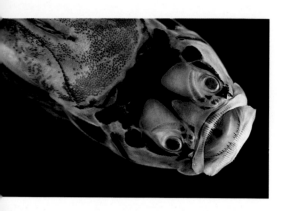

The highly developed skull of a stargazer.

DEEP-SEA PHOTOGRAPHY

deep-sea fish are surprisingly small, ranging in size from two inches to three feet. Their bodies are light and oily, and their bones and teeth are brittle and flexible, the better to hover motionless in the water.

The bizarre and grotesque forms of deep-sea fish were once thought to be extremely primitive. However, the photographs of the cleared and stained specimens graphically illustrate the fact that these fish are highly advanced animals that evolved in upper surface waters and were forced out of their original habitat by competition from other species millions of years ago. As they adapted to life in the deep ocean, these creatures evolved the many features now characteristic of deep-sea fish: light organs; oily, soft bodies; tubular eyes; needle-sharp teeth; and huge mouths and stomachs.

Dr. Richard Rosenblatt of Scripps put these specimens through acids and dyes to show their internal structure. Bones are stained red, and cartilage blue. Cartilage is the dominant internal structure of sharks, rays, and more primitive fishes. In deep-sea fish, however, the entire internal structure is stained red indicating bone, a feature of advanced fish. Only recently has technology enabled man to catch firsthand glimpses of deep-sea life. Even in deep-sea submersibles, however, these creatures are rarely seen. The photographs seen here are a first look at a virtually undiscovered, untouched realm.

A deep-sea fangtooth.

NOTES FROM THE FIELD

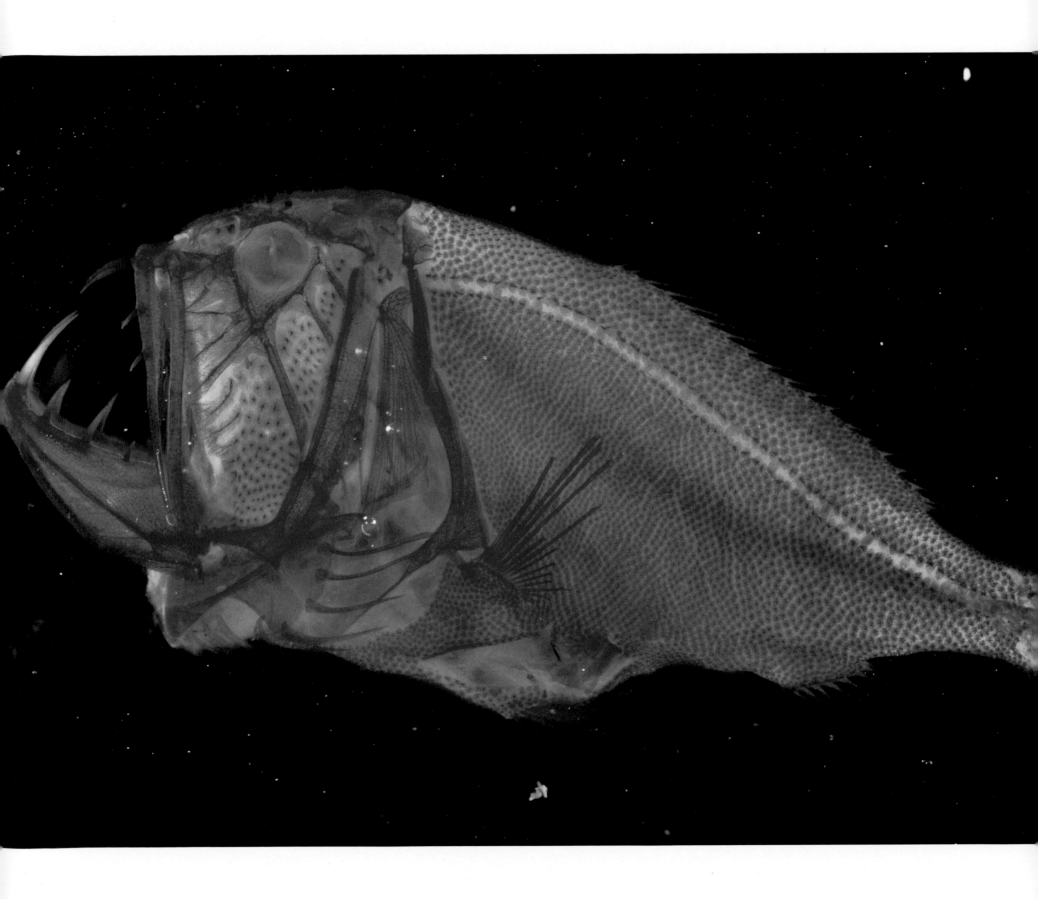

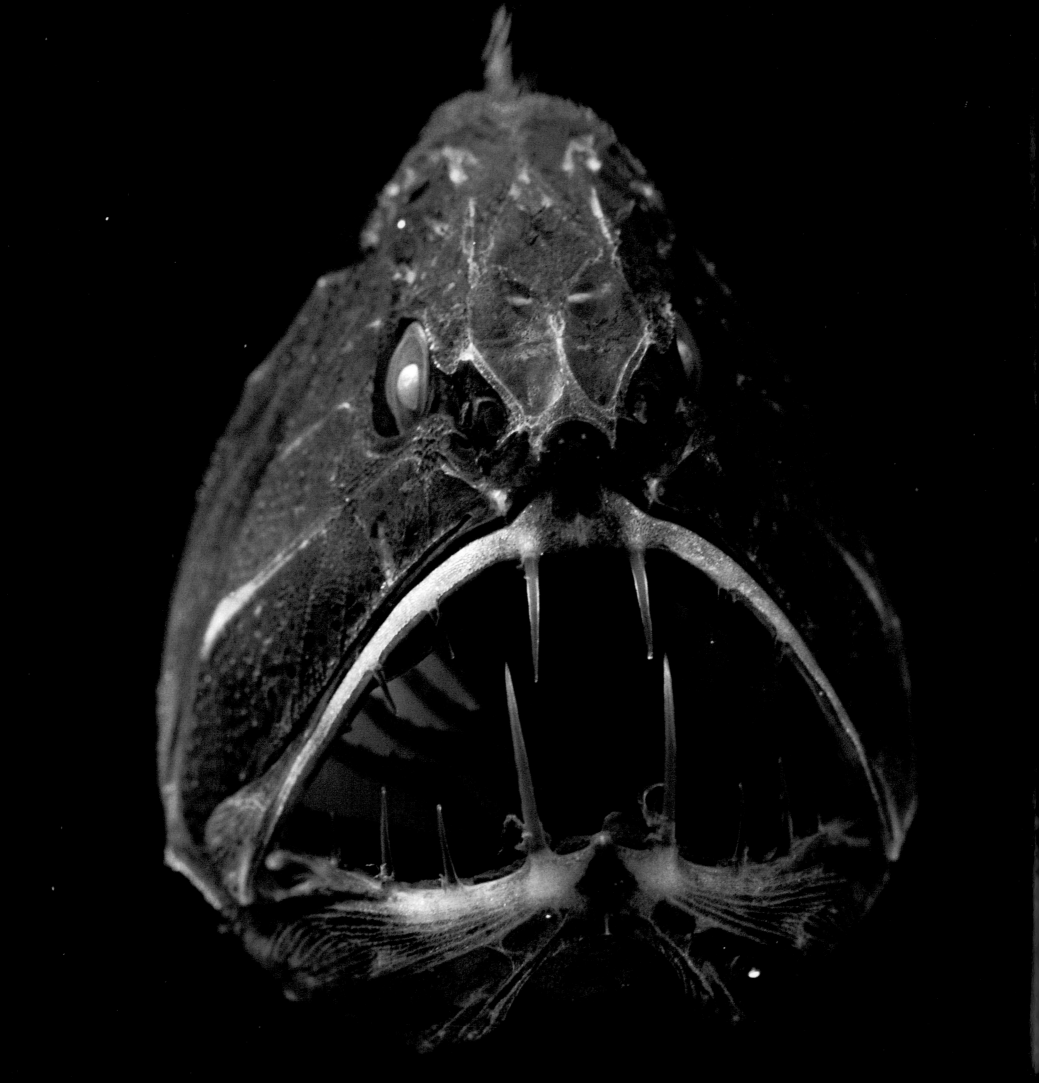

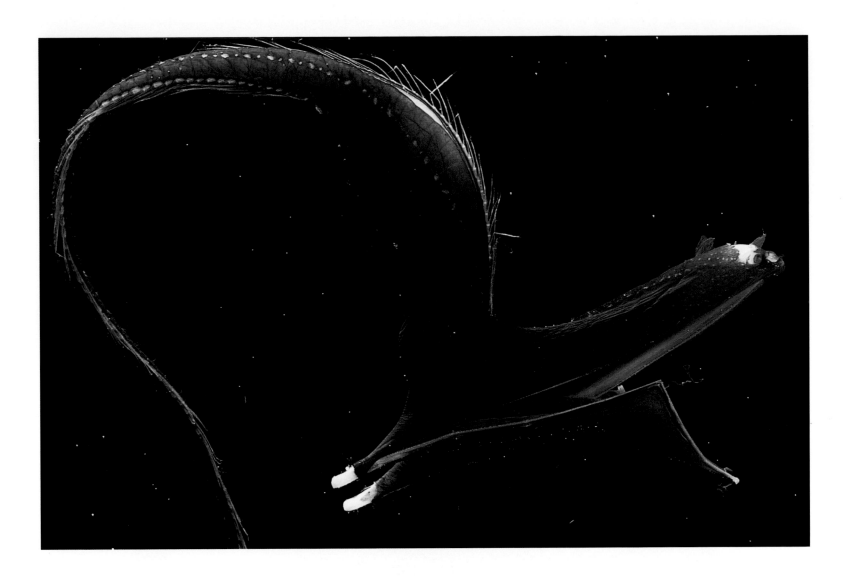

*Far fewer creatures live in the
deep sea than in shallower
depths. Predators like this deep-
sea gulper must be capable of
eating anything that comes their
way. San Diego, California.*

*The fangtooth (left) is one of the
few deep-sea fishes considered
well armored. For the most part,
deep-sea fishes have soft and
flimsy bodies. Eastern Pacific.*

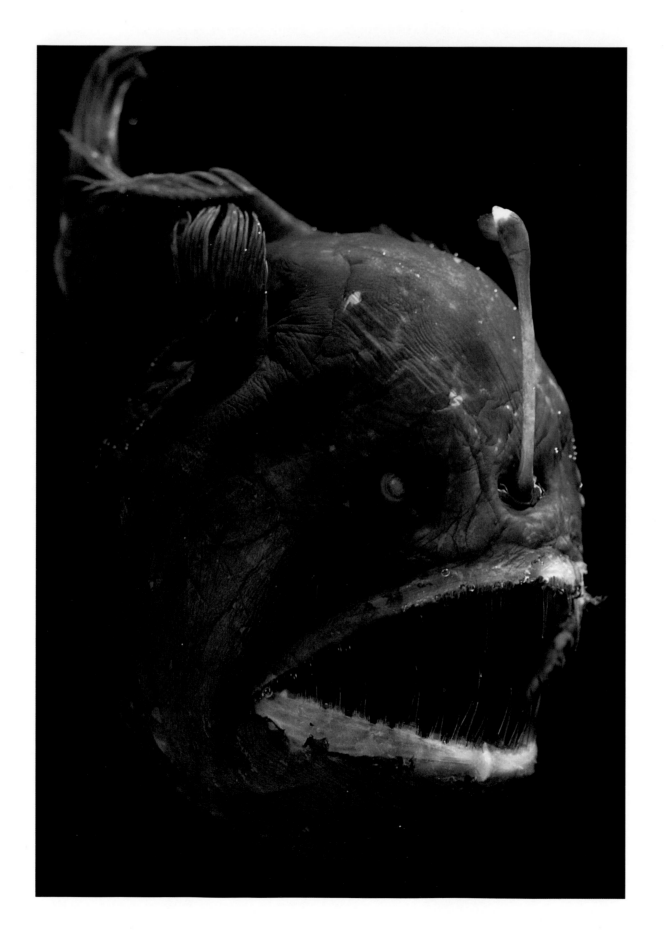

SEX AND THE
DEEP-SEA ANGLERFISH

Predators in the abyss, like the eight-inch-long anglerfish, must contend with very restricted food supplies. As a consequence, their populations are extremely small. Scientists may trawl miles of ocean for days only to find one female anglerfish. The scarcity of individuals in a species creates a great problem for sexual reproduction. How such lonely hearts find each other in the vast reaches of the deep sea remains one of the great unsolved mysteries of deep-sea biology.

We know that female deep-sea anglerfish use "fishing poles" with luminous lures to attract prey. The rod is an extension of a basal bone, at the tip of which hangs a bulbous light lure. The basal bone is moved by two main pairs of muscles — one pair pulling it forwards, the other backwards — thus extending the rod and lure well in front of the enormous head and jaws of the female anglerfish. If the winking lure attracts a gullible prey, prey can be drawn towards the large and powerful jaws with long pointed teeth.

Scientists believe that these lures also play a role in mating. Males have special eyes to detect flashing bioluminescence, which can lead them to the flashing lure of a potential female partner. Fishes of all kinds have the ability to orient themselves to a current, and so males are probably able to follow pheromones — special scents released upcurrent by females — much like a dog following a scent upwind.

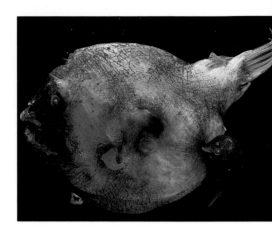

Dwarf male attached, this female ceratoid anglerfish presents a grotesque appearance. Parasitic males are an unusual solution to the problem of finding a mate in the deep sea. Japan.

Equipped with a luminous lure between its eyes to attract prey, this female deep-sea anglerfish was found by scientists at depths below 1,000 feet. Mid-Pacific Mountains, Northern Pacific.

NOTES FROM THE FIELD

SEX AND THE ANGLERFISH

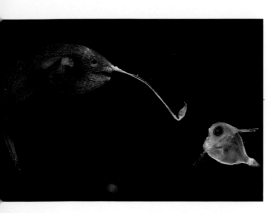

This deep-sea anglerfish is poised as if to draw in a larval fangtooth with its luminescent lure. The lure, attached to a modified dorsal spine, acts much like a fishing pole. Central Northern Pacific.

Once a male and female anglerfish meet, they employ a strategy to guarantee a fruitful encounter. Males are much smaller than females. When a male of most species encounters a female, he will attach himself to her with his mouth. Gradually, the male becomes a parasite of the female; his mouth fuses to her body, and blood vessels actually form between the couple. The male becomes little more than an attached sperm supply, about one-twentieth the size of the female.

Dwarf males solve many problems, not the least of which is being there for the female all the time every time, all night every night. Not only is the energy budget of the population reduced, but there is less competition for food between the sexes. Dwarf males are small, mature quickly, and are short-lived. They range in size from a half-inch to two inches long and are much better shaped for swimming than their partners (which range in size from four inches to three feet long). Males possess well-formed muscles and ample fuel supplies to fulfill their sole purpose in life — finding and fertilizing a female. Scientists term him "an obligatory sexual parasite." In some cases, multiple males are found attached to a single female, lifetime partners all.

Anglerfish are not the only deep-sea species to have developed an intriguing reproductive strategy. The lightfish goes through a most interesting life history. At one year, individuals attain sexual maturity as males; in

This larval deep-sea anglerfish (right) has no problem staying afloat. Its gelatinous casing keeps the larval fish from sinking, and may deter predators by making the fish appear larger than it actually is. Celebes Sea.

In this reenactment of a possible abyssal scene, a predatory viperfish attacks a deep-sea hatchetfish. The viperfish's long, sharp teeth are so large that the mouth may actually hang open. Southeastern Pacific. / 250-251

NOTES FROM THE FIELD

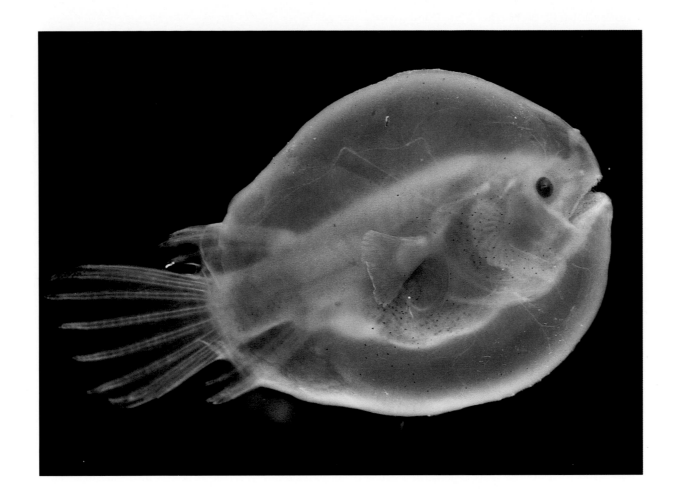

SEX AND THE ANGLERFISH

the summer of the second year, males become females. This ensures that females responsible for putting energy into producing eggs are the larger ones, and it solves the problem of food competition between sexes. Barracudina and lancetfish have both ovaries and testes. In these fish, if the sexes fail to meet, self-fertilization is an alternative, albeit not an entirely satisfactory solution in terms of genetics or romance. It's hard to find a mate down in the abyss, so reproductive patterns often are very economical.

NOTES FROM THE FIELD

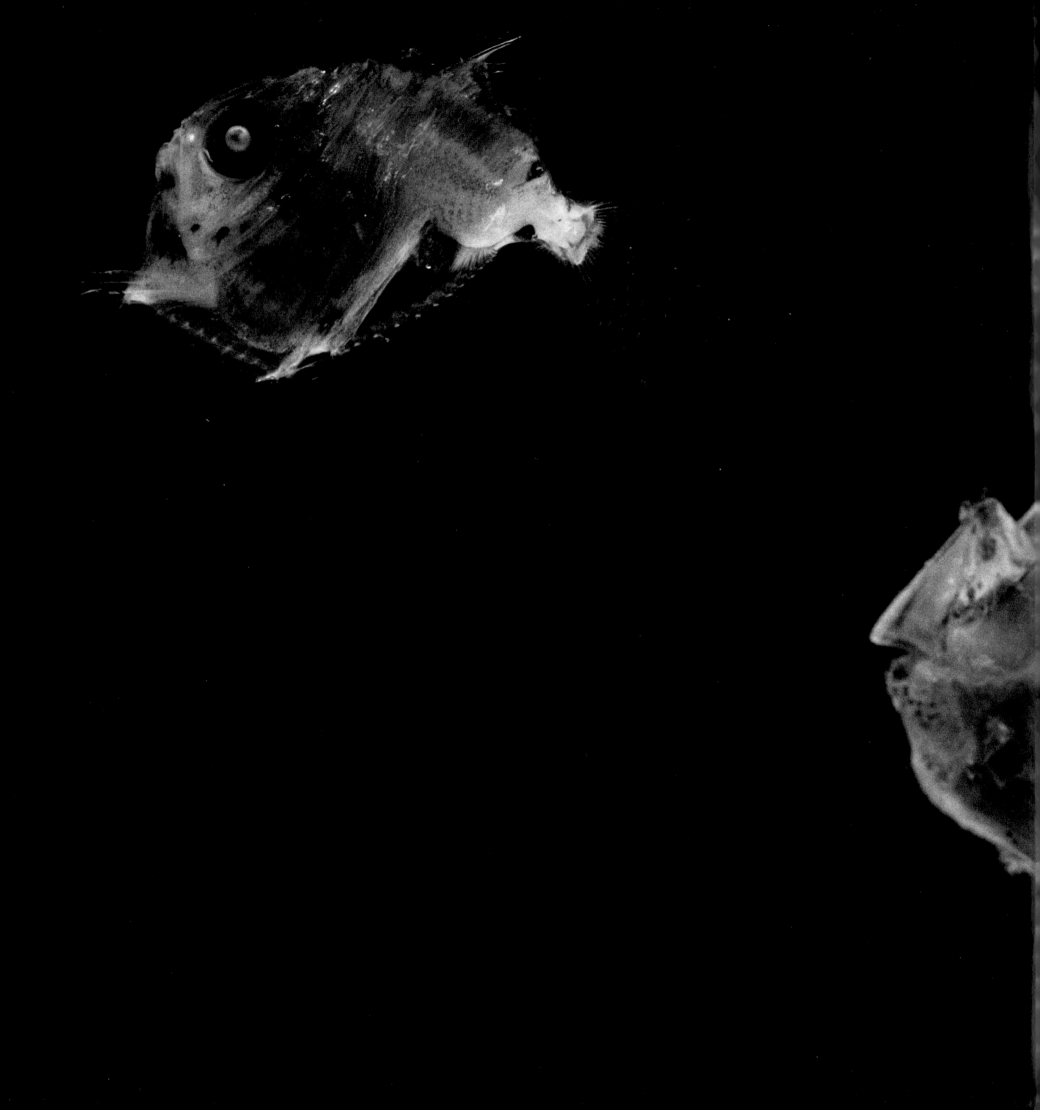

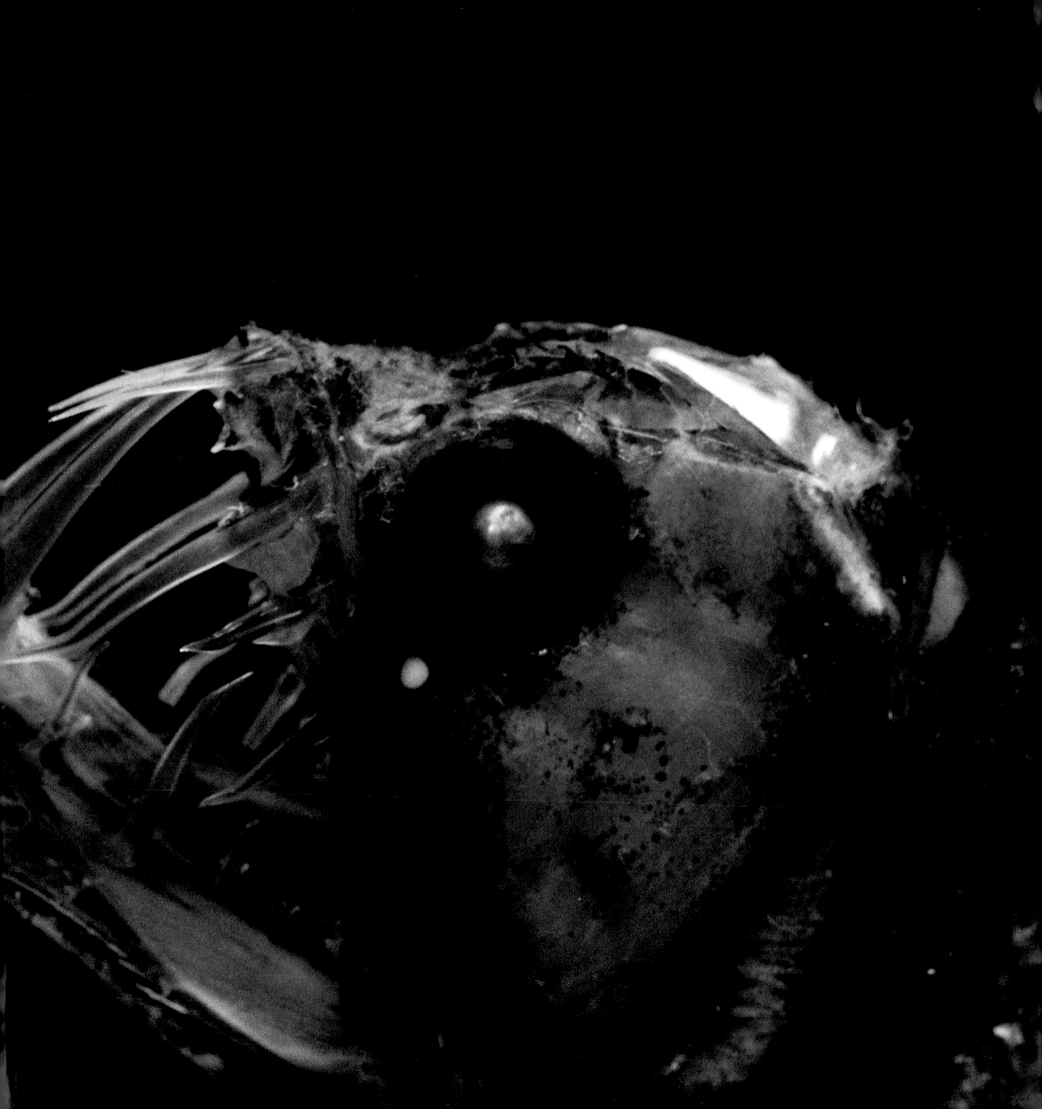

Tripodfish propped up on their elongated caudal and pelvic fins have been seen from deep-sea submersibles and remote cameras. Their upper "feelers" are extended into the water column and are probably used to sense potential predators or prey coming towards them. Magellan Rise, Equatorial Pacific.

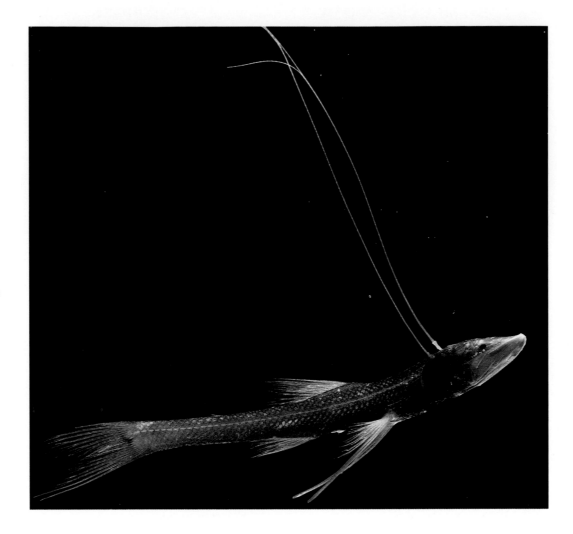

Perhaps nothing in the seas better fits the popular concept of a monster than these deep-sea fishes. It is ironic that these grotesque, hideous animals are actually quite small, and their bodies soft and flabby. Although they may look the part, these creatures aren't quite the monstrous man-eaters that most people associate with the deep sea. They are but one of the many tales of the sea that are far from the truth. We've come a long way since the days when everything that looked strange seemed threatening. These and the many other inhabitants of this last great wilderness have become more familiar to us, but certainly no less fascinating.